D1471585

This catalogue accompanies an exhibition from the National Collection of Watercolours at the Victoria and Albert Museum. In a study of paintings spanning some two hundred years, by artists as renowned as Gainsborough, Turner, Cotman and Paul Nash and as little known as Harriet Lister and Robert Tucker Pain, Lewis Johnson explores the familiar and the unfamiliar in one of the most apparently tradition-governed practices of painting. Taking as his starting point the formation of the Collection in the mid nineteenth century, he examines contemporary claims for watercolour as a modern art, and shows how certain notions of the modern were interlinked with nationalist and imperialist culture in Britain. His analysis of traditional criticism's dependence on these ideas, and of its limitations in the face of a complexity of historical, social, political and philosophical questions raised by the paintings, makes this study a bold and timely contribution to the reappraisal of the history and theory of art in Britain.

Published in association with the Victoria and Albert Museum.

Prospects, thresholds, interiors

Prospects, thresholds, interiors

WATERCOLOURS FROM THE NATIONAL COLLECTION
AT THE VICTORIA AND ALBERT MUSEUM

LEWIS JOHNSON

*Published in association with the
Victoria and Albert Museum*

CAMBRIDGE
UNIVERSITY PRESS

Published by the Press Syndicate of the University of Cambridge
The Pitt Building, Trumpington Street, Cambridge CB2 1RP
40 West 20th Street, New York, NY 10011-4211, USA
10 Stamford Road, Oakleigh, Melbourne 3166, Australia

First published 1994

Printed in Great Britain at the University Press, Cambridge

A catalogue record for this book is available from the British Library

Library of Congress cataloguing in publication data

Johnson, Lewis, 1960–
Prospects, thresholds, interiors : Watercolours from the National
Collection at the Victoria and Albert Museum / Lewis Johnson.
 p. cm.
Published in association with the Victoria and Albert Museum.
Accompanies an exhibition of watercolours from the National
Collection at the Victoria and Albert Museum.
Includes bibliographical references and index.
ISBN 0 521 44488 8 (hardback) – ISBN 0 521 44927 8 (paperback)
1. Watercolour painting, British–Exhibitions. 2. Watercolor
painting–England–London–Exhibitions. 3. Victoria and Albert
Museum. National Collection–Exhibitions. I. Victoria and Albert
Museum. National Collection. II. Title.
ND1928.j64 1994
759.2'07442134–dc20 93–3423 CIP

ISBN 0521 44488 8 hardback
ISBN 0521 44927 8 paperback

TAG

For W. L. and J. A. Johnson

Contents

List of illustrations *page* xi

Preface xv

Acknowledgements xix

Introduction

 Watercolour as a modern art 1

 Painting, progress, the modern and the national 5

 Maintaining the prospects of progress 12

 Prospects and interiors in question 19

1 Events on the horizon 23

2 Surveying a city 43

3 Staging the event 61

4 Prospects of the past 93

5 Thresholds of the domestic 111

6 Thresholds of the foreign 137

7 Prospects of the picturesque 159

8 Prospects of the land 183

9 Doubling thresholds: still-life and flower painting 199

10 Thresholds of modernism 219

Bibliography 243

Index of artists 251

Illustrations

1 Richard Wilson, *Landscape*

2 Jonathan Skelton, *Tivoli: The Great Cascade*

3 William Pars, *St Peter's, Rome: View from above the Arco Scuro, near Pope Julius' Villa*

4 Lady Diana Beauclerk, *Group of Gypsies and Female Rustics*

5 William Pars, *Killarney and Lake*

6 Charles Catton, *View of the Bridges at Hawick*

7 Francis Towne, *Rydal Water*

8 John White Abbott, *Corra Linn. One of the Falls of the Clyde*

9 Harriet Lister [Mrs Amos Green], *View of the Castle and Cavern at Castleton, Derbyshire*

10 John Baptist Claude Chatelain, *A View from the Summer House in Richmond Park down the River Thames*

11 Thomas Theodosius Forrest, *York Stairs, the Thames, Blackfriars Bridge and St Paul's Cathedral*

12 Paul Sandby, *Moonlight on a River*

13 Paul Sandby, *The Round Temple*

14 Paul Sandby, *The 'Old Swan', Bayswater*

15 Thomas Rowlandson, *Vauxhall Gardens*

16 Edward Dayes, *Buckingham House, St James's Park*

17 Robert Dighton, *A Windy Day - Scene outside the Shop of Bowles, the Printseller, in St Paul's Churchyard*

18 Alexander Cozens, *Landscape*

19 Thomas Gainsborough, *Landscape: Storm Effect*

20 Robert Adam, *Romantic Landscape, with Figures crossing a Bridge*

21 John Robert Cozens, *View in the Island of Elba*

22 John Robert Cozens, *Mountainous Landscape, with Beech Trees*

23 John Varley, *View in the Pass of Llanberis*

24 Cornelius Varley, *Part of Cader Idris and Tal-y-Llyn*

25 Charles Vincent Barber, *On the River Mawddach, Merionethshire, Cader Idris in the Distance*

26 David Cox, *A Welsh Landscape*

27 John Constable, *View in Borrowdale*

28 John Constable, *Stoke Poges Church, Buckinghamshire: Illustration to Thomas Gray, 'Elegy in a Country Churchyard'*

29 John Constable, *Design for an Illustration to Gray's 'Elegy', Stanza 3*

30 John Sell Cotman, *The Devil's Bridge, Cardigan*

31 John Sell Cotman, *On the Tees at Rockcliffe*

32 Joshua Cristall, *Hastings Beach*

33 Thomas Hearne, *Durham Cathedral from the Opposite Bank of the Wear*

34 Thomas Girtin, *Louth Church, Lincolnshire*

35 Thomas Girtin, *Rievaulx Abbey, Yorkshire*

36 Thomas Girtin, *Porte St Denis, Paris*

37 Joseph Mallord William Turner, *Interior of Tintern Abbey*

38 Joseph Mallord William Turner, *Warkworth Castle, Northumberland*

39 Joseph Mallord William Turner, *Vignette: Linlithgow Palace by Moonlight*

40 Joseph Mallord William Turner, *Lyons*

41 Francis Wheatley, *The Dismissal*

42 Francis Wheatley, *The Reconciliation*

43 Henry Fuseli, *Woman in Fantastic Costume*

44 William Blake, *Moses and the Burning Bush*

45 William Blake, *Christ in the House of Martha and Mary* or *The Penitent Magdalen*

46 John Everett Millais, *The Eve of St Agnes: Interior at Knole near Sevenoaks*

47 Dante Gabriel Rossetti, *The Borgia Family*

48 Simeon Solomon, *Isaac and Rebecca*

49 Ford Madox Brown, *Elijah Restoring the Widow's Son*

50 Edward Coley Burne-Jones, *Dorigen of Bretaigne longing for the Safe Return of her Husband*

51 Edward Killingworth Johnson, *A Young Widow*

52 Albert Moore, *An Open Book*

53 William Alexander, *Emperor of China's Gardens, Imperial Palace, Pekin*

54 Samuel Prout, *Porch of Ratisbon [Regensburg] Cathedral*

55 Richard Parkes Bonington, *Corso Sant'Anastasia, Verona, with the Palace of Prince Maffei* (Front cover)

56 Thomas Shotter Boys, *Quai de la Grève, Paris, in 1837*

57 James Holland, *Hospital of the Pietà, Venice*

58 Alfred Elmore, *Two Women on a Balcony*

59 David Roberts, *The Interior of the Capilla de los Reyes in Granada Cathedral, showing the Tombs of Ferdinand and Isabella, Philip and Juana*

60 John Frederick Lewis, *The Hhareem*

61 John Frederick Lewis, *Life in the Harem, Cairo*

62 Edward Lear, *Tripolitza*

63 Cornelius Varley, *The Market Place, Ross, Herefordshire*

64 Luke Clennell, *The Sawpit*

65 John Crome, *Old Houses at Norwich*

66 Peter De Wint, *Old Houses on the High Bridge, Lincoln*

67 David Cox, *Water Mill, North Wales*

68 John Sell Cotman, *Interior of Crosby Hall*

69 George Cattermole, *Interior of a Baronial Hall*

70 George Price Boyce, *Tithe Barn, Bradford-on-Avon*

71 Helen Allingham, *Cottage at Chiddingfold, Surrey*

72 Walter Fryer Stocks, *The Last Gleam*

73 John William North, *1914 in England*

74 Samuel Palmer, *At Score, near Ilfracombe*

75 Samuel Palmer, *Landscape with a Barn, Shoreham, Kent*

76 John Linnell, *Collecting the Flock*

77 Anthony Vandyke Copley Fielding, *The Moor of Rannoch, Perthshire, Schiehallion in the Distance*

78 John Ruskin, *Pines under the Petit Charmoz*

79 Robert Tucker Pain, *A Misty Morning at Tal-y-Llyn, North Wales*

80 John Kennedy, *Rumbling Bridge, near Dunkeld*

81 Mary Moser, *Vase of Flowers*

82 James Hewlett, *Hollyhock, Roses etc.*

83 Anne Frances Byrne, *Roses and Grapes*

84 Louisa Hay Kerr [Mrs Alexander Kerr], *Opium or White Poppy*

85 Peter De Wint, *Still Life. A Barrel, Jug, Bottle, Basin etc. on a Table*

86 William Henry Hunt, *Hawthorn Blossoms and Bird's Nest*

87 Marian Emma Chase, *Wild Flowers*

88 Vanessa Bell, *Flower-Piece*

89 David Jones, *The Violin*

90 James Dickson Innes, *Seaford*

91 Robert Polehill Bevan, *Rosemary, Devon*

92 Paul Nash, *Old Front Line, St Eloi, Ypres Salient*

93 Edward Burra, *Back Garden*

94 Charles Ginner, *Through a Cornish Window*

95 David Jones, *No. 1 Elm Row*

96 Gilbert Spencer, *Winter Landscape seen through a Window*

97 Edward Bawden, *'Christ! I have been many Times to Church'*

98 Eric Ravilious, *A Farmhouse Bedroom* (Back cover)

99 John Piper, *The River Approach, Fawley Court, Buckinghamshire*

100 Frances Hodgkins, *In Perspective*

Colour plates (between pp. 241 and 243)

1 Charles Catton, *View of the Bridges at Hawick*

2 Paul Sandby, *The Round Temple*

3 John Robert Cozens, *Mountainous Landscape, with Beech Trees*

4 John Constable, *Stoke Poges Church, Buckinghamshire: Illustration to Thomas Gray, 'Elegy in a Country Churchyard'*

5 John Sell Cotman, *On the Tees at Rockcliffe*

6 Thomas Girtin, *Rievaulx Abbey, Yorkshire*

7 Joseph Mallord William Turner, *Lyons*

8 John Everett Millais, *The Eve of St Agnes: Interior at Knole near Sevenoaks*

9 Simeon Solomon, *Isaac and Rebecca*

10 William Alexander, *Emperor of China's Gardens, Imperial Palace, Pekin*

11 John Frederick Lewis, *Life in the Harem, Cairo*

12 Cornelius Varley, *The Market Place, Ross, Herefordshire*

13 George Price Boyce, *Tithe Barn, Bradford-on-Avon*

14 Samuel Palmer, *Landscape with a Barn, Shoreham, Kent*

15 David Jones, *The Violin*

16 Frances Hodgkins, *In Perspective*

Preface The exhibition catalogue appears to be an unstable genre. From pamphlets to book-length publications; from checklists and *catalogues raisonnés* to collections of essays, theses, monologues, dialogues, polylogues: there seems little but the requirements of *identification* of the things catalogued by which the genre is marked.

To have cited the above examples in the order given, however, is already to have acceded to a not uncommon prejudgement. While it might be admitted that identification is common to all texts which are, in turn, identifiable as catalogues, it might seem that there is a kind of obvious hierarchy: from the simple to the complex, from the checklist to the thesis or polylogue. The notion of the *catalogue raisonné* seems to mediate between the extremes of this hierarchy: a text identifiable by the apparent descriptiveness of what accompanies its identifications, its titles of works, dimensions, media, materials, history of exhibition, of commentary and ownership.

This division between the apparently identificatory and the apparently descriptive is, however, an effect and not merely a cause of catalogues. The divisibility of catalogue texts in this way might be salvaged if we were to maintain that identification depended on description. We might maintain that titles, systems of measurement, accounts of genre, media or materials derived from the descriptive possibilities of languages: of so-called natural languages and of the (apparently metaphorically termed) languages of dimension, even perhaps, occasionally, weight. But as soon as we recall that there are more languages than the English of this text, and realise that any description is maintained, in order to be taken as descriptive, within a horizon of prescription, then the priority of the descriptive – logical, chronological or historical – disperses.

In the text which follows effects of the dispersal of the descriptive and its

imagined priority may be traced, at least in the following ways. This selection of watercolour paintings from the National Collection of Watercolours at the Victoria and Albert Museum is preceded by an essay which attempts to trace the important interests at stake in the identificatory discourse of the formation of that collection. The priority of the descriptiveness of the first 'Descriptive Catalogue' of the collection is put in question, to see what the collection was expected to serve: the ends of a collection of a particular kind of visual art in the name of a nation and of a national school.

It is no accident, of course, that this particular kind of visual art was identified as descriptive. This projection of the aims and ends of description has marked not only the criticism of watercolour, but of other kinds of painting and other kinds of images. There is perhaps no more usual way in which a discourse distributes and, sometimes, disguises its prescriptiveness than by an appeal to an image, to something which appears to be a record of appearance. The notion, however, that descriptiveness occurred in paint so that identification of paintings of and for a collection might follow is, once again, to accede to a prejudgement about the priority of the descriptive, one which we may call, recalling the condition of history as text, chronological.

We may, in turn, question the logical priority of the descriptive. We may conclude that there could be no effect of logic were there not a language of which description appeared to be derivable and separable. Perhaps this is one of the ways in which visual art attracts commentary, by appearing to offer something by means of which the descriptive might be identified. Barthes called this a dream of an 'Edenic state': of denotation, a dream of a time when the image, speaking and writing had not already begun to err from and exceed their apparent functions of communication.[1]

The text which follows is by no means free from the apparent division between the descriptive and the identificatory. Nor is it free from traces of the attractions of visual art. I have sought, however, in the entries on the individual paintings, which follow the introductory essay below, to question traditions and tendencies of commentary which have attracted and been attracted by these paintings. This has led me to the construction of a kind of network, internally related if necessarily not closed, in which the history of watercolour, as a particular kind of painting identified as British, gives way to histories which differ from that unifying narrative of cultural heritage.

The bias of the text which follows, given the dispersal of the descriptive mentioned above, is to encourage reading to pass on, within the ten different

sections, from entry to entry, to inquiries into different strands of the history of painting in Britain, from the middle of the eighteenth century to the middle of the twentieth century. Thus, I hope that this text contributes to reexplorations of that history, but ones which do not expect to replace the narrative of imperial and nationalist criticism with another unifying narrative. In this way, this text remains a catalogue text, and not a general thesis about the history of painting in Britain. I doubt that there is such a general history to be written. Rather, I hope that the entries to the individual paintings provoke and sustain further reinquiry into the paintings in question, histories of critical reaction as well as inquiries into the lack of critical reaction. I do not believe, as will emerge below, that the history of watercolour painting can be separated from the history of other kinds of painting without tending to remain unconscious of the interests which have maintained that separation. It is my hope that this book may provoke further reading and writing on questions of the history and theory of painting, of other images and other practices of visual arts, by enabling recognition of something of the complexity which emerges once the cover of a common past disappears.

Thus this text remains a catalogue, one which enables selective readings, from entry to entry and chapter to chapter. Perhaps for those of its readers who have seen the exhibition, it will enable a kind of recollection of having been able to wander with and against the grain of the hanging of the paintings. For those who may not have done, I hope that it enables such activities to be imagined. Instead of anxieties about the instabilities of genres, of writing and of visual art, may there emerge questions of the singularity of the example.

1 Roland Barthes, 'The Rhetoric of the Image', *Image–Music–Text*, trans. Stephen Heath, Fontana Books, London, 1977 (pp. 32–51), p. 42.

Acknowledgements

The work that has become this text was begun as part of a joint venture by the Center for the Fine Arts, Miami and the Victoria and Albert Museum, London in the spring of 1987. My involvement in the project of an exhibition of works from the National Collection of Watercolours at the Victoria and Albert Museum and a catalogue to accompany it is thus indebted to Professor Marcia Pointon, then of the University of Sussex, who recommended me. John Murdoch, then Keeper of Prints and Drawings at the Victoria and Albert Museum, and Robert Frankel, Director of the Center for the Fine Arts, helped me to find ways around the collection, and to decide on the aims of the project.

The subsequent publication of this book by Cambridge University Press and the staging of the exhibition with which it is associated at the Victoria and Albert Museum owes much to many people. Thanks are due to the Center in Miami, for releasing the text from copyright. Richard Beardsworth's demands for clarity have been a vital spur. David Solkin encouraged me in the early stages of the project's second phase. Céline Surprenant has helped to maintain the effects of that encouragement and to achieve something of the clarity of what follows. Jonathan Bignell's more than a little Latin has been of more than a little help.

Once again, staff at the museum have been encouraging and helpful, including Mark Haworth-Booth, Susan Lambert and, with his patience apparently intact, John Murdoch. Thanks are due to them for assisting at many stages. The Picture Library – Edwin Wallace in particular – and the Photography Department have been similarly helpful. Ronald Parkinson's careful combing of and for the text has been most beneficial. John Trevitt's enthusiasm for the project as editor at Cambridge University Press was instrumental in enabling this publication to appear. Following his retirement in 1990, Rose Shawe-Taylor took over the responsibility for guiding

me in the production and review of a manuscript with care and consideration. Their advocacy of the project has been vital and their assistance and advice invaluable. Hilary Gaskin and Caroline Murray have assisted with editorial and production matters with patience, diplomacy and skill. Alison Gilderdale's contributions, questioning and advice as copy-editor have been better than merely supplementary: the readability (to select a term significant to both of us) of the text owes much to her.

Perhaps statements of debts in thinking are always incomplete. I want, however, to record my thanks to John Barrell who enabled me to realise that teaching was still taking place in the University of Cambridge. I hope that he finds more to approve in the following than I imagine he still expects. Timothy Hilton might not recall having taught me and he might not recognise very much of what I have to say about Ruskin. Still, I hope that he does. I hope too that Marcia Pointon finds that her belief that I had something interesting to say about painting, its criticism and history, has some reward in this work.

I would also like to record the immeasurable debts I have to three people. Carolyn Burdett's care and attention, and her interest in this work from the beginning, sustained and recreated mine. Finally, I hope that my mother and father will recognise in this book something of my indebtedness to them. For opportunities which they have given me, and helped me to have, and for many arts which I have enjoyed, something of at least one of which I hope now to understand, I dedicate this book to them.

The illustrations in this catalogue are reproduced by courtesy
of The Trustees of the Victoria and Albert Museum.

Introduction

WATERCOLOUR AS A MODERN ART

It may be difficult to imagine the conditions under which painting in watercolour was thought to exemplify a modern and progressive practice of visual art. Given its associations with amateurism and perhaps apprenticeship, certainly with instruction in painting and an often associated notion of the appreciation of art, watercolour is more likely to be thought of as mere diversion than as a modern and progressive practice. However, such a positioning of watercolour begs the question of what a modern and progressive practice in art might be. Indeed, since the advent of critical languages of post-modernism, the identification of painting and other practices, such as photography, as modern and progressive in so far as they arise from particular media and discover their aims in relation to the limits of them has been put in question. The possibility, however, that the lack of an understanding of histories of the modern and the progressive as notions in the criticism of art might make recognition of their occurrence and return less likely suggests that an inquiry into this surprising identification of watercolour painting might be more than a mere diversion or entertainment.

The differentiation of the modern and the ancient will have been an occurrence which is neither modern nor ancient. In proposing this, I want to indicate that the time of this differentiation may be put in question. The exemplification of the modern and the ancient, the identification of something with one and of something with another, presupposes a coexistence of these things, the having arisen of the former and the survival, if not the continued production, of the latter. The time of this co-existence is neither modern nor ancient.[1] However, the linking of the modern *and* the progressive together suggests the effacement of this question, an effacement in

which identification of the time of the modern holds out a prospect of the becoming common of the benefits of progress. Limitations of this prospect, however, may be missed. One of the ways in which this happens is a consequence precisely of the forgetting of what exemplifies the modern. So far as this concerns the practice, history and criticism of art, the forgetting of the positioning of watercolour as a modern and progressive art becomes important.

Having mentioned the term 'prospect', I want to suggest one of the reasons for using this term in the title to this catalogue. As part of the title to a selection of paintings, it might suggest that what is offered here is a categorisation of these paintings according to the three classes, prospects, thresholds and interiors. From time to time, this will seem to be what I have been doing. However, it is not my aim to bring about a reorganisation of the National Collection of Watercolours, categorised in these ways, although such an undertaking might not be without its benefits. The process of categorising itself, which is essential to this or to any other collection, if only as what enables there to be a collection, is something which needs to be understood in order that the limits of organisation and reorganisation may emerge.

A first move in this respect is therefore to stress that, in so far as some of the watercolour paintings considered below, which have been and may again be identified as prospects, were used to exemplify the modern and progressive, a conservation of the time of the modern may be traced. In place of the loss of determination associated with modernity, such prospects, as the paradoxical survivors of this loss of determination by the past, and as examples of the further paradox of a tradition of modernity, become the sites of projection: projections of the conservation of this time, of its articulation as a time of progress and development, of the prospects of the extension of that progress and its benefits to all. Certain crucial limitations on this last case of the extension of such benefits to all will emerge below. Meanwhile, I want to concentrate on the questions of time, space and the modern.

The exemplification of the modern and the progressive by means of watercolours identified as prospects may be understood to entail an effacement of space. In so far as such prospects may be identified as representing, a certain effacement and conservation of space as place occurs. As examples of the modern and the progressive, then, such images present occasions for the projection of place as the site of progress. If there is no pure creation of space, then such an identification of space with place entails the effacement of the work of spacing, the predetermination of painting as a work of representation, as well as the determination of space as a site of appropriation. In such a construction of watercolour painting may be traced the inclusions and, by inference, exclusions of the spaces of the project of the modern, the production of space as place as the site of the projection of the modern as progress.

The categorisation of these watercolours as prospects, thresholds and interiors risks repeating this movement and this promise. Part of the aim of this selection has been to bring to notice the tendency to ignore questions associated with the watercolour paintings which may be categorised as interiors. Some of the reasons for this will emerge below, in this introduction and in the different sections dividing this selection of a hundred paintings. Most importantly, however, the effacement of this question of interiors has depended on an identification of watercolour painting with landscape. Interiors seem secondary, as if what has been produced is a redivision of the possibilities of watercolour painting once the discovery of its potential for painting prospects took place. This hierarchy of the notional potential of watercolour has tended to reaffirm the containment of the interior, of different sites as interiors, within an exterior. The consequences of this redivision of watercolour painting, as a modern and progressive art, thus not only produces that possibility of an affirmation of space as place, the inclusion of space in the production of the site of the modern as progress, but also the production of that site's guarantee. With certain sites identified as interiors, as closed and quartered spaces, the inclusive movement of the identification of the prospect with space as place may be misrecognised and forgotten.

Neither prospects nor interiors, therefore, are primary or secondary in the history of watercolour painting. The former is primary and the latter secondary in a version of that history which has been determined by such generic categories. This study proposes no simple reversal. To claim that the production of interiors preceded or should have preceded the production of prospects would be merely to repeat the dependence of the history of watercolour painting on these generic categories. Rather, I want to suggest, in the phrasing of the title to this study, an interruption and a deferral of the aims of categorisation of watercolours as prospects and interiors. To slow down these identifications by the introduction of the term threshold is to recall the process of the differentiation of works into generic categories and to indicate the complexity that is suppressed when this takes place. For, if neither prospects nor interiors can be identified with places or sites without the effect of an inclusion of something to guarantee the differences between the outside and the inside, then the notion of a threshold may be used to change our sense of the works which seem to exemplify both of these categories. The notion of a threshold thus marks the effects of the differentiation of outside from inside and inside from outside which happens when the identification of prospects and interiors occurs. There is no one threshold betwen these two. Rather there are spaces of borders which are forgotten in these identifications.

The indication of the thresholds of prospects and interiors is thus designed to suggest how any particular work may be or has been mistaken for an assurance of

the differences between inside and out: differences, among others, of territory and of domestic space, of the cultivated and the wild, of the national and the local, of the extra-national and the intra-national. To displace the reliance on such assurances brings into question the identities which have depended on them. Among these, perhaps it is the question of the identity of the nation and the national which is most pertinent here. This reexamination of the paintings in the National Collection of Watercolours needs to begin with that apparently benign slide from the possession of the works in the name of a nation to the naming of the works in terms of the nation's name: from the National Collection of Watercolours to a collection of British Watercolours. Yet, what is benign about a nation or identifications of the national? The nation as locus and site remains exclusive, as do the consequential identifications of what belongs to it. Collections of visual art in the name of a nation are no exceptions to this, as the logic of categorisation outlined above suggests.

The aim here, however, is not merely to speculate on the inclusions and exclusions of particular works in this national collection. Rather, it is to explore the meanings and values of the national as it is marked in the terms of the formation of that collection, to see in what ways the already political naming of what belongs to the nation may be understood to have conditioned a tradition of criticism of paintings in watercolour. Under what conditions does it seem desirable and justifiable to claim possession of paintings in this way? Those who would protest that the languages of politics are inappropriate or excessive to the proper attentiveness to works of visual art would need to repress this case of the claims of the nation. Along with this reaction of repression would go a turning away from the possibilities of conflict which are produced, as well as deferred, by that claim; a risk of complicity with the movements of inclusion and exclusion on which nations depend and which, in so far as the movement of founding and maintaining the nation and the national depends on this, testifies to the expansionary moment of the identity of nations, as well as the drive to control this proprietary movement.

This review of the politics of a collection in the name of the national is not meant as a recommendation that this proprietary claim be withdrawn. It is something of a current prejudice that ownership is the proper and sometimes apparently exclusive function of the individual. It remains the case, however, that the state exercises proprietary claims, even and perhaps especially over individuals. Why and for what ends such proprietary claims are exercised, including those concerning collections of visual art, may be examined and reexamined. Those involved in the care and maintenance of collections of visual art in the name of the nation are already implicated in this claim and the question of the ends which it brings with it. It may appear to some, therefore, that they should serve the ends that those who are

engaged in the apparently legitimised government of the nation dictate. Such a conclusion, however, presumes that there could be such a dedication of curatorial and interpretative activity to the ends of the nation and its government. The following examination of examples of such claims and promises may contribute, therefore, to a recognition that such dedication is not simply undesirable, but moreover, without certain misapprehensions, and without misapprehensions of certainty, impossible.

PAINTING, PROGRESS, THE MODERN AND THE NATIONAL

In part IV of *Modern Painters*, 'Of Many Things', first published as volume III in 1856, John Ruskin pursues an argument and a division of his subject which are not insignificant among his treatment of 'many things'. This division of his work suggests that something other than mere variety is at stake here. A tripartite division of the history of landscape painting into classical, medieval and modern is made. Chapters on these epochs of landscape painting are then followed by one entitled 'The Moral of Landscape' and one, concluding part IV, called 'Of the Teachers of Turner'. I want to trace his argument back from the conclusions which he offers in this last chapter of part IV of *Modern Painters* to indicate some of their conditions and suggest some of their consequences, in his work and elsewhere.

It is inevitable that in beginning with the example of Ruskin's art criticism that two related risks are taken. On the one hand, there is the risk of simply confirming a notion that Ruskin is central to and formative of the criticism of art in the mid and late nineteenth-century in England. On the other, if this is not the case, there is the perhaps more serious risk that the repetition of this common exemplification fails to indicate how and why he is unoriginal and, furthermore, fails to suggest how he differs from other discourses of art criticism so that the illusion of his originality has arisen.

This latter risk has been brought to notice by certain recent work suggesting a context for reading Ruskin's work which relates his interest in landscape to a political discourse of civic humanism.[2] This contextualisation of Ruskin's work suggests something important concerning the conditions of emergence of Ruskin's writing. However, just as the theory of civic humanism is inadequate for conceiving the sources and effects of painting, that discourse is an incomplete version of the sources and effects of Ruskin's writing. In what follows I want to indicate that events of writing (and also, by extension, of painting) may intervene between sources and effects in ways which disrupt the confinement of the relations between

writing (and painting) and history to any completed history or to any discourse pre-conceived, or disavowed, as political.

What will emerge below, I hope, is that Ruskin's writing itself is marked by constructions of the ends of history and of politics, suppressions of politics and political relations by morality, but also by history, as well as suppressions of histories by politics and morality. To recover, as I hope to do, the question of the idiom of Ruskin's writing from generalised claims about his originality, idiosyncrasy or his influence, in order to show that the idiom is neither for certain his nor not his, is to read in a way which is itself irreducible to any preconceived politics, morality or history. If there is to be a separation between these three, then their indifference in particular instances needs to be diagnosed. In seeking to diagnose this indifference in Ruskin's work, I want to suggest why it occurs and in what ways it depends on the identification of a particular art with the modern. His notion of watercolour as a modern art will be shown to promote that indifference, one which remotivates his sense of the tie between landscape and a fiction of the body in and as a relation to a nation.

To undo this in the following will suggest something of the complexity of a part of Ruskin's work, relative both to other parts and perhaps to other discourses of the visual arts of the time. To question the indifference of politics, morality and history which the misidentification of watercolour promotes depends on the irreducibility of that art to any preconceived notions of the identities of either politics, morality or history. What emerges is that, if these are to be differentiated, and shown in their various complicities in tradition, then no programmatic statement of their identities or relations of mutual determination by another can accomplish this for us. Questions of the relations between art and modernity, history, politics and morality may not be answered once and for all: if there is to be differentiation, then it remains to be accomplished.

'Of the Teachers of Turner' provides a history of the practice of landscape painting in Italy, France, Holland and Britain. The destination of Ruskin's history emerges as he reaches the end of section XXXII. If we had been in any doubt before, it is now to be dispelled. While it may be the case, says Ruskin, that Turner may have received something from the contemporaries of his early career, particularly those 'who showed high promise in the same field, Cozens [probably John Robert] and Girtin', their deaths meant that there was not to be 'a struggle between one or other of them and Turner, as between Giorgione and Titian'. They 'lived not':

and Turner is the only great man whom the school has yet produced, – quite great enough, as we shall see, for all that needed to be done. To him, therefore, we now finally turn, as the sole object of our inquiry.[3]

Resisting this turn, I want to indicate how Ruskin's notion of the emergence of Turner, through this brief plot of rivalry, is a consequence of a particular version of the modern. The notion that there was a totality of tasks 'that needed to be done' is a particular version of a project, one which depends on the prior identification of the modern with the school on which Turner, initially, depended.

Ruskin has summarised his history of landscape painting. Painters from the Dutch school, 'more or less natural, but vulgar' and from the Italian, 'more or less elevated, but absurd' comprise, for Ruskin, 'the dead schools of landscape painting'. What Claude Lorrain, Gaspar Poussin or Aelbert Cuyp failed to do, whatever their differences, is presented as follows:

The grace of Nature, or her gloom, her tender and sacred seclusions, or her reach of power and wrath, had never been painted; nor had *anything* been painted yet in the true *love* of it; for both Dutch and Italians agreed in this, that they always painted for the *picture's* sake, to show how well they could imitate sunshine, arrange masses, or articulate straws, – never because they loved the scene or wanted to carry away some memory of it.[4]

There are many issues worthy of note here: the moral notion of love; the personification of nature as female, an assurance of the division of inside and out, nature happening out there, to 'our' interiors, the implicit limitation of an audience of 'us' to men controlling Ruskin's notion of humanity. Some of these issues will be considered below. Initially, however, I want to concentrate on the notion of memory implied here, which is important in enabling Ruskin to proceed to his determination of the modern.

The implication of wanting 'to carry away some memory of a scene' as a picture is the possibility of forgetting it. If we did not forget, it would not be desirable to do this. To paint in order to enable memory is to expect to forget. Latent therefore in this brief proposition, this supplement to the love of the scene – as if, without the supplement, we might forget which scene it was that we loved – lurks the possibility of a recognition of having remembered, realising that one had forgotten. This absence of a determination by a present and the failure to realise determination by the past is a moment of modernity which Ruskin suppresses as he moves on to his account of a movement from the past and the dead to the 'modern school', 'the only true school of landscape which has yet existed'.[5]

This exemplification of the modern entails the forgetting mentioned above, the forgetting of forgetting. The 'true moderns' in the following passage emerge to enable the foundation of a 'true school of landscape', the foundation of which is articulated spatially, as if providing a base from which subsequent development may take place. For Ruskin, given the example of Turner, this also promises fulfilment:

And thus, all that landscape of the old masters is to be considered merely as a struggle of expiring skill to discover some new direction in which to display itself. There was no love of nature in the age; only a desire for something new. Therefore those schools expired at last, leaving a chasm of nearly utter emptiness between them and the true moderns, out of which chasm the new school rises, not engrafted on that old one, but from the very base of all things, beginning with mere washes of Indian ink, touched upon with yellow and brown; and gradually feeling its way to colour.[6]

This account of the emergence of watercolour painting in Britain is the most dramatic I know. To dismiss it as melodrama, however, would be to miss the general appropriateness of some theatrical judgement here. For there is a conservation of space in play in Ruskin's rhetoric which supplements that forgetting of the difficulties of an emergence from the past. When Ruskin repeats the word 'chasm' he does so in a way which suggests that the second chasm is the proper chasm. First we have 'nearly utter emptiness'; then we have the beginning 'from the very base of things'. The 'very base' is the guarantee of the truthfulness of the possibility of the development that has been undertaken, or might be undertaken, discovered as prior to and underlying 'all things'. The movement of inclusion that this entails and promises is thus clear: from the imagined encounter with the chasm, which was not a chasm – for if it were, there could be no encounter – there is yet an emergence from the chasm; the chasm is *re*presented, somewhat theatrically, and the possibility of encompassing all things appears to be possible. The new school has become the chasm into which all else might be taken and emerge, represented and presented in watercolour.

It is telling that in this account of the formation of a national school, at that moment when the possibility of a foundation for an art which is properly modern has been identified and the prospect of inclusiveness presents itself, the first means of this is given by 'mere washes of Indian ink'. There is a double denial at work here. That attribution to the 'dead schools', who lacked that notion of love and whose paintings testify to nothing other than 'a desire for something new', fails to acknowledge the continued dependence of painting on an international complex of trade and of manufactures.[7] There is also a denial of the reformation of the modern here around the nation. The movement implied, therefore, is the denial of an importation, a reattribution of that which is imported to the site of another country and a possibility of a reaffirmation of the one to which it has been imported. As a consequence of the movement of inclusion at work here, the forgetting of the differences of nations and of the dependence of nations on one another which emerges characterises the complicity of Ruskin's account with expansionary nationalism.

This will be returned to below, in other texts, to explore how this notion of expansion can be understood to relate to a collection of visual art. Before doing so,

however, I want to follow some other strands of Ruskin's text to suggest why, during the middle of the nineteenth century, watercolour was identified with the national in this way. This involves returning to the construction of the modern school in contradistinction to 'the dead schools'. No longer the classical, nor the medieval, but indifferently the dead, it is their expiration which has apparently left that 'chasm of nearly utter emptiness' which the moderns then recovered. The 'nearly utter emptiness' is a loss which is not quite a loss. Loss is something, however, which Ruskin goes on to testify to, in section XXXIII, the conclusion of part IV of *Modern Painters*, a testimony which explains his promotion of the national school as the possibility of a redemption of the dead.

This concerns the necessary return of the example of the works of those from the 'dead schools', the maintenance of a way of affirming the difference between the modern and its other. This way of treating the remains in the chasm is not, it seems, sufficient. For section XXXIII opens by apologising for pursuing 'questions about our arts and pleasures in a time of so great a public anxiety as this'. This generalisation of anxiety and the production of the public is part of a treatment of Britain's involvement in the Crimean War, one which argues for a redemption of the deaths of soldiers during that war, in particular at Balaclava and Sebastopol.

It remains an argument in a particular sense, by maintaining and reinventing an adversary. For, as Ruskin argues, if the alliance of France and England in the Crimean War can stand, the one with her 'love of liberty' and the other with 'the standard of the Commonwealth', 'and so join in perpetual compact our different strengths, to contend for justice, mercy and truth throughout the world, – who dares say that one soldier has died in vain?'[8] Anyone who would dare to say this would be the other of the nation, the other of the international alliance of France and England, someone who would deny the possibility of the redemption of the dead, their sacrificial end in the contention for 'justice, mercy and truth throughout the world'.

It is a possibility of loss which Ruskin will not admit, this among the uncontrollable possibilities of war, and it is from such a possibility that redemption is to be achieved. It is, however, a notably incomplete redemption:

The scarlet of the blood that has sealed this covenant will be poured along the clouds of a new aurora, glorious in that Eastern heaven; for every sob of wreck-fed breaker round these Pontic precipices, the floods shall clap their hands between the guarded mounts of the Prince-Angel; and the spirits of those lost multitudes, crowned with the olive and rose among the laurel, shall haunt, satisfied, the willowy brooks and peaceful vales of England, and glide, triumphant, by the poplar groves and sunned coteaux of Seine.[9]

The interruption of the plot of Christian redemption which threads a way through this passage to be tied up with the redemption of the 'lost multitudes' of the nations of France and England results in this haunting. The redeemed land recaptures its dead as sacrifices to its own identity and project, its projected identity. Living in this time of the apocalypse, which is yet a scene of apparent peace at home, requires, if this haunting is not to be forgotten, the staining of the dawn, the reminder of the dead in the very return of the horizon of a new day. The staining of the dawn sky as 'that Eastern heaven' is confirmation that there must be some who will not be allowed to forget. If the nation is to recover itself after the imagined loss of its own heaven, there must be others to be put under the sway of that nation, others who have witnessed the reminder and know what it means, do not mistake it for their own heaven, in order that the nation can remember the dead which have been, so Ruskin argues, sacrificed to it. In these ways, Ruskin proposes an agenda of a culture of imperialism.

This recovery of the nation in war provides a limit of Ruskin's sense of landscape and a sense of its limits. The haunting of England and France begins and ends near water, 'the willowy brooks' and 'sunned coteaux of Seine'. To call these arterial would be to remind us of a metaphor of the body of the nation which is latent in Ruskin's argument for redemption of those bodies which died during the battles of the Crimean War.[10] To remember that they are divisions as well as links in the ground of the territories of those nations, lapses in the certainty of the grounding of them, is to realise why Ruskin wanted them for the unreleased spirits. Here they would guard the internal bordering of the land, while the external borders could be reaffirmed, whether extended or not.

This reading is not meant to imply that it was Ruskin's version of watercolour painting which determined these reflections on the Crimean War. To infer this, from the order of Ruskin's text, would be neither sufficient, nor necessary. What is at issue, however, is the fulfilment of a possibility of an analogy between an art exemplifying the modern and some other project and projected identity of the modern. It is as if the redemption of the possibility of projects of modernity were at stake. Ruskin himself goes on to develop and defend his analogising. Maintaining that 'true liberty, like true religion, is always aggressive or persecuted', Ruskin argues that Britain's involvement in the Crimean War has itself to become aggressive. In doing so, this will show that Russia's attack was 'appointed, it seems to me, for confirmation of all our greatness, trial of our strength, purging and punishment of our futilities, and establishment for ever, in our hands, of the leadership in the political progress of the world.'[11] This version of progress is a modern one in the sense that Ruskin established the possibility of a true modern earlier, in relation to painting: a time without end, to be begun as the modernism of watercolour painting was begun, in which progress might be identified with one leader, if more than one hand. To read in this the modernism of Fascism reminds us that more than one

nation has passed through, and not beyond, this possibility.

Ruskin links this passage of the redemption of the blood of the dead *as sign* with a prospect which argues for the kind of order which a nation victorious in the Crimean War, bearing that standard, might expect to establish and maintain. This is governed by 'that clearest of commandments, "Let no man seek his own, but every man another's wealth"'. This licence for appropriation and exploitation will operate under the covers of 'a newly breathed strength' and 'the newly interpreted patriotism'. The prospect which Ruskin presents suggests that the more or less casual identification of him as a prophetic writer depends on an avoidance of a recognition of the significance of anticipation in his work. Here, the anticipation of return on investment from the projects of the modern, political and artistic, becomes intertwined in an imperial agenda for British culture. Given its stress on the appropriation of the works and lives of others, somewhat in that order, one might say, further, that it was capitally imperial:

Learning, unchecked by envy, will be accepted more frankly, throned more firmly, guided more swiftly; charity, unchilled by fear, will dispose the laws of each State, without reluctance to advantage its neighbours by justice to itself; and admiration, unwarped by prejudice, possess itself continually of a new treasure in the arts and thoughts of the stranger.[12]

The movement of the extension of law-making from state to state, guided by charity, depends on a universalisation of a Christian ethic as a source of law, one which would regulate the relations of jurisdiction between one state and another. This guarantee of a source of law, a sketch of the possibility of a colonial governmental policy, demands in turn a return. Ruskin's notion of progress, by means of learning and charity, offers enlightenment at a price. Charity, as donation rather than as love, requires, in exchange for learning, some 'new treasure'. Envy of what the other appears to be able to receive gives way to admiration of what the other has or appears to have. The possibility of rule is given on condition that something may be given back, 'the arts and thoughts of the stranger', the good and goods of the unknown other.

This justification of a policy of the appropriation of the treasures of others, unknown, knowable on pain of instruction, but only therefore as the same, links Ruskin's criticism to the agenda of appropriative anthropology and museology which was such a large part of nineteenth-century British culture. The relations between this and the collection and care of works by those identified as of and for the nation–state, as already the same as their British audience, may emerge below, as I turn to consider the terms at work in the formation of the National Collection of Watercolours at the Victoria and Albert Museum. Here too, the identification of the modern with the national and with watercolour which has been found in Ruskin's criticism is at work.

MAINTAINING THE PROSPECTS OF PROGRESS

Among those most involved in the formation, maintenance and development of the
collection of watercolours at the then South Kensington Museum were the brothers
Richard and Samuel Redgrave. As the Art Referee at the Museum, Richard
Redgrave's responsibilities included buying for the collection, to add to the dona-
tion, in 1857, by John Sheepshanks of 298 watercolours and 233 oil paintings. The
identity of the collection as a collection of watercolours by British artists was some-
thing which his selections and purchases, including works by Thomas Hearne,
William Alexander and Thomas Girtin, developed and confirmed. Samuel
Redgrave's part as the author of the introductory text of the first single-volume cat-
alogue of the collection, begun in 1876, nineteen years after the Sheepshanks dona-
tion, was the occasion of a reiteration of those identifications, one with another, of
watercolour painting and a national school.[13] Already latent in this, however, was an
anxiety about the maintenance of the possibility of progress. The grounds of the
identification of works in the collection as watercolours was already a problem, if
the collection was to seem to exemplify the possibilities of the progress of this
national school, the national and its arts, the one interlaced in progression with the
other.

This interlacing can be traced back to a work coauthored by Richard and Samuel
Redgrave and first published in 1866. In *A Century of British Painters*, identified sub-
sequently as 'the first *popular* account of British Painting',[14] there is a chapter entitled
'Painters in Water-Colours' which, when read in conjunction with other moments
in the text, suggests that the popularity which has been claimed for this book
depends not on any mere measurement of its numbers in circulation, but rather on
a particular appeal to and maintenance of a notion of the identity of members of
the nation–state. The part played by paintings as images and paintings in a collec-
tion in the maintenance of this identity is complex and indirect. Indeed, it is in the
very possibility of a notional control of indirection and of orientation that paintings
are asked to play a part in that not unusual identification of visual art with the
national. A collection is one way of appearing to bring this about, both in the nec-
essary process of identification of its elements and in its arrangement.

The relations between these two possibilities are complex. In a certain sense, the
identification of the elements of a collection of visual art remains supplementary to
the possibilities of its arrangement. This is the case in so far as the collection is
designed to involve others, produce and reproduce them as members of the nation,
sharing in that identity. As one or other presentation, a collection always risks not
being able to promote and sustain those identifications. This is *necessarily* the case.
Hence the significance of particular presentations and representations of a collec-

tion: the latent and perhaps manifest conflicts between production and reproduction of possibilities of identification and the emergence, or not, of differences between them. The relations, therefore, between texts, catalogues, hand-bills and, like the Redgraves' *A Century of British Painters*, works of criticism and history, are caught in complex relations of supplementation of these possibilities of the presentation of a collection. So far as this concerns this work by the Redgraves, these relations of supplementation involve the suppression of possibilities of indirection and disorientation which are latent in the National Collection of Watercolours, and which it is an aim of this study to release.

The suppression of the possibilities of indirection and disorientation by the Redgraves is a necessary consequence of the nationalism of their text. Indeed, it is a necessary consequence of any text of nationalism, as it was seen to be, for example, in Ruskin's text above. The reasons for this will emerge below. The suppression by the Redgraves is more violent, more obviously nationalist. It also indicates how notions of progress, the modern and the national in art such as Ruskin developed were rearticulated as a paranoia of racial identity, as the maintenance of a possibility of the national.

The following excerpt from the chapter from *A Century of British Painters*, 'Painters in Water-Colours', might not, excised like this, appear to demonstrate this. It resembles nothing so much as a version of Ruskin's beginning of the modern, national school. However, adapting that model by the introduction of the all but commonplace notion (which Ruskin did without) that the practice of topography was the source of the proper identity of this school, there is already a sense of place in which a notion of progress may be situated. This, however, brings its own problems:

The direct reference to nature, both at home and abroad, which was of the essence of the art of these men, was beginning to work a change, and was itself a source of progress towards true art. It was impossible for men who as topographers were brought face to face with nature, though at first attending only to the most obvious facts and details which were their chief aim, not to observe also nature's more varied moods and changes; and it only required a man of genius to arise, who, pursuing the same course, should be able to give life to the meagre truthfulness of the topographer, to place the art on a wholly different footing. In such hands, and with the new materials, there were no traditions of the 'black masters' to stand in the way of progress – to prevent a man from using his own eyes, and seeing Nature as she really is.[15]

It is my contention that we can read here, in the cited phrase 'black masters', the possibility of that paranoia of racial identity mentioned above, as well as a paranoia of the nation as the exemplification of political progress. This is not the authorised

significance of this text, as I shall indicate. However, it is prepared for by a reframing of the logic of the progress of a national school which will come to haunt later significant accounts of the collection.

The similarities with and differences from Ruskin are telling. The reliance on a notion of the topographical as the source of this school renders the appeal to Nature all the more ineluctable. The topographical as the possibility of an inclusive representation of space as place depends on a forgetting of the space of the representation, save as this site of apparent reference to nature. Nature is thus that which is supposed to exist *indifferently* in all things outside and beyond the frame. The space of the image is absorbed in this guarantee of a name of what is represented there, and space beyond the image becomes the possibility of place, of being placed in place, moving from place to place, recognition promised in advance. Progress is thus advertised and assured. The personification of nature as female serves to repair in advance anything which might be imagined to go wrong. From image to image, the dialectic of place and space still threatens disorientation and loss of the terms of identification and recognition. Nature as the name of what exists of being in beings prepares the unknown and unnamed for an encounter, for a 'face to face', and for representation. What differs, according to this programme, differs only inessentially, in its 'moods and changes'. Of the essence of the art of these men is therefore nature as the essence, what may be found having faced them, having enabled them to overcome disorientation. From having been exiled from nature, required to refer, she enables their resurrection, their overcoming of this lack in being to which referring refers, her invention the guarantee of their own.

This personification is also a displacement of and maintenance of the notion of a person as such. Why the authors of this text should be compelled to reinvent this figure as that illusory guarantee depends on the denial of relations of state and colonies such as are implicated in this sense of maintaining being in place in a place. The suppression of the chasm, of that possibility of the very lack of possibility of identification, is recovered here as the division between topography and the expressive practice of Turner. The first *must* be forgotten as the source, for the resources of nature to be recovered, and recovered as exploitable. The return to life and vitality in the works of Turner is thus the recovery of being in beings, the identification of the former with a limitation of the latter. The need for a 'wholly different footing' is a consequence of misrecognising the possibility of finding yourself in the domain of the other, forgetting the possibility of claims of possession and rule already in place, aiming to reestablish all the identities that that might put in question.

Turner's role is thus, for the Redgraves, to establish and maintain the destination of this national and modern practice as a placing beyond place, a situation of the

viewer in place, in nature, beyond the very possibilities of boundary and limitation. Such a version of the notion of progress in the development of the national school was to come to appear, for certain inevitable reasons, more and more difficult to sustain. In general, the separation here between truthfulness and an aesthetic destiny for the practice of painting, the separation of fact and value, entails such a division of works and tradition in order to ensure a regulation of truth and pleasure in vision, the latter possible as a reward for satisfying an obligation to the former.

Some of the consequences of this critical inheritance are explored in the chapters of this catalogue which follow this introduction. I want now to return to the Redgraves' text. One sense of the claim that 'there were no traditions of the "black masters" to stand in the way of progress' is therefore as a denial of the claims of property and authority already in place elsewhere in the world, claims which, if they were acknowledged, might mar the apparently inaugurating work or obstruct the passage of the British topographers, preventing them from playing their part in the progressive development of British culture. As was noted above, however, this is not the authorised significance of the 'black masters' passage. I want to explore the significance that this passage would have if the authority of the authors, the Redgrave brothers, were to be followed. This will show how the notions of authenticity which were discovered above, deriving from and belonging to Nature as the guarantee of the source and meaning of art, were to be regulated by the control and management of the collection. For the significance which their text would have us give to the phrase 'black masters', this quotation, this little bit of the outside *in* their text, trying to guarantee its inside, involves the very reliability of the collection as such.

Indeed, it involves the possibility, so it seems, of the reliability of all collections, especially in England. In the introduction to *A Century of British Painters*, we are informed that 'the works of the black masters' are forgeries.[16] Quoting Hogarth, the Redgraves detail the practice of deceiving collectors in the late seventeenth and early eighteenth century in England. The first culprit, it seems, was a restorer, Hieronymus Laniere. The unreliability of the restorer, his turn to deception, is narrated as if to control this possibility of corruption of the ends of connoisseurship and the consequent duping of the collector and curator:

William Sanderson in his *Graphice* (1658), tells of this old master of the cleaning craft, as 'the first who passed off copies for originals, by tempering his colours with soot, and then by rolling them up, he made them crackle and contract an air of antiquity'. Laniere's inventions have survived until the present day.[17]

The Redgraves' interest in this continued circulation, as collectors, for themselves and for the state, is clear enough. Their interest in watercolour thus emerges as

being partly determined by their desire not to be duped: watercolours, for them, do not let themselves be disguised in this way; rather, they let the marking of the mark be seen, let the connoisseur see his way. This version of watercolour, its identity determined as translucent, becomes important to them in so far as they want to ensure the reliability, value and validity of a collection of them. As servants of the state, they want to be able to appear to be able to ensure that the Hieronymus Lanieres of this world, those who are in a position of being trusted by a master, can be identified and controlled.

Such a control, moreover, would also be a control of time. If the old may be faked by being blackened, then the division between old and modern becomes unreliable, and the time of the modern may not be guaranteed, without the effect of a supplementary claim, such as that of the connoisseur, that there are indeed modern works and old works. The difference between these is not self-evident, however, and the time of the claim itself, repeating the differentiation of modern and old, occurs in a time neither old nor modern.

To justify their role as judges of the forgery and the original, the inauthentic and the authentic, the Redgraves suggest that they are indeed serving the interests of the painters. Hogarth is said to have had 'no sympathy' with the practices of the likes of Richard Brompton, Parry Walton, Giovanni Cipriani, John Rigaud and William Kent, all of them painters, cleaners *and* forgers. This prosecution of the bad painters, having called upon Hogarth's testimony, then quotes the painter Benjamin Robert Haydon, recently deceased. Introduced as an account of 'the cruelties suffered by a picture under such hands', the Redgraves in effect use this testimony to suppress the problem of forgery. Haydon does not mention it; instead of a question of the identity of the image, he presents evidence for the crisis of the identity of the painter, a man as painter, one which the Redgraves can thus figure themselves as also serving and maintaining:

They may talk as they please of the sufferings of humanity, but there is nothing so excites my sympathy as the helpless sufferings of a fine old oil picture of a great genius. Unable to speak or remonstrate, touching all hearts by its dumb beauty, appealing to all sympathies by its silent splendour, laid on its back in spite of its lustrous and pathetic looks, taken out of its frame, stripped of its splendid encasement, fixed to its rack to be scraped, skinner [*sic*], burnt, and then varnished in mockery of its tortures, its lost purity, its beautiful harmony, and hung up again, castrated and unmanned, for living envy to chuckle over, while the shade of the mighty dead is allowed to visit and rest about his former glory, as [*sic*] a pang for sins not yet atoned for.[18]

Haydon's anxieties and defences against them are too complex to be detailed in full here.[19] The reasons for there being envy of the castrated no doubt involve the

desire not to be a man, not to have to suffer that identification, the desire to be able to imagine a resurrection of a time, a time his pictures may yet survive to witness, when being a man would not involve this possibility of castration. The identification with the suffering of the picture would thus render this notional identity truly imaginary, if there were any such possibility.

The haunting to which the Redgraves' text testifies is the haunting of the living by the dead, the threat of their presence transformed, by this citation of Haydon, into the possibility, as their text unwinds, of curating and maintaining these identities, including this anxious identity of the male artist. The tricks of the black masters, their tortures of the picture, its body and soul, would be circumvented by the keeping of the identity of the watercolour tradition, its modernism, its genealogy and the possibility of living on in that tradition. Watercolours cannot suffer like this, and survive. Once in their care, in and out of their frames, there would not be this possibility of the haunting of the identity of the work and of the artist.

There is a pathology of the transience of the watercolour which might be written, one which would remark on the identities put at risk and yet sustained by their collection, if not their production. A letter from Ruskin to *The Times* of April 1886 would be part of this: in answer to a protest by J.C. Robinson about watercolours being shown for too long at the South Kensington Museum, he assures his audience that if 'properly taken care of...a water colour drawing is safe for centuries', supplementing the improbability of this claim by concluding rhetorically 'is it for your heir that you buy your horses or lay out your garden?'[20] This anxiety about inheritance indicates the difficulty of letting watercolours, as at the South Kensington Museum, serve their roles as examples in the national collection, and at the same time appear not to put at risk the survival of that identity or the other identities which the collection of them might maintain.

The exclusion of the 'traditions of the "black masters"' by the Redgraves maintained the collection of watercolours as modern, national and progressive. It ensured the identity of a tradition of masters at the same time as it allowed an apparent freedom from this, a margin of and for the identities it served. The possible crises of those identities and those narratives are thus deferred, as I mentioned above, by a displacement of anxiety, with the consequence of a paranoia of racial identity. This reading of the 'traditions of the "black masters"' presumes the anxiety of the modern and its necessary suppression in any exemplification of it.

The 'black masters' passage quoted above from the Redgraves' 'Painters in Water-Colours' chapter was taken from a text which enables the necessarily exclusive identification of the national to be confirmed, despite the failure to recognise such exclusivity. Preceding that long quotation given above is a passage which considers the activities of topographers abroad. Described as 'extending their knowl-

edge and observation of nature', we are then offered two examples. First is that of John Webber (1752–93) who was draughtsman on Cook's last voyage in 1776. The second is William Alexander. His work, purchased by Richard Redgrave, enables an identification of the racial and the national to be made, the Chinese in China. But it also interrupts the particular search for a face-to-face confirmation of racial identity, the search of the white spectator imagined by the Redgraves for an image which confirms his narcissism. Hence the displacement of that imagined and promised totality and its recapture in the personification of nature in their general argument about the progress of the national watercolour school:

> William Alexander (1767–1816) was draughtsman to Lord Macartney's embassy to China in 1792, and some of his drawings, swarming with groups of Chinese, sparkle with life and colour. The direct reference to nature, both at home and abroad, which was the essence of the art of these men, was beginning to work a change, and was itself a source of progress towards true art.[21]

Emperor of China's Gardens, Imperial Palace, Pekin by Alexander, one of the works purchased by Richard Redgrave for the collection, is considered below in chapter 6, 'Thresholds of the Foreign' (see entry 53). As a preliminary to that, however, it may noted that the notion of the image 'swarming with groups of Chinese' indicates, by means of this metaphor from natural history, an assimilation of the social and political life of China and of the Chinese to nature. Furthermore, the effective *denial* of an imaginary face-to-face relation, which that work nevertheless makes possible, indicates that the notion of the swarm, the entomological metaphor, is overdetermined by a desire for a relation to a face in which the imagined community of the British might recognise themselves, the British as the non-Chinese. Thus the other who is not the same is repressed and disavowed.

There is, moreover, an avoidance of an implicit contestation of political power and of empires. For those like the Redgraves who wanted to maintain the possibility of the preeminence of British rule, conceived as a nondespotic power, the true face of the Chinese would be despotic. The possibility of recognising this is denied, however, as the Redgraves go on to announce that 'there were no traditions of the "black masters" to stand in the way of progress', the progress of the topographical artists from England.

Perhaps what follows will now seem inevitable. Having concluded that these painters, without the obstruction of those 'black masters', could now see 'Nature as she really is', the Redgraves go on to complete the possibility of reading dictated by a racial identification as a guarantee of the integrity of the national in an account of the construction of a tradition of painting which was modern, national and progressive:

It was soon found that Nature did not attitudinize into set compositions; that it was not necessary to be brown like her; that she did not insist upon dark foregrounds; and, *in fine*, that the imitation of Nature's great truths was not inconsistent with the utmost variety; with the selection of subject, and the choice of what is beautiful.[22]

The image returns to its role as site of confirmation of identity. To be natural, it is not necessary to be brown; it is not necessary to get caught up in the obscurities of dark foregrounds, in the difficulties of the impossible face to face with the chasm, or with others. There may be 'the utmost variety'. Nevertheless, given this protective identification of our artists with nature, and nature with a woman, we may still select our subjects and choose what we find beautiful. The national school recovers its preeminence, the 'advance' though 'necessarily slow' may now be traced 'step by step',[23] reassured that the members of a nation and a race can discover and rediscover themselves, still on the move, still progressing.

PROSPECTS AND INTERIORS IN QUESTION

As I mentioned above, the relations between a national collection, the notion of the national and the items in that collection are indirect and complex. However, after following the complexity of the reading necessary in order to discover the indirections of these relations in the text by the Redgraves, some more general notions may now be considered. It has been proposed, by Benedict Anderson, that the modern nation is 'an imagined political community – and imagined as both inherently limited and sovereign'.[24] The imagined meeting of one nation with another, as in the imagined meeting of England and China above, both empires, the one seeking not to have the prospect of the extension of the limits of its empire and, indeed, the continuation of its existence as a nation thwarted, suggests the sovereignty mentioned here reestablishes itself only in illusion. If a nation is to be a community, then the existence of sovereignty exercised within it is incompatible with that identity, the community which Anderson defines as 'a deep, horizontal comradeship'.[25] The modern nation, however, can only be construed as such a *horizontal* community on condition that there is a misrecognition of an absence of bonds within the nation. Relation to the state, of being for that organisation, in war for example, is one not uncommon misrecognition among others which sustain, and indeed inaugurate, such notions of horizontal bonds.

Along with this form of the articulation of the modern nation as a horizontal bond, there is also a relation to a ground proposed here. The relations of the horizontal bond would be guaranteed simultaneously by their depth. This notion, that

there needs to be a fixing in vertical of the horizontal and a fixing in horizontal of the vertical, would be something which the controlled disposition of visual art in the name of a nation, or of the national, can provide a sense of bringing about. However, these definitions of the modern nation, as we have seen them at work in the criticism of watercolour painting, suggest indeed that the modern nation, as that dream of horizontality, of an absence of hierarchies, and as a reaching of its limit, embedding itself in the site of the sovereignty of its general will, never arrives as such. The incompatibility of the horizontal as a metaphor for relations between members of the nation and the sovereign has been noted. The question of the limit now returns.

When Ruskin imagined that the dead of the battles of the Crimea would arise to haunt the brooks of England and the Seine in France, he gave notice that the idea of the modern nation cannot quite suppress the openness of the interior of its site. The desire to have that open interior policed is, furthermore, testimony to the permeability of the border between interior and exterior. The haunting of the dead, a haunting both by and of them, is indicative of a failure of two times of that nation: the time of the present, the time given by that imagined break with the past, now apparently in need of this suspension in existence in order to recover, double and maintain itself; and the time of progress. As we saw, progress was only reestablished as generalised possibility of and for the nation on condition that others, other nations, other people, were held in suspension, their time the time of the witness of what the progressive nation needed to forget. Meanwhile, their laws would be held in abeyance: subjects of different heavens, these now displaced to reveal the site of appropriation, a generalised accumulation of the wealth of the world under the aegis of leader in its political progress.

When the Redgraves took it upon themselves to exclude and circumvent 'the traditions of the "black masters"', they promised both that the programme of political progress as imperial appropriation might continue and that they would be responsible for maintaining a collection of works which would neither upset the audience's opportunity to recognise itself as members of the imaginary community of the nation, nor fail to indicate how that nation might imagine itself as preeminent over others, progressive, advancing. Their impossible promise to exclude the forgery, as the corruption of these ends, as something the possibility of which might itself be gone beyond, and which watercolour was in some sense exempt from, indicates their complicity with a hierarchy of laws, itself a colonial structure.

Maintaining the prospects of the nation in this way involved the desire, always impossible, to present the public with the perpetual and gathered present of all of the prospects in their charge. This entailed conceiving of the museum as the site of a reliable interior where what was exterior, out there, was still waiting to become

part of the imaginary interior of the nation. The pessimism, which marks the criticism of later keepers, such as Martin Hardie, finds a necessary condition here.[26] As part of this project, as a regulation of the interior of the collection, a hierarchical organisation was to be imagined among the works. Partly as a vestige of the hierarchy of genres such as had been maintained in the Royal Academy (see below, especially chapter 9), this was to operate to confirm the order that obtained in the nation, the interior of the exterior of the museum, of and for which this was national collection. The generalised horizon of prospects was to serve the perpetual present of the modern nation.

Accompanying this, as may be seen below, are a variety of dreams of things being embedded, of attaching to their imaginary ground, in sites imagined as both open and closed. Thus Anderson's version of the modern nation comes to appear to take root. However, if it is remembered that the nation is originally open, its borders passable, its territory open on the inside to the effects of the outside, and that moreover its territory, however great, is finite, then we can see how the inclusion within this apparently guaranteed interior of the institution of the state, starts to come undone.[27] Instead of the fictions of the horizontal community, we have instances of relations between the horizontal and vertical, in which are caught other hierarchies, misrecognised under this notion of a common belonging. And as these hierarchies unwind, so the times of these prospects come not to contribute to that present of the nation, but instead remind us of the time of their homogenisation, traces of times not simply part of and not redeemed in the exemplification of the national.

Instead of the time of the perpetuity of the nation, we may be alerted to its historicity and finitude; instead of its movements to assure itself of its perpetuity, by gathering in what is exterior or by reaffirming its control over its interior, indications of its necessary lack of control over what lies outside and even apparently within its borders may emerge.

1 Cp. Gillian Rose, *The Broken Middle: Out of Our Ancient Society*, Blackwell, Oxford, 1991.

2 See John Barrell, *The Political Theory of Painting from Reynolds to Hazlitt: 'The Body of the Public'*, Yale University Press, New Haven and London, 1986, pp. 338–9.

3 John Ruskin, 'Of the Teachers of Turner' in *Modern Painters* (1856), vol. III, part IV, ch. XVIII, *The Works of John Ruskin*, eds. E.T. Cook and A. Wedderburn, 39 vols., George Allen, London, 1903–12, vol. V, p. 410.

4 Ibid., p. 408.

5 Ibid.

6 Ibid.

7 See Michael Clark, *The Tempting Prospect: A Social History of English Watercolours*, BM Books, London, 1981, especially 'Introduction', pp. 9–20.

8 Ruskin, *Modern Painters*, vol. III, part IV, ch. XVIII, *Works*, vol. V, pp. 416–17.

9 Ibid., p. 417.

10 See note 2 above.

11 Ruskin, *Modern Painters*, vol. III, part IV, ch. XVIII, *Works*, vol. V, p. 416.

12 Ibid.

13 See Lionel Lambourne, 'Introduction: The Growth of a National Collection of
 Watercolours' in Lionel Lambourne and Jean Hamilton, eds., *British Watercolours in the Victoria
 and Albert Museum: An Illustrated Summary Catalogue of the National Collection*, Sotheby Parke
 Bernet, London, 1980, pp. ix–xv.

14 Ruthven Todd, 'Editor's Preface' in Richard and Samuel Redgrave, *A Century of British
 Painters* (1866), Phaidon Press, London, 1947, p. v.

15 Redgrave and Redgrave, *Century of British Painters*, p. 147.

16 Ibid., p. 5.

17 Ibid., p. 4.

18 Ibid., p. 5.

19 See John Barrell, 'Benjamin Robert Haydon: The Curtius of the Khyber Pass' in J. Barrell,
 ed., *Painting and the Politics of Culture: New Essays on British Art 1700–1850*, Oxford University
 Press, 1992, pp. 253–90.

20 See Clark, *Tempting Prospect*, pp. 149–52.

21 Ibid., p. 147.

22 Ibid.

23 Ibid.

24 Benedict Anderson, *Imagined Communities: Reflections on the Origin and Spread of Nationalism*,
 Verso, London, 1983, p. 15. With this version of Anderson's notion of the modern nation,
 cp. Homi K. Bhabha, 'DissemiNation: time, narrative, and the margins of the modern
 nation', in H. Bhabha, ed., *Nation and Narration*, Routledge, London and New York, 1990,
 pp. 291–322.

25 Anderson, *Imagined Communities*, p. 16.

26 See Martin Hardie, *Watercolour Painting in Britain*, eds. Dudley Snelgrove, Jonathan Mayne and
 Basil Taylor, 3 vols., B. T. Batsford, London, 1966–72: his separation of the topographical,
 'the careful and realistic recording of places and buildings', and 'the painter's personal
 interpretation of some aspect of Nature', confirms his indebtedness to the Ruskinian
 tradition of criticism, failing, however, to allow for any greater significance to the apparent
 excesses of some of the works in question than a notion of 'the personal' (vol. I, p. 73).
 Hardie's text is referred to on a number of occasions below; indeed, this text may be
 construed, in part, as a displacement of the languages of criticism employed by Hardie, often
 in consideration of the examples which he recommended.

27 Cp. Geoffrey Bennington, 'Postal politics and the institution of the nation' in Bhabha, ed.,
 Nation and Narration, pp. 121–37.

I

EVENTS ON THE HORIZON

I Richard Wilson
(1714–1782)

Landscape

Oil and gouache
41.1 x 57.3 cm; P.15-1915

The inclusion of a work in oil and gouache in an exhibition of watercolours deserves an explanation, particularly when it is by a painter who refused on principle to work in watercolours. Richard Wilson's objection to the medium, which, as far as can be ascertained, was never dislodged, was that it was impermanent. It seemed to him to lack the density of oil paint, but Wilson's objection misidentified the quality of oils with the connotations which he and his aristocratic patrons wanted his landscape paintings to have: connotations of order, but also of permanence.[1]

Wilson, however, did not manage to avoid producing sketches, even if it was regarded as a humiliation for him when, during certain periods in his career, he found it necessary to sell some of them. As the *Library of Fine Arts* recorded it, 'When Wilson, the pride of art and father of British landscape-painting was reduced to the necessity of selling his beautiful studies from nature to print-sellers for a few shillings, Mr Sandby requested he might have the refusal.'[2] It might seem surprising that Paul Sandby, as a prolific watercolour painter, did not identify his interest with a more generalised availability of the sketches of Wilson. However, it was in Sandby's interest for a selection of Wilson's work to be available only at his discretion, so that he might seem to be able to control the double lineage of watercolour painting in Britain of which he himself became identified as a paternal authority. That lineage, as it has come to be identified, ideally separable from oil painting, but engaged also in the genre of landscape, would have found a work such as this oil and gouache sketch by Wilson an awkward hybrid.

Subsequent interest in Wilson's work tends to bear out the success of Sandby's tactic of controlling refusal. Ruskin, whose criteria for landscape painting were, as the introduction above suggests, in large part derived from what he thought watercolour could accomplish, was critical of Wilson who, despite appearing capable of the occasional 'freshness of feeling', was indicted for spending his apprenticeship in Italy. That 'district about Rome', wrote Ruskin, was 'especially unfavourable, as exhibiting no pure or healthy nature, but a diseased and overgrown flora, among half-developed volcanic rocks, loose calcareous concretions, and mouldering wrecks of buildings, and whose spirit I conceive to be especially opposed to the natural tone of the English mind.'[3] Ruskin's rhetoric here is not only likely to mislead us into over-estimating Wilson's time in Italy, but is also misguided by a sense of the relative priority of nature over representation, as if it was not a tradition of landscape *painting* which Wilson followed when in Italy and which he subsequently deployed in his representations of Welsh, English and Scottish countryside.

For Ruskin, Wilson, during his time in Italy, had become a kind of infected and infectious body. His failure to render pure nature in a fashion imagined to be proper to the British tradition which Ruskin wanted was an inability to have purged himself of the classical landscape tradition on which he depended. Such a sketch as this would have once again been refused admission to the canon of that project of the rendering of a feeling properly modern and national.

Refusal in this case is subsequent to incorporation, as the existence of this work in the National Collection indicates. Here it testifies not only to its status as counter-example in the Ruskinian canon, but also to that project of the borrowing of pictorial rhetoric from classical and Italian precedents. Considered in relation to this latter project, Wilson's sketch can be understood to indicate what was rendered articulable and what was repressed in British classical borrowings.

This sketch is difficult to date. It is probable, however, that it was painted *after* the large and most successful oil painting of Wilson's career, *The Destruction of the Children of Niobe*, which Wilson showed at the Society of Arts in 1760, the picture which made his name.[4] In that image, Niobe, who had, in Roman legend, staked her fertility above that of Latona, the mother of Apollo, stands in the foreground trying to guard her children from the retributive thunderbolt of Apollo, which is ready to be released to turn her and her offspring to stone. The storm rages. The 'unnatural' claim of the mortal Niobe to usurp the position of an immortal is conveyed by the extent of what was read, according to certain eighteenth-century discourses, as the 'unnatural' disorder of the elements.

Reynolds later complained that Wilson's landscapes 'were in

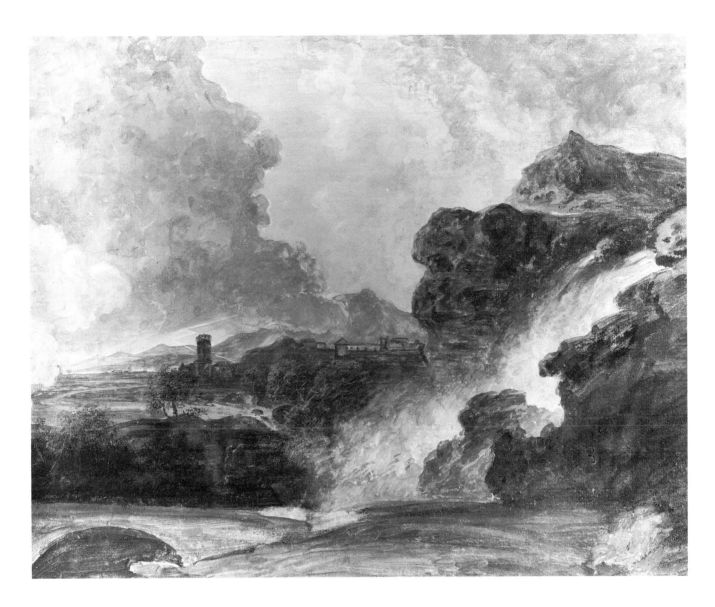

reality too near common nature to admit supernatural objects'.[5] This 'common' is overdetermined: slipping away from the designation of the storm, which would rather be called, in Reynolds' terms, 'accidental' nature, towards the identification of the mortal woman; towards, therefore, an anxiety about the absence of any credible constraint on the reproductivity of women. Comparison of this sketch with the 1760 *Destruction* suggests, indeed, that Wilson had accepted some such similar criticism. Later versions of the *Niobe*, as Wilson moved to take advantage of its popularity, seem to have been developed along the lines of the sketch, which is *more* centrally ordered than the initial image. Rather than turning to nature to discover a more violent, more potent dramatisation of the plot of the retribution of Niobe, Wilson seems to have been seeking to represent a nature less disordered, less agitated by the anxieties of controlling and

enforcing punishment upon the procreative powers of the heroine. She had seemed, it appears, rather too much of a heroine. Absent from this scene, nature now seems less agitated, less the scene of a struggle of forces, even if not quite the mere vehicle for feeling that later criticism wanted.

1 See David H. Solkin, *Richard Wilson and the Landscape of Reaction*, Tate Gallery, London, 1982, p. 103.
2 William Sandby, *Thomas and Paul Sandby, Royal Academicians*, Seeley and Co. Ltd., London, 1892, pp. 81–2.
3 John Ruskin, *Modern Painters*, vol. I, part II, sec. I, ch. VII, *Works*, vol. III, p. 189.
4 Solkin, *Richard Wilson*, p. 200.
5 Joshua Reynolds, 'Discourse XIV' (1788) in *Discourses on Art*, ed. R. R. Wark, Yale University Press, New Haven and London, 1975, p. 255.

2 Jonathan Skelton

(*circa* 1735–1759)

Tivoli: The Great Cascade

Signed and dated 'J. Skelton 1758'
50.7 x 36.3 cm; P.12–1955

Skelton's *Tivoli* is one among about ninety views of Rome and its vicinity, painted in Italy in 1758 and 1759, which together comprised the then largest group of watercolours of that region. They help to demonstrate that the fascination which Italy then held for a large number of British artists was not an unqualified pleasure in attention to the relics of the imperial and renaissance pasts. For any attempt to absorb these pasts into what no doubt became merely a repertoire of styles had to reckon with the suspicion that the decline of those past societies might well be latent, contained as if ready to migrate, in the works which appeared to offer themselves as models.

Skelton suggests as much in the following: 'One may draw many pleasing reflections from these venerable Relics of ancient Roman Grandeur. They show how Time erases everything: for these noble and immense Edifices were certainly (by their manner of building) intended to stand for ever.'[1] Yet, at the same time as he appears to face the issue, he also turns away from it. To 'draw many pleasing reflections' signifies the possibility of reflection on time and society which his pictures enable; but it also maintains a particular theory of drawing reflecting what is drawn. This dedication of what was then called watercolour drawing to such a project of reflection tends to efface the conditions of that project, among them a struggle with the precedents of this kind of landscape painting.[2] That it issued in fragile paper works such as this suggested further that time's capacity to erase everything was being accepted, even while it was not.

Tivoli, as a site of these negotiations, lay on the periphery of this region of contention, at the heart of which lay the complex example of Rome. By the 1770s, as the painter Thomas Jones reports, the town had become a destination for English visitors who wanted respite from the 'task' of 'seeing the curiosities of Rome and its environs'.[3] It had become a 'beauty spot', not least because of representations such as this one by Skelton. Furthermore, this image demonstrates that the reputation that Tivoli had acquired, of being a relief from the efforts of trying to discover order in the Roman chaos – of being not only well composed, but also composing – depended on the very viewing of it being part of that which would enable Tivoli not to suffer that fate of decline which much of the rest of Italy had suffered.

The town is composed so as to attract our look. High on the hill, well lit from the left by what seems to be a setting sun, but darker than the wash indicating the hills beyond, we are drawn by the relative intensity of this contrast. But another route to the town is also offered. Following the line of sight of the figure which reclines naked on the bank above the waterfall in the foreground, two figures can be seen, illuminated as if by the same setting sun, standing on the parapet of the bridge, perhaps washing clothes. If our eye then follows another diagonal movement, this time from right to left, towards the even more brightly lit ground on the far side of the river, we can identify a shepherd, standing at some distance from his flock, two of which seem to have strayed into the water. From here, our eye can rise to the tower, pan out, and take in the town.

These figures demonstrate, in their various desultory poses and activities, much of what the poet Thomson had argued, in his poem 'Liberty' (1734–6), was the fate and condition of an Italy that now lacked the leadership and yet had once suffered the dictatorship of Rome. In part one of the poem called 'Ancient and Modern Italy Compared', he writes:

> Pale shine thy ragged towns. Neglected round,
> Each harvest pines; the livid, lean produce
> Of heartless labour: while thy hated joys,
> Not proper pleasure, lift the lazy hand.
> Better to sink in sloth the woes of life,
> Than wake their rage with unavailing toil.
> Hence, drooping art almost to nature leaves
> The rude unguided year.[4]

The shepherd and the two figures washing clothes, gazed at by the reclining naked figure, who might be identified as one of the nymphs abandoned by the deity on whom nymphs are supposed to attend, do not dispute the not uncommon notion, articulated by Thomson, that Italy had declined as a consequence of an absence of industry. Indeed, even their looking, led by that nymph-like figure, has become desultory. The pale shining of

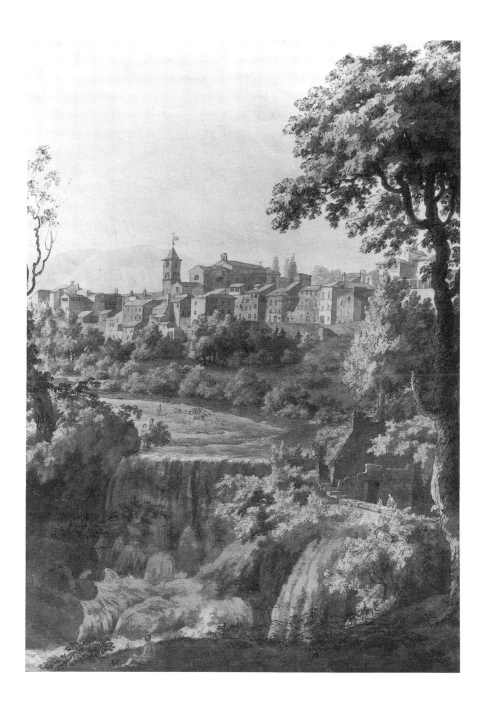

their towns is, as it were, only not neglected by the more complex and strenuous looking in which we engage in the second of the routes to the town on the hill. This labour of vision, the work of identification of the tourist, succeeds in composing not only what is imagined to be the appearances of contemporary Italy, but also the strangeness of its past.

1 Quoted in Solkin, *Richard Wilson*, p. 43.

2 Cp. for example Gaspar Poussin (1615–75), *The Falls of Tivoli* in Wallace Collection, *Pictures and Drawings: Text with Historical Notes*, 6th edn., William Clowes and Sons Ltd., London, 1968, p. 246, acc. no. P139.

3 Quoted in Hardie, *Watercolour Painting*, vol. 1, p. 88.

4 James Thomson, *Poetical Works*, William Nimmo, London and Edinburgh, 1878, pp. 266–7.

3 William Pars
(1742–1782)

St Peter's, Rome: View from above the Arco Scuro, near Pope Julius' Villa

Signed and dated 'W.P. 177[?]'
17.8 x 24.4 cm; P.31–1932

It is reputed that Pars died from a fever contracted while standing sketching in the waters of the falls at Tivoli. Legendary as this may be, it indicates something of that imperative to dramatise and make difficult the view of those Italian sites then recognised as significant to which others among his images testify. This making difficult often involved the relative separation of fore- and backgrounds: of some of his works produced on his first tour of Italy, probably in 1770 and 1771, Martin Hardie noted that the foreground was often in heavy gouache, sometimes varnished, while the distance had been rendered in transparent washes. This view of St Peter's, probably painted in 1777, two years after Pars had left England for Italy on his second trip, indicates that he was still similarly preoccupied.[1]

Much of Pars' work, done on tours of Greece and what was then called Asia Minor as well as Italy, suggests that he was particularly concerned with scenes which restaged relics of different classical civilisations. This restaging did not, however, simply concern relations between the past and present, as might be imagined from this scene of Rome seen while the sun appears to set. As with the other works identifiable as prospects in the selection, it is possible to infer anxieties about the imaginable future.

The conclusion of Edward Gibbon's *Decline and Fall of the Roman Empire*, written in Lausanne in 1787, provides us with signs, not simply of censure, but of ambivalence concerning the post-imperial papal dominion of Rome. As he approaches his final reflections he is concerned to divert attention from 'the influence of superstition', which he identifies with Catholicism, towards an understanding of what he believed to be the proper root of Rome's glory and its greatest legacy, its imperial past. Pointing out the hypocrisy of the familial dynasties of the supposedly 'childless pontiff[s]', he writes:

The palaces of these fortunate nephews are the most costly monuments of elegance and servitude: the perfect arts of architecture, painting, and sculpture, have been prostituted in their service; and their galleries and gardens are decorated with the most precious works of antiquity, which taste or vanity has prompted them to collect. The ecclesiastical revenues were more decently employed by the popes themselves in the pomp of Catholic worship; but it is superfluous to enumerate their pious foundations of altars, chapels, and churches, since these lesser stars are eclipsed by the sun of the Vatican, by the dome of St Peter, the most glorious structure that has been applied to the use of religion.[2]

Gibbon's warning not to mistake the splendour of what was founded, raised and collected by the papacy for the splendour of their religion is conducted in moral terms, terms which fantasise artistic production as outside the prevailing economies of tax and exchange. Moreover, in so far as the criticism depends on a moral discourse, Gibbon's judgement reverses on itself: St Peter's is *so* glorious that it may not only survive, but is all but magnified by being used by religion.

The figure of the sun employed to represent the dome in this passage by Gibbon, and his admiration for it, all but returns him to a paganism, with the dependence of his moral discourse on the religion of Christianity now unrecognisable. This retreat would not be overcome, but would rather be supported by the more literal rendering of St Peter's in the sun by Pars. Here, as St Peter's is all but eclipsed by the sun, we can imagine it as that which risks but which, none the less, will be able to survive a diurnal revolution. But we witness this from afar, from near one of those 'costly monuments of elegance and servitude', Pope Julius' villa, and from beyond a gulf between near and far distance. In this way, we can imagine witnessing the splendours of Rome without risking being tainted by what supported and supports it; without getting so close as would risk our being seduced. Caught imagining the corruption which underlies that seductive superstructure, we are suspended before the recognition of our repetition of that moral discourse.

1 Hardie, *Watercolour Painting*, vol. I, pp. 90–1.
2 Edward Gibbon, *The Decline and Fall of the Roman Empire* (1787), abridged D.M. Low, Penguin Books, Harmondsworth, 1960, p. 902.

4 Lady Diana Beauclerk
(1734–1808)

Group of Gypsies and Female Rustics

69.8 x 90.2 cm; 9–1883

The appeal of Diana Beauclerk's watercolours and drawings of children was complex. Popular with the well known, including Reynolds and Horace Walpole, but also with a wider audience, in the form of engravings by Bartolozzi as well as reliefs on Wedgwood pottery, this appeal came to exceed the metropolitan market for images.[1] The role of such children in this staging of an encounter between women labourers and a group of gypsies, set in what is recognisable – according to pictorial precedent – as the countryside outside Rome, can help us to understand something of that complexity.

For it is the figures of the children in the variety of their poses and expressions which tend to receive and deflect from the tensions, moral and economic, that this scene can be understood to involve. The enthusiasm which they display for the basket of apples overcomes the dilemmas which the poised drama of gestures of the other figures dramatises. These dilemmas – of the relations between commerce and ethics, the question of the just deserts of labour and its demands – were at the heart of the transformation of moral discourse by the powerful mercantile middle classes during the eighteenth century.

The poem 'Charity', written by William Cowper in 1781–2 during what was probably the same decade as Beauclerk painted this picture, explores the transformation of the meaning of its titleword: from love, to benevolence, to almsgiving. This displacement from the tradition of Christian morality to the morality of a commercial society allows Cowper apparently to justify the necessity of charity 'here below' as an imitation of charity which is 'all in all above'. Any failure of what he calls 'the band of commerce...To associate all the branches of mankind' is to be redeemed, so the new morality would go, by charity.

Thus trade, which is identified as 'this genial intercourse and mutual aid':

Cheers what were else an universal shade,
Calls nature from her ivy-mantled den,
And softens human rockwork into men.[2]

This phrase, 'human rockwork', is systematically ambiguous: on the one hand, it signifies human being as that which has been made out of rock; on the other, it signifies the rockwork performed by humans. Given that the destiny of this all but unrecognisable figuring of labour is to produce men, what we witness here is the effacement of the differences between men and women and the occlusion of reproduction in the discourse of production.

Beauclerk's image treats some of these occlusions. The gypsies, who are outside this cycle of disciplined production, such as is mentioned in this discourse, are beckoned to across that division. The children, as the demanding and hungry players in this drama, are thus drawn across a divide between the nomadic and the labourers of the land. But like the apples, in and out of the basket, they figure an excess in the system of commerce and its regulatory morality. The passions of the children can thus be understood to substitute for the demiurge of nature on which Cowper relies in order to make imaginable the drawing of those outside the band of commerce, such as these gypsies, within the expansionary culture of mercantilism. But, once more, according to that discourse, such passions would remain ones which were likely to require the trade which Cowper's poem recommends, if they were to be imagined as subject to regulation.

The artist, who before her marriage to Viscount Bolingbroke, was known as Diana Spencer, was censured by Dr Samuel Johnson for what he judged to be her too hasty remarriage, following the death of the Viscount, to his friend Topham Beauclerk: 'My dear Sir', he is reported to have said to Boswell, who claims that he had tried to defend her against Johnson's accusations, 'never accustom your mind to mingle virtue and vice'.[3] It would appear, therefore, that while minds were being exhorted not to mingle such things, eyes were allowing spectators to forget as much. Diana Beauclerk and her work could not quite be controlled by the moralists of the day.

1 For a brief account of her career, see Iolo A. Williams, *Early English Watercolours and Some Cognate Drawings by Artists Born Not Later than 1785*, The Connoisseur, London, 1952, pp. 231–2.

2 William Cowper, *Poetical Works*, Drane and Chant, London, *circa* 1895, p. 71.

3 James Boswell, *Life of Johnson*, ed. G.B. Hill, 6 vols., Oxford University Press, 1934–50, vol. II (1766–76), p. 247.

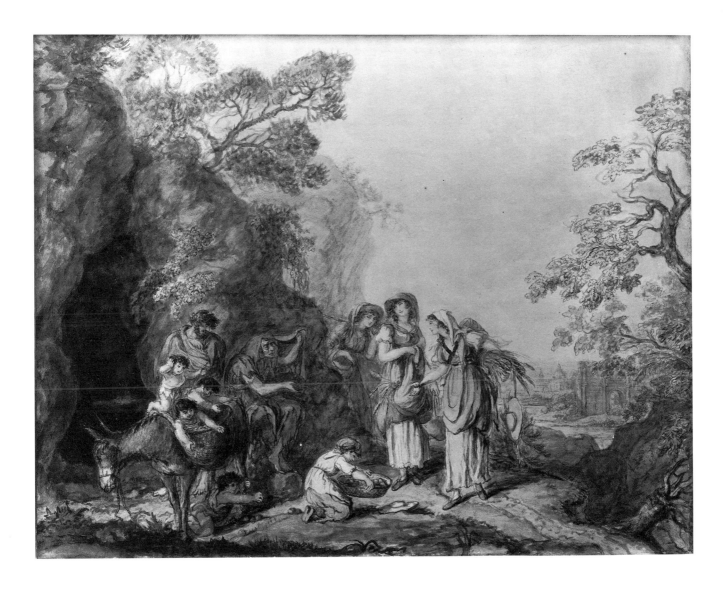

5 William Pars
(1742–1782)

Killarney and Lake

31.8 x 48.3 cm; 179–1890

In that tradition of the criticism of watercolour painting which I have sought to put in question in the introduction to this selection, Pars, as Martin Hardie wrote, 'is difficult to place'. On the one hand, he appeared to have anticipated the supposed drive towards the watercolour painting articulated by no more than washes of more or less diluted pigment. On the other, while his work sometimes does not involve pen and ink work, his washing, as in this example, often tends towards the monochromatic. Hardie claims that the articulation of the distance in *Killarney and Lake* 'recalls J.R. Cozens and that, consequently, the pen marks used to delineate the figures and the upper edges of the wall are not really "structural"'.[1]

Thus, for Hardie, *Killarney and Lake* is both overelaborated and incomplete, backward and forward looking at the same time. The trouble for Hardie is, however, not simply that he cannot place Pars, but that he cannot quite place the senses of place that this work by Pars presents. His desire to subtract the pen marks from an imagined consistency of the scene suppresses difficulties of identification which the figures in this scene would have presented to a contemporary audience.

As was the case with *St Peter's, Rome* and in Pars' earlier Italian views, there is a separation of foreground from the receding distance. That gulf in the earlier work was designed to put at a distance something attractive in such a way as it could still be enjoyed, without risking a closer view. Suspended, as it seemed, between appearance and disappearance, the dangers that its attractions presented could be imagined to slide from it, even while it defined a prospect of a time when those dangers would be no longer. The distance between foreground and distance in *Killarney and Lake* is also a means of separation, this time from a town which, at that distance, may be imagined to lie far enough away for us not to be involved in it, not too concerned with its existence.

There is none the less reason to imagine that that town would also be something the limit and integrity of which an eighteenth-century British audience would have wanted to believe. During

the 1760s, poor harvests in Ireland, and unfavourable trading relations with England, had been the cause not merely of suffering in the coutryside, but also rebellion. By the end of the decade, things seemed less disturbed; at least, so they might, if Pars' image is interpreted.

The town seen from so far off would perhaps have seemed rather too unavailable, given England's interest in the availability of Ireland. The interposition of figures in the scene would thus have seemed a way of indicating to us where to look. If we imagine them to be from this region – or, at least, not mere surrogates for those who are not travelling to Ireland – then their position on this shallow rise, looking towards the town, can be interpreted as confirming that this indeed is a good position from which to view the town. However, as soon as this identification is made, other problems emerge. If these figures are imagined to be Irish, their relations with this town become complex. Either they are from it, or they are not. If they are not, and they are itinerant, then they are not to be found in a certain place. They become reminiscent of a displacement of population which some in England would have preferred to forget. If they are from the town – and given the younger figure, sitting on the ground, apparently in the charge of the older one – their look back to where they have come from becomes a figure of a pathos of having left that place.

Perhaps this is the most likely interpretation, among the possibilities outlined above. It certainly suggests why Pars would have inclined to the use of pen here for those figures and that wall. The senses of definition and of superscription are both important here. The sense of definition in pen would suggest that these figures are not difficult to identify; the sense of superscription, of adding them on top, would suggest that they might have been subtracted. Hardie certainly treated them in this way. As with other imperfect cancellations, however, what might have been cancelled remains all the more noticeable for not having been removed. This would be one of the reasons, I suggest, why Pars extended the use of pen to the wall. Not only does it give us a sense of another border, one which does not lie around the town, or around the island within which these figures may be imagined to circulate, but it gives it in such a way as to associate it with those figures. It seem to be their wall, at least in the sense that a subtractive reading, such as Hardie gave this work, could imagine removing limits to the view and thus seeing beyond borders altogether, forgetting the problems that those borders seemed to have created.

This rather generalised account of the significance of Pars' representation ought not to be dismissed on those grounds. For

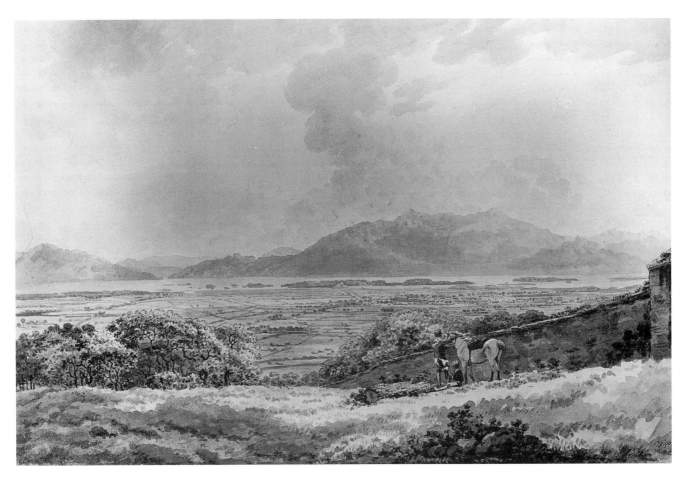

representations of Ireland in the eighteenth century suffered from having to remain generalised, if such representations emerged at all. One example of a singular nonemergence is Oliver Goldsmith's late poem *The Deserted Village*, written in 1769 just before Pars painted this picture. Goldsmith, who was born and educated in Ireland, but who moved to London, writing and publishing there, seems, on the one hand, to be drawn in his poem to a passionate lament for the past joys of a village, 'Sweet Auburn, loveliest village of the plain'.[2] His past cannot quite be spoken even as it seems to threaten to erupt in this narrative of the loss of contentment and the possibility of 'blest retirement, friend to life's decline'.[3] The clarity of his attack on the values of trade and commerce is coupled with a prospect of a colonisation beyond the shores of England, led by the drive to draw others into a network to confirm these values.

'This wealth is but a name / That leaves our useful products still the same', writes Goldsmith.[4] His version of the land might have stood as one version of this image by Pars, were it not for Ireland remaining unexplicit in his poem, and identifiable in Pars' image:

Even now the devastation is begun,
And half the business of destruction done;
Even now, methinks, as pondering here I stand

I see the rural virtues leave the land.
Down where yon anchoring vessel spreads the sail,
That idly waiting flaps with every gale,
Downward they move, a melancholy band,
Pass from the shore and darken all the strand.[5]

Indeed, perhaps Goldsmith's conclusion that there is a lesson which can:

Teach erring man to spurn the rage of gain;
Teach him that states of native strength possessed,
Though very poor, may still be very blest[6]

is so much part of a language of reconciliation of the colonised to the coloniser that his poem, which fails to speak of Ireland, can stand as one reminder of the moral discourse which would speak the identity of the figures in Pars' painting.

1 Hardie, *Watercolour Painting*, vol. I, pp. 90–1.
2 Oliver Goldsmith, 'The Deserted Village', Dennis Davison, ed., *The Penguin Book of Eighteenth-Century Verse*, Penguin Books, Harmondsworth, 1973, p. 127.
3 Ibid., p. 130.
4 Ibid., p. 134.
5 Ibid., p. 138.
6 Ibid., p. 139.

6 Charles Catton
(1728–1798)

View of the Bridges at Hawick

40.3 x 59.8 cm; P.53–1921

The shadow which falls across the high arch of the nearest bridge helps to guide our look along the route of the river, skirting the buildings on the bank which are also cast in shadow, and out either under or over the arches of the successively more distant bridges to the hills beyond. This meandering and somewhat awkward journey may be supplemented, however, by imagining the journeys of the figures in the scene: either falling in with the young man carrying bags and his dog, walking on the path at the right; or, following the gaze of the man standing on the rocks at the foot of the bridge, we might imagine ourselves trailing after the man on horseback as he rides off across the bridge and, perhaps, out of town.

Finding our way across Scottish terrain might be less difficult if we shared the apparent know-how of the woman leaning over the parapet of the bridge. She would appear to be addressing the man standing on the rocks leaning at the foot of the bridge and the boy who sits by him, clasped by the wrist. But some of her gesture and her gaze is not absorbed in this encounter. The boy, hand raised to head perhaps in puzzlement, seems, like the man with him, to be more interested in the figure riding by. The woman's finger, pointing back downstream, seems to go unnoticed by them.

What else could help us to discover where we are? The innsign, hung above the route that we might imagine following along the far bank of the river, appears to represent two figures holding between them a shield, but neither the detail of this coat of arms nor the space beneath it where we might expect to find the inn's name is legible. The knowledge that such inns were often named after some aspect or aspects of the local landowner's heraldic attributes, whose crest was used simultaneously to identify the inn and its licensing agency, does not enable us, in this case, to locate ourselves more precisely.

As indicated in the introduction above, so-called naturalistic topography has been identified as a significant aim determining the development of watercolour painting in Britain. The shifts in visual representation of places that have occurred since the seventeenth century need to be reconstrued in a nondevelopmental fashion. Indeed, as may be inferred from this example by Charles Catton, we may discover insuperable limits to the generalised aim of naturalism: aspects of the topographic which would lie outside the proper bounds given by the naturalistic.[1] The representation of the innsign is, rather than a touch-for-appearance correspondence, more mediatedly a touch-for-touch which, given its topic, does not simply lead us to something which we could imagine as preexisting its appearance in this or in some other, prior picture. The project of naturalism, deriving from an exclusion, a bracketing out, of the apparently conventional, of differentially appearing and signifying elements such as heraldic signs, is undone every time that there is a painting of a sign, a photograph of writing, a *mise en abîme* of imagined pure phenomenality.[2]

Moreover, it is telling that this occurs in one of the most carefully differentiated works in this selection, one which sustains prospects of passage, with its luminous colouring and detail of tones, but which also, as a consequence of its compositional complexity, blocks and checks that prospect. Furthermore, the supplementation of this imaginary passage of vision by means of the variety of figures exemplifies a characteristic, but often overlooked aspect of many of the works gathered together here. For, not only does this supplementation reenable imaginary journeys to be recommended, but, in so doing, also allows for a forgetting of the imaginariness and the otherness of that figure.

In the case of Catton's *View of the Bridges at Hawick*, perhaps the most significant figure is the woman leaning down over the bridge, indicating a route back downstream. This apparently generous gesture may be understood, however, to give little more than some among the Scots appeared to be prepared to give the English, following the mid-century wars of resistance and subjugation, in the last quarter of the eighteenth century.

1 For a recent reiteration of this, see Clark, *Tempting Prospect*, p. 23.
2 Cp. Jean-François Lyotard, 'The Dream-Work Does Not Think', trans. Mary Lydon, *Oxford Literary Review*, vol. 6, no. 1, 1983 (pp. 3–34), pp. 29–32.

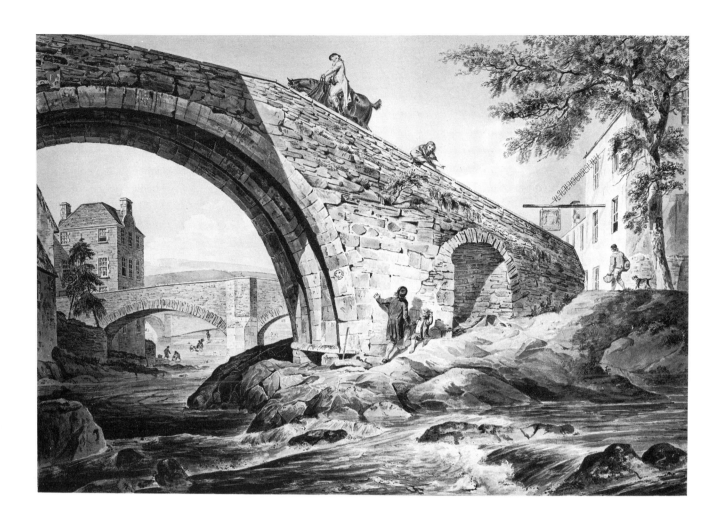

7 Francis Towne
(1740–1816)

Rydal Water

Signed and dated 'Francis Towne delt 1789'
15.7 x 23.7 cm; P.19–1921

For the hundred years or so after his death, the watercolours of Francis Towne seem to have been the subject of little critical interest. This was despite a shift in the focus of his apparent ambition in the early years of the nineteenth century. His applications for membership of the Royal Academy grew more frequent and, despite being turned down by the then premier exhibiting institution of the capital city, in 1807 he moved from Exeter, where he had worked for many years as a teacher of drawing, to London. And this, in turn, had been despite the lack of notice given to his self-sponsored one-man exhibition in 1805 at a gallery in Lower Brook Street, the site which, later that year, was to be the venue for the exhibition by members of the recently formed Society of Painters in Water-Colours. In London, Towne continued to work as a teacher of drawing, but he failed to achieve the notice and the income from sales which other watercolourists were beginning to achieve.[1]

It is significant that none of the Victoria and Albert Museum's holdings of Towne work were acquired before 1904. For it was only during the early decades of the twentieth century, notably in the critical writings of Laurence Binyon and A. P. Oppé, that Towne's work came to be thought of as worthy of critical approval.[2] The quiet of nineteenth-century critics and the relative volubility of early twentieth-century ones, concerned as they were with criteria of Cézannesque classicism such as Roger Fry employed in his selection and presentation of post-impressionist work, shared a certain neglect of the conditions which enabled Towne to produce his relatively spare, linear, often somewhat flat-washed pictures.[3] It is appropriate, therefore, to consider those conditions if we are to understand why Towne's work gave rise to such different reactions.

Towne's pictorial geometry may be described as an attenuation of compositional logics which had preoccupied landscape painting in the eighteenth century in England and which can be understood to derive from the works of Claude Lorrain. In

Rydal Water, for example, the wings formed by the hills rising to the left and right curtain the view which, according to the logic of the Claudian *coulisse*, ought to create a sense of theatrical space, guiding the eye between them as if in expectation of the discovery of a represented event. Such a search is not entirely discouraged in *Rydal Water*. However, in this, as in many other works by Towne, we find that the Claudian scheme is dislocated by what should, according to its logic of representation, serve the end of that expectation of an event.

What appears to be taking place here is the staging of a staging, a certain theatricalisation of the light which emerges from the clouds, passing across the peak in the distance as if to disappear behind the hills to the left, a kind of suspension in expectation of something happening which is only to be overcome by a recollection of the paintedness of the scene. Towne's reiteration in watercolour of the Claudian scheme, with its stress on the event of painting, lacks something of a dedication of colour and tonal values to the apparent representation of an event.

Thus, according to the drive to justify watercolour painting as worthy of the interests invested in oil painting at the beginning of the nineteenth century, Towne's work not only failed to efface the mark of the watercolourist, but it also failed to deliver works in which the represented event could be imagined to hold the attention of the audience. This lack of something apparently about to happen, which was the ground of the neglect of Towne's work towards the end of his life and for many years afterwards, was just what critics of the early twentieth century were delighted by. When Hardie praised his work for displaying 'the immanent and eternal simplicities',[4] however, he was also steering clear of a different recognition of the time of the delivery of image, the time of the apparent presentation of what appeared immanent and eternal. In the terms of this review of the history of watercolour painting, Towne was rejected and accepted for failing to deliver any prospect of change; what has been missed is the threshold between past and future, which is not simply a present either in the process of fulfilling the past or one which could guarantee its repetition.

1 Hardie, *Watercolour Painting*, vol. I, p. 124.

2 See A. P. Oppé, 'Francis Towne, landscape painter', *Proceedings of the Walpole Society*, vol. 8, 1919–20, pp. 116–19.

3 See for example Roger Fry, 'Retrospect' (1920) in *Vision and Design*, Penguin Books, Harmondsworth, 1937, pp. 229–44, especially on 'agreeable arrangements of form, harmonious patterns, and the like', p. 243.

4 Hardie, *Watercolour Painting*, vol. I, p. 122.

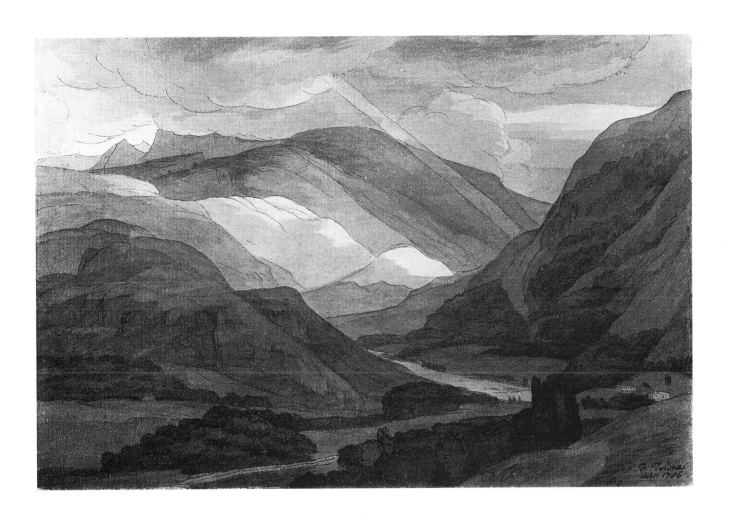

8 John White Abbott
(1763–1851)

Corra Linn. One of the Falls of the Clyde

Signed and dated 'J W A July 5. 1791'
24.3 × 19 cm; E.324–1924

Save for a tour of Lancashire, the Lake District and Scotland, where on 5 July 1791 he painted this work, Abbott has left little evidence that he was often away from Exeter and its more immediate region. There, besides working as a chemist, Abbott took lessons in drawing and painting from Francis Towne, from whom he derived much of what seems characteristic of his work: a centripetal tendency in composition, linework of careful regularity and, allowing for a shift towards a lighter key, a certain range of colours. Abbott did not follow Towne, however, in seeking to exhibit his watercolours. Putting aside the possibility that Abbott was discouraged from doing so by Towne's failures, some of the reasons for this nonexhibition of watercolour works can be inferred from Corra Linn.[1]

For Abbott's career as an artist was not restricted to watercolours: he exhibited a number of oil paintings at the Royal Academy.[2] Corra Linn, however, is interesting because it does not quite exemplify either the logic of a sketch as something designed to serve as the source for an oil painting, in a classic hierarchy of artistic production; or the apparently radical romantic practice of sketching for its own sake. This indeterminacy of a work such as this by Abbott can be followed if we consider the relations between the inscription and the representational in Corra Linn.

The dating of a painting such as this has an undecidable referent. 'July 5. 1791' could refer to the day on which the work was produced or, at least, completed; or, perhaps less probably, to the appearance of that which is represented, as if to say that this, that which bears the inscription, shows how the waterfall on the Clyde fell or was falling on that day. The strangeness of the latter consideration suggests how accustomed we are to reading the dating of work as testifying precisely to this sense of the reliability of the represented scene. We are also, however, accustomed to doing the opposite as well: taking works which bear

dates, particularly when they come accompanied by something recognisable as a signature, as apparently radically unreliable testimony to anything other than that there was a subject who could sign.

This, I think, indicates something of the strangeness of this work by Abbott to some of the categories of the understanding of painting. On the one hand, there is an image which would, no doubt, be usable in the making of another work, yet it is, at the same time, so carefully and methodically made, with its regularities of line and its control of colour and tone, that it seems not to lack that which might be expected in a subsequent work. On the other hand, the marks are so regular and so controlled that there is not a sense that the image is expressive of the difficulty of witnessing a subject which, after all, would be an obvious topic for the thematisation of the difficulty of testifying to the always unstill and changing.

Such difficulties of categorisation help to explain why Abbott's work, like Towne's, did not fit into the new divisions of the recognisable in watercolour painting at the beginning of the nineteenth century. But, as with Towne's work, we can trace something of what resists the categorical. The complaint of a local and contemporary critic that Abbott 'does not attend to aerial perspective, but finishes his middle-distances equally with his foregrounds'[3] can be understood to relate to that expectation of watercolour painting that it provide a differentiated stage on which an event can be imagined to be taking place. The lack of such a differentiation of a foreground in Corra Linn prevents us from being able either to imagine involvement, such as might be exemplified, in its earlier eighteenth-century form, by Skelton's Tivoli: The Great Cascade (see entry 2), or to remain fully detached, such as the narrative of the failure of testimony in romanticism allows.

Thus, Corra Linn presents us with a certain undecidability in the narration of that which appears. With the waterfall either falling or having fallen, we are, as that protest about lack of aerial perspective suggests, unable to assimilate the temporality of this prospect to a future in which happening will succeed happening in a developmental progress of history, a history which would guarantee, among other things, the progress of artistic forms.

1 See Williams, Early English Watercolours, p. 241.
2 Lambourne and Hamilton, eds., British Watercolours, p. 1.
3 Hardie, Watercolour Painting, vol. I, p. 128.

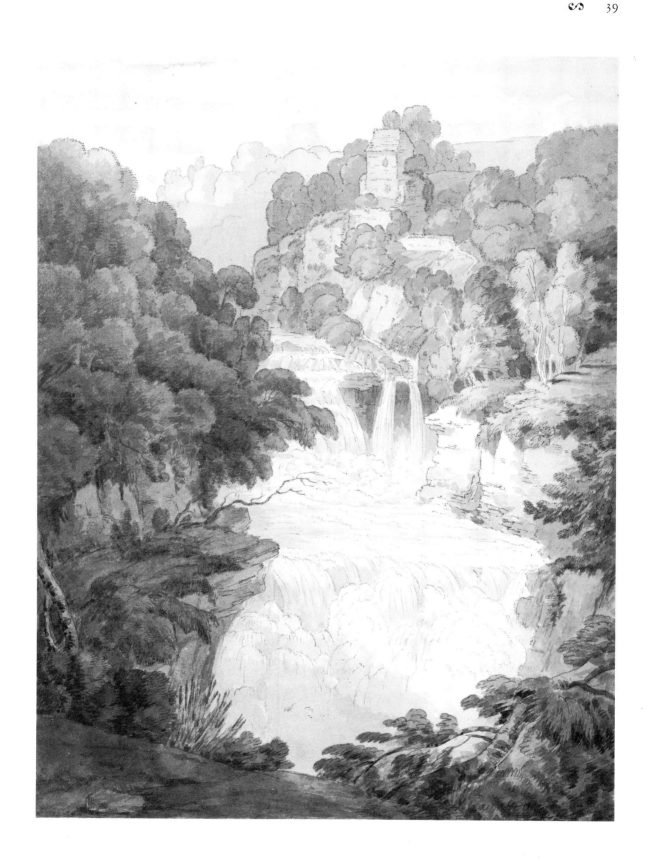

9 Harriet Lister [Mrs Amos Green]
(active *circa* 1780–1810)

View of the Castle and Cavern at Castleton, Derbyshire

Signed and dated 'Harriet Lister Jany 1795'
43.8 x 32.8 cm; P.11–1944

This watercolour shares several characteristics with those preceding it in this section. From the low foreground vantage-point, our eye can look up, between the trees at the side, skirting the nearest outcrop of rock on the right, climbing the face of the cliff on the left, towards the high horizon. There, we may imagine looking along the hill-top, in and out of the trees, over the ruined castle, occasionally as if beyond. Unlike Towne's *Rydal Water* (see entry 7), however, we are not led so inexorably into the distance. Neither is the searching for the distance, unlike Abbott's *Corra Linn* (see entry 8) or even Skelton's *Tivoli: The Great Cascade* (see entry 2), so disappointed.

Harriet Lister's use of certain compositional elements of late eighteenth-century landscape painting does not, in this work, force any of them to their limits. Unlike William Pars' *St Peter's, Rome* (see entry 3), there is not the violent separation of a fall into an undifferentiated foreground or the reaching out for a distant horizon. In *View of the Castle and Cavern at Castleton, Derbyshire*, the painter has brought these possibilities into a closer, less spatially or temporally divided relation.[1]

The means by which this complex articulation of near and middlegrounds has been achieved are worth careful consideration. Like the fall of light from the sky in Towne's *Rydal Water*, the beam of light crossing from right-hand distance to left-ground middle-distance between the crests of the hills serves to hold our eye from the furthest imaginable passage. Unlike Towne's, it does not leave us with quite such a sense of unsatisfied suspense. This is because that light serves to illuminate the castle and its hill, but also because the figure on the path which runs into the cavern seems to be turning back and looking up to follow the fall of that light which we cannot continue to trace. Thus, our eye is provided with several routes into the imaginable

scene, none of which can, on their own, quite be completed; none of which – despite what may appear to be a somewhat dispersed composition – quite exclude the others.

That figure, which plays such an important role in relieving our eye of its solitary search and the possible accompanying sense of frustration, is itself very carefully defined. The twist of the torso and the inclination of the face are distinctly reminiscent of the figure of Niobe, famous during the eighteenth century from the many engravings in circulation of the Roman statue, but also from Richard Wilson's *The Destruction of the Children of Niobe* of 1760 and engravings of the same (see entry 1). Whatever the uncertainties of any imagined precision of the identification of this figure in Lister's painting, it shares with the figure of Niobe in Wilson's image a function for allowing an imaginary condensation of the significances of a landscape. The striking difference is, however, that this figure is not exhibited for any easy judgement of unnaturalness, such as Wilson's Niobe attracted.

Turned as she is towards the fall of light, she appears to act out a sort of looking which would be drawn by what appears to take place, but would not be held in suspension by it. Her passage towards the cavern is thus interrupted and, whatever the pathos of the imaginable fate of that apparent destination, there is also a sense in which the occlusion of the imaginable source of light and the differentiation of the cavern's interior do not allow us to narrate this image as a fall into some indifferent limbo, some absolute banishment from access to the light. Harriet Lister's image offers us a careful articulation of the differences between light and dark, of near and middlegrounds, rather than any imagined purity of distinction between them. Thus it disturbs what these distinctions would connote.

1 For an account which ignores most of these differences, and suggests, indeed, that Lister derived her works from her husband, Amos Green, even to the extent of signing his works as hers after his death, see Williams, *Early English Watercolours*, pp. 240–1.

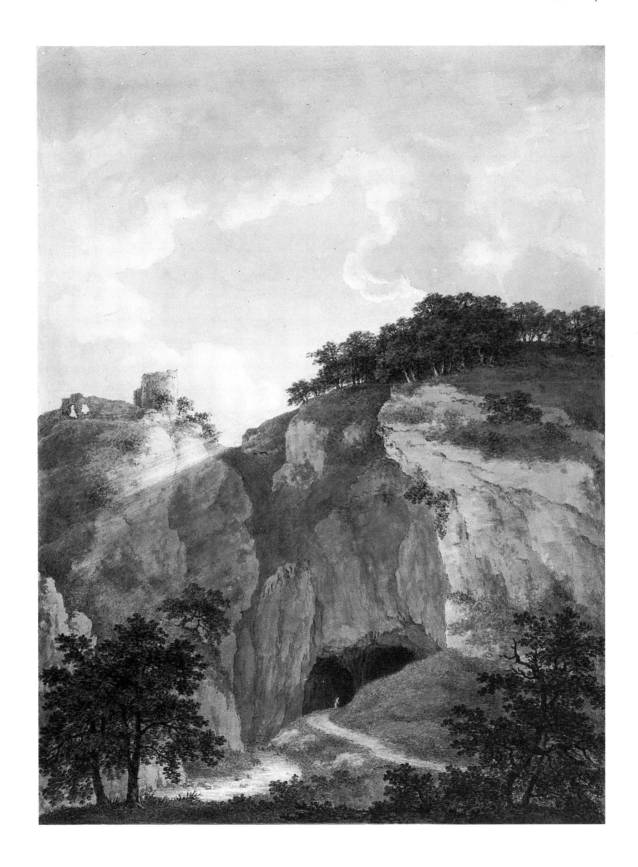

2

SURVEYING A CITY

10 John Baptist Claude Chatelain (1710–1771)

A View from the Summer House in Richmond Park down the River Thames

Signed and dated 'Chatelain [del?] 1750'
28.4 x 46.3 cm; P.12–1915

Before coming to work in London, Chatelain was employed as a draughtsman to the French army in Flanders. The aims of such a task, to delineate images which would enable the celebration of conquest as well as the planning of campaigns, were not unsuited to his subsequent activity in producing and publishing views from and of estates, among other sites, in and around the city of London.[1] This example, which we might at first construe as a modest and unassuming sketch, was, on the contrary, part of an immodest and politically significant practice of representation.

The all but monotonous succession of narrow areas of dark and light, receding to the horizon, getting lighter as they do, and the near loss of foreground in that general pattern, which encourages the eye to fall rather into the distance before discovering an imaginable vantage point, both have a place in sustaining a notion of a spectator who was especially well placed to judge that the landscape was well ordered. This fall, which puts in danger that notion of being well placed, none the less tended to sustain the notion that the one best placed to judge the condition and the direction of the whole was the one who could remain in retirement.

In 1744, six years before Chatelain produced this image, James Thomson published a revised version of his poem 'Summer', one of the quartet of poems forming his work 'The Seasons'. A long account of the apparently easy cooperation of season and 'the blended voice / Of happy labour, love, and social glee'[2] in the agrarian landscape of Britain is followed by a long and unfavourable comparison of tropical and equatorial lands with the 'merciful' climate of 'Happy Britannia'. The former, immoderate and excessive, where nature's super-abundance

goes unmanaged, a 'wondrous waste of wealth', presents a landscape in which:

> the wandering eye,
> Unfix'd, is in a verdant ocean lost.[3]

In comparison, the landscape of Britain is apparently more easily composed for and by the eye. 'While radiant Summer opens all her pride', Thomson invites his reader to test this comparison by ascending the hill at 'delightful Shene', 'Shene', Saxon for 'shining' or 'splendour', being an old name for Richmond.

From here, Thomson leads 'the raptured eye' over 'a glorious view', a scene 'calmly magnificent', up and down the reach of the Thames. Taking in the residences of a number of notables who, along with the poet himself, had formed an alliance against Walpole's Whig government, and who, from their estates, sought to act out and exemplify what by then had become traditional Tory values of the preeminence of the propertied over the mercantile, the poet proceeds to praise the 'goodly prospect':

> Enchanting vale! beyond whate'er the muse
> Has of Achaia or Hesperia sung!
> O vale of bliss! O softly swelling hills!
> On which the power of cultivation lies,
> And joys to see the wonders of his toil.[4]

The strange inactivity of 'the power of cultivation' which, in apparent contradiction to the earlier efforts of 'happy labour', none the less remains energetic, argues simultaneously for the excess of that 'power' over and above labour and its harmonious relation to the land – and, by extension, to labour – which it controls and directs. Thereby, 'cultivation' comes to signify not only agriculture, but also whatever over and above that can be organised and controlled, including the acts of consumption and taste of the one who would control.

The composition of Chatelain's image would have sustained that project of an apparently comprehensive view, one which could be used as if to justify other forms of mastery, being maintained from a position of retirement. Yet it is not only the difficulty of an imaginable foreground vantage-point which indicates the insecurity of this ideal. The absence of variety in the view, one brought about partly by the control of scale, is reminiscent of a desire not to witness signs of disharmony or disorder. The imaginary fall into the image serves this desire by dramatising disorder *as* that fall, and rewarding it with the

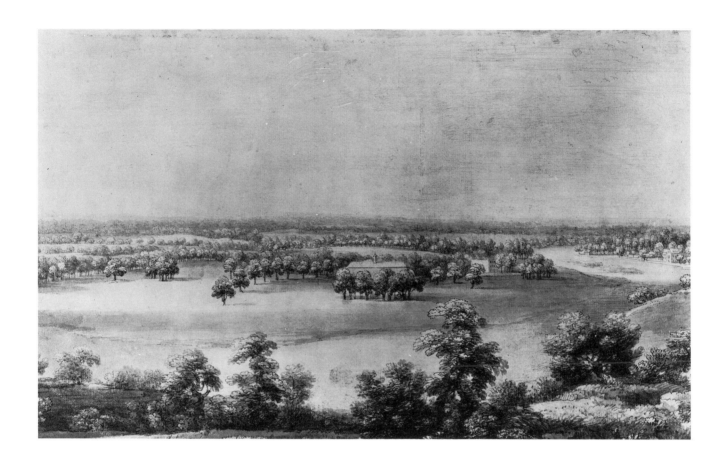

ordered view which would stretch out before it. The relative lack of incident and of detail in the image by Chatelain reminds us that the construction of an empyrean point of view was easier if it could, like Thomson on labour and tropical lands, praise and forget those over whom it sought dominion. What was required, as Thomson put it, was 'a goodly prospect' in which 'the stretching landscape into smoke decays'.

1 See Lambourne and Hamilton, eds., *British Watercolours*, p. 62 and Williams, *Early English Watercolours*, p. 25. For a possible use of this work see J.L. Roget, *A History of the 'Old Water-Colour' Society Now the Royal Society of Painters in Water Colours*, 2 vols., Longmans, Green and Co., London, 1891, vol. I, p. 17 on Chatelain's, *Fifty Small Original And Elegant Views of the most splendid Churches, Villages, Rural Prospects, and Masterly Pieces of Architecture adjacent to London* of 1750.

2 Thomson, *Poetical Works*, p. 57.

3 Ibid., p. 67.

4 Ibid., p. 93.

II Thomas Theodosius Forrest (1728–1784)

York Stairs, the Thames, Blackfriars Bridge and St Paul's Cathedral

35.3 x 55 cm; P.11–1931

Thomas Theodosius Forrest, son of Ebenezer Forrest, who was a friend of William Hogarth, exhibited as an amateur or honorary exhibitor at the Society of Artists' exhibitions and, later, at the Royal Academy between 1762 and 1781. This watercolour is probably part of what turned into the preparatory work for a painting called *A View From the Terrace of York Buildings* which was shown at the Royal Academy in 1770, a view which he would have derived from the area just outside his house on the north bank of the Thames.[1]

It might be thought that the apparent incompletion of some of the figures and buildings in this work could be attributed to Forrest having notated all the elements necessary for the later work, proceeding to reorder them there. Hardie adds to the circumstantial evidence in favour of this view by speculating that this was probably drawn out of doors.[2] However, given that the later work was also in watercolours, it is conceivable that Forrest left this version in this unelaborated state for reasons other than these extrinsic considerations.

The composition, emphasis of contrasts and drama of the scene are deployed so as to create a point of vantage which, although being situated on the same side of the river as the view in the distance, is at the same time detached from it. Differences of light and shadow both enable and require this to happen. The figures in the image tend to address themselves along the shallow diagonal of the line of the bridge, back along the north bank towards the Cathedral, along the bank in the opposite direction or across the river towards the south bank of the Thames. Our view takes in theirs, but it also encompasses St Paul's, a building which recent controversy has indicated is required by some to maintain its position of visible eminence if the city is to be imagined as organised and inhabitable.[3]

Forrest has composed St Paul's in such a way that it may become part of that culture in which the significance of the cathedral as a symbol is disputed. Here those out wandering, leaning on a balustrade and just left playing in the gutter risk being unable, under conditions of intense illumination, even to see what they seem to face. Perhaps, more importantly, we cannot be sure that we see what they see. Given this, and the implied absence of an understanding concerning what preoccupies them, the production of certain sites of imagined common interest becomes all the more desirable.

This can be provided by a view such as this one which, as Hardie's speculations suggest, can be imagined as being taken from outside, while at the same time not being explicitly marked by a loss of a discrimination of distance which that might imply. As viewers of the image, we do not suffer the apparent lack of the power of focus that the figures in the image do. Yet, were the image to have moved closer to a state of imaginable completion, then it would have become clearer that this variety of figures, in their dislocation from what is given as the object of our vision, on the bank which is, in turn, dislocated, remain apparently unconcerned about that apparent absence of a centre. Perhaps Forrest's later painting did not put this sense of a centre in question for those wandering around the site of its exhibition.

1 See Williams, *Early English Watercolours*, pp. 23–4 and Hardie, *Watercolour Painting*, vol. I, pp. 169–170.
2 Hardie, ibid., p. 170.
3 See H.R.H. The Prince Charles, 'The Mansion House Speech', *Modern Painters*, vol. 1, no. 1, Spring 1988, pp. 29–33.

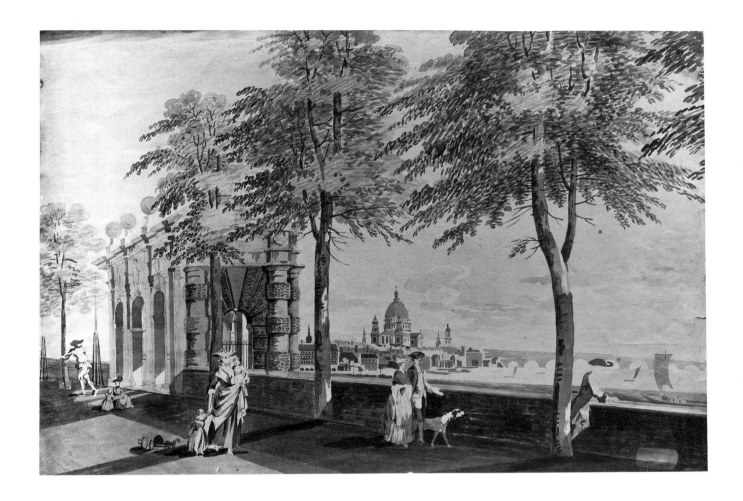

12 Paul Sandby
(1730–1809)

Moonlight on a River

Gouache
42 x 58.4 cm; D.1839–1904

Sandby's reputation as a founder of what has been identified as watercolour painting proper relied, at least in one of its versions, on the judgement that, even if his technique appears to have depended on a three-stage process of ink drawing, monochrome washing and finally colour washing, then the first two processes did not preclude him from developing, as a consequence of the third, what Martin Hardie called 'a just and proper management of values in their true sequence from foreground to remote distance'.[1] Sandby himself, however, was at least as concerned with techniques of bodycolouring, the works deriving from which he hoped would make his reputation. This example, which is perhaps the work which was exhibited under the title *A Moonlight* at the 1765 exhibition of the Society of Artists, demonstrates particularly well that the 'management' of those values which allowed Sandby to wash in colours to articulate what appeared to be an open and apparently endless prospect produced, as a curious counterpart, a view which was anything but endless.

An account of Sandby at work on one of his bodycolour works in 1805, late in his career, suggests how the segregation of washed and translucent from opaque colour was never, for the artist, completely established. 'He began', wrote his friend Colonel Gravatt, describing Sandby at work on the sketch of an oak tree, 'by mixing liquid black, verditer, and white for a dull sky, which he covered his paper with'.[2] Unlikely as it appears for someone who has been supposed to have established the proper vocabulary of watercolour painting to be preoccupied with such a procedure, Sandby remained attached to this process, even after its wider popularity declined, often sending greetings cards painted in this way.

Such a destiny as is plotted in histories of watercolour painting of the liberation of translucent or floated colour is therefore a justification of a preference by means of a formal teleology. But while this might now be admitted, it remains difficult, although not impossible, to place Sandby's gouache *Moonlight on a River* other than in this opposition of opaque and translucent. If watercolour is determined in the dominant formal account as proceeding from the lights to the darks, then this gouache would seem rather inevitably to have gone in the opposite direction, the light moon and its slightly less light reflection being laid on after the darker ground was prepared, supporting the argument about the segregation of systems in Sandby's practice.

The deconstruction of these apparently separate systems needs to discover a hierarchy in the opposition of lights and darks. And it is in relation to that notion of the endless prospect, signifying in complex ways both the limitless and without purpose, with which watercolour painting has been identified, that the lights gained their preeminence. No doubt metaphoric identifications of light with knowledge, as well as derivatives of this dominant metaphor such as 'clarity', referring to thought, or to argument, have determined this in part. In relation to this dominant key, Sandby's *Moonlight on a River* would therefore be read if not as the victory of light over dark, then as a certain holding of a position which might later contribute to that victory. The pluralisation of the appearance of the moon, its reception by the reflecting surface of the river, would fit this scheme.

These general implications of systems of representation with metaphors of knowledge is not the only way in which a mid-eighteenth-century scene such as this can be understood to be involved with a wider articulation of values than those that have been misidentified as belonging solely to such systems. In 'Ode to Evening', published in 1746, William Collins' extended personification of evening as a woman can be read to demonstrate how anxieties about darkness might be controlled by imagining compensatory pleasures. In the following passage, Collins introduces us to the moon, personified as male:

> For when thy folding Star arising shows
> His paly Circlet, at his warning Lamp
> The fragrant Hours, and Elves
> Who slept in Flow'rs the Day,
> And many a Nymph who wreaths her Brows with Sedge,
> And sheds the fresh'ning Dew, and lovelier still,
> The Pensive Pleasures sweet
> Prepare thy shadowy Car.[3]

The imminent turn of evening into night is staged as a departure, a loss. This loss, according to a reading of the rest of the

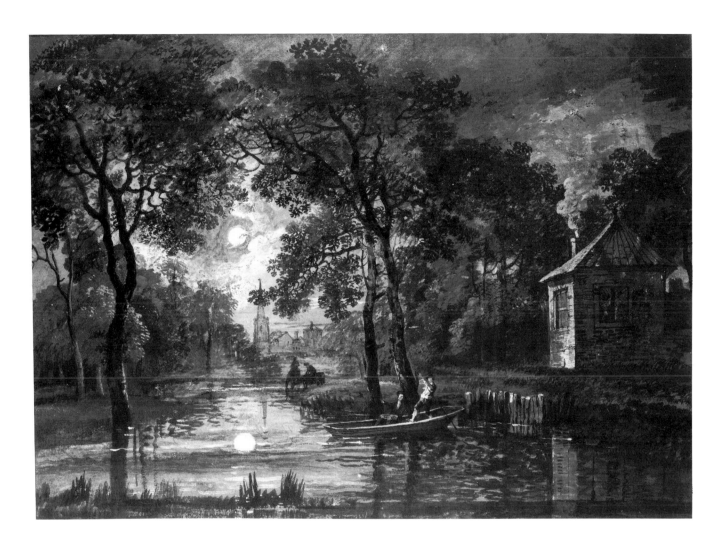

poem, would be as much of the woman who is imagined departing as of the apparently literal evening. This loss, of a relation to the woman and the succeeding threat of darkness, is defended against by that personification of the moon, the 'folding Star', the apparently self-enclosing 'Circlet', which, while gendered male, is none the less the property of the female eve. It is his 'warning Lamp' which arranges for the departure of the woman and of the dusk. And it would be he who would oversee and bind together the differences between evening and night, growing stronger as evening grows weaker.

This sexual politics of representation is not, of course, immanent in Sandby's image. There, the scene is complicated by the figure in the boat, steering a course under the light of the moon. But the reading of Collins' text does have the benefit of suggesting that that narrative of values in the imagined development of

watercolour painting which praises the luminous and abhors the dark repeats, without overcoming, anxieties about the instability of its representational systems. Sandby's continued attachment to gouache painting can be understood to testify to this more or less latent anxiety.

1 Hardie, *Watercolour Painting*, vol. I, p. 109.
2 Sandby, *Thomas and Paul Sandby*, p. 122. (See also Hardie, *Watercolour Painting*, vol. I, p. 108.)
3 William Collins, 'Ode to Evening' in T. Gray amd W. Collins, *Poetical Works*, ed. R. Lonsdale, Oxford University Press, 1977, pp. 156–7, lines 21–8.

13 Paul Sandby
(1730–1809)

The Round Temple

Signed and dated 'P. Sandby 1788'
26.4 x 36.4 cm; F.A. 561

Paul Sandby, like his brother Thomas, and like J.B.C. Chatelain, was employed on military campaigns to depict the terrain of war and conquest. As draughtsman to the Military Survey of 1746, Sandby was involved in the redefinition and redesign of Scotland, the rebellion of 1745 against rule from London having been defeated. His work was instrumental in allowing for the development of a new system of roads which not only made access to Scotland from the south easier, but which also sought to redetermine those regions which had formed an alliance against the English the year before. In 1768, he was appointed chief drawing master at the Royal Military Academy at Woolwich, retaining the position until 1796.[1]

It has been common to treat this part of Sandby's career as separate from his work as a producer of works for exhibition, as a mere apprenticeship, and there might be no obvious connection between a work such as *The Round Temple* and his practice as a military map-maker and painter. Yet Sandby's ability not only to make maps of the terrain of Scotland but also to provide scenes of extensive tracts of land that appeared integrated *as scenes*, as if repaired of the damage caused by conflict, was one which had its role in staging scenes less obviously marked by conflict. This tended to take the form of the construction of extensive prospects in which the limitation of the vision of others can be postulated.

The view between and beyond the trees here is relatively uninterrupted. Down a river, as if out to sea, the view allows us to imagine approaching the very boundary of the realm. Returning to the foreground, we can see that there are two who do not share our opportunity to see to the horizon, as if beyond any particular object of vision. Two women, their backs towards us, on their knees before the temple, seem to be worshipping. In the niche in the temple wall stands a rather baroque statue of a Madonna and child, an object which would have connoted, given its continental sources, and given its apparent denotation, Catholicism. While they

pay homage to the transnational, we are given a view that can recognise, because it can go beyond, borders.

The enjoyment of the apparently limited horizon of the worshipping women is made more complex by another possible object of their vision. Next to the niche in the temple wall, there is what appears to be a painting of a naked figure of a woman, standing upside-down against that wall. Would this too be some censurable Baroque excess? According to a certain Protestant account of Catholicism, the latter is culpable for not punishing enough a pleasure in appearances and in flesh, for forgiving it, preempting the forgiveness of God. The worshipping women might thus be judged foolish to worship that which implicitly allowed them also to be the objects of a desiring vision. But, of course, they are also available to be judged as not worthy of such exhibition and vision, especially given the construction of the view and the ideal of extensive, objectless vision which judgements against vision and visibility sustain. Some such narrative of the unworthiness of the women to be seen is possible: one of them seems to be seeking to glance up towards the picture, as if to identify it, difficult as its upturned position might seem to make this.

For why and with what effects is this image within the image upturned? We need to consider both the scene as represented and that it is a representation, itself a possible object for vision. The surreptitious look of the woman indicates something of her relation to the image and to us. Were she not to glance like this, it may be imagined, she might betray her interest, leaving herself vulnerable to the judgement that she worships because she herself is not worshipped. For us, however, we can imagine ourselves not overlooked – and this would be decidedly easier for a man than for a woman – as if able to turn the image so that that which we wanted to see could become the object of our control.

That establishment and maintenance of an ideal of control by means of vision is supported by this image. The complexity of the drama taking place almost as if off stage before the round temple indicates that this ideal of control through comprehensive vision is easier to maintain if there is, along with the possibility of a view beyond a limit, a view also of viewing which can be identified as being more limited, less comprehensive, less apparently enlightened than that which would be established by and for the controller. Qualification for this ideal, which, if it is to be operative in the world, *must* be exclusive, needs to include certain viewers as disqualified, those of apparently narrower sight.

1 See Clark, *Tempting Prospect*, pp. 39–44.

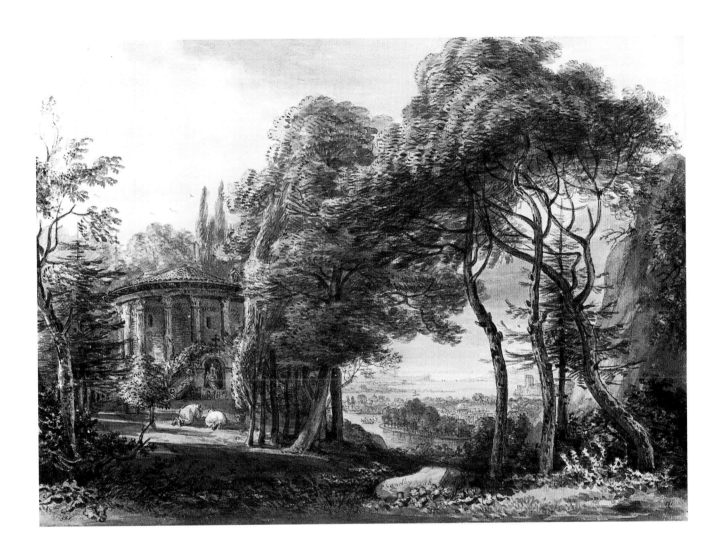

14 Paul Sandby
(1730–1809)

The 'Old Swan', Bayswater

Signed and dated 'P. Sandby 1799'
62.4 x 89 cm; D.1831–1904

This is one of a number of images of Bayswater which Sandby painted after moving, in 1772, a mile or so westwards beyond the limit of the city of London, to a house overlooking Hyde Park. Just a little beyond what is now the site of Marble Arch at the western end of Oxford Street was, then, out of London. His biographer, descendant W. A. Sandby, records that this move took him 'some distance from the city' to a spot 'commanding an extensive view towards the Surrey hills'.[1] Here Sandby lived until his death, not quite wanting to detach himself completely from the city, where he had a number of professional involvements, but keen, none the less, if his biographer's narrative of semi-retirement is to be believed, that it should be mostly behind him.

Matters were not as simple as that, however. Sandby's views of the Bayswater turnpike and its gate, in this middleground of this view, were staged as if from both east and west. At the Royal Academy in 1807, he exhibited views from these apparently opposite positions.[2] This earlier version is a view looking as if back towards the city, not away from it, once again establishing something like a command of 'an extensive view', not of the easily imagined submissive hills of Surrey, but of some rather less tractable subjects. This scene of the construction of the turnpike, a road which was to require payment to its owners by its passengers, is not yet under that control. It provides a site of activities which, in breaching the limit and extending the access to the city, is simultaneously a site of the overflow of that imagined centre.

The apparently disarranged composition of figures – soldiers, labourers, men and women not identifiable by task, horsemen riding by – at this interesting limit suggests a mingling, an unplanned arrangement. But the composition is less unmotivated than this implies. Most of the soldiers appear to be resting, letting things go. But there remains one, towards the centre

of the composition, bearing a pike and leaning on a tree. These two conditions imply differing modes of attention and involvement: ready yet relaxed, armed but not addressing. From this point of concentration, there is a sort of diffusion of the less attentive, which even seems to permit the relaxation of the efforts of the labourers.

In the foreground, however, to the left of the men working, stand two shadowy figures. It is as if Sandby has observed the rule which Robert Blair, at the end of a section of his poem 'The Grave', had articulated, having described a somewhat disorderly city scene:

What would offend the eye in a good picture,
The painter casts discreetly into shades.[3]

Sandby has situated those tattered figures well away from the fall of light. The gesture of the man carrying the bucket is thus here not simply interpretable as an exhortation to the labourers to continue working; it is overdetermined as a gesture to repel those figures by the wall, keep them at a distance, outside an economy of regulable labour and its aim of the production of the conditions of leisure.

Another poet suggests how these figures were identifiable as those who appeared to refuse and were feared to threaten to transgress this economy of labour and property. Describing another part of London where 'wide space is railed around', he remarks:

there is oft found
The lurking thief, who, while the daylight shone,
Made the walls echo with his begging tone.[4]

As if to beg were tantamount to stealing. Sandby's composition admits disarrangement and casual commingling only to the extent that an establishment of an identity of being in the light and being acceptable to an economy of production, traffic and leisure can be accomplished. The extension of the city, the risk of its limit, appears to have required a more comprehensive articulation of control.

1 Sandby, *Thomas and Paul Sandby*, p. 48.
2 See ibid., appendix I, p. 211.
3 Robert Blair, 'The Grave', in Davison, ed., *Penguin Book of Eighteenth-Century Verse*, p. 104.
4 John Gay, 'Pickpockets', from 'Trivia, or, The Art of Walking the Streets of London', in ibid., p. 102.

15 Thomas Rowlandson
(1756–1827)

Vauxhall Gardens

48.2 x 74.8 cm; P.13–1967. Bought with the aid of
a National Art-Collections Fund contribution

A contemporary of Rowlandson reported a conversation in which Mr Mitchell, a banker, friend and purchaser of Rowlandson's work, while carrying a portfolio of drawings away from the artist's house, met a man who was also fascinated by what the narrator called the 'graphic whimsies' of the artist. Mitchell, who is reported to have been rather fat, complains that his obsession for these works requires that he climb lots of stairs in order to get to the artist's rooms: 'Bless the man! why will he live so high?', he laments. 'Yes', the other man replies, 'I should not be surprised if he is taking a bird's-eye view of you and I at this moment'. Mitchell agrees that Rowlandson always appears to be on the look-out for a subject: 'I know not what to compare his prolific fancy to', he remarks, hesitatingly, 'unless – unless it be to this increasing population'.[1]

This comparison with what was then, in late eighteenth-century England, a growing cause for concern for those who wanted to think of themselves established in possession – as fears about population growth may still be articulated today – indicates a rather paranoiac motive for this banker to keep an eye on Rowlandson's work.[2] Not that he was himself the subject of what is usually identified as the caricaturing art of the artist. Indeed, as now, caricature was by no means simply abhorred by its subjects. Rowlandson's work was bought by the Prince Regent, later George IV, who may seem to be parodied in this example.[3] What is at stake in caricature is not simply the deformation of appearance, but what that might imply, by one means or another, about the relations of eminence with others which someone may want to preserve, at least in fantasy.

Paranoia is thus still pertinent, and we can trace something of its operation beneath this fantasy, articulated by Mitchell's narrator and repeated, with apparent benignity and gratitude, on a number of occasions since, that Rowlandson, from his bird's-eye view, left a comprehensive record of his age.[4] The apparent compendiousness of Vauxhall Gardens, often described as Rowlandson's masterpiece, has been remarked upon. This part of his supposed œuvre has been imagined to be large enough to

enable definition of the whole – partly because it was one of the few of his works that was large enough and apparently well finished to warrant exhibition at the Royal Academy, in 1784.[5]

What is less often noted is the plurality of points of view which the work implies. Martin Hardie protested against what he called Rowlandson's 'deliberate obtuseness' in the rendering of perspective:

> With his wish to suggest animated groups and violent contrasts of features or movements, he overcame the problem by seeing his rooms, in many instances, from somewhere near the ceiling, his streets partly as from the ground and partly as from a window, and by this means he obtained a recession, allowing head to rise above head, and group above group. Again and again, the perspective of figures, or of walls, windows, buildings, trees, is quite untrue and unrelated, showing two angles of vision.[6]

Hardie's protest is in effect the anxious double of the paranoiac thesis of the bird's-eye view, a failure to recognise its latent anxiety which returns in this protest about Rowlandson failing to abide by a rule. For what is 'the problem' which Hardie maintains that Rowlandson overcame if not the problem of this viewer who does not want animation and the risk of violence that that entails; who does not want an apparent rule bent as if to bring into question not only that rule for the production of pictures, but also that which that production would seem to confirm, the proper rising of 'head above head, and group above group'? The untruth of which Hardie complains is testimony to this implication of pictorial and social values, as a consequence of the failure of the projection of a controlling, a bird's-eye view.

If we pursue further this implication of compositional and social values in Vauxhall Gardens, however, we can see that there are, in turn, limits to the articulation of chaos, which is what we are supposed to fear when we are reassured (and threatened) by such criticism as I have outlined above. There is a kind of economy to the viewing which Rowlandson's work enables which might be described as a varying of the horizontal and vertical holds. The left wing of the bandstand-cum-theatre seems turned in towards us and its curve appears flattened out. Thus, the musicians in the upper storey seem to be able almost to crane round to see the crowd, including the performer for whom they seem, therefore, to be somewhat grudgingly playing. This craning of the musicians is itself a kind of figuration of the limits of any imagined bird's-eye view, which, at the same time, puts into question those who might imagine that they had such a view, the important figures below.

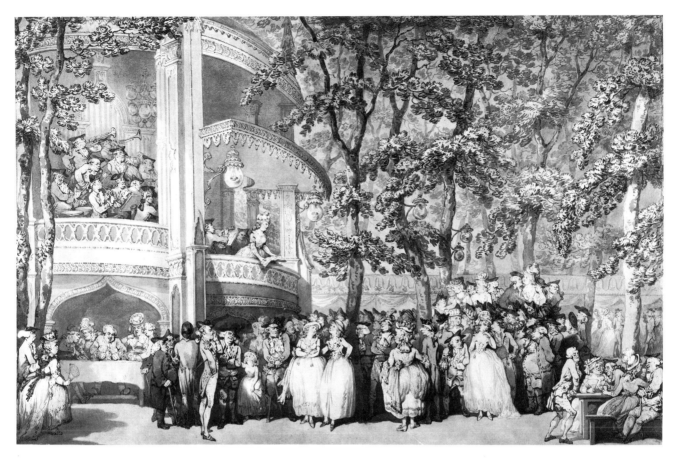

The group of figures to be observed sitting down and eating, among whom may be identified Samuel Johnson, James Boswell and Oliver Goldsmith, are caught engaged in a pursuit which men who pretended to a significant metaphoricity of *taste* might prefer not to be so noticeable. The figures furthest from us, who would be identifiable, according to some pyramidal model of society, as furthest from the apex, are visible, craning from their otherwise earth-bound situations to see the performer, above the front row of assorted notables. This craning, which Hardie would not remark, given that his neck and his taste seem to have already been twisted to their limit, does not however simply invert that imaginary pyramid. For that group coexists with the obviously raised group towards the right which is, somewhat oddly, illuminated, while others below are not. That the Prince and his companion, Perdita Robinson, are identifiable as the most prominent of the figures in this group suggests that Rowlandson has compensated for risking to show the Prince at play by enabling the assurance that, nevertheless, his pleasures are not quite of the lowest.[7]

This work, then, is neither simply documentary, nor comprehensive of all elements of society of late eighteenth-century London. Paranoiac criticism has reiterated these impossibilities about Rowlandson and his work to obscure any careful thinking about questions of pleasure in and anxiety about visual representations. For is not the limit to the mere reversal of the hierarchies imagined to be under threat in a work such as

Rowlandson's *Vauxhall Gardens* something to do with the establishment in vision of the object which, while imaginable as an object of desire for the subject, would be, in the same movement, raised by that evaluation to a position of possible command? Such a politics of vision is implied in Rowlandson's complex works.

1 Quoted by Hardie, *Watercolour Painting*, vol. I, p. 218.

2 On the 'prodigious power of increase in plants and animals', the limitations of 'the resources of the land' and the prospect of diminishing returns thereof, see Thomas Robert Malthus, 'A Summary View of the Principle of Population' (1830) in *An Essay on the Principle of Population and A Summary View of the Principle of Population*, ed. Antony Flew, Penguin Books, Harmondsworth, 1970, pp. 223–6.

3 For details of purchases and commissions by the Prince Regent, later George IV, from 1786 onwards, see Hardie, *Watercolour Painting*, vol. I, pp. 212–13.

4 For example, from his work as testifying to the 'present life and the aspect of the world we live in' in Roget, *History*, vol. I, p. 204; to 'the recorder of every kind of social activity', in Adrian Bury, *Rowlandson: Drawings*, Avalon Press, London, 1949, p. 79.

5 For a study which treats some of the divisions in scale and finish of Rowlandson's works in relation to the comic, see John Barrell, 'The Private Comedy of Thomas Rowlandson', *Art History*, vol. 6, no. 4, December 1983, pp. 423–40.

6 Hardie, *Watercolour Painting*, vol. I, p. 210.

7 For these identifications see John Hayes, *Rowlandson: Watercolours and Drawings*, Phaidon, London, 1972, p. 80; and Bury, *Rowlandson*, p. 79 (entry 8).

16 Edward Dayes
(1763–1804)

Buckingham House, St James's Park

Signed and dated 'Edw. Dayes 1790'
39.3 x 64.2 cm; 1756–1871

If Rowlandson's *Vauxhall Gardens* risks a complexity of views of position of royalty and commoners, debutantes and the disreputable, then Dayes' *Buckingham House, St James's Park* seems rather concerned not to do so. There is, in this picture exhibited in 1790 at the Royal Academy, six years after Rowlandson's, a variety which, rather than tending to put in question hierarchies, seems to maintain one, even as it varies the homogeneous.[1]

Dayes' version of the genre of the promenade scene, a tradition of representation which, before Rowlandson, derives from certain French models such as Watteau and Debucourt, shows a selection of relatively well-dressed men and women gathered as if arrested during what might seem to be, were it not for the attendant guards, an apparently unconstrained stroll before the main residence of the head of the British state. One might imagine that this image simply represents that place at a time when access to the monarch was not so constrained by political logics. One might think, indeed, that this was, as it is imagined today, simply a question of some general notion of privacy. One might note the absence of traffic in front of the then unaugmented Buckingham House and imagine that it was simply circulatory difficulties which had caused some problem to develop. If, however, we attend to some of the compositional details and their connotations, we can infer the existence, somewhat latent, somewhat emergent, of the problems of the motivation of the monarchy as a symbolic force.

Dayes' facility in what were then often taught as the separate disciplines of architectural, landscape and figure drawing does not seem to have overcome the odd necessity of effectively elevating, as Martin Hardie complained, the series of lightly shadowed figures behind the front group.[2] Indeed, the very contrast of light and shade would appear to throw those figures further back than their height would appear to warrant. The combined effect of these differences is to minimise the distance that would otherwise obtain between those figures at the front and the house beyond them in the background.

The sense, then, that the palace is both rather faint and distant but none the less quickly approachable – its door is brought to our attention, visible between the heads of the crowd – is thus due not simply to the inherent properties of the architecture of the building, whatever they might be imagined to be. Dayes' work, even in that style which appears to do justice to architecture by attending to the skeletal lines of a building, gives cause for interpretation, here helping to produce a strong effect of intimacy between the crowd and the residence of the head of state.

George III's monarchy had had its problems. In November 1788 he suffered the first occurrence of symptoms of madness, recovering signs of lucidity, for the time being, the following February. Meanwhile, in France, Louis XVI was having difficulties of a more widespread and perhaps less contingent kind: intensive negotiations with the French Parliament only delayed the uprising in July 1789 which led to the monarchy's abolition. While the powers of the monarch in England had been more constrained than those of the French monarch, the example of Republicanism in France put the monarchy in England in question and can be understood, at least, to have influenced the moves further to limit the powers of the heir to the throne. The Regency Bill, passed by Parliament in February 1789, invested the heir, the future George IV, with the title of Regent, but disallowed him from creating peers or granting offices.[3]

This prelude to the more widespread questioning of the monarchy after the French Revolution provided certain terms of a temporary resettlement of constitutional powers, ones to which Dayes' picture can be understood to be related. That mixture of nearness and distance from a differentiated crowd, which is part of the effect of the compositional mechanisms of Dayes' image, established terms of fantasy: fantasies of intimacy *and* of unapproachability which the later George IV was to benefit and to suffer from, and which continues to condition relations with the monarchy today.

1 For these details, see Hardie, *Watercolour Painting*, vol. I, pp. 180–1.
2 I. e. 'the background figures seeming to be standing on chairs', ibid., p. 181.
3 See Neville Williams, *Chronology of the Modern World 1763–1965*, Penguin Books, Harmondsworth, 1975, p. 54.

17 Robert Dighton
(1752–1814)

A Windy Day – Scene outside the Shop of Bowles, the Printseller, in St Paul's Churchyard

32.4 x 24.7 cm; D.843–1900

Robert Dighton may be remembered not only as a draughtsman, who during his career rivalled the prolific James Gillray as a political satirist, but also as a thief. In 1806 it was discovered that Dighton, with the collusion of the Rev. William Beloe, the Keeper, had been stealing prints from the collection at the British Museum. The practice, of hiding them in a portfolio ostensibly used to carry in what were his own prints which were to be compared with those in the public collection, appears to have begun as early as 1806.[1] Why did he do it? What was so compelling about his desire to remove these works from the public collection?

It would be mistaken, I think, to project a sense of Dighton being overwhelmed by the desire, as certain advertising copy encourages us to be, to possess original works of art. After all, the works which he expropriated were so-called reproductions, albeit those of rather limited and, in some respects, unrepeatable editions. The evidence seems rather to suggest that his motive was something like revenge.

It was not until 1735 that the first copyright act was passed in England. Instrumental in persuading the legislators that such a law ought to exist was Hogarth, who had protested against what he regarded as being the illegitimate copying and selling of engravings of his work. After the act, engravings had to be published 'as the Act directs', as many of them were subsequently engraved.[2]

Dighton's *A Windy Day* can be understood, in turn, to protest this act. Some of the then popular engravings are effectively reproduced on such a scale as to be quite recognisable. Dighton's picture allows an audience to view these works even when conditions, such as weather like this, let alone unnatural law, tend to preclude it. Part of the effect of the picture might be to expose the determined and apparently foolish appetite of the people who go so far as to risk loss of dignity, vanity, temper and good manners – a woman losing her hat and wig, men their equanimity

of appearance; the door of a shop being banged at, the fish-seller sadly trampled under foot – in order to get a look at these prints. But the picture none the less allows those pictures to be looked at. The greatest foolishness and indignity seems to belong to the man banging at the door of the closed shop, when he might be taking his chance with the others outside the window.

Given, however, that the copyright act was so framed as to try to ensure that prints were distributed through a single outlet, we might pause before mocking the man on the step. He may have nowhere else to go to see the objects of his desire without being buffeted by the wind. Without the benefit of being outside Dighton's picture, from where he *could* get a good look at the pictures on display, he can only appear somewhat desperate.

The copyright law brought pressure to bear on artists who specialised in engraving. Some sought to attach themselves, often by contract, to a particular painter, whose works they could then reproduce; others formed workshops contracted to particular printsellers. These various solutions to the problems of making a living separated that pursuit from that of education. Blake, for example, that imagined nonpareil among advocates of originality, was driven partly by his failure to secure himself in the trade of engraver to 'invent' and not only 'sculpt', as it says on some of his designs. Blake's difficulty had in part stemmed from the recognition that, if an engraver was to succeed, it was desirable to be able to copy and to trade, which the act prohibited. Thus, protestations like 'To learn the Language of Art, "Copy for Ever" is My Rule' need to be understood as partly determined by this law.[3]

Dighton's reaction to the act, I suggest, indicates some among its other undesirable consequences. *A Windy Day* subtly exposes the pretension of the law to protect originality of invention against apparently illegitimate copying, as if invention and copying could always be found perfectly separable. Perhaps his passion for the prints in the British Museum and his breaking the rules of that institution – which, in part, seem to be designed to seek to ensure respect for what are often examples from editions of the works of well-thought of artists – were finally, however, signs of a reconciliation with a culture which is apparently obsessed with values of invention.

1 See Hardie, *Watercolour Painting*, vol. I, p. 221.
2 See Ronald Paulson, *Hogarth's Graphic Works*, 2 vols., rev. edn., Yale University Press, New Haven and London, 1970, vol. I, pp. 8–9.
3 See 'William Blake's Annotations to Reynolds' *Discourses*', appendix I in Reynolds, *Discourses*, p. 285.

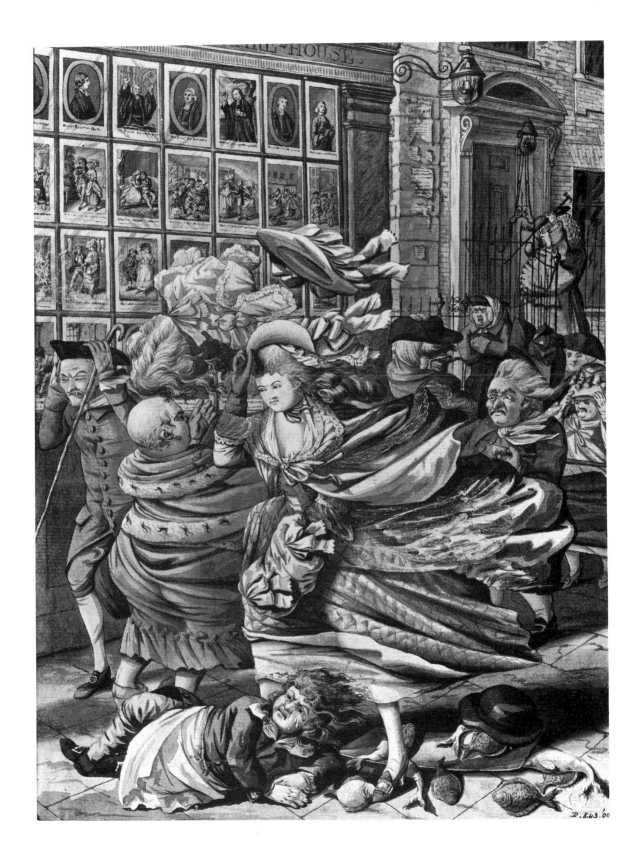

3

STAGING THE EVENT

18 Alexander Cozens
 (1717?–1786)

Landscape

45.4 x 65.1 cm; P.6–1928

The work of the prolific and inventive Alexander Cozens has been subject, in significant ways, to exclusion from the tradition of watercolour criticism that is outlined in the introduction to this selection. Now renowned for his advocacy of 'blotting' in order to encourage variety and novelty in the composition of landscapes, as set out in his treatise *A New Method of Assisting the Invention in Drawing Original Compositions of Landscape*, published in 1785, Cozens was edged from the ranks of the so-called national school of watercolourists, by the Redgrave brothers and by J.L. Roget. The latter's *History of the 'Old Water-Colour' Society* of 1891 was critical of Cozens – paradoxical as it may seem – for lacking the proper sort of originality.[1] His procedures of deriving landscapes not from an attempt to witness nature but from what he called 'an assemblage of dark shapes or masses' ran against the grain of an epistemology which wanted to be able to sustain judgements which blamed illegitimate subjective involvement for the unreliability of representations in contributing to an imagined store of visual facts. With Cozens' frank advocacy of beginning with what was 'rude and unmeaning', such a determination of unreliability was displaced from the outset.[2]

The desire to exclude Alexander Cozens produced some interesting symptoms. To a certain extent, Cozens the elder was forgiven his tendency to disrupt nationalist and empiricist critical schema for having fathered Cozens the younger, who, in going mad, could be admired for his daring. It was admitted that he had been an effective teacher. But his success in cultivating others seems to have been in some inverse relation to his own cultivation. It was reported that he was the so-called 'natural' son of Peter the Great: thus, according to the vocabulary of this tradition, his one claim to naturalness corresponded to illegitimacy. Born in St Petersburg, this *émigré* did not, to mid and late nineteenth-century critics, seem to belong.[3]

Since the Second World War, critical judgements have shifted. In *Art and Illusion*, first published in 1959, E.H. Gombrich argued that Cozens' method of blotting indicates what he called 'the beholder's share' in conventions of representation, and showed that even Constable was indebted to Cozens' suggestions for the depiction of clouds.[4] Not only did Constable's much praised cloud studies have their precedents, but their correspondence with nature needed to be qualified. Gombrich's qualifications, however, did not go so far as to acknowledge the dependence of the spectator, searching for correspondences with nature, on the image: the relations between legislative art and subjectivity implied, but disguised in the phrase 'the beholder's share'. Nor did it suggest how we might assess a work such as *Landscape*, which is more elaborated than an exercise in blotting.

Such a project is not assisted by the retrospective and unreliable classification of landscapes as classical or romantic. For this could be both: classical, because of its use of *repoussoirs* of the tree to the left and the mass of rock to the right and of the differentiation of planes of the view in alternating planes of light and dark tonality; romantic, because the effect of these means is to produce a scene which might seem desolate, a site of banishment.

A near contemporary of Cozens, describing what he then termed classical landscape, but which might also be mistaken for a description of a romantic view, indicates the difficulty of this classificatory distinction and allows us to relate Cozens' *Landscape* to more significant contradictions:

> Its qualities are sought in commanding situations, and bold projections; in masses of rocks and mountains; or whatever nature presents as solemn and stupendous; in noble fabrics, temples, palaces; in ruins of capital buildings; and the most magnificent executions of art, the lofty turret, the ivy-mantled tower, the consecrated aisle, the melancholy tomb.[5]

If Cozens' *Landscape* has a commanding situation, it is one of the distant horizon which is yet interrupted by 'bold projections', 'masses of rock'. The term 'projections' in the above notice names both that which would interrupt command and that which would, as a signal of artistic construction, testify to it. That it has come to identify a faculty which is often stigmatised as merely subjective indicates something of the inheritance of the difficulties of understanding treated, but reinforced by Gombrich.

Indeed, it might be thought that we can definitively separate and classify, in one of the ways outlined above, but that it is

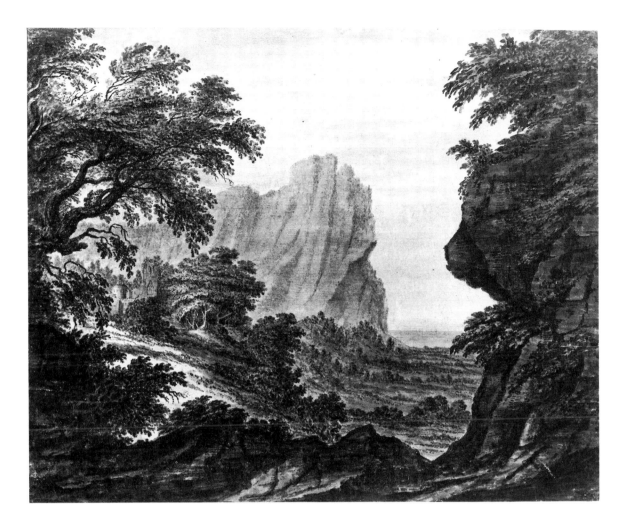

precisely what this painting by Cozens resists. Like the infection of nature with art, nature presenting something 'solemn and stupendous'; like the enablement of nature by art, as in the 'ivy-mantled tower', Cozens' *Landscape* tends to complexify this distinction. The juxtaposition of what might be an English gothic church spire and a series of Italianate cupolas stages a kind of compendium of architecture, the examples of which vie to define the region. Neither quite gives a dominant note to the scene: the Gothic, alongside the Italianate seems a little less than magically autochthonous; the Italianate a little less than fully commanding.

As I mentioned above, if there is something which might be imagined to be in the command of vision, then it would have to be imagined as lying beyond the horizon. But with what border would that horizon be identifiable, given the mixed sources of the architecture here? Perhaps it was this grafting, mingling and indeterminacy of site that, after all, was responsible for something of the neglect and disapproval of the work of Alexander Cozens.

1 For this implication see Roget, *History*, vol. I, pp. 56–7 on Cozens the teacher as someone 'who, moreover, let his pupils get away without imposing upon them the hard study and careful observation of nature necessary to a thorough practitioner in art'.
2 For these quotations from Cozens see Jean-Claude Lebensztejn, 'In Black and White', in Norman Bryson, ed., *Calligram: Essays in the New Art History from France*, Cambridge University Press, 1988 (pp. 131–53), p. 135.
3 See Redgrave and Redgrave, *Century of British Painters*, p. 149. Lawrence Binyon, in his *English Watercolours*, 2nd edn., Black, London, 1946, summarises the research which discredits this as fantasy.
4 E.H. Gombrich, *Art and Illusion: A Study in the Psychology of Pictorial Representation*, 5th edn., Phaidon Press, London, 1977, pp.154–69.
5 F. Fitzgerald, *The Artists' Repository II*, London, 1787–90, p. 199.

19 Thomas Gainsborough
(1727–1788)

Landscape: Storm Effect

Chalk and watercolour, varnished
21.3 x 26.8 cm; D.678

Like Richard Wilson's *Landscape* (see entry 1), this work in chalk and watercolour by Gainsborough requires an explanation, one which does not simply fall back on its being varnished to explain the differences in its appearance from most of the other eighteenth-century watercolour works brought together here. Like Wilson, Gainsborough regarded the developing practice of specialist watercolour painting with some censure. Less preoccupied with the values of permanence than Wilson, he was none the less critical of the apparent dependence of certain watercolourists on the scene which they sought to paint. Discussing the work of Paul Sandby, he is reported to have said that, despite its merits, nevertheless, 'with respect to *real Views* from Nature in this country, he has never seen any place that affords a Subject equal to the poorest imitations of Gaspar [Poussin] or Claude'.[1] Unlike Wilson, however, Gainsborough did not object to producing small works in watercolour and exhibiting them. In 1772 at the Royal Academy, he showed several 'drawings' in imitation of oil paintings. They were, save for their larger size, not dissimilar to this example from the later years of the decade. Indeed, it appears that Gainsborough was quite proud of them, enjoining a friend not to let the knowledge of his varnishing technique go any further.[2] These were among the works, moreover, which Reynolds recommended 'should be seen near as well as at a distance', in order that the strangeness of the effect of what he called the mixture of 'diligence' and 'chance and hasty negligence' could be noted.[3]

Gainsborough's interest in preserving his secret varnishing technique can be understood to imply a certain coincidence of his views with those of Reynolds, from whom he is often differentiated, not least because Reynolds took such pains, and got into some difficulties, trying to reconcile his admiration for Gainsborough's works with their contradiction of his hierarchy

of genres.[4] The following account by Reynolds of the values of manner, selection and style reiterate, in a more complex rhetorical fashion, something of what Gainsborough was protesting in the dependency on 'real Views':

> If we suppose a view of nature represented with all the truth of the *camera obscura*, and the same scene represented by a great artist, how little and mean will the one appear in comparison of the other, where no superiority is supposed from the choice of subject! The scene shall be the same, the difference only will be in the manner in which it is represented to the eye. With what additional superiority then will the same artist appear when he has the power of selecting his materials as well as elevating his style?[5]

The fear which permeates this argument – that devices like the camera obscura show that illusion is not simply in the hands of man, but that it lies between and across outside and in, part of the very possibility of the technological from which the painter's art is not entirely separated – governs the preoccupation with signs of control and the justification of the selection of a view. Reynolds had no systematic theory of illusion, and perhaps this fear is one of the several reasons for this. He did exhort his pupils and his larger audience to seek after style, achieved over and above the dedication to appearances, raised as high as possible in a scale of control.

Paradoxically, the apex of that scale of style was, for Reynolds, the style without style, a Raphaelesque artlessness.[6] Of course, it could only be readmitted as a possibility to the scale of values at the apex. In any other position, it would have threatened to be the product not of the relaxation of control, but of its failure. Gainsborough's sketches can be understood to put at risk this hierarchy determined by the inference of the once controlling presence of the painter. Close to, the sketch might appear to be composed of a disconnected variety of marks, the scene remaining separated in a repertoire of parts, perhaps no one mark appearing like the next. Inferences of style require not one example, but at least two; style is intrinsically reiterable, as problems with forgeries indicate.

Gainsborough's concern for the secret of his varnish, then, would be to defend the protection of a surface on which marks of his style could remain readable. Perhaps it was this, among other issues, which enabled him to be drawn to a subject which, in its rhetorical connection with these more general questions, allows us to imagine that he has risked his distinctive manner in relation to a destructive force of nature.

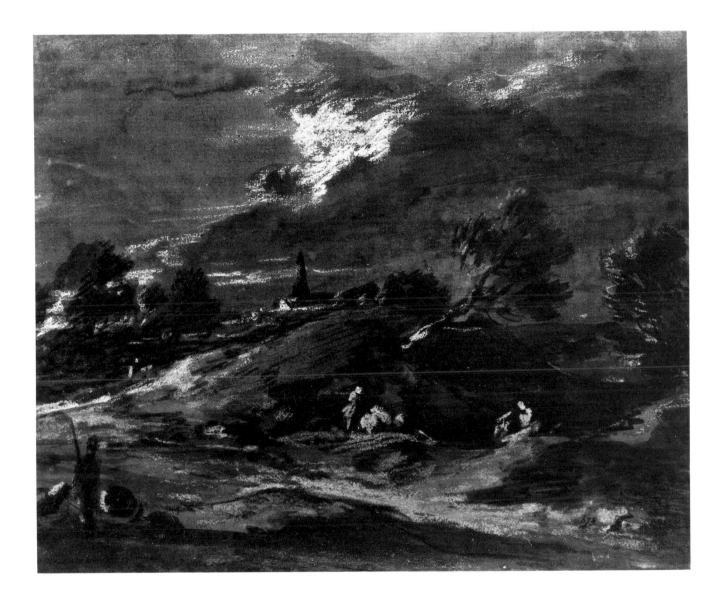

1 Quoted by John Hayes, *Gainsborough: Paintings and Drawings*,
Phaidon, London, 1975, p. 36.
2 See ibid., p. 25. Also Hardie, *Watercolour Painting*, vol. I, p. 38.
3 Reynolds, *Discourses*, p. 258.
4 See Barrell, *Political Theory of Painting*, pp. 120–3.
5 Reynolds, 'Discourse XIII' (1786) in *Discourses*, p. 237.
6 For example, see 'Discourse IV' (1771), ibid., pp. 59–60.

20 Robert Adam
(1728–1792)

*Romantic Landscape, with Figures
crossing a Bridge*

30.2 x 49.5 cm; P.3–1938

Adam's acquaintanceship with Piranesi, the Italian architect and archaeologist, during his visit to Rome between 1755 and 1757, encouraged the Scottish-born architect in interesting reconstructions of architectural elements of Rome's past. He was also encouraged to experiment in the manipulation of perspective.[1] This latter activity may be exemplified by Piranesi's *Carceri d'Invenzione* (begun *circa* 1745), images of spaces of imprisonment, without entrances or exits. Adam's *Romantic Landscape* might stand as a counter-example to Piranesi's *Carceri*. Instead of an imaginary closure of the scene, there is a concern for an openness, a kind of dilation of perspective. Such a practice of a loose elaboration of parts can be understood as a condition of some of his innovations in architectural practice.

It may be that this work was, in some more specific sense, part of a preparation for one of Adam's architectural projects, most obviously one of his remodellings of castles, such as that carried out at Alnwick, Northumberland, late in his career. Given, however, that Adam has been credited, among other things, with creating a sense of space even on smaller sites, in domestic neoclassical architecture, we can infer from this image something of the conditions for the range of his architectural work.[2]

It is not unusual for architects to seek to demonstrate, by means of plans and models, that there is space enough for a particular plan to seem feasible. In such a practice, one need not imagine that they are merely aiming to deceive their clients. Rather, they may be in the process of clearing a margin in which invention and reinvention can appear to take place. The implicit clearing that has taken place in this work involves, in that dilation of the view, the relations between a site of the feudal and the dwellings below it in the valley. Such an opening would have reminded those who occupied the heights that their relation to what lay below was now more mediated, less direct, and thus more complex. The reworkings by Adam of the remnants of a feudal order, in which Gothic elements, derived from the architecture of church rather than that of the state, were deployed, suggests a certain doubling of indications of power in that vocabulary. Moreover, given that Gothic architecture was itself coming to be associated with the indigenous (see chapter 4), it is more likely that these reworkings would have come to seem to belong.

The identification of this image as a *Romantic Landscape* suggests an avoidance of these questions of the possible role of this work in the rhetoric of architectural projects. Such an identification may be understood, in certain usages, as a way of identifying and confining excess. In the following extract from William Gilpin's 'On Picturesque Travel', one of his three essays of 1792, the promised reemergence of a notion of the romantic from 'romances' indicates that the kind of classification which this work has been subject to carries with it a restriction of excess in moral and in political terms:

> Some artists, when they give their imaginations play, let it loose among uncommon scenes – such as perhaps never existed: whereas the nearer they approach the simple standard of nature, in its most beautiful forms, the more admirable their fictions will appear. It is thus in writing romances. The correct taste cannot bear those unnatural situations, in which heroes, and heroines are often placed: whereas a story, *naturally*, and of course *affectingly* told, either with pen, or a pencil, tho known to be a fiction, is considered as a transcript from nature; and takes possession of the heart. The *marvellous* disgusts the sober imagination; which is gratified only with the pure characters of nature.[3]

Gilpin's concern to put under control the excesses of powerful representations, which threaten his moral discourse, is to appeal to a 'simple standard of nature' by which such fictions, written in pen or drawn in pencil, ought to be guided. Given the propensity of artists to let imaginations play 'among uncommon scenes', then perhaps it is only the viewer or reader who can be reined in by this code: sobriety of imagination, itself a figure opposed to the improprieties of excess, finds satiety 'in the pure characters of nature', a phrase which elides nature and the human, to sustain, if not to produce, notions of proper human nature.

This general argument about human nature misses the range of significance of its own terms. The dangers of play among

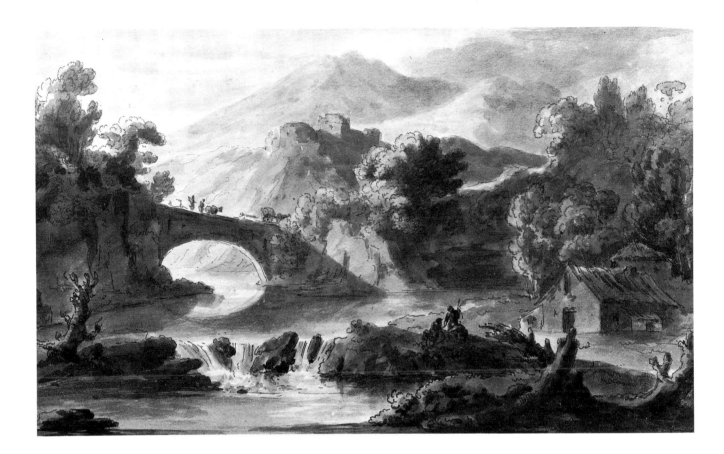

'uncommon scenes' is not simply that loss of sobriety, but also a threat of a discovery that there are things which are not common, not available to all, despite a legal and political framework which is articulated, in parts, as if there were. Adam's image, in treating these remnants of feudalism, in opening a margin in which that history of political relations and obligations might be renegotiated, in imagination, or in the promises of architecture, is found here, in this collection, identified as mere excess of invention. That moral discourse of Gilpin, conditioned in reaction to, but misrecognising the failures of notions of the common, the commonwealth, seeks its control of excess in a society which remained not unrecognisably related to the feudal.

1 See Lambourne and Hamilton, eds., *British Watercolours*, p. 3 and Hardie, *Watercolour Painting*, vol. III, p. 173.

2 See John Fleming, *Robert Adam and his Circle in Edinburgh and Rome*, John Murray, London, 1962, pp. 310–14 and Hardie, ibid., p. 174.

3 William Gilpin, 'On Picturesque Travel' in *Three Essays: On Picturesque Beauty; On Picturesque Travel and On Sketching Landscape to which is Added a Poem, On Landscape Beauty* (2nd edn.: 1794), Gregg International, Westmead, Hampshire, 1972 (pp. 39–58), pp. 52–3.

21 John Robert Cozens
(1752–1797)

View in the Island of Elba

Signed and dated 'J. Cozens 1780 [or 1789]'
36.8 x 53.7 cm; 3042–1876

When, on 10 April 1805, Christie's held a sale of a collection of works by John Robert Cozens, described as 'High-Finished Drawings', which had been brought to them by William Beckford, Cozens' sponsor on his second journey to Italy where these works had been painted, and 'from whose Cabinet they are now first brought forward to Public Inspection', the sale-house demonstrated something of the change that had taken place in the market for watercolours over the preceding decade or so. The claim that the 'Drawings' were 'High-Finished' was important: even if they did not quite seem to merit the name of paintings, they were not studies and appeared to have something of that completeness as images which might seem to justify the attentions of a buyer. As a corollary, the shift from Beckford's 'Cabinet' to 'Public Inspection' indicates something of the greater claim that could now be made for the exhibitability of watercolours.[1]

Cozens' work was soon eclipsed, in its market value, by works painted so as to appear to emulate oil paintings, thereby appearing to justify their sale and their position, hung on a wall. The variety and strength of the colouring of Cozens' works were being surpassed and they were soon to be returned to portfolios, partly, no doubt, for fear of their decay. Perhaps this was where Sir George Beaumont, a particularly strong opponent of the development of sales of framed watercolours, thought they ought to reside; nevertheless he owned some of J.R. Cozens' watercolours, and is reported to have hung at least one of them alongside four oil paintings by Claude. It is most likely that this was to seek to demonstrate a lack; but, whatever Beaumont's intentions, a scene of rivalry was staged.[2]

This and the second painting by John Robert Cozens in this selection might suggest why. His work, borrowing from his father and his compositional inventions, seemed also to be part of a development of the paring down of Claudian patterns, in a

logic of minimisation and intensification of that tradition. In the case of View in the Island of Elba, the composition seems to have been developed from one of his father's works, derived from a visit to the island in 1746. This had found its place later in the compendium of compositions, A New Method of Assisting the Invention...of Landscape (1785), in the second of sixteen kinds, one in which 'the tops of hills or mountains' are shown, the horizon being said to be 'below the bottom of the view'.[3]

Reflection indicates that such a horizon would necessarily be an imaginary one, one which would have to be inferred as a limit of the image as a scene, a representation. The compositional rhetoric operates, in View in the Island of Elba, not only by means of this inference, but also as a consequence of the difficulty of imaginary access to the scene created by the dark relative indifferentiation of the foreground. The massing of the trees to the lower left, set off against the fall of light on the side of the mountain and merged in darkest shadow with the unlit slope of the mountain at the centre of the lower limit of the view constructs a threshold between the spectator and the scene. This gulf, however, can be bridged in imagination by an interpretation of the landscape which lies beyond, one which seeks to reconnect it – as that logic of the inference of a horizon suggested – with our situation.

At the heart of the chasm in the mountain lying beyond this difficult foreground, the temple-like structure surrounded by trees which are more differentiated than those around, and which thus may be identified as cypresses, offers both a trace of previous passage and a figure for this difficulty of linking scene and position of view. That previous passage has left something which allows for the construction of recuperative oppositions: grounded and ungroundable; the habitable and the inhabitable. That this trace of previous passage is discernible in the chasm which so dramatically falls away into the impassable foreground all but requires such an interpretation.

John Robert Cozens' madness has often been used to sustain narratives of his having been able to testify to the experience of limits.[4] This sacrificial narrative of the artist has found it convenient to ignore the indications of that which cannot be experienced in his works, that which lies beyond their horizons, and the necessarily recuperative nature of an interpretation of them. In this, this narrative of the artist of limits has been in complicity with that market valuation of the imagined completeness of his works mentioned above.

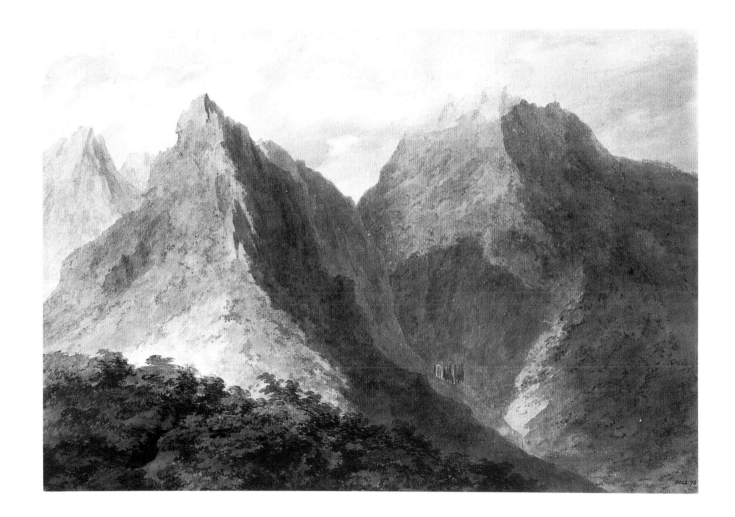

1 Andrew Wilton, *The Art of Alexander and John Robert Cozens*, Yale
 Center for British Art, New Haven, 1980, p. 15 and Clark, *Tempting
 Prospect*, pp. 130–1.

2 Ibid., pp. 132–3.

3 See Kim Sloan, *Alexander and John Robert Cozens: The Poetry of
 Landscape*, Yale University Press, New Haven and London, 1986, p.
 158. (Cp. C. Bell and T. Girtin, 'The Drawings and Sketches of John
 Robert Cozens: A Catalogue with an Historical Introduction',
 Proceedings of the Walpole Society, vol. 33, no. 433, 1934–5.)

4 For example, see Redgrave and Redgrave, *Century of British Painters*,
 pp. 149–50, quoting C.R. Leslie and Constable.

22 John Robert Cozens
(1752–1797)

Mountainous Landscape, with Beech Trees

Signed and dated 'J R Cozens 1792'
37.1 x 53.4 cm; 90–1894

This work of 1792, painted in the last year of Cozens' career as a painter, suggests a more complex series of oppositions and comparisons than the previous *View in the Island of Elba*.[1] The foreground, though broken by the river, presents more points of imaginary entry, though they are indeed points, difficult to link because of their varied degree of recession from us. We view the scene as if withdrawn from the wide area of ground to the right in order both to see the grander view and to be able to associate this with that more distant stretch of pasture where sheep are grazing. As if to mark this path of vision, here the painter has repeated, with some variation, the grouping of trees that we have stood back from, as if both to admire and to see round.

Seeing beyond, in this sense of seeing round, can never quite be accomplished in painting, much as Cozens' image is constructed so as to encourage us to try: around the *repoussoir* cliff to the left down the river valley; around and over the outer limits of the trees to the right, in the centre and, indeed, to the left. The vastness of the mountains that we are led to infer rising to the right behind the large foreground trees is no more than an inference, as they seem to disappear into the clouds, the articulation of which by means of a whiteness which doubles as the whiteness of the paper on which this scene is painted, brings us to another limit of this desire to see round.

To discover what the approach to these limits was, and may again, be thought to signify, why they were sought and what might be imagined to have been achieved in reaching them, it is instructive to compare Cozens' image, which probably derives from a number of sketches of the Alps and their foothills, with Wordsworth's famous account of a journey through those mountains in Book VI of the 1805 *Prelude*. While most of Wordsworth's accounts of the contrasts between mountain and valley tend to be given as if from above, descending, there are

passages, during the account of the journey through France, of *passage* along two rivers which take him towards the Alps:

> Among the vine-clad hills of Burgundy,
> Upon the bosom of the gentle Saône
> We glided forward with the flowing stream:
> Swift Rhone, thou wert the wings on which we cut
> Between thy lofty rocks. Enchanting show
> Those woods and farms and orchards did present,
> And single cottages and lurking towns –
> Reach after reach, procession without end,
> Of deep and stately vales.[2]

Just as Cozens' composition is apparently unprecedented, then so is Wordsworth's use of 'cut' as an intransitive verb. Using 'cut' without a direct object, which Wordsworth, encouraged by Coleridge, was to censure in the 1850 text, suggests a movement which, as the rest of the passage shows, appears to exemplify an endless freedom. It suggests, moreover, that the traveller might be forming the very landscape as he goes, cutting not 'a winding passage' as it became in the later edition, but, following the identification with the river, the very pass itself.

The description of endlessness, much as it is contradicted by the poem as its narrative moves on to tell of the climb of the Alps, allows Wordsworth at this point to suggest a terrain which can support, with its 'procession without end' of vales, an innumerable number of sites of habitation and cultivation. The difficulty of witnessing them, testified to by the violence of 'cut', turns into spectacle around the word 'show', which might, until we reach the word 'present', be read as a verb. Returning to Cozens' painting, we may note a similarity of limit and of the figuring of the pastoral, of cultivation. But if we do not recall the activity of looking involved in finding this foreground scene, and the resistance with which that activity has been met by the interrupted composition, then we may turn the landscape into nothing more than another example of spectacle.

1 See Wilton, *Art of Alexander and John Robert Cozens*, p. 29.
2 William Wordsworth, *The Prelude, 1799, 1805, 1850*, eds. J. Wordsworth, M.H. Abrams and S. Gill, Norton, New York, 1979, Book VI, lines 384–91, p. 206.

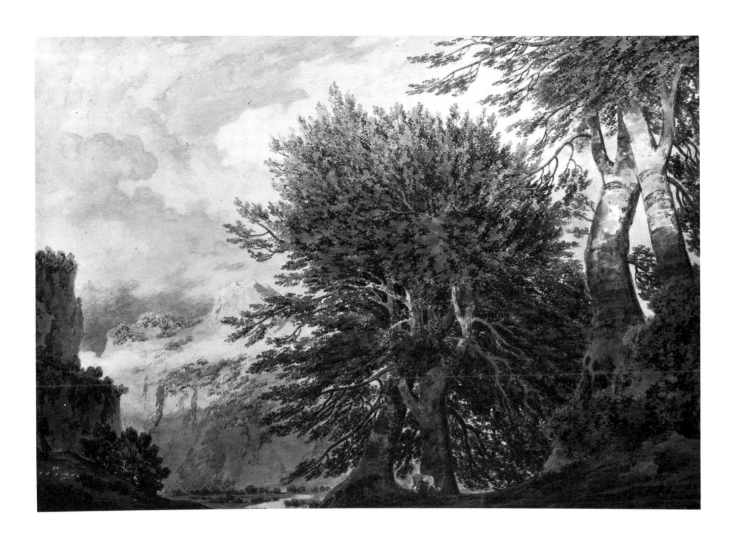

23 John Varley
(1778–1842)

View in the Pass of Llanberis

Signed and dated 'J. Varley 1803'
27.3 x 40.6 cm; 2954–1876

This work by Varley was probably derived from notes made on his first trip to Wales in 1798 or 1799, a trip which seems to have provided him with much of what became his repertoire as a landscapist.[1] Like the previous works by Cozens the elder and younger, it supports interpretations in terms of oppositions between habitable and inhabitable, fertile and barren. Unlike them, however, such readings find little resistance in the composition which might indicate the difficulty of such readings or, indeed, such states or projects. For the composition gives us rather easy access to what might be a certain limitlessness, while at the same time appearing to conserve that which occurs on the way: clouds pass, but do not quite occlude the hills in the valley; beyond, despite the clouds and the intensity of light, the summit rises into view. If we think of the sublime as a genre of landscape art, then Varley's work might seem to be an example of such a genre; if we think instead of the difficulties of representation and of presentation in, for example, J.R. Cozens' *Mountainous Landscape*, and think of the sublime as the problematic presentation of the unpresentable, then Varley's *View* will not seem to instance sublimity.

Consideration of Varley's work has often not moved beyond a criticism that it failed in the representations of such landscapes to develop compositions beyond the legacy of the practice of predecessors like Richard Wilson. Ruskin, for example, at the end of the first volume of *Modern Painters* (1843) criticised Varley for denying his audience variety: 'put off', as Ruskin had it, 'with stale repetitions of eternal composition'. Such a criticism was directed at Varley's notoriety for seeming to repeat his compositions, but also against a prevailing sense of the stasis and easy order of his works. Ruskin conceded that Varley's work showed a 'solemnity and definite purpose', but he did not go on to suggest what that purpose, other than the carrying of this value of 'solemnity', might have been.[2]

In *View in the Pass of Llanberis*, however, we can discover something of what enabled the apparent repetition of well-established subjects in well-used compositional formulae. For if such formulae were not to seem to be simply the reiteration of reassuring platitudes, then they needed to be employed to represent that which could be understood to benefit from, or at least be contained by, the values of the order implied by them. On the back of the painting, Varley wrote:

> View in the Pass of Llanberis N. Wales. Looking towards Llanberis Lake.
> From near the Large fragments of Rock in which an old Woman liv'd for some years

This inscription might lead us to discover, if we hadn't already noticed, the figure standing in the landscape, along the main right-hand diagonal of the composition. A consideration of a near contemporary articulation of the situation of such a solitary woman can help to indicate how such a figure in such a landscape may have been interpreted.

In *The Female Vagrant*, published in *Lyrical Ballads* in 1798, Wordsworth provides a largely first-person account of a condition of vagrancy which, given the qualification that this is *supposed* to be the condition of the figure in Varley's image, nevertheless suggests how that possibility of the loss of connection with society may well have been considered by an audience for Varley's work. The vagrant of Wordsworth's poem tells how a large landowner moved into the area where she lived with her father, tending her 'fleecy store', and proceeded to drive out the farmers of smaller holdings. Her decline, having been forced from her home amid 'the green mountains', deepens as her father, husband and children all die, and, having related her plan to leave for the 'western world', there to become a wanderer, she protests:

> Oh! dreadful price of being to resign
> All that is dear *in* being! better far
> In Want's most lonely cave till death to pine,
> Unseen, unheard, unwatched by any star...[3]

At least, so the comparison of Varley's image and Wordsworth's text may run, the figure in the image seems to have somewhere to live, somewhere to move from and return to, in however narrow an orbit; somewhere, even, where she might live unseen, unheard or unwatched. Not that she would necessarily need it, of course, for she might not have suffered such a loss as the

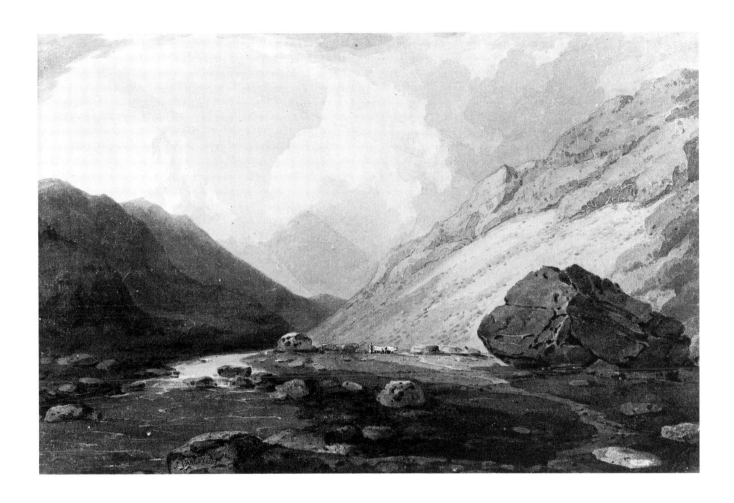

comparison suggests would be worse than never having had somewhere to live; indeed, by extension, worse than never having lived.

Some of the limits of this greater pain might have been approached by a viewing of this image by Varley, were it to be so imagined that the solitary figure has withdrawn having suffered loss. However, viewing would also be able to justify itself – thereby producing a morality of vision – by imagining that she was not someone who had *lost* the pleasures of a society. Furthermore, just in case the implication of this – that she was someone who had lain outside the boundaries of the recognisable and the comprehensible – was too disturbing, then the familarity of the composition would have been available to suggest that such marginality existed within a framework provided by well-known figures of order.

1 See C.M. Kauffmann, *John Varley 1778–1842*, B. T. Batsford/Victoria and Albert Museum, London, 1984, p. 13.

2 Ruskin, *Modern Painters*, vol. I, part II, sec. IV, ch. V, *Works*, vol. III, pp. 471–2. Cp. Michael Clark, *Tempting Prospect* on the first exhibition of the Society of Painters in Water-Colours (22 April 1805) at which 'one fifth [of landscape subjects] depicted Welsh mountain scenery', pp. 77–8.

3 W. Wordsworth, 'The Female Vagrant' in W. Wordsworth and S.T. Coleridge, *Lyrical Ballads* (1798), ed. H. Littledale, Oxford University Press, London, 1931, p. 76, lines 118–21.

24 Cornelius Varley
(1781–1873)

Part of Cader Idris and Tal-y-Llyn

Signed and dated 'C. Varley 1803'
25.4 x 36.8 cm; E.1398–1924

Cornelius Varley's painting career was more sporadic than that of his brother John. After 1810, he ceased to contribute regularly to the annual exhibition of the Society of Painters in Water-Colours, detaching himself thereby from the aims of the Society to attract the attentions of a picture-buying public. Their promises of adherence to 'academic standards' of drawing, colouring and, above all, 'finish' – as John Varley put it, members of the Society were 'hostile to "sketchiness"'[1] – may have seemed to have been fulfilled by a work such as Cornelius Varley's *The Market Place, Ross, Herefordshire* (see entry 63), but this work by him would not have suited their criteria. Allowing that this may well have been expected to be the source of a more apparently finished work, it can also be understood to exemplify some of those interests of the artist which later caused his involvement with the Society to lapse.

Varley was to become more and more involved in technologies of vision. On 5 April 1811, he was awarded a patent for 'a New construction of a Telescope or Optical instrument for Viewing Distant Objects & for other Useful Purposes'. This portable device projected an image, with the aid of lenses, a prism and a mirror, on to a sheet of paper, much in the manner of the more famous camera lucida, patented four years before. By 1851, Varley and Sons were displaying telescopes, microscopes and a camera at the Great Exhibition.[2]

It is interesting to note that Varley expressed his instrument's foremost purpose as being for 'Viewing Distant Objects'; not, therefore, primarily as an aid to the manufacture of images; not primarily as enabling the development of more accurate or comprehensive representation. A certain fascination for the distant and its difficulties seems to have preoccupied him, a desire to bring it into a certain sort of view. Such a fascination can be understood to be at work in *Part of Cader Idris*, in a way unmitigated by the compositional reliability or the obvious narratability of his brother's painting, such as is exemplified by *View in the Pass of Llanberis* (see entry 23). But we can also understand somthing of the limitations of the representation of the distant as well, something which is subtly marked in Varley's later application.

The composition of *Part of Cader Idris and Tal-y-Llyn* invites us to look down the valley to the right as if looking upwards into it. This imaginary entry and ascent tends to be diverted as it reaches the indistinctions of the furthest reaches of the scene to the right, instead offering us the shadowed and carefully detailed painting of the patterns of rock and vegetation of the lower and middle slopes of the peak of the mountain to the left. This turn in vision is emphasised by the apparent lack of finish of some of the near and middleground. Such a turn back towards the peak high on the left of the scene supplements the failure of discrimination and imaginary passage beyond the horizon with a delay, an imaginary ascent which, although it does not, indeed cannot, take us beyond another part of the horizon, allows our expectation of passage to be maintained. The implied closer focussing of the eye enabled by the greater detail on the slopes of the peak enables, in its turn, the displacement of some of the appetites of the imaginary eye.

Such a structure allows the notion that we can see beyond the horizon to be maintained even as it is diverted. Such a work, therefore, while it can be understood to prefigure the artist's interest in technologies of vision, is also indicative of the complex routes that need to be taken if that desire, which the technology was supposed to satisfy, to view 'Distant Objects' was to be maintained. Indeed, on reflection, we may come to the conclusion that that technology was instead designed to perpetuate and intensify that desire, under the cover of satisfying 'Useful Purposes'.

1 See Roget, *History*, vol. I, p. 139.
2 See ibid., p. 408 and Clark, *Tempting Prospect*, p. 19. For illustration see Alison Cole, *Perspective*, National Gallery Publications/Dorling Kindersley, London, 1992, p. 45.

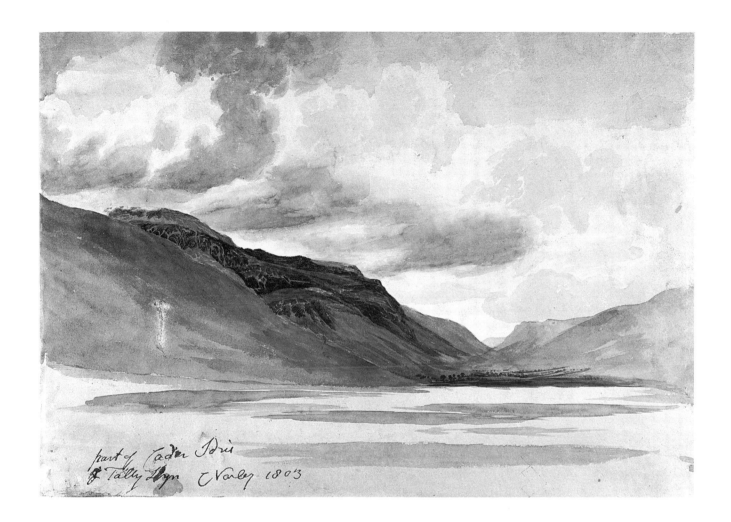

part of Cader Idris
& Tally Llyn C Varley 1803

25 Charles Vincent Barber
(1784–1854)

On the River Mawddach, Merionethshire, Cader Idris in the Distance

33 x 47.8 cm; 1454–1882

Son of the artist Joseph Barber, Charles Vincent was a contemporary of David Cox in his father's drawing classes in Birmingham in the last years of the eighteenth century. Cox and the younger Barber pursued comparable careers for a number of years: in 1805, they went together to Wales to sketch; in 1812, they were elected to membership of the Society of Painters in Water-Colours. However, unlike Cox, Barber does not seem to have proved versatile enough in the development of his watercolour practice. After 1812, the Society changed its name to the Society of Painters in Oil and Water-Colours and began to display works in both media. In 1816, Barber moved to Liverpool to teach, later becoming president of the city's institute, but ceasing to exhibit in London.[1]

From this, we might infer that it was merely because Barber failed to play the part of justifying watercolour by rivalling painting in oils that he ceased to exhibit in the capital. Consideration of *On the River Mawddach*, and comparison of it with the works by John and Cornelius Varley in this selection (see entries 23, 24 and 63), will suggest that this stage of spectacular rivalry also entailed issues of more general social significance.

The eye is encouraged to move in a rather regularly measured way, from plane of light to plane of dark, from ridge across hol-low of the receding landscape, a movement which terminates in a rather awkward leap of transition from well-defined middle-distance to the flat and rather undifferentiated line of distant peaks. Such a movement of the eye would not have maintained the interest in the search for the distant, as was evident in Cornelius Varley's *Part of Cader Idris and Tal-y-Llyn*; nor would it have been supplemented by the kind of diversion into obviously narratable incident that is possible in John Varley's *View in the Pass of Llanberis*.

Such absence of more obvious supplementarity may seem to be no more than a perverse demand for difficulty. But that detachment of the further peaks from the middleground landscape would have not necessitated a kind of effort which enabled other images to appear to justify the efforts of the eye. And this is a source of an interest in Barber's painting, one which indicates how, if that transition to the distant is made to appear too easy or too impossible, it ceases to provoke and maintain that effort to gather in that which lies beyond reach. Such an image would have seemed too purposelessly civilised.

1 See Roget, *History*, vol. I, p. 341.

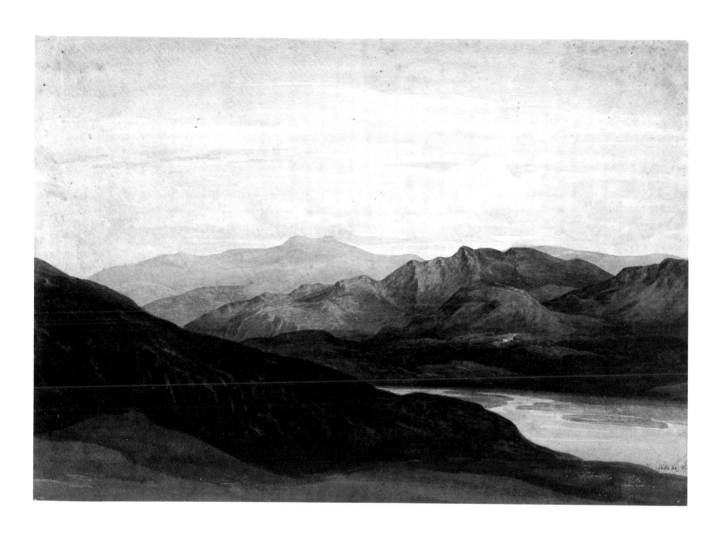

26 David Cox
(1783–1859)

A Welsh Landscape

Signed 'David Cox'
25.4 x 35.8 cm; 1924–1900

There is a passage in Cox's *Treatise on Landscape Painting*, first published in 1813, which gives guidelines for the painting of mountainous landscape, guidelines which one might expect the painter himself to have followed:

> In tracing the distinct objects of a landscape, it is recommended to attend more particularly to the general forms than to detail: for example, in sketching a mountain, it will be sufficient to describe the extreme Outline, without descending to the diversified and numerous ridges which may appear; for although these uneven divisions arrest the attention of the Student, when engaged in tracing the particular form of an eminence, they are lost to the eye which embraces, at one view, the whole of a scene.[1]

A Welsh Landscape, however, does not quite follow these recommendations. Something of the deviation can be put down to this work having been painted, in all likelihood, some thirty years after the publication of the treatise. But there is a certain radical impossibility in his theory which means that, for Cox, deviation in practice was unavoidable.

Cox has neither fully described the 'extreme Outline' nor avoided 'descending to the diversified and numerous ridges'. At certain points, the horizon of the mountains is occluded by low cloud or, for example, on the far left, has been left without definition. Furthermore, these two deviations from his recommended course seem related. The detailing of the 'diversified and numerous ridges' is sometimes so strong as to satisfy a notion of 'general' form such as Cox maintained would be best ensured by the articulation of the 'extreme Outline'. Thus, even while it may sustain a notion of general form in relation to some of its parts, the image tends to resist an eye which would seek to gather in 'at one view, the whole of a scene'.

It is certainly the case that, late in his career, Cox's work became apparently less careful. While later criticism has tended to value these works for their expressivity, his contemporaries were often critical, among them the Committee of the Old Water-Colour Society – as the one-time Society of Painters in Water-Colours became known[2] – who objected to the 'roughness' of his works. Cox's response to this criticism was not to defend himself on grounds of expression, but on the classic, Reynoldsian ground of general form: 'They forget that these are works of the mind.'[3]

Cox's retreat into this vocabulary of the theory of the work of painting is all the more surprising if we recall that theories of expression in painting tend to rely on a notion of an excess – of energy, of mark-making – over and above depiction or representation. Cox's practice *and* theory, however, are difficult to assimilate to this model. In order to reconceptualise that theory of excess and expression, we may return to that earlier theory of landscape painting to see what was radically impossible about it, for it is there that we shall find the reasons for the resistance which Cox maintained under the name of 'mind'.

Cox's resistance was, in effect, to that gathering in of a scene 'at one view'. Hence, the darkness of some of the central passages of the painting, a darkness which not only tends to obscure the meeting of the two figures on the path in the near middleground, but which also might cause us to miss entirely the smaller figures beyond. The trouble with this project of resistance is that it tends to forget that such a viewing is not in principle possible. For what does 'one view' mean here? Granted, painters are no doubt concerned to try to paint work to which people are attracted and to which they want to return, work which is not glanced at and passed over in one *viewing*. But this is not quite the same proposition for, no matter how brief, there is a duration to viewing, a temporality which tends to be neglected in the theory of the 'at one view'. That idea of general form to which Cox was attached is, indeed, one version of such a theory, one which depends indeed not on any examination of viewing as such, and its duration, but on a notion of artistic production dependent on an idea of 'mind'.

'Mind' is, in this theory, that which has supertemporal powers of apprehension, ones which can show the fittedness of phenomena for their apprehension by us. Painting, in this model, is understood to deliver such evidence. If we return to *A Welsh Landscape* to consider how it is, in the parts of a scene, that the effects of regularities of marks are created, we can understand that such a theory always forgets that the whole is the effect of a

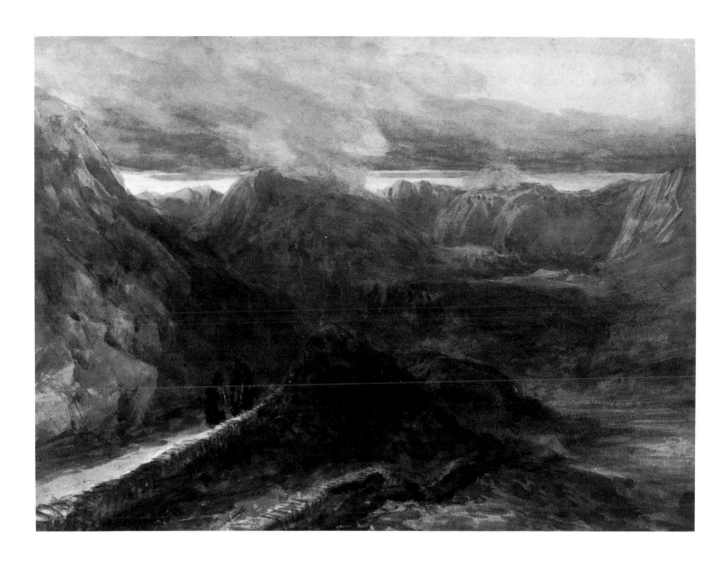

particular, but apparently transferrable marking of a part. In this sense, therefore, there was always a radical impossibility in Cox's recommendations to his readers to take in a scene at 'one view'.

As a corollary of this, there is necessarily an apparently more local issue at stake in a work such as this. In the case of *A Welsh Landscape*, this involves a question of belonging. Not a question of the belonging of the work to the artist, as Cox would have it; not a suitability of the work to belong to someone among its audience, as the Committee might have wanted it; but a staging of a drama of people and landscape which concerns belonging. For those figures who meet on the road are also likely to be interpreted as that which represents a whole of which this apparently Welsh scene were part: namely, Wales, the country as that to which land and people belong. What may be forgotten,

in those more generalised arguments about watercolour landscape painting, is this reading which would, in its turn, have neglected to note that such a meeting may have been of the itinerant, the migratory, those who do not sustain this identification of people and territory such as the discourse of nationalism maintains. Perhaps it is to such errancy that excesses recaptured as expressive relate.

1 David Cox, *A Treatise on Landscape Painting and Effects in Water-Colours: From the First Rudiments to the Finished Picture*, S. & T. Fuller, London, 1813, partly reprinted in *The Studio*, Special Autumn Number, 1922, pp. 13–4.
2 Probably in *circa* 1832 at the institution of the New Society of Painters in Water-Colours – see M. Clark, *Tempting Prospect*, p. 74 onwards.
3 See Roget, *History*, vol. II, p. 162.

27 John Constable (1776–1837)

View in Borrowdale

Inscribed and dated '25th Sepr. 1806'
24.3 x 34.6 cm; 192–1888

The sketches in watercolour made by Constable during his visit to the Lake District in September and October 1806 are notable for being the most sustained series of landscape works in this medium that he produced. By 1808 he had translated his interests in sketching into oils, beginning a practice that was to engross him for many years and which was later, and largely posthumously, to bring him fame.[1] It would therefore be tempting to construe this watercolour and others from that same tour as representing the germ of an interest that was to find fulfilment in those later oil sketches, works in which Constable, without regard for the public acceptability of the products, sought merely to match pigment against the experience of observing the changing phenomena of the natural world. But, even if we do not accept without qualification all of this thesis about the later work, perhaps, as E.H. Gombrich suggested in *Art and Illusion*, Constable had, partly by means of such sketches as this, established a framework of experimentation. This experimentation, so Gombrich's argument goes, could now proceed at such a pace, with a kind of unprecedented rapidity, that the painter's audience could only catch up with his work many years later, when other practices of representation had accustomed them to such images.[2]

However, as with any inauguration of new practices of experimentation, in science as in Constable's 'inquiry into the laws of nature', not only does the experimenter require a hypothesis by means of which the supposed results of the experiment can be recognised, but, before such recognition, there needs to be a displacement of the legitimacy of prior hypotheses, and the possibility of the inscription of a different one.

Constable's watercolours of the Lake District can be understood, therefore, to exemplify a process of delegitimation. On the back of this sketch, the painter has written:

25 Sepr 1806 – Borrowdale – fine clouday day tone very mellow like – the mildest of Gaspar Poussin and Sir G B & on the whole deeper toned than this drawing – [3]

This note allows us to qualify the import of the famous anecdote about the exchange between 'Sir G B', George Beaumont, the well-known collector, and Constable. Their exchange is usually reported as a dispute about 'truth to nature', the correspondence between image and world, of paintings by Gaspar Poussin and others, which Constable is supposed to have concluded by placing a violin on the grass in order to demonstrate the disparity of the tones of those images, for which the violin substituted, and those of the scene before them. The note on this watercolour, however, suggests that Constable had failed to approach the success of the correspondence between the day in Borrowdale and some of the 'mildest' of the tones of Poussin. We might then infer that watercolour could not do what oils were discovered later to be able to do, namely go beyond Poussin in a closer correspondence of image and phenomena.

This would be a little too hasty. Note that Constable's judgement in this remark on the reverse of the painting is qualified. It was only 'on the whole' that the day in Borrowdale was 'deeper toned than this drawing'. 'On the whole' signifies mostly; which signifies, to whatever extent, only *in part*. If Constable were to have recognised this, however, he would never have gone on to claim, perhaps never have gone on to inspire the claim, that his later works were the capture of the range of hues and tones in a scene before him. If he were to have recognised that *part* of the scene remained lighter than his sketch, even while most of it appeared to be darker, he would have been constrained to decide that the systematic comparison of the range of tones of an image and that which it might be imagined to represent was never simply to be concluded in favour of the image. To do so would thus have been not to commence his project, not to have sought to put the past painters definitively into the shade, not to have appeared to displace the hypothesis that a picture can never be as bright as that which it represents.[4]

Not that I want to suggest that he ought not to have done. Rather, more simply, that there was no perfect justification for so doing, only a variety of techniques of delegitimation, including presenting violins and sketching in watercolours. What remains, therefore, if there was and is no legitimation for the shift, is to seek to explain why the shift went in the direction it did. Why did Constable not seek, or not also seek, to outdo

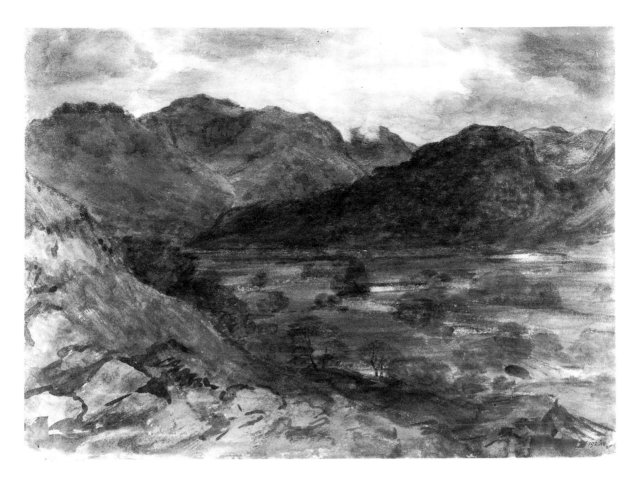

prior painters in painting in darker tones? Why did he not pursue that other project of correspondence suggested by this sketch and its occasion? A famous passage in Leslie's biography of the artist helps towards an explanation: 'I have heard him say the solitude of the mountains oppressed his spirits. His nature was peculiarly social and could not feel satisfied with scenery, however grand in itself, that did not abound in human association.'[5] The trip to the Lake District in 1806 was his sole visit to that terrain; he never went anywhere more mountainous. Indeed, it was on this trip that he outstayed his companion to discover, it would seem, that sense of oppression. He never again risked an encounter with such scenery.

What Constable lacked, therefore, was a sense of correspondence, between his sense of 'spirits' and 'the solitude of the mountains', a phrase which needs to be read as implying not simply his solitude there, but also the mountains' solitude. This projection, this sense of their not being in *his* company, is testimony to another limit of Constable's career: precisely, that search for correspondence, not simply between nature and image, but between a nature with which he could identify, his nature, nature subject to his propriation, and his paintings. Were

he to have pursued that other, suppressed project implied in this early work, then he might not have been left with the other of that search for correspondence, melancholy, which can be understood to have conditioned some of his later works and which remained, as we may see below, associated for him with watercolour painting itself.

1 Cp. Leslie Parris, Ian Fleming-Williams and Conal Shields, *Constable: Paintings, Watercolours and Drawings*, Tate Gallery, London, 1976, pp. 59–69, especially entries 69, 71 (entry 27 in this selection), 73, 76, 77, 83.
2 '[Constable] thought, and rightly, that only experimentation can show the artist a way out of the prison house of style toward a greater truth', Gombrich, *Art and Illusion*, p. 271.
3 Parris, Fleming-Williams and Shields, *Constable*, p. 65.
4 For a reconstruction of this tenet of classical theory see Michael Podro, 'Poussin and the Golden Calf' in Norman Bryson, Michael Ann Holly and Keith Moxey, eds., *Visual Theory: Painting and Interpretation*, Polity Press, Cambridge, 1991, (pp. 163–89), especially pp. 165–70.
5 C.R. Leslie, *Memoirs of the Life of John Constable R.A.* (1843) quoted in Michael Rosenthal, *Constable: The Painter and His Landscape*, Yale University Press, New Haven and London, 1983, pp. 38–9.

28 John Constable
(1776–1837)

Stoke Poges Church, Buckinghamshire: Illustration to Thomas Gray, 'Elegy in a Country Churchyard'

Inscribed, signed and dated
'John Constable R.A. July 1833'
13.3 x 19.8 cm; 174–1888

This watercolour and the one following it in this selection are two among a number of works, including several oils, which John Constable painted in the 1830s which he related to Gray's poem.[1] I want to go on to suggest a reading of those relations, as a way of understanding the images, but first it might be as well to indicate why this is important. It is symptomatic of a certain effacement of this possibility that Gray's poem, first published in 1751 as 'Elegy Written in a Country Churchyard', has, in the title given to this work, lost that word 'written'. The effect of this is to imply a desire to imagine a scene in which the text of the poem can be construed as a posterior record of a voice; a site of utterance which might itself become the topic of a visual image. This is not simply in order that we construe the scene as that site of the poet's supposed speech, although we may. Rather, it testifies to a certain lack of recognition, perhaps a desire not to recognise, that the image itself sustains certain significances, certain interpretations. Among these, perhaps most obviously, are interpretations of the poem itself, but also interpretations of other of Constable's later works and of some of the important topics with which they were concerned.

The church in this watercolour looks rather unlike the parish church at Stoke Poges, the supposed location of the occasion of Gray's poem.[2] To stop at this comparison, however, would just be to remain captivated by the kind of fantasy which the image itself can be understood to promote. Beyond any mere comparison of appearances of image and imagined referent, we may note that the church in Constable's work is both identifiable as a small parish church, such as one might expect to exist in the 'hamlet' of Gray's poem, but that it is also, given the composi-

tion and lighting of the scene, a structure which does not simply belong there. The situation of the building on the crest of the rising ground has obviated the need to show the meeting of its tower and that ground. Imagine viewing this structure from a point opposite to our viewing position: the tower and its steeple, which appear rather sunk over the horizon, might have to soar in order to be able to meet the ground. This instability of the relation of the tower and steeple to the ground, an effect assisted by the masking of the tower to the right by the tree and enhanced by the bright light which falls on it, is something in which other aspects of the scene get caught.

The lack of compositional rootedness of at least part of the church's structure may go unnoticed, as the rest of the scene is so painted as if to receive its displacement: the sky as if fast moving overhead; the trees as if moved by that which moves the sky. The light which falls as if from the sky, and which helps to pick out that tower and steeple mentioned above, also picks out the graveyard and its gravestones. Beyond the darkened foreground, in that unstable ground, these gravestones become part of that which is under threat.

The sense of instability in the image differs in significant ways from the disturbances implied in that part of Gray's poem which Constable inscribed on the reverse of this painting:

> The breezy call of incence breathing Morn,
> The swallow twitt'ring from the straw-built shed,
> The cock's shrill clarion, or the ecchoing horn,
> No more shall rouse them from their lowly bed.[3]

For Gray, then, 'the rude Forefathers of the hamlet', those who cannot be roused 'from their lowly bed', cannot be disturbed by the sounds of morning, the birds and the horn. The logic of this verse, therefore, implies also that they would not be roused by other noise or utterance, the poet's word unable to succeed at anything other than commemoration. That the poem concludes with an epitaph to an unnamed young man, which is to be imagined as inscribed on a gravestone in the churchyard, indicates moreover the kind of role for writing that Gray's poem promotes. Indeed, the anonymity of the dead 'youth' and the renown of Gray indicates further the logic of outbidding in which this poem is involved.

Constable is involved also in a logic of outbidding, not only of fast-moving appearances by means of his painting, but also of Gray's poem. The often quiescent and subservient relation assumed between a text and its illustration does not hold here, if

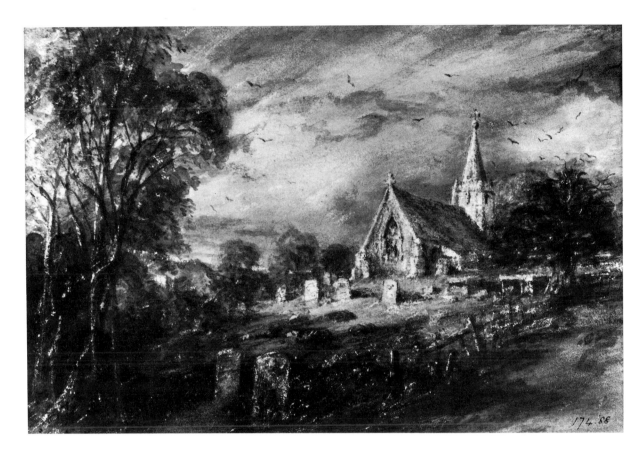

indeed it ever does. For the threat that the gravestones in the image are under is not simply that they might be disturbed by the general instability of the composition, but that, under the fall of light, as much as in the foreground shadows, they seem to have become unreadable. It is as if Constable, like Gray, is involved in a gamble with time. If he anticipates the erasure of inscription by effacing, then he himself will have left a mark, albeit an effacing one. As if in compensation for this, for the scene before us which displays the unreadable in an irreversible relation to time, he has inscribed the verso of the sheet which bears such an image.

It has been noted how, during the 1820s and 1830s, Constable became more and more interested in the church, the established church of the state. His large-scale oils of Salisbury Cathedral, for example, painted for Bishop John Fisher, have been interpreted as indicating an anxiety about the instability of life in rural England, an instability brought about, in part, by a crisis of falling prices, loss of income, purchasing power and consequent difficulties in surviving in an increasingly money-dominated and international economy.[4] Such events and effects, which were responsible for a crisis in free-trade ideology and ideals of stability found in and promoted by the land, can be understood to condition this work by Constable in both its sub-

ject-matter and its style. Not that there is any direct correspondence between apparent agitation of brush-marks and that anxiety; rather, the turn to the church being less obviously a question of order, as it is, perhaps, in those larger, more controlled works, and more a question of conveying the risk of disorder if that institution is not acknowledged as eminent.

It is in this light that the compositional drama of this image and the topic of the unreadability of the graves, the disturbance of the possibility of inferring lineage and thereby of being able to trace a sense of having belonged, may be interpreted. Perhaps it is a measure of the threat that Constable felt that he turned to watercolour on this occasion. The threat of the loss of a project of the repair of loss, with which watercolour was associated by him (see entry 27), is once again at stake here. Its role in reestablishing possibilities of a practice of painting governed by a search for correspondences with feeling, once again by exceeding a particular reading of a text, reiterates the logic of its use in his earlier career.

1 Parris, Fleming-Williams and Shields, *Constable*, pp.173–5.

2 Ibid., p.174.

3 Gray and Collins, *Poetical Works* (pp. 33–9), p. 35, lines 17–20.

4 See Rosenthal, *Constable*, pp. 143–6.

29 John Constable
(1776–1837)

Design for an Illustration to Gray's 'Elegy', Stanza 3

10 x 16.2 cm; 813–1888

Like the previous work in this selection, this watercolour seems to have been used as a source for a design to an edition of Gray's *Elegy* published by John Martin in 1834, this one for a vignette design printed with the third stanza of the poem. Interestingly, the composition, particularly in this watercolour, recalls both the 1828–9 and the 1829 versions in oils of Hadleigh Castle.[1] If we compare the image with the text and question how it might be imagined to operate as an illustration, we can again come to understand something of the complex relations to which these images by Constable testify concerning the position of the church and its authority in England at that time and, indeed, subsequently.

It is significant that this is an image of a structure which is somewhat un-church-like. The comparison with the paintings of Hadleigh Castle is therefore germane. The later, more finished of the two oil paintings was exhibited at the Royal Academy in 1829 under the title *Hadleigh Castle. The mouth of the Thames – morning, after a stormy night.* In the catalogue to the exhibition, in the entry for Constable's painting, there appeared the following text from James Thomson's 'Summer':

The desert joys
Wildly, though [*sic*] all his melancholy bounds
Rude ruins glitter; and the briny deep,
Seen from some pointed promontory top,
Far to the dim horizon's utmost verge
Restless, reflects a floating gleam.[2]

Notable about this accompanying quotation is how it implies a kind of unstable placing of the image. As noted in the remarks about Thomson's 'Summer' above (entry 10), the poem is concerned with a comparison of equatorial and tropical lands with Britain. Constable's use of the text 'The desert joys...' implies, therefore, that the desert has migrated to within the shores of

Britain. Here too are to be found ruins, melancholy and a desire to escape. The desert is incorporated in imagination, allowing for the recovery of the horizon and its 'utmost verge'. In the foreground of Constable's oil painting stands a man, gazing out to the horizon as if to perform this function.

Such an incorporation is part of the very movement of expansion beyond boundaries which I have outlined in the introduction to this selection, one which characterises the agenda of subjugation and annexation of British nineteenth-century imperialism. Not that I am suggesting that, in moral terms, Constable's work is responsible for such a movement. Rather, that a certain interpretation of this work such as is provided by the text from Thomson is part of such a movement, at least in so far as it is, and was, a nonrecognition of these issues. Interestingly, we can observe further issues of nonrecognition in the reuse of the composition in this later watercolour sketch.

If we consider the text of Gray's poem which this image came to accompany, we can trace some of these issues. The third stanza of the *Elegy* runs:

Save that from yonder ivy-mantled tow'r
The mopeing owl does to the moon complain
Of such, as wand'ring near her secret bow'r,
Molests her ancient solitary reign.[3]

Are we to imagine, therefore, that the ruined and somewhat mantled tower of Constable's sketch is to be thought of, now, as an ecclesiastical structure, rather than the remnant of feudal architecture that the tower of Hadleigh Castle appeared to be? The excision of this portion of Gray's poem indicates, I think, that we are given licence not to do so. His curfew-knelling tower is, indeed, the object of a displacement of ancient despotism: mantled, like a monarch, it is now the site of the abode and reign of a rather resentful and wary owl, who would enlist the moon in making that position of eminence unapproachable by others.

Something of this can be understood to be in play in Constable's image, not simply as some kind of repetition of the text, but, intially at least, as a question of its size and form. Small, relatively unelaborated, its appropriateness for a vignette design may be noted, the effect of such a form being to render apparently more placeless the represented place. Furthermore, in a book, often without further, formal framing, such an image is presented as if receptive of the text. This double logic of the vignette, both placeless and available for a multiplicity of read-

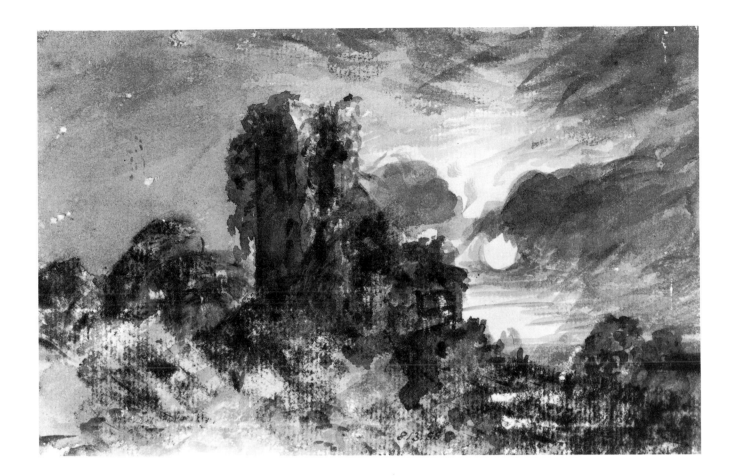

ings, was perhaps a fitting development of this watercolour: more detached from that difficult topic of the borders of a realm in the Hadleigh Castle oils, a detachment which enabled the reiteration of a certain regret for the passing of a feudal order, such an order and power of command could be reimagined, displaced and received by the church. Thus, a ruin would be restored, that ruin of command. The risk of this apparently modest image is thus that we do not recognise that such attempts at restoration are inevitably an incorporation of something from outside; a process condensed here into a question of ecclesiastical authority, but which others were involved in pursuing 'far to the horizon's utmost verge'.

1 Parris, Fleming-Williams and Shields, *Constable*, pp. 153–4 and 156, entries 261 and 263.
2 Thomson, 'Summer' in *Poetical Works*, p. 50, lines 165–70.
3 Gray and Collins, *Poetical Works*, p. 35, lines 9–12.

30 John Sell Cotman
(1782–1842)

The Devil's Bridge, Cardigan

Signed and dated 'J S Cotman 1801'
27.9 x 18.5 cm; P.29–1939

Similarities may be remarked between this watercolour and others made later by the young Cotman relating to extracts from Collins' 'Ode to Fear' and Dante's *Inferno*, probably in the early months of his presidency of the Sketching Society. It shares with them not only similar subjects – a chasm and a bridge seen from below – but also a restricted palette and a sense of emphatic design. The indeterminateness of the foreground and the positioning of the recognisable elements of the scene beyond it are comparable, in effect, with that vignette form about which I remarked in the previous entry. This holding at a distance, along with a restriction of detail and the narrow range of colour, operate as if to *provoke* interpretation. (Similar principles obtain in the Rorschach test.) Such provocation was one among the more significant aims of the members of the Sketching Society, at whose regular meetings particular passages of poetry would be selected to provide the occasion for painting.[1] As remarked above, the vignette form is particularly suited to making the image seem available for interpretation.

The establishment of the Sketching Society may thus be understood as a particular formation of artists who aimed to resist some of the other tendencies in watercolour painting of the time. These would include not only the kind of generalised agenda of naturalism, such as was in effect encouraged by the Society of Painters in Water-Colours (to which Cotman failed to be elected in 1806), but also the identification of watercolour landscape painting with antiquarian projects, such as can be understood to condition some of the works in the following chapter.[2] Resistance was phrased in terms of a defence of a tradition of 'Historic Landscape', a practice which, by the staging of significant events in landscape views, aimed to provide its audience with narratable works, ones which could therefore be understood to promote understanding of those events, thereby justifying the practice of the painter. This practice, one which

depended, in part, on a hierarchy of genres, with history painting standing above landscape, in which the latter could be understood to be aspiring upwards, was understood to be under threat. One sign of this was the apparent loss of exclusive eminence as an institution of art that the Academy had once seemed to have, the Society of Painters in Water-Colours being one among those more recent institutions which qualified the Academy's importance.

Resistance to the tendency of the dissolution of that hierarchy of genres, and against the naturalist notion that landscape related to history only by being able to represent sites which had been of importance, was thus part of the agenda of Cotman and the Sketching Society. However, if, as it appears, this work was made by Cotman before he became a regular member of the Sketching Society and, instead, was one among a number of drawings, derived from his first tour of Wales in 1800, which he presented to the Society of United Friars of Norwich, to which he had been elected in January 1801, then we can further explore and refine the significance of this painting in the history of landscape painting in watercolour.

The members of the Society were rather pleased, it seems. They enjoyed, it is recorded, 'some very masterly sketches of scenes in Wales'.[3] Such enjoyment would not, however, have been as surprising as one might imagine: for the Society was not a fraternity of friars dedicated to promoting the example of Christ, but a group of assorted connoisseurs, antiquarians and the like, whose enjoyment was no doubt partly conditioned by the apparent perversity of their self-identification. Such perversity, furthermore, was maintained by the possibility that the painter appeared to be able to exercise mastery for the purposes of interpretation. The pleasures of the members of the society may well have been in something like the following.

In Canto XXIII of *The Inferno*, Dante follows Virgil from one chasm of hell to the next, escaping some demons in the former, descending deeper into the concentric circles that lead towards the domain of Lucifer, there to meet with some friars. These friars wander to and fro, weighed down by the lead copes which, as penitents, they have been forced to wear. Dante's conversation with them is interrupted by the sight of Caiaphas, pinioned to the ground in the form of a cross. This is, symbolically, an appropriate punishment for Caiaphas, whose crime was to encourage the Pharisees to support the crucifixion of Christ. It is not appropriate, other than symbolically, for the appropriateness would be given by the rule of the Christian code, such as

Caiaphas has been instrumental in bringing about. Virgil marvels at the fate of this figure and then he turns to ask one of the friars if he knows of any way out of 'this pit'. The friar replies:

Nearer than thy hopes foretell
A rock that from the encircling wall doth go
Maketh a bridge across the valleys fell,
Save here where the arch is broken and roofless, so
That you may mount the ruin, which is spread
All down the slope, and heaps itself below.[4]

Virgil and Dante then climb the ruin of the bridge which was, we are informed, all but destroyed by the earthquake at Christ's crucifixion.

Such a linking of image and text is necessarily speculative. In this case, the indeterminacies of the image play their part in sustaining a sense of this. But it is to the point that such societies as those of the United Friars of Norwich sustain their identities by means of such unprovable processes of interpretation. Moreover, this suggests that the goals of resistance to the apparent *loss* of significance of painting which characterised the stated aims of the members of the Sketching Society need to be reconstrued. Such projects of resistance are, in a certain sense, endless: it will always be possible to dispute such interpretations; thus it *may* always seem as if such projects need to be undertaken. The aim of consensus in interpretation is secondary to the impetus given by what, as a consequence of interpretation, remains undecidable.

The formation of groups like the Sketching Society testifies to an incipient *avant-gardism* in nineteenth-century art. The failure to recognise this might well have been determined by a desire to avoid recognition of something of the fate of such groupings. In this case, the particular concern of that group to explore the exemplification of text in image suggests something of the humour that may emerge on the other side of a dream of a correspondence of image and text, and the associated dreams of common culture and community. In a letter to his son John, some years later, Cotman remarked on his habit of changing the subject of some of his pictures: '*What effect*! What contrast!!! from the sublime to the ridiculous, not one space between.'[5] Whether this change took place for Cotman concerning *The Devil's Bridge, Cardigan*, whether there was the realisation of the tendentious aspects of the narrative and a displacement of them, despite their importance, by the image, may not be proven. That such possibilities, of humour and apparent perversity, haunt the

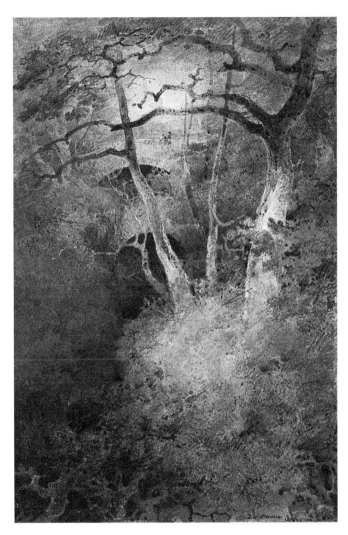

relations between text and image is something that generalised projects of resistance to cultural fragmentation forget.

1 See Jean Hamilton, *The Sketching Society 1799–1851*, Victoria and Albert Museum, London, 1971; also Hardie, *Watercolour Painting*, vol. II, pp. 74–5.
2 See Marjorie Allthorpe-Guyton, 'Cotman and Normandy' in Arts Council of Great Britain, *John Sell Cotman 1782–1842*, Arts Council/Herbert Press, London, 1982, pp. 27–9, to which these interpretations are indebted.
3 Arts Council, ibid., p. 30.
4 Dante, *Inferno*, Canto XXIII, lines 133–8, trans. Lawrence Binyon in Paolo Milano, ed., *The Portable Dante*, Penguin Books, Harmondsworth, 1977, p. 125.
5 Quoted in Michael Pidgley, 'Cotman and his Patrons' in Arts Council, *Cotman* (pp. 20–2), p. 20.

31 John Sell Cotman
(1782–1842)

On the Tees at Rockcliffe

Signed 'Cotman'
21.5 x 31.5 cm; 93–1894

This watercolour was once known as *Landscape with River and Cattle* and this, I think, better indicates the effects of the clear design, careful control of tones among washes and the strong contrasts of colour than the more recent titling by location. Such an identification by location is, in part, related to a kind of fascination with the imagined occasion of the work. Whether Cotman knew this location in the north-east of England – and, given his repeated visits to Yorkshire between 1803 and 1806 and at least one to Durham during this period, he might well have done – the complexity of his situation in 1808, when he painted and probably exhibited this painting, needs to be considered when seeking to account for its appearance.[1]

In 1806, Cotman had moved from London to Norwich. Having failed to be elected to the Society of Painters in Water-Colour, he withdrew from seeking to exhibit in the capital city to set up a drawing school, teaching and showing in the town where he was born. Cotman's practice did not suit the growing market in London for watercolours which strove for an effect of completeness, in density of colour, for example, but also in terms of an effect of representation, in rivalry with oil painting.

That effect of representation is important in this case. For it was not just a fidelity to the possibilities of the medium, that teleological and often moral reconstruction of a tradition which I have outlined above, which caused Cotman to leave *On the Tees at Rockcliffe* in something like the condition that it is now found, often judged to be one of that imagined tradition's best examples.[2] There are also issues of the significance of the representation which can be interpreted to indicate some of the larger issues at stake of which the concentration of a certain market for art in the capital city was a symptom.

The structure of the composition of this work can be understood as an economy of distance and proximity. The falling away of the foreground, which discourages imaginary entry to

the scene, is offset by the horizon and the middleground landscape of hills and trees which appear to curve in towards us. The sense of their being distant is further moderated by the comparability of the touches delineating them and the sky. So strong is this effect of the composition that the passage of the river away to the right may be forgotten. It is as if the river flows away beneath us, rather than ahead into the distance. A certain vertigo is held at bay, moreover, by the line of cows, which, in joining river bank and river, help to create a stable middleground.

Thus, that which seems distant is kept away from us, not as the object of an impatient search, but as that which enables that which is closer to remain apart. In the controlled drama of appearances in this work, the reflection of the sky and trees in the river below plays a part, not as that figuring of time passing such as we get in Constable's work, but as a certain excess of appearance over significance. Unlike some of the works on show in London, there is not the effect of a delivery of a scene of some place in all its particularity. Nor is there the possibility of imagining that order only occurs elsewhere, outside the frame, as if the delivery of that scene from elsewhere were being relayed to the site of control, possible or actual, which the capital might want to be. Perhaps, to the extent that this is what has occurred, then certain of Cotman's early works seem to have become unrepeatable.

1 See Arts Council, *Cotman*, entry 77, and 'Chronology', p. 30.
2 For example see Graham Reynolds, *British Watercolours*, Victoria and Albert Museum, London, 1951, pl. 17. Also Hardie, *Watercolour Painting*, vol. II, p. 83.

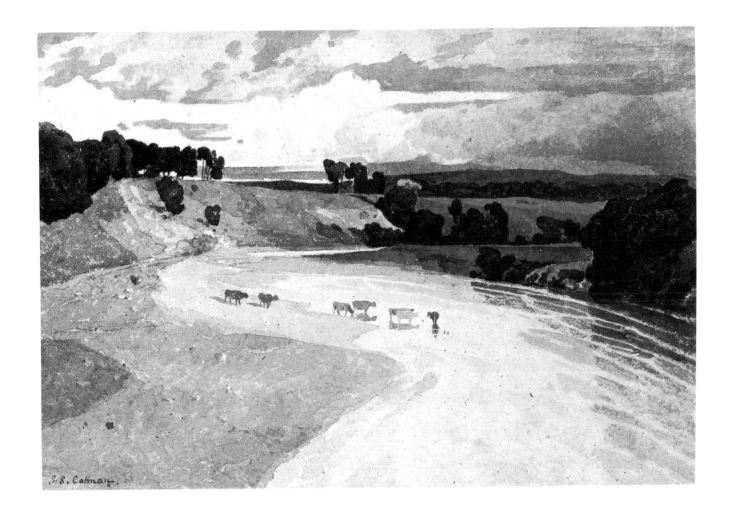

32 Joshua Cristall
(*circa* 1767–1847)

Hastings Beach

Signed and dated 'J. Cristall. Hastings Aug '20'
16.3 x 27.6 cm; P.4–1957

There is a great variety among Cristall's watercolours representing Hastings. After 1802, when he exhibited *Fishmarket on Hastings Beach*, renowned as being one of the largest and most populated figure compositions in watercolour yet shown, he painted many others, the last in 1826.[1] This work of 1820 is notable among these for the absence of any clearly delineated figures and boats, the usual subjects of his attention, and thus the apparent absence of themes of work, exchange or leisure.

For the relations between these concerns had become, by 1820, too complex and too involved for Cristall to be able to provide images which sustained a sense of the happy coexistence of these activities. The notion that the town was a kind of self-contained haven, feeding itself with its fish, even while it received more and more visitors, could not be maintained. The popularity of the place with large numbers of artists, among them many of Cristall's colleagues from the Society of Painters in Water-Colours, in itself further testifies to the absence of that ideal of integration.

The composition of *Hastings Beach* indicates a retreat from these thematic issues. The remnants of the town appear in the distance, with the boats on the horizon only just recognisable as such. We view the bay from behind the large outcrop of rocks in the foreground, the differentiation of which contrasts notably with the lack of differentiation in the distance. By comparison with some of Cristall's larger and more complex figure compositions, this is a work which, if it relates to those themes of work and leisure, it does so by withdrawing from them, as if to restore the distance from the town which the involvement of visitors in search of the restorative pleasures of the sea had rendered a site of *fantasies* of harmonisation.

There has been a tendency to seek to classify Cristall's numerous works in watercolours by style, perhaps because they are so numerous.[2] The apparent proliferation of these styles – neoclas-

sical, rococo, naturalistic (that category for those works which have an awkward lack of style) – has tended to result in a certain embarrassment at a failure to be able to claim that the artist established something obviously his own. What this approach fails to recognise is that these apparent shifts were not simply the result of Cristall's apparently perverse desire to avoid the notice of posterity. Rather, it is testimony that most of Cristall's career was occupied with projects aimed at a market which often seemed to want no more than different styles. On the other hand, as with *Hastings Beach*, this is never a sufficient account of what determined the framing and rendering of any particular work. The recovery of a sense of order in a site disturbed by an economy of leisure might have seemed to have been accomplished here.

1 See Basil Taylor, *Joshua Cristall 1768–1847*, Victoria and Albert Museum, London, 1973, p. 38.
2 On Cristall following 'many courses in search of patronage and an appeal to taste', see Taylor, 'Introduction', ibid., p. 15.

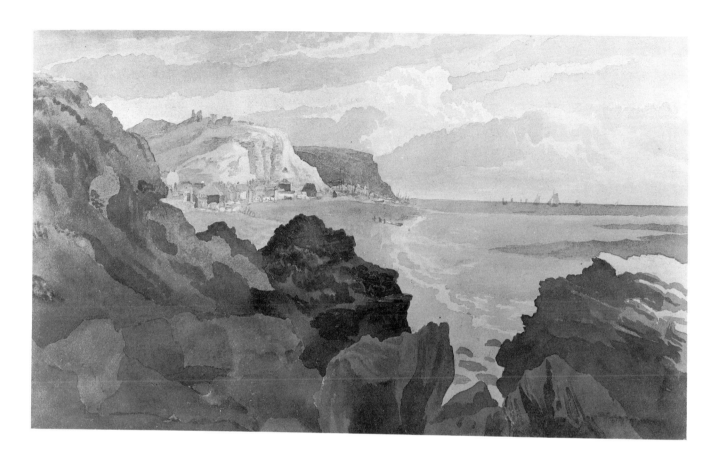

4

PROSPECTS OF THE PAST

33 Thomas Hearne
(1744–1817)

Durham Cathedral from the Opposite Bank of the Wear

Signed and dated 'T. Hearne 1783'
37.2 x 53.9 cm; 4–1891

Open before us lies a scene which hardly seems to conceal. Even the clouds seem drawn back, as if to enable us to view as far as possible, along the river, to the bridge and beyond. The far bank of the river is stretched out before us, turning into our view even as it recedes, bearing its woods and buildings as if to display as much of them as possible. Even where there is obstruction, with the cathedral lying partly obscured behind those woods, a certain clarity of delineation has been employed as if to compensate for this. Our vision, from its raised position, would appear to be encouraged to absorb with easy comprehensiveness.

Why, then, do those figures appear on the bank beneath us, as if to catch us out at second glance? Why do they obstruct our view of the river, that passage of relatively unreflecting clarity on either side of them? More significantly, why does the standing figure gesture out to the right and slightly backwards, as if out of the composition, beyond those shadowy reflections on the river? What – we might join his companion in inquiring – is so interesting as to divert your attention and interrupt ours to the view before us?

The usual explanation for this, when an explanation has been ventured at all, is anecdotal. Hearne's activities as an architectural and topographical draughtsman, which issued in such projects as the multi-volume *The Antiquities of Great Britain* (1778 onwards), required him to travel extensively. Despite being dedicated to this task, perhaps unquestioningly involved in it, the months on the road would have been dull without some company. So, not unusually Hearne went with friends, such as Joseph Farington and George Beaumont. Having completed his task of recording a monument such as Durham Cathedral, there was a kind of relaxation and entertainment in including his friends in the composition; a note in the margins of his record, as it were.[1]

Given the terms of the publishing projects that Hearne was involved in, however, the inclusion of such figures seems either incidental or corrosive of its apparent seriousness. As Richard Gough put it, one of Hearne's better-known employers and publishers, there was a need for artists who would stay in England, not wander off abroad, perhaps to Italy, to paint the monuments of other cultures and in so doing achieve 'fame in preserving those of our forefathers in their own country'.[2] This project of preservation is promoted, then, by a kind of sacrifice: not only of the painter's activity in the careful and faithful recording of those sites judged worthy of being painted; but of the very possibility of imagining that these sites exist in your domain, belong there. The dedication to forefathers and to 'their country' – which is one reading of the grammar of Gough's phrase – haunts the very project of taking into possession for the eye those scenes of castles, cathedrals and churches which were such a large part of Hearne's work.

The inclusion of these figures, then, might be compared to the practice of getting a friend to stand in front of some remarkable site before photographing it. Perhaps this occurs so often because the remarkability of a site is given in advance: maybe a preordained stop on a tour, but, more fundamentally, if it is remarkable, then its marking out has already occurred, the trace of another or others which preceded you there. Furthermore, much as photography seems to promise to hold our attention by virtue of its reliable comprehensiveness, nevertheless, in its dedication to the obviously remarkable, it often threatens to record not the site in question, but rather the act of seeking to record it; not the showing of the site, but the reminder of the taking of that which would show it and the showing of that which might show.

The request for a friend to pose in front of something to be photographed is often met by reluctance and embarrassment, as if to say 'not again' and 'not me'. Perhaps struggles ensue, as the demand of the photographer grows more insistent and the resistance of the friend more intense. The painter would not be in the same position of having to demand the presence of the other. But a further consideration of the logics of such apparently unnecessary inclusions, such as they concerned Hearne, will tell us something more about such scenarios.

It might be tempting to imagine that these tensions of drawing signs of presence into what will become a record of a recording, as well as a recording of a record, of something which already exists, did not preoccupy someone or other who preceded us. But the logic of a recording requires it. There must

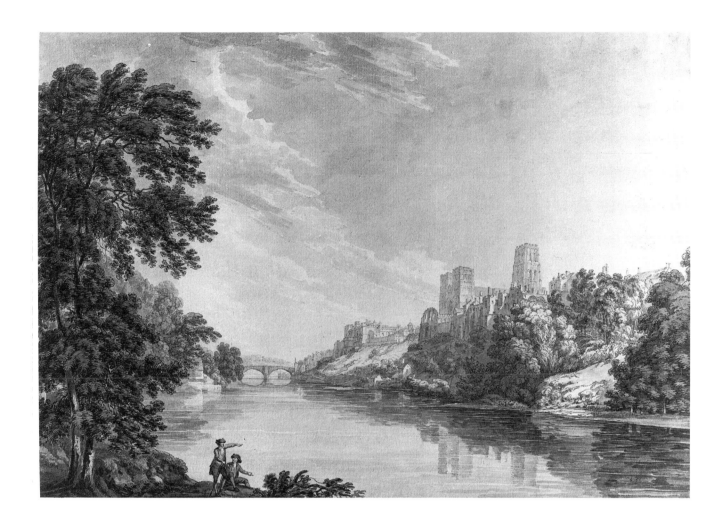

be something which preceded the recording to record. For Hearne, indeed, there was a demand to respond to a kind of *precession* of 'forefathers', a kind of generalised patriarchal past. The way in which he managed this, in the example of *Durham Cathedral* at least, was to act out the position of inheritor, as if demanding his friends, perhaps, to take up their positions or, at least, imaginatively, to put himself in charge of the dispossession of those who will, by this very act, become the inheritors. A similar logic *pre*occupies the field of the family snapshot recording and record of a holiday. That gesture of the figure in the foreground who diverts our gaze towards what it cannot see is a deflection of that desire of vision to come into possession, as if to indicate that we are not to pretend that we can take possession here.

This picture, then, testifies to conflict: of the present with the past, of the sacrifice required in order to deploy these, and other, means of recording in the service of what has already been made; but also of the present with the present, no doubt always between inevitably copresent generations (without which copresence, there would not be generation at all), but also, by implication, among members of generations. Perhaps the imagination of the painter defers and diverts it better than the requirements of the photographer, but, in any case, the maintenance of a prospect, in which the future may be figured, requires that the conflicts of the present be recognised.

1 See David Morris, *Thomas Hearne 1744–1817: Watercolours and Drawings*, Bolton Museum and Art Gallery, 1985, p. 55 (entry 24).
2 Quoted in ibid., p. 6.

34 Thomas Girtin
(1775–1802)

Louth Church, Lincolnshire

Signed 'Girtin'
38.2 x 48.6 cm; P. 24–1934

Girtin's early career enabled him to become familiar with the practices of topographical and antiquarian draughtsmanship. Apprenticeship from 1788 under Edward Dayes (see entry 16 above) was followed, from about 1791, by work for the publisher James Moore, whose *Monastic Remains and Ancient Castles* was one of the more notable publishing projects of its kind. The usual construction of his subsequent employment under Dr Thomas Munro, with Turner, is to claim that he was thereby released from this apprenticeship partly by the example of a peer and partly by the opportunity of working from the work, in Munro's collection, of more sophisticated artists, such as Sandby, Hearne and J.R. Cozens. But this movement in Girtin's work never went from the merely topographical to the aesthetically complete, as has often been claimed.[1]

Louth Church, Lincolnshire of about 1796 remains a little inconvenient for that construction of his career. It is usually spoken of as a kind of demonstration, when demonstration would have been superfluous, that he had mastered all the techniques and manners of topographical and antiquarian draughtsmanship.[2] But, as consideration of the work by Hearne in this selection showed (entry 33), the effects of mastery are not simply the result of technical competence, but involve thematic questions as well. Furthermore, this kind of prospect cannot, in itself, ever quite conclude the issues of time, history and remains with which it is concerned.

We can begin to discover some of these issues at stake in this work by considering, as in Hearne's *Durham Cathedral*, the role of the figures. First consideration might suggest that the inclusion of figures of different and diminishing size is to provide a sense of scale for the main object of the artist's attention, a little security of progression in a dramatic foreshortening of the church. Such a foreshortening is not simply the result and effect

of technical mastery, as we have noted. Instead, it is a significant aspect of the very project of recording that Girtin is involved in here. A remark by Richard Gough, that publisher for whom Hearne worked, can be understood to indicate the framework of issues here, notably concerning a particular anxiety which accompanied that drive to preserve Gothic remains: 'One cannot enough regret the little regard paid to Gothic architecture of which so many beautiful models are daily crumbling to pieces before our eyes.'[3] The regard which Gough sought is something which the dramatic perspectival rendering is involved in achieving. Simultaneously, however, it also enables a certain control of that sense of decay and the production of a sense of the virtue of this kind of architecture as a model.

There are certain signs of decay which are *included* to be transformed in this way in Girtin's image. Towards the foreground, on what would be the west end of the church, above the figures of the man, woman, baby and older child, the building can be read as both in shadow and also in decay. The open touches of brushwork support both interpretations. Yet, down the vista of the view, that building moves into a state of apparently easy visibility. The lines delineating the north transept are less broken, cleaner, as if to reveal the essentials of the building's construction. The figures stand below, marking out another possibility of vision, this time one which can inspect what appears to be the clarity of the architecture. As it appears in this prospect, the church moves in and out of various states, in and out of neglect and decline: as if that portion nearest us were in decay and that portion furthest from us in the very process of construction. The control of line, thus, has the effect of indicating the possibility of a modelling of such a structure as this, one which, before this period, seemed to some to lack design and order.

The figures also play another role. That idea of order is further enabled by their apparent presence. The unconcern for the state of the edifice shown by the figures in the foreground renders them subjects who unconsciously attend the saving of the appearance of this building and its production as model. That they appear so unaware of the drama which is so conveyed to us allows them, furthermore, to be identified as locals, members of a community, overseen by this edifice which endures, has endured and promises to carry on enduring into the future.

Such a construction of the drama of the perspective of Girtin's image shows how that notion of a prospect was used in the projects not only of the preservation of the signs of the Gothic, but their remotivation as elements to be used in the

buildings of the present. The text by Gough quoted above continues: 'Had the remains of antient buldings been more attended to we should before now have seen a system of Gothic architecture in its various areas; we should have had all its parts reduced to rules; their variations and their dates fixed together.'[4] That concern with 'areas' is indicative of the coincidence of this classificatory project with a definition of region and locale, such as this example would serve. Similarly, the 'reduction to rules' is also so served. What might be missed, though, is the difficulty of the fixing of the 'variations and their dates', variation being of those parts which were threatened by decay and also of those various regions to which they might seem to belong. The impossibility of the control of time gives way to the fixing of the date, part of the classic disguise of the antiquarian as someone only concerned with the past.

However reluctantly Girtin may have been involved in this, we may see, when we consider other, later paintings, that his work did not definitively escape being marked by the past, no matter how powerful his prospects appeared to be.

1 For example on 'romantic synthesis' of 'topographical tradition' and 'elegiac mood', see T. Girtin and D. Loshak, *The Art of Thomas Girtin*, Adam and Charles Black, London, 1954, pp. 18–25.
2 Ibid., p. 57.
3 Quoted in Morris, *Thomas Hearne*, p. 6.
4 Ibid.

35 Thomas Girtin
(1775–1802)

Rievaulx Abbey, Yorkshire

Signed 'Girtin'
41.9 x 55.3 cm; F.A. 499

The differences in appearance between *Rievaulx Abbey* and *Louth Church, Lincolnshire* (entry 34) cannot be accounted for simply by that narrative of Girtin's release from the servitude of architectural topography to the free exercise of expressive painting mentioned above. To make *Rievaulx Abbey* an example of freedom of expression would always be to forget what simultaneously enables and constrains that ideal, namely that if there is to be expression, then there needs to be that which can be employed to express. In this case, that relation to the projects of redefinition of the present by means of an engagement with the remains of the past that preoccupied architectural topography can be seen to provide the conditions of meaning which are pressed to certain limits here. Indeed, the very subject of the abbey can be understood to have been part of the demand which conditioned this strong and powerful work.

The transformation of the meanings attributable to Gothic architecture was a long process. From something stigmatised as irregular and bizarre, and thus outside the values of order, political as well as architectural, into something apparently to be celebrated as having its own laws of regularity and proportion, the excesses of which might be imagined either as the expression of individual invention or as a sort of striving to belong to the territory of Britain of which it was therefore a part, was no one step.[1] The differentiation of 'Gothic' into Early English, Decorated and Perpendicular styles by Thomas Rickman in 1817, a categorisation which was soon widely adopted, was a case in point. This had been preceded not merely by a simpler categorisation, but by a more exclusive one. Most of the buildings which Rickman would have categorised as Perpendicular had been known as 'pointed'. By 1802, it was not uncommon to refer simply to 'English' to denote that style and a certain number of earlier, less obviously 'pointed' buildings. This was the source of Rickman's 'Early English' category.[2]

Rickman's categorisation proved influential because it enabled a certain forgetting of this nationalist claim: by identifying 'Early English', one could appear to acknowledge a certain passage towards the 'English', without now having to claim it. Stressing such a passage forwards, as if towards the properly national, was important as it enabled the forgetting of what had been the initial problem: the association of Gothic and Norman architecture with the nomadic Goths, the Norman conquest and thus with the French. In the later nineteenth century, Rievaulx Abbey was categorised as a building in the transitional style, which signified a certain hybrid of the Norman and the Gothic. It could, by then, be so identified by that categorisation, as if it had been on the way to something, in this case that apparently properly English style of Gothic architecture.

Girtin's treatment of the ruined abbey dramatises it as if to suggest that, despite its ruined state, it is on the way to something. The composition, implying a point of view close to the building, lifts it towards the sky. The walls of its ruined transepts rise above the horizon. The contrast of the yellow ochre of the building and the blue of the sky allows us to pick out the detail of the structure, in particular the three pointed arches clearly outlined against the background. The meeting of the ground and the building has been carefully treated. Minimised by the foliage to the left and the right, where such a meeting seems to occur, the colouring of the ground in similar tones of yellow ochre allows for a sense that the structure is associated intimately with that ground, but also that it dominates it, as if the light falling onto it from the left were being relayed.

Thus the building seems involved in a drama of the present, outlasting its ruined state, exhibiting its durability and strength, as well as its strong lines. If we were inclined to forget this last point, by imagining, for example, that the real interest of the scene, the source of the light, lies off-stage, then the figure in the choir is there to remind us of the interest of those higher arches. His attention takes us away from the complexity of round and pointed inner and outer arches to the right, back towards the pinnacle, that which the building seems thereby to be dedicated to showing.

The drama of this work by Girtin was partly detemined by the difficulty of representing a building such as Rievaulx Abbey. To see it staged as such a participant in the fall of light, attracting and holding the interest of that spectator, is to see it less as an example of disorder and more as an agent of an occurrence. Such an apparent occurrence of this building allowed it to

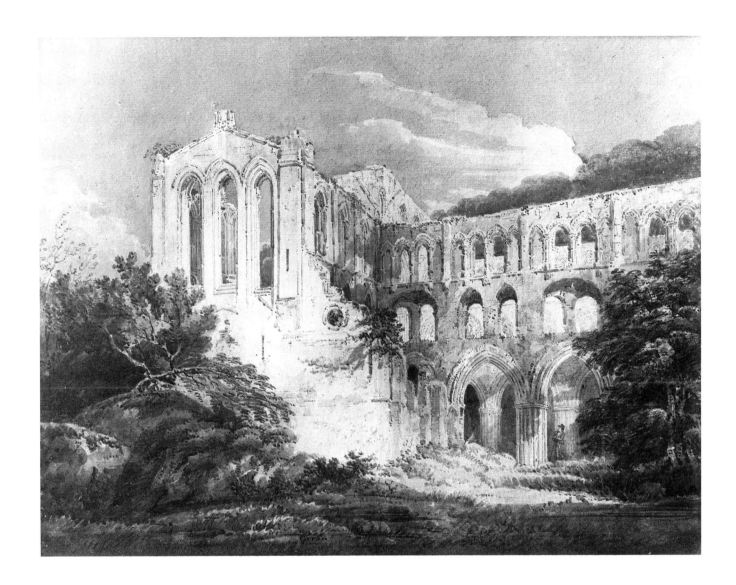

become part of an imagined future, one in which the Gothic could be redeployed as English, as a consequence of its past being reimagined. It awaited its recategorisation as transitional.

1 Contra, for example, the dismissal of the displacement of the term 'Norman' by 'Early English', 'Gothic' and 'Perpendicular' as a 'dull controversy' by Kenneth Clark, *The Gothic Revival: An Essay in the History of Taste*, Constable and Co., London, 1928, p. 88. Clark's passing admission that 'Gothic' had had connotations of the 'barbaric' and his (more and less explicit) diagnosis of 'national feeling' as a symptom of 'Romanticism' belies his judgement.

2 See Terence Davis, *The Gothick Taste*, David and Charles, London/Newton Abbott, 1974, p. 139.

36 Thomas Girtin
(1775–1802)

Porte St Denis, Paris

46 x 60.3 cm; 37–1886

It has been supposed that this sketch formed part of a projected panorama of Paris which Girtin planned to execute, having completed and shown one of London.[1] Reflection on the composition of the picture indicates some of the difficulties that would have attended such a project. The buildings to the left and right are oddly askance. The one to the left positions us square-on to the view, even if we are also, following the shadow under its eaves, leaning a little backwards. The one to the right, although it turns away from us into the view, does not seem to turn quite far enough, as if it was required both to complete the positioning accomplished by the building on the left, that we stand facing this prospect, and to offer us the possibility of leaving this mooring to wander off down the boulevard.

Similarly disquieting uncertainties cannot be completely suppressed by the apparently most successful panoramas, although the history of the vogue for such constructions for viewing might suggest otherwise. The circular view of Edinburgh, shown in London by Robert Barker in 1789, was followed by a number of others, including Girtin's *Eidometropolis*, which was first shown in November 1802. The *Eidometropolis*, it is reported, was a 360-degree view of London from a position as if poised above the River Thames somewhere near Blackfriars Bridge, scenes laid out on the inside of a section of a cylinder, viewed from inside.[2] The finished project has not survived, but we can imagine a certain instability, as well as excitement, in the implied viewing position.

Perhaps such a representation of London is more easily imaginable than one of Paris. Even before Haussmann's reconstructions of the city later in the nineteenth century, stressing the boulevards and the connectedness of the centre with the periphery, those aspects of Paris drew attention, as Girtin's image suggests, and yet would have challenged any project to construct a panorama. For the instability of the implied position of viewing in panoramas takes us to certain limits here. The tensions

between being able to inspect the appearances of things represented around one and being able to imagine entering that scene, as if one might participate in what one was encircled by, can be better understood if we imagine what kind of panorama this image by Girtin might have formed. To bend this image and attach a sequence of others to it would perhaps leave the joins showing. For where would we be standing? Are we on the inside looking out, or perhaps, more insistently, on the outside looking in? This view of the gateway would only contribute to placing us in a centre which would be exposed to access from the points of recession from it. If we imagine ourselves on the outside of the city, instead of the inside, then we might also imagine ourselves on the outside of a cylinder, viewing a kind of impossible double of the view from inside, from the periphery.

These speculations about the occasion of this watercolour by Girtin suggest, therefore, that the notion that this was part of a project for a panorama of Paris is determined largely by a fantasy, one which Girtin *may* have shared, but which remains a fantasy none the less. The ideal of security of and by means of vision at work in those projects, to provide a place in which one can imagine seeing all round without either missing something or without fearing being seen from a currently unobserved point, threatens to collapse into the recognition that one *is* outside, unable to influence what might be imagined to be going on there. This work by Girtin is marked by the precise other of that anxiety, a desire to see a view open up ahead which would give room to imagine a field of action.

The fantasy that this might have contributed to a panorama betrays, then, not simply the fantasies of panoramic viewing, but also the maintenance of the promise of the prospect of a field of action. To imagine an unending series of prospects, each appearing to sustain and extend the last would perhaps get us close to that desire. What such a fantasy fails to recognise, then, is that what exists, while it may appear to be within our control, also sets limits to it. Indeed, the setting of the limit is precisely what would enable purposeful action to take place at all.

Girtin's enthusiasm for the Republican cause in France may be understood to bear on this work.[3] The opening out of the city may have seemed to be part of an ideal of a continuation of a liberatory politics. The reversals and constraints outlined above would thus relate, in complex ways, to the prospects of Republicanism. One of the limits that can be noted, however, is that if politics is thought of as the attaining of visibility, getting noticed by others, then that would also be a kind of end of poli-

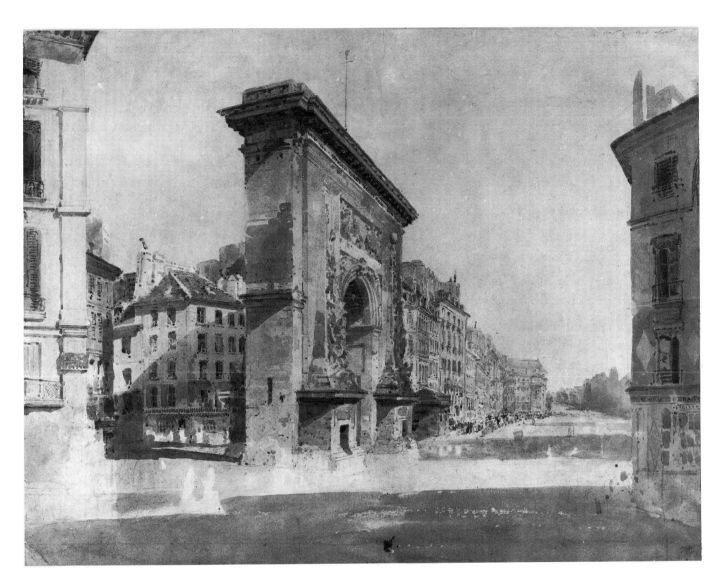

tics, a dream of an end of the exercise of power over oneself or over others. The desire for the prospect is, in some of its forms, the misrecognition of that.

1 See Francis Hawcroft, 'Introduction' in Whitworth Art Gallery/Victoria and Albert Museum, *Watercolours by Thomas Girtin*, London, 1975 (pp. 15–18), p. 18 and H.J. Pragnell, *The London Panoramas of Thomas Barker and Thomas Girtin*, London Topographical Society Monograph no. 109, London, 1968, pp. 16–17. See also Girtin and Loshak, *Art of Thomas Girtin*, pp. 44–5.
2 Ralph Hyde, *Panoramania! The Art and Entertainment of the All-Embracing View*, Trefoil Publications, London, 1988, pp. 18–19, 29 (entry 34).
3 On Girtin's 'crop' haircut as sign of allegiance to Republicanism, see Girtin and Loshak, *Art of Thomas Girtin*, p. 112.

37 Joseph Mallord William Turner (1775–1851)

Interior of Tintern Abbey

32.2 x 25.1 cm; 1683–1871

Both this painting and the following *Warkworth Castle, Northumberland* were exhibited at the Royal Academy, the former in 1794 and the latter in 1799.[1] The differences between them signal a widening of a range of possibility for watercolour landscape painting. The death of Reynolds in 1792, the end of a long presidency during which a certain strictness of the separation of the genres had been stressed, was part of the reason for this widening range, one which encouraged the ambition of the later work. There was, however, already a certain pressure on the hierarchy of genres as a model of artistic performance, as *Interior of Tintern Abbey* suggests; and this is so despite its apparent exemplification of the topographical, that margin reserved for watercolour landscape painting at the Academy since its inception.

Like Girtin's *Louth Church, Lincolnshire* and *Rievaulx Abbey* (entries 34 and 35), Turner's *Interior of Tintern Abbey* is part of a movement which would seek to make Gothic form identifiable. To this end, Turner has employed vocabularies deriving from a number of sources: compositional aspects from the work of his early teacher, Thomas Malton; dramatised in ways not unlike those deployed by J.R. Cozens; with a restraint of colouring, even compared with some of Turner's earlier works, similar to the palette of Edward Dayes and Thomas Hearne. From the latter, too, he has taken what Andrew Wilton has called 'a certain very recognisable mannerism when painting foliage, employing disjunct strokes of the brush to build up form almost as though it were made of bricks'.[2]

It is where the structure of the abbey appears to crumble – along the top of the high arches receding from us, or in the fragments of masonry lying on the ground – that this kind of brushwork is most noticeable, suggesting analogies between the stonework and, more particuarly, the tile or brickwork and the growth of foliage. It is as if that growth has intervened to bandage the vulnerable parts of the work of the medieval builders.

But that vocabulary could not appear to accomplish this work of protection if it did not also seem to reveal. Where the brickwork and masonry meet, Turner's brushwork suggests that the latter is revealed as if unaffected by the decay that has afflicted what seem to be the less important parts of the abbey.

This effect is carried by the grander parts of the structure. While the pattern of light and dark touches of the brickwork and foliage seems to suggest intrinsic qualities of form, on the standing stonework the differentiation appears extrinsic: as if we were watching the play of light across the forms. This is most noticeable in the double row of arches extending to the far window, the plane of the building which receives the clearest fall of light.

The figures are situated to encourage such a reading of the architecture. The two in the foreground on the left standing behind some fallen masonry occupy a spot from which the connotations of vitality derive. By standing amid the mingling of masonry and foliage, their vitality enables the imaginary synthesis of the connotations of both. The direction of their gazes further supports this, as they seem intrigued by the apparently transferrable vitality between building and flora. The other figure appears to be about to step into the light illuminating the ground inside the building. Indeed, it is his function to create a sense of this inside. As we notice his apparent progress, we can forget that the building is a ruin. The fall of light – which would be impossible were the building not in such a condition – seems nevertheless to reveal that imaginary interior. The series of brightly illuminated arches nearby seem restored to being part of a greater whole.

The creation of a sense of the interior of this ruin is marked by the title of the picture. Topography here operates to create a sense not simply of place, but of a recovery of place against the effects of the passage of time which threatens to erase place. Such complexity was already part of a movement towards the claims of historical landscape painting.

1 Andrew Wilton, *The Life and Work of J. M. W. Turner*, Academy Editions, London, 1979, p. 307 (entry 57).
2 Ibid., p. 38. See also entry 38 below.

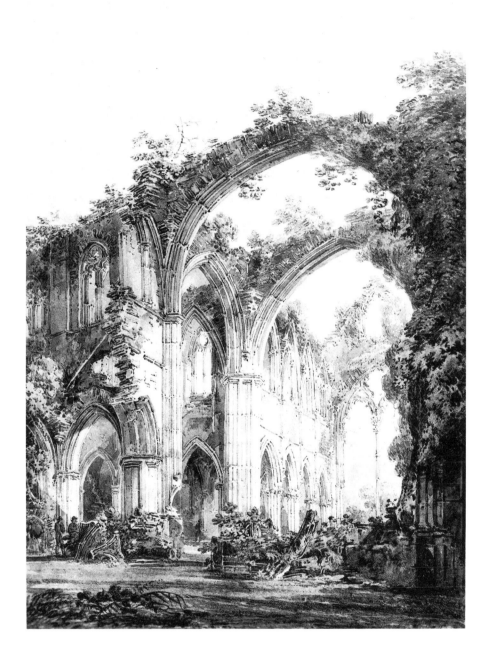

38 Joseph Mallord William Turner (1775–1851)

Warkworth Castle, Northumberland

50.8 x 75 cm; F.A. 547

Like the oil paintings of 1798 shown at the Royal Academy, this watercolour shown the following year was accompanied by a quotation. For this work, as for one of the oils, *Dunstanburgh Castle*, Turner selected and edited a passage from Thomson's 'Seasons' to print in the catalogue. Such a text needs not to be taken as simply extrinsic to the work. One of the conditions of a work of visual art, as even the numerous paintings identified as 'Untitled' suggest, is identifiability by a text. The full title of this work was given in that Royal Academy catalogue as *Warkworth Castle, Northumberland – Thunder Storm Approaching at Sunset*.[1]

These associated texts were part of the movement seeking to justify the attention of the Academy to landscape painting. The title assists in disarming one objection: by being apparently descriptive, it is indicative of a confidence that the work will *not merely* be read as descriptive, as many landscapes were stigmatised as being. The longer quotation then functions as a way of claiming a significance beyond the descriptive. We can infer the nature of that claim from that text.

The excerpt is taken from a section of 'Summer' from Thomson's 'Seasons' which succeeds a long disquisition on the violence and excessiveness of the climates of tropical and equatorial lands. (Parts of this section of the poem are quoted in entries 10 and 29 above.) The transition in the poem to the argument that the climate of the English summer is one of perfect beneficence is made via a passage from which Turner takes his quotation for the catalogue. The transition is through conditions which are anything but beneficent:

> Behold slow settling o'er the lurid grove,
> Unusual darkness broods; and growing, gains
> The full possession of the sky ...
>
> ...
>
> ... and on yon baleful cloud
> A redd'ning gloom, a magazine of fate,
> Ferment.[2]

Turner omits from this text about six lines which give an account which suggests that the coming storm has gathered its elements from the hot earth: 'nitre, sulphur, and the fiery spume / Of fat bitumen, steaming on the day'. This seems to have been too much for Turner: the threatened eruption of the very earth being too diabolic, too excessive. But the painter has not only omitted some lines; he has also misquoted. Turner's 'on yon baleful cloud' should be 'in'. This trace of the omitted lines, with the cloud the carrier of those unstable elements, Turner has effaced. In so doing, he has also stressed a drama of appearance, the storm now appearing 'on' the cloud, as if that cloud might itself survive the storm it brings. Thus it loses some of the maleficence it has in Thomson's poem.

Such a shift forms part of the general claim to significance of Turner's work. The painting, read in relation to this text, would be an example of an effort of the painter to control this manifestation of nature's force: as if the painter has outlasted the threat to his art that the 'unusual darkness' has threatened to be able to show the portents of the 'redd'ning gloom' as they mark the storm clouds. Turner's interest in the storm, then, is a result of an interest in the limits of representability, but one which is not simply a formal one. There is a politics to this version of his painting, one which an interpretation of the image can indicate.

The composition of the castle, high on the hill, catching more of the light than the church in the valley, standing over the houses between, suggests a hierarchy of protection and vulnerability. With the fishermen below seeking somewhat anxiously to bring in their nets, it is as if the castle stands both as a beacon of warning and as an emblem of outlasting the storm. This implied structure would be generalised by Turner's use of the quotation from Thomson, with the threat of 'a magazine of fate' being a kind of indifferent force. Nature, in this condition, would square with that critical and philosophical notion, deployed in the criticism of Reynolds for example, of an 'accident of nature', which was used to imply that such exceptional conditions ought not to be represented. Turner's presentation of his painting allows this argument to be redeployed, by claiming that there is one single fate implied here, as if unrepresentability affected all things equally. However, in that very phrase, 'a magazine of fate', the metaphor of ammunition allows attention to be subtly drawn to the castle, as if to enable a tacit acknowledgement that this structure is poised in a position guaranteeing what order one could expect in such a situation.

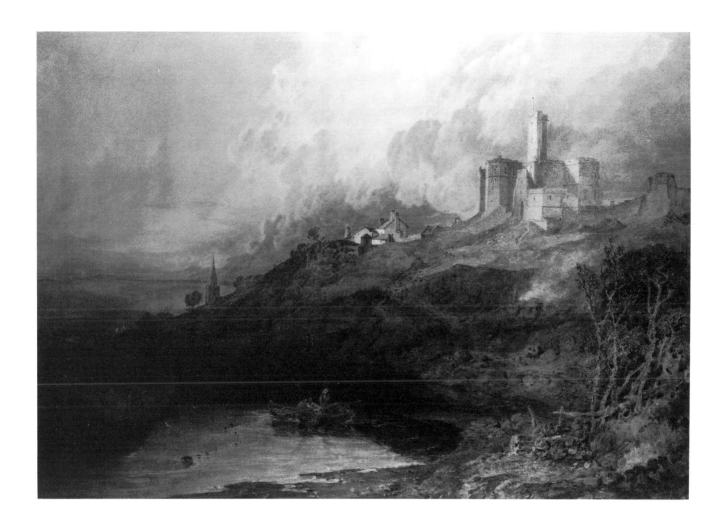

Such a presentation of this painting at the Academy thus placed landscape painting in a position in which, whilst it challenged for recognition as a genre deserving of the attention which history painting might receive, it did so in terms which were acceptable to the project of a general articulation of the conditions of social life which such history painting sometimes sought to achieve, but which it failed to accomplish.[3]

1 See Wilton, *Life and Work*, p. 328 (entry 256). For oil paintings of 1798 exhibited at the Royal Academy, *Morning Among the Coniston Fells*, *Dunstanborough Castle* and *Buttermere Lake*, see Martin Butlin and Evelyn Joll, *The Paintings of J. M. W. Turner*, rev. edn., Yale University Press, New Haven and London, 1984, pp. 3–5 (entries 5, 6 and 7).
2 See Wilton, ibid., p. 328 (entry 256).
3 Barrell, *Political Theory of Painting*, pp. 90–112.

39 Joseph Mallord William Turner (1775–1851)

Vignette: Linlithgow Palace by Moonlight

10.5 x 10.7 cm; P.6–1945

In considering the two works by Turner above, I have implied that composition and style may be interpreted to show how landscape painting was involved in a variety of negotiations with questions of the significance of natural phenomena, as well as architecture and place. This is the case too with this small watercolour of 1833. But before I indicate how this is so, the notion that such interpretation is impertinent, which, for certain reasons concerning its vignette form, has attached to this work, needs to be considered.

The first owner of this work was John Ruskin. It was unusual, moreover, that such a work was available to be so owned. Painted in about 1833, this was one of a long series of designs which Turner produced to be engraved as illustrations in an edition of the collected prose works of Sir Walter Scott. Scott's publisher, Robert Cadell, had commissioned Turner to illustrate Scott's *Poetical Works* in 1831, the painter being invited to stay with the writer in Scotland. From 1834 to 1836 the prose works were published in forty volumes, all with illustrations by Turner. As with most of his designs for Samuel Rogers' poem 'Italy', on which Turner worked from 1826 to 1832, most of the watercolours for Cadell seemed to have remained with the publisher.[1]

Ruskin acquired a copy of Rogers' 'Italy' in 1832.[2] This first encounter with the vignette engravings from Turner's designs encouraged his enthusiasm for Turner's work to develop in a particular direction. It was these which enabled him to identify what he termed 'the infinity of nature', an infinity which was to become for him 'almost an unerring test of all truth'.[3] The vignette of Linlithgow Palace, being so closely associated with that part of the artist's project, would thus have been a particularly important part of Ruskin's collection of Turner's watercolours. It is interesting to note, further, that Ruskin also owned a more conventionally composed watercolour by Turner of Linlithgow Palace, painted in about 1801. This other work supplemented Ruskin's understanding of this vignette in ways which enabled him to promote a version of the impertinence of interpretation concerning watercolours.

In part IV of *Modern Painters*, following the argument concerning the superiority of modern landscape over traditional, outlined in the introduction above, Ruskin goes on to try to exemplify all that is best in that modern art. And as he had done when considering his notion of the 'pathetic fallacy', he develops a comparison of Turner and Scott. While both of them exemplify a view of nature which is neither simply benign nor simply dreadful, Scott's writing shows that he was less corrupted by affectation than Turner. Somewhat oddly, however, according to Ruskin, this is a consequence of Scott's experience of architecture:

> Scott gathered what little knowledge of architecture he possessed, in wanderings among the rocky walls of Crichtoun, Lochleven, and Linlithgow, and among the delicate pillars of Holyrood, Roslin, and Melrose. Turner acquired his knowledge of architecture at the desk, from academical elevations of the Parthenon and St Paul's; and spent a large portion of his early years in taking views of gentlemen's seats, temples of the Muses, and other productions of modern taste and imagination; being at the same time directed exclusively to classical sources for all information as to the proper subjects of art. Hence, while Scott was at once directed to the history of his native land, and to the Gothic fields of imagination; and his mind was fed in a consistent, natural, and felicitous way from his youth up, poor Turner for a long time knew no inspiration but that of Twickenham; no sublimity but that of Virginia Water.[4]

Ruskin's version of that growing belief in nineteenth-century British culture, that Gothic had taken a properly indigenous form, which I have considered above, for example in relation to Turner's *Interior of Tintern Abbey* (entry 37), takes a particularly interesting turn of phrase. The 'Gothic fields of imagination' that Scott is supposed to have enjoyed is a metaphor which neatly expresses the forgetting of the complex landscape of which Gothic architecture was a part. It is a way of forgetting that neither that architecture nor those fields, in relation to which it stood, were themselves either natural or harmoniously coexistent. Indeed, the feudal landscape which Ruskin's account of Scott's encounter with Scottish baronial architecture evokes would have been marked by the owing of fealty and dues from the fields to the castle and to the church. The feeding of Scott's mind is an image which suggests that a voracious consuming of the traces of this past can overcome its lack of harmony, recover its felicitousness by an act of creative ingestion.

Turner, by contrast, is tainted for Ruskin by an inheritance of

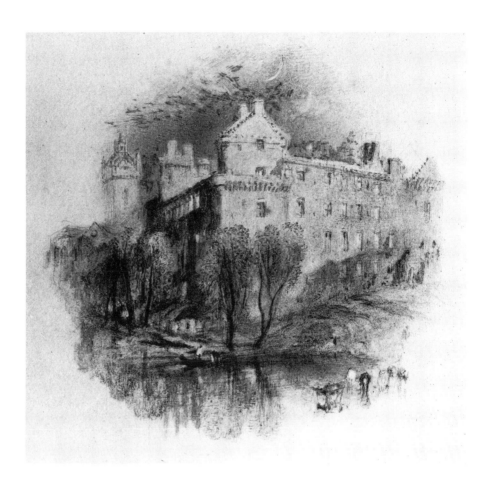

'classical sources', foreign models which constrained the development of someone whom he wanted to regard as belonging to and expressing a modern national culture. The confusion here in Ruskin's sense of what constitutes the modern, earlier expressed as deriving from the formal properties of watercolour painting, now identified with a kind of pastiche of the classical, indicates the kind of difficulty that architecture represented for him: an art of explicit control and order, an attempt to organise and direct building, difficult for an imagination which wanted the lack of constraint by tradition of the modern to be the end of control and rule. Hence, for Ruskin as for others, the Gothic represented the fantasy of a society developing in harmony with itself, coming into its own.

This vignette would thus for Ruskin have been an example of Turner having managed later in his career to expel all those preoccupations with the classical. How could he have forgotten, though, that Turner had also been the artist of images which, like *Interior of Tintern Abbey* and, no doubt, the earlier watercolour of Linlithgow Palace, were versions of that style of painting which Ruskin wanted to identify as belonging to the modern national inheritance, versions which moreover treated that very architecture which became for him that figure of the very possibility of a national tradition? The vignette provides the answer.

The positioning of the palace in this apparently unbordered image enables any more difficult meeting of building and site to be neglected and forgotten. As I suggested above, when considering the vignette-related watercolour by Constable (entry 29), that apparent absence of a frame allows for interpretations which would otherwise risk coming into starker contrast and contradiction. This can itself be forgotten by the very sense of proximity to a text which the vignette was often intended for, as if in exposing itself to that text, it rendered itself without need of protection, fantasmatically resistant to interpretation. Around such an image as this, which Ruskin could read as the result of Turner having overcome the baneful influence of the foreign, a kind of borderless dominion simultaneously of nature *and* of the national could be imagined. That Britain seemed to have both modern artists and a tradition which at once included and were ruled by nature enabled the misprision of a history and a destiny of that nation.

1 See Wilton, *Life and Work*, p. 427.
2 See Ruskin, *Praeterita* in *Works*, vol. XXVI, p. 97.
3 Ruskin, *Modern Painters*, vol. I, part II, sec. III, ch. III, *Works*, vol. III, p. 387.
4 Ruskin, *Modern Painters*, vol. III, part IV, ch. XVIII, *Works*, vol. V, pp. 389–90.

40 Joseph Mallord William Turner (1775–1851)

Lyons

24.2 x 30.8 cm; 977–1900

During the 1840s Turner was accustomed to painting water-colours known as 'samples', which would be sent to prospective purchasers of his work to encourage them to order more elabo-rated versions of a scene.[1] It is probable that this watercolour was painted during that period for that purpose. Such a consid-eration reminds us of a shift in the criteria for the judgement of watercolours: while we might prefer the 'sample', Turner expected his customers to want a more defined painting, one in which the detail and the general effect collaborated. Careful con-sideration of a work such as this can help us to understand some of the reasons why such a shift of criteria took place.

That forgetting of the significance of a prospect, the involve-ment of an image with temporal as well as spatial issues, may be exemplified by *Lyons*. The notion that modern watercolour land-scape painting exemplified a 'love of liberty', as Ruskin put it, ignored the difficulties of these effects of time and space of images.[2] Freedom of passage, such as might be exemplified by the escape from the city and from the constraints of national boundaries, is not simply the cause of such images. It is also, as I suggest Turner's practice indicates, an effect, albeit in a quali-fied way. One reading of *Lyons* would indicate that to 'gaze in rapt manner at sunsets and sunrises', as Ruskin put what he imagined the painters did when they reached that position sup-posedly beyond the limit, is to imagine that one might escape spatial limits by participation in the time of an event.[3] This par-ticipation, however, is qualified when we realise that what appears to deliver that event – in this case, the bleaching of what appears by light and the apparent staining of light by what appears – is created by something in which we have not partici-pated, an image which is the consequence of a time which is not our own. If a prospect involves us in a time of anticipation, what it might appear to prefigure, as an event, is always an event of happening to something, somewhere. Such an image of the apparent dissolution of a view of Lyons would, interpreted in such a way as to forget this somewhere, seem to fulfil this notion of a participation in the time of an event.

These strictures about space and time ought not to imply that the forgotten space is, in this case, Lyons. It is not some already nameable, identifiable space that is forgotten. Rather, it would be the very space that enabled the apparent representation itself which would be forgotten, turning the work into the possibility of exemplifying that exercise of 'love of liberty' of which Ruskin spoke. In so far as this involves a forgetting of a different space, a space where what is represented exists, then the effect of an indifference to space ensues, which is one of the ways in which a project of modernisation, such as characterised certain aspects of the programme of British imperialism, can – we might say – get off the ground.

It is interesting to recall the possibility of an interpretation of this and, by implication, other late works by Turner which would express a resistance to such a project. A work such as *Rain, Steam and Speed* would be a good case in point: an image of a train, racing towards us on a viaduct, with a small hare running across in front of it, figuring a moment of destruction which such means of transportation threaten. The very composition, too, tells of this, with the train heading towards us as well. *Lyons* is thus interpretable as the threat of the sun, a threat which would involve, at a limit, the threat of blindness which Turner addresses to us under conditions of partial control, a control, however, which only enables a partial visibility. Such would be the appropriate interpretation, I suggest, of this work as a sam-ple, an advertisement for a more detailed work. Turner's invita-tion is to offer an image in which the painter's control is shown exercised at a limit, one which might therefore be respected by the prospective owner of the work, who would thereby come to seem qualified to understand it.

It is this rather generalised narrative of threat which can show, in turn, why Turner's project tended to fail. An extension of the comparison with *Rain, Steam and Speed* may suggest why. That work, thematically involved with the effects of industriali-sation, is more difficult to detach from the general question of the transformation of society which that movement effected. That is not the case with many of Turner's other works, this one included. Indeed, the destructive force of that generalised threat which may be understood to mark his later work in particular becomes attractive precisely as a kind of undifferentiated idea of force, a force which can be imagined, like the sun in *Lyons*, to threaten, but leave untouched that which, beyond this scene of representation, still exists.

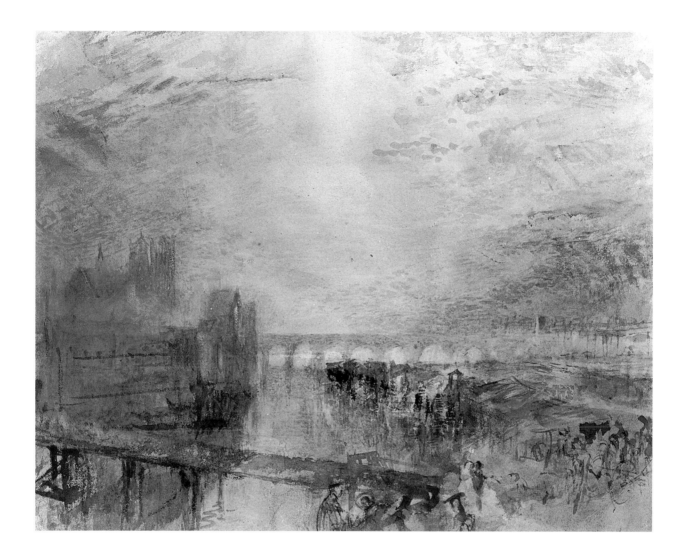

This effect of Turner's later work, the relative detachment of it for most interpreters from other questions of change and destruction, is acknowledged in a confused fashion by Adrian Stokes:

> we cannot altogether believe that ['the poignant beauty' of the countryside] no longer exists: a gleam from what remains reconstitutes an unaltered conviction about the countryside, reinforced especially by Turner's panoramas of the coast from out at sea or from near the beach where, often, there has been no change.[4]

Confusion marks the conclusion of this excerpt, with the claim that there has been 'no change' in those sites of water which would, of course, be a scene of apparently perpetual changing. Stokes, of course, would claim that he need not mean that sort of change; not natural forces, but forces of industrialisation and, perhaps as we would recognise today, effects of pollution. But, nevertheless, the reinforcing of this split, which suggests that nature lives in a condition of harmony somewhere beneath and outside those forces of industrialisation and pollution – the source of the 'gleam' – is part of a fantasy of retrospection. The idea that we can look 'backwards' in this way, not 'altogether' believing that that harmonious nature 'no longer exists', is part of the effect and an avoidance of the question of prospects in which Turner's works have been implicated.

1 Wilton, *Life and Work*, p. 487 (entry 1555).
2 John Ruskin, *Modern Painters*, vol. III, part IV, ch. XVI, *Works*, vol. V, p. 319.
3 Ibid., pp. 324–5.
4 Adrian Stokes, 'Turner' (from *Painting and the Inner World* (1963)) in *The Image in Form: Selected Writings of Adrian Stokes*, ed. R. Wollheim, Penguin Books, Harmondsworth, 1972 (pp. 211–35), p. 214.

5

THRESHOLDS OF THE DOMESTIC

41 Francis Wheatley
(1747–1801)

The Dismissal

Signed and dated 'F. Wheatley delt 1786'
34 x 28.6 cm; 1720–1871

This work and the accompanying piece, *The Reconciliation* (entry 42), setting out as they do a drama of the disruption and apparent repair of the harmony of a home, allow us to understand some of the conditions in which the values of domestic order were called into question in England at the end of the eighteenth century and how far those values might be reestablished or redefined.

These paintings, like other similar watercolours by Wheatley of the 1780s, appear not to have been derived from any particular literary sources.[1] They do compare, however, with some of the works of the French painter, Jean-Baptiste Greuze, whose scenes of domestic strife Wheatley probably saw in Paris when he visted between 1763 and 1765. Over twenty years later, the traces of a debt have become rather dispersed, excepting, however, the strong resemblance between the figure of the older man in *The Dismissal* and those in such images by Greuze as *The Paternal Curse* and *The Paternal Blessing*.[2]

It is significant perhaps that there is the possibility of such a recognition here. The curious maladroitness of the gestures of the paternal figure in *The Dismissal*, gestures which suggest that this dismissal is a rather over-obvious invitation to leave, tends to repeat the awkwardness of Greuze's figures. Perhaps Greuze's images manage to keep apart the connotations of force and frailty, imperiousness and pathos, more successfully than Wheatley has, in this painting. Reference to previous paintings might be part of the desired effect here, in some movement to shore up the contradictions. Certainly, such questions of relay and reference are in play given that companion piece might be thought to conclude and solve these problems of authority. If we try to infer the narratives of this first scene, though, we may come to understand why this is not quite the case.

The similarities of appearance of the older and the younger man, including not only some of their facial characteristics and perhaps hairstyles, but also their dress, allow the inference that they are father and son, even if somewhat separated in years. Given this identification, we might continue to identify the woman as someone from outside the home, a more or less local acquaintance of the younger man, and the child as their child, the presentation of the mother and child to the younger man's father being greeted by this turning away at the threshold of the paternal home. The strange excessiveness of the older man's gesture, both forceful and fallible, could be then read as a mixture of moral determination to refuse this liaison and its apparently illegitimate offspring and a reluctance to do the same, given the breakdown in the propriety of the imagined lineage that he is none the less protesting. The companion piece indicates that this is probably the least latent of possible narratives, one whose very possibility – the identifiability of a resemblance between man and man – is what is being called into question by the drama, as if narratability of images itself depended on that paternal lineage.

Another narrative haunts this one. If the woman were thought of not as being from outside the home, but instead from inside, one of its residents in the process of being banished, a number of fantasies can be understood to be in play. Comparison of her dress with that of other representations of women by Wheatley and others of this period suggest that she is identifiable as a maid. Her cap, in particular, suggests as much, its ribbon thereby identifiable as a kind of meretricious display. As she is dismissed from the home, a pile of pans and a churn is left behind. Thus, we could also read the gestures of the older man as a kind of symptom of a panic at a looming crisis in the domestic economy, the management of the house.

The reason, of course, that this narrative remains more latent than the first is the unlikelihood that her pregnancy would not have been noticed were she to have shared the house with the older man. The crisis, if that is what it may still be imagined to be, would thus be expected to have been addressed before this scene at the threshold. Consideration of the second image will suggest that this more latent narrative possibility has been given room, one in which the identity of the woman – perhaps not a maid, but a daughter – is seen to be a sort of effect of a recovery of paternal authority over this scene of authorship.

Before turning to that, however, we should remember that among the possibilities of belonging and not belonging to the house that have not been considered above is that the older man is the interloper, dismissing a young couple and child from their

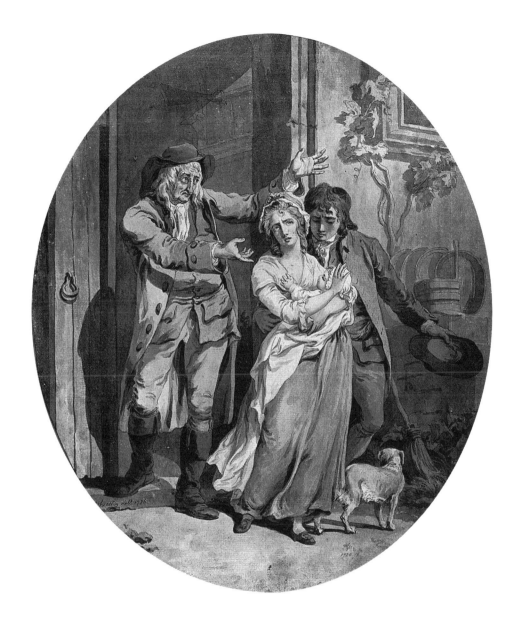

home. Such a possibility, which is perhaps the most latent of all, suggests that this would be understandable perhaps only as a reaction to a desperation about his situation, economic, moral, political. Its very latency, if that is what it has seemed to be, indicates further, however, that the very making legible of the image by means of the identifications set out above tends to remain blind to its own force, sublimating it in an identification with the figure who appears to exercise force to some end.

1 For a general survey of such works see Mary Webster, *Francis Wheatley*, Paul Mellon Foundation, London, 1970, especially 'Bourgeois Life', pp. 66–9. See also Paul Mellon Foundation, *Francis Wheatley R.A. 1747–1801; Paintings, Drawings and Engravings*, Aldeburgh, 1965, pp. 29–30 (entries 41 and 42). (Catalogue of exhibition at the Aldeburgh Festival and City Art Gallery Leeds.)

2 See Norman Bryson, 'Greuze and the Pursuit of Happiness', *Word and Image: French Painting of the Ancien Régime*, Cambridge University Press, 1981, pp. 122–53, especially p. 137.

42 Francis Wheatley
(1747–1801)

The Reconciliation

Signed and dated 'F. Wheatley delt 1786'
34 x 28.6 cm; 1721–1871

There are various apparent discontinuities between this image and *The Dismissal* (entry 41). Let us – following a principle enacted by many television dramas of recuperating in subsequent shots the detail of appearances of things in previous shots as significant for the unfolding of a narrative – explore some of the possible reasons for them. The figure identified as the father above seems much larger, despite being without a coat, which now seems to lie on the chair behind him. He stands across both light and shade, casting a continuous shadow over part of the woman's dress and almost whatever lies behind him. He is balder than the fringe under his hat in the first picture suggested; his forehead has become broader, partly as a consequence of this apparent balding; and his profile seems to have become more firm. Given this, and his posture, connotations of wisdom and strength, as well as reserve, now predominate. The appearance of two books, perched to the right of what is not insignificantly called a grandfather clock, although they appear to drift somewhat, in and out of the shadows, their place in the room, across some imaginary threshold, never quite discreet enough, confirms with a combination of directness and compositional indirection, that he is now much wiser. More than this, it is difficult to believe that he is the same person.

The young man has acquired not only some text or other, but also a stick to go with the cap with which he managed to convey a certain deference in the first image. The stick thus seems to be a sign of a recovery of a potentiality for force. If we interpret the text he carries as a marriage contract, being shown to the father as a sign of a reconciliation with the law of the patronym, then the stick becomes interpretable as a symbol, as a *phallic-ism*. The appearance of the woman – perhaps the overdetermined turn to be taken from a consideration of the symbolism of a phallus – is interpretable in one way as submission and contrition, as if confessing the fault which this law of paternal succes-

sion would accuse her of; in another, though, and more disturbingly, it is interpretable as misery. Still accompanied by a logic of submission, her position may be accountable for by what we may infer, as we trace the narratives from one to the other, to be the loss of the child.

For that child is now nowhere to be seen. All that reminds us of its disappearance in this second image is the sack-like form hung on the wall above the woman. Identification of this object as a swaddling sack for a child to be kept in, out of harm and in view, while work was being done, as was common practice in the homes of families without servants during the eighteenth century recalls that interpretation of the first picture which I suggested: namely, that the woman is of this house, perhaps the maid, who has now failed to make the transition to the status of mother in that same domain. The reconciliation that this picture may be imagined to support, and its title claims, would thus be partial, one in which, if we are to interpret this scene as one of legitimation of procreation by marriage, the recognition of the woman and the recognition of the child, confirmed in this process as being illegitimate, are inferable as being exclusive of one another.

This interpretation of the sack reinforces that latent narrative possibility of the woman as a maid. Her failure to achieve the status of mother and wife simultaneously reminds us that that narrative of the maid would, in one of its versions, not want to recognise her as sexual, but also not as someone who works. The practice of hanging children in bands from the wall, given its association with domestic labour, makes its odd reappearance here, I think, as a kind of reactionary retreat to a fantasy of harmonious paternalist economics: that if what is produced, provided that it is recognisable within that narrative of succession which patrilineal genealogy requires, is disposed according to the authority of that power, then all will be well. It might be appropriate, therefore, to identify the most likely site of this dramatisation of domestic relations being a small landowning farm, one which would have been under pressure, perhaps from the larger concerns which enclosure encouraged, perhaps just from shortage, from the anxieties of these and other pressures.

Whatever the case – and it is probable that all of these cases have a bearing here – the significance of the image would differ if the paper which the younger man bears were considered to be a certificate not of marriage, but of adoption. This is unlikely in one sense, in that it seems that adoption was not accompanied, in any widespread way among those who form the cast of this

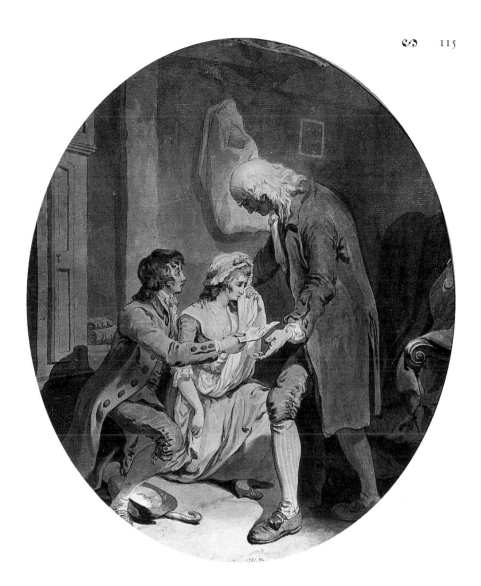

two-part drama, with legal certification. Nevertheless, the possibility remains as fantasy, one which would call into question involvement in a narrative drama in which an older man had seemed to lose so much cool in sending a young couple off to get their child adopted, but one which might seem to be able to solve all the issues at stake by recourse to law.

Perhaps this is the most enduring effect of the various fantasies here. I have already remarked on that mode of the construction of sequences of images which picks up detail from previous images in subsequent ones, appearance enfolded in a closure of the telling of a tale. The crisis of the empty sack, therefore, would be one in which such narrative closure could not be definitively achieved, at least not as one narrative. However, perhaps this is not so unusual. The playing at the completion of visual representation in a narrative of objects –

given that they appear under conditions of being necessarily partial – would be something which always had to risk there being the emergence of more partial objects than could be resolved in the end of the narrative. This – and not any simple inability to tell fiction from fact – is one reason why involvement with soap opera seems to some excessive. Perhaps that involvement would be interrupted by playing video recordings backwards to discover an interest which did not seem to be played out by the characters and the succession of images. Perhaps we could upset the very narratives of succession which would bind this drama of the threshold of the domestic back into a certain inside and outside by thinking of *The Dismissal* taking place after *The Reconciliation*, and not before it. That would be more than just another story.

43 Henry Fuseli
(1741–1825)

Woman in Fantastic Costume

Dated 'Jany.3.91.'
27.7 x 16.5 cm; 1723–1892

In 1788 Fuseli married Sophia Rawlins. Subsequently, Fuseli produced a number of drawings and watercolours representing a young woman, sometimes young women, in a variety of poses wearing elaborate clothes. Interpretations of these works have changed, along with them the imagined significance of these biographical details. Something of this can be traced from the history of their titles. This one is unusual: the 'woman' of *Woman in Fantastic Costume* has been displaced, in most cases, by the more specific *Mrs Fuseli*. One watercolour held in the Kunsthaus, Zurich is now referred to as *Mrs Fuseli Seated in the Corner of a Sofa, in a Wide-brimmed Hat.*[1] Fuseli himself inscribed that work in Greek, which has been translated as: 'Restlessly I chased the image of my dream through the passing fashions.' This 'dream' tends to disrupt that logic of recent scholarship, which seems to want to suppress some of the complexities at stake here by appearing to document the source of the work. Even if we maintain that Fuseli's dream would have in some way derived from what existed, as I shall do below, it is not sufficient merely to append a name in order to understand the problems of the drive to identification which that scholarship itself betrays. In order to do so, we need to understand the role of dream, in relation to 'passing fashions', but also in relation to the production of the very notion of the general 'woman', a dream which is bound up, in this case, with a fantasy of politics which is itself, following Fuseli's use of Greek in that inscription in that other image, and a certain neoclassicism in this one, associated with problems of the ideal.

Fuseli himself would have resisted the identification of works such as this one as portraits. As professor of painting at the Royal Academy, he expressed the view that portraiture was radically inadequate to satify his aims for painting. Portraiture was, for him, 'the remembrancer of insignificance, mere human resemblance, in attitude without action, features without mean-ing, dress without drapery, and situation without propriety'.[2] In a failure to recognise the drive to a making significant of appearance, Fuseli goes on to complain that in portraits what we really see is the painter 'not the insignificant individual that usurps the centre'. The terms of these objections to portraiture were governed in part by the theory of history painting. This, according to Fuseli and others, the highest in a hierarchy of the genres, would exemplify all those things which portraits appeared to lack: the representation of events of general significance, with figures whose attitudes, according to an Aristotelian logic, could be understood to be a consequence of their actions, the meaning of their features similarly determined and readable, their bodies in action thereby moving their clothes in ways expressive of those actions. This conveyance of the lessons of the past was understood to be of general significance in so far as it might instruct, by an act of significant commemoration, the audience in present conduct.

This was often understood to be a moral instruction, as can be inferred from one sense of the word 'propriety'. However, there is another, more buried issue at stake here. That logic of action, which excluded portraiture on the grounds that its figures appeared passive, betrays an aim of maintaining an ideal in which action is seen to control and take possession of its field, an ideal of command: what we may call a propriation of situation. Fuseli's objection to portraiture that what emerges into view is the painter and not what is painted – signs of the activity of the artist, not the significance of the action itself – was determined by these goals of history painting to exhort its audience to act.

The drawings and watercolours like this one would thus seem to have been produced in a movement of transgression of Fuseli's own rules. To think of them only as transgressive, however, is to confirm the rule as a rule. Indeed, that is how they functioned for him, with the subject of the portrait threatening to usurp 'the centre', displaced, for him, by a return of the signs of himself, reproducing that hierarchy mentioned above. We need to recognise the questions of propriety implied here, and their involvement in a distribution of the values of activity and passivity in order to understand what determined him in his apparent transgression.

Marriage, the law being what it was in the late eighteenth century, would have given Fuseli certain proprietorial rights over his wife: she construed as his property, a right limited only by the implicit sanction of divorce. Fuseli's notion of the function of

the painter, to efface the signs of their activity, in favour of a moral lesson for the public falls into crisis here. For that dedication repeats itself in this series of works, in which she would be the topic of the work. Positioned against a relatively unspecified background, the figure of the woman, her head turned away, seems passive. Too passive to justify as an image, according to his theory. But inferences of her activity cannot be suppressed entirely. That turn of the head, the holding of the skirts, all threaten to show that she is not purely passive, not an object of simple possession. Indeed, perhaps the more she were to show herself, the fewer would be the signs of her belonging.

It is in relation to this that Fuseli's pursuit of the image of his dream through 'the passing fashions' can be understood. Each new costume, perhaps more elaborate than the last, fails to hold her, except as a dream of her being able to belong as the clothes might belong to their owner. Instead, as he seeks to reproduce that sacrifice of the artist to that code of painting, he produces image after image of her in which she seemed to him to usurp the centre that he wanted to be able to create. Searching for the signs of that centre, variously moral and political, what he produced testifies to a subjection to an image of a woman who did not, despite being his wife, ever seem quite to be his. The identifiability of these images thus served, but failed to ensure, the desire for possession of her.

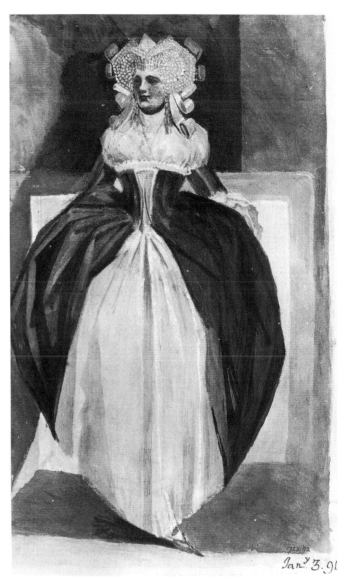

1 Tate Gallery, *Henry Fuseli*, London, 1975, p.130, entry 180 (Kunsthaus, Zurich, inv. no. 1934/2).

2 J. Knowles, ed., *The Life and Writings of Henry Fuseli*, 3 vols., London, 1831, vol. II, p. 216.

44 William Blake
(1757–1827)

Moses and the Burning Bush

Signed 'W B inv.'
39.4 x 30.1 cm; A.L. 9285

This is one of over two hundred paintings, in watercolour and in what Blake claimed was tempera, which he produced to illustrate the Bible.[1] *Moses and the Burning Bush* and the following *Christ in the House of Martha and Mary*, both watercolours, were sold to Thomas Butts who, from 1799, enabled Blake to practise as a painter. This was important for Blake, as his practice as a printer had seemed to fail him. The printing of his poems and designs together had been suspended in 1795, partly for fears of being tried under new laws against sedition. Although he probably began to write *Milton* in 1800, it is unlikely that he printed it before the middle years of the decade.[2]

It may be inferred from this that these paintings represent a loss of a possibility of radical, formal invention in Blake's work.[3] One of the sources for such an assessment comes from one of those printed works, in which Blake mentions two projects concerned with the Bible which most interpreters have presumed remain unfulfilled. However, I want to suggest that these paintings of the Bible can be understood, if not as Blake's conscious working through of these projects, then as a reaction to the promises which Blake makes to deliver them.

The promises are made in the section of *The Marriage of Heaven and Hell* (*circa* 1793) called 'A Memorable Fancy'. The text describes a scene 'in a Printing House in Hell' where 'the method in which knowledge is transmitted from generation to generation' is witnessed. This printing house is a kind of furnace in which a 'Dragon-Man', a viper, an eagle, some 'Eagle-like men', lions and 'Unnam'd forms' work, casting 'metals into the expanse'. These are then 'receiv'd by Men' and they take 'the form of books'. The argument then turns explicitly to the text of the Christian law: a figure, called alternately a devil and an angel, advises that 'no virtue can exist without breaking these ten commandments'. This figure is then consumed in fire, rising as the prophet Elijah. Blake then makes his promises:

Note. This Angel, who is now become a Devil, is my particular friend; we often read the Bible together in its infernal or diabolical sense, which the world shall have if they behave well.

I have also, the Bible of Hell, which the world shall have whether they will or no.[4]

Blake does not seem to have fulfilled these promises, at least in the form of printed works like *The Marriage*. But the argument set out in the poem implies that such printed work, in so far as it involves text, is inevitably involved in oppression. Reading, Blake implies, is always limited by the law that the text has relayed, with transgression the only possibility of escape. We are required to transgress, of course, if we are to receive the 'infernal or diabolical sense' of the reading of the Bible, that being the way we are instructed to 'behave well'.

This circuit of reading, the law, virtue and vice would only be confirmed by the 'Bible of Hell'. For this could only pretend to be the law of the reversal of the laws of good and evil. A certain limit of Blake's work is approached here, one in which this image of Moses and, by extension, the other images relating to texts of the Bible, is implicated. For that circuit of the law of the text was, for Blake, only broken by the image. As he puts it, in his text on his picture *The Last Judgement*, the spectator was to 'enter into' the image on the 'fiery chariot of his contemplative thought'.[5]

The impossibility of this and the associated qualification of freedom in and by means of the image marks *Moses and the Burning Bush*. The figure of Moses is drawn by the sight of the bush burning, the event of which preceded him being informed by God that he is required to lead the Jews from Egypt. Thus what appears prefigures a duty to respond to the call of the law. The representation of Moses as a shepherd with a crook confirms this. There is a typological reading of Moses prefiguring Christ in the Christian tradition, one which would focus on this representation of Moses as a shepherd (as he is described in Exodus 3. 1, tending his father-in-law's flock, in the verse preceding the account of the burning bush).

This reading of Blake as maintaining the Christian tradition is supported by his later career and the example made of him by artists who came to know him during the 1820s, such as Samuel Palmer and John Linnell. The latter's *Collecting the Flock* (entry 76) is a case in point of the use of Christian metaphors of the flock to defend the genre of the pastoral, one which can be traced also in Blake's illustrations to Virgil.

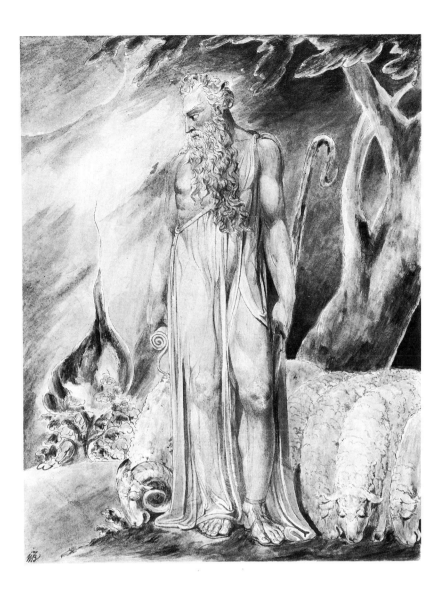

This image by Blake, then, is part of a movement which became indistinguishable from a rather conservative rearticulation of Christian values. The problem seems to have been this: that Blake, despite the position he seems to have articulated in, say, *The Marriage of Heaven and Hell*, was trapped by an expectation of redemption which he found in that tradition. This is as true of that notion of a release from the text, in that formal version, as it is in his notions of the possibilities of not interpreting images. In the case of this image, then, Moses would be an example in so far as he was a reluctant bearer of the scroll he carries. In so far as he is also captivated by the burning bush, he testifies to the limitation of Blake's search, among the patriarchs, for a model.

1 Martin Butlin, *The Paintings and Drawings of William Blake*, Paul Mellon Centre/Yale University Press, New Haven and London, 1981, p. 317 (entry 441).

2 See William Blake, *Milton*, eds. K.P. and R.R. Easson, Thames and Hudson, London, 1978, p. 59.

3 Anthony Blunt's claim that these paintings represented the development of 'a personal religious idea' has been difficult to sustain: 'the [Biblical] watercolours frequently seem to fall into small groups concerned with a single theme' (David Bindman, ed., *William Blake: Catalogue of the Collection in the Fitzwilliam Museum Cambridge*, Fitzwilliam Museum/W. Heffer and Sons, Cambridge, 1970, p. 21). For a recent reiteration of the notion of the radicality of the illuminated books see Edward Larrissy, *William Blake*, Oxford University Press, 1985, p. 3.

4 William Blake, *The Poems*, eds. W. H. Stevenson and D. V. Erdman, Longmans, London, 1971, p. 121, lines 287–92.

5 D. V. Erdman, ed., *The Poetry and Prose of William Blake*, New York, 1965, p. 550.

45 William Blake
(1757–1827)

Christ in the House of Martha and Mary
or *The Penitent Magdalen*

Signed 'W B inv.'
34.9 x 33 cm; A.L. 9286

The differences in idiom between this watercolour and *Moses* (entry 44 above) suggest connotations which sustain that movement described above of confirming, even while questioning, the fulfilment of the promise of the Judaic tradition by Christ. The colours are less bright, more diffused in washes, supporting an interpretation of the generalised light which Christ brings. Interestingly, the linearity, which is often noted of Blake but less often interpreted, seems stricter, despite the greater elongation of proportions of the figures.[1] This corresponds to a control of that generalised light and its associated benefit, which is very much part of the tensions within and between the possible narrations of the image.

To investigate these with reference to the text of the Bible is not simply to defer to the traditional identification of the topic of this painting. The compositional precedents warrant such a reading, too. Similar to the composition of his 1799–1800 so-called 'tempera', *The Last Supper*, which Blake is likely to have derived from an engraving of Nicolas Poussin's picture of the same subject, inferences can be made about a kind of general assimilation of a Western, Christian tradition of painting which is likely to have influenced the interpretation, as well as the making, of this work. However, the lack of absolute propriety of these precedents means that this picture does not simply belong there. This is not exceptional; rather, it is the rule (contrary to the apparent security of much interpretation of that tradition). Still, it is as well to trace those possible narrations to see how those tensions are deflected, resolved or exacerbated by the image.

The canonical text would be from the end of chapter ten of St Luke's gospel. Jesus has just narrated the story of the Good Samaritan to his disciples. Given as an answer in parable to the question, 'Who is my neighbour?', the telling of the tale is concluded – as if the message were clear – by Jesus telling his audience, 'Go, and do likewise'. This is followed by his arrival on his continuing journey at Martha and Mary's house. Martha is described as being 'cumbered about much serving'. She asks Jesus to instruct Mary her sister to help her with her work. He replies that, while he recognises that Martha is indeed 'careful and troubled about many things', Mary, who is listening to 'his word', 'hath chosen that good part, which shall not be taken away from her'.

That this account of events in Martha and Mary's house is preceded by the story of the Good Samaritan is not irrelevant. The lesson that your enemy is your neighbour, perhaps the strictest possible interpretation of the parable, is followed by a threat to the apparent order of a house, brought about by Christ's insistence on having Mary remain to listen. The notion of neighbour has been displaced from a possible literal meaning of one who lives nearby; this is followed by a risk of a break in relations between sisters living in the same house.

Some of the idiom of the picture suggests a certain suppression of the conflict here: that diffused light, with its connotation of beneficence (the halo would give it holiness too); the relatively uncontrasted washes supporting this. The enclosure in line of the figures suggests a kind of limited recognition of the risk of separation that is at stake. The composition confirms this. Martha, Mary and Jesus are situated in front of what looks like a stage. And, if we follow the likely identifications here, Martha looks as if she has entered from nowhere; the other two, Mary in particular, caught at the boundary which marks a limit of the house. This drama of the composition implies the possibility of a recognition of Mary's fate to leave the house and follow Christ supposedly to redeem herself of her sins. The position of Martha, however, sustains the nonrecognition of the possibility that what are determined as Mary's sins of concupiscence have been determined, in so far as there is a question of prostitution at stake here, by the requirements of the house.

This inference indicates that Blake's turn to the Bible as a pictorial source did not result in images which were without the effect of the confirmation of Christian morality and its rearticulation as a way of appearing to solve, while binding over the difficulties of social life. Yet, as I said above, that tradition does not have the final word over the narratability of the image. Perhaps it is the figure of Martha who most threatens the rearticulation of that tradition here. While Mary stands at the edge, drawn by the promise of release, Martha exists as if she had arrived from nowhere, as if it was who she had breached the limit of the house. Inferrable here is the possibility of not recognising domestic work in the construction and maintenance of society, and instead imagining it solely as the scene of the word.

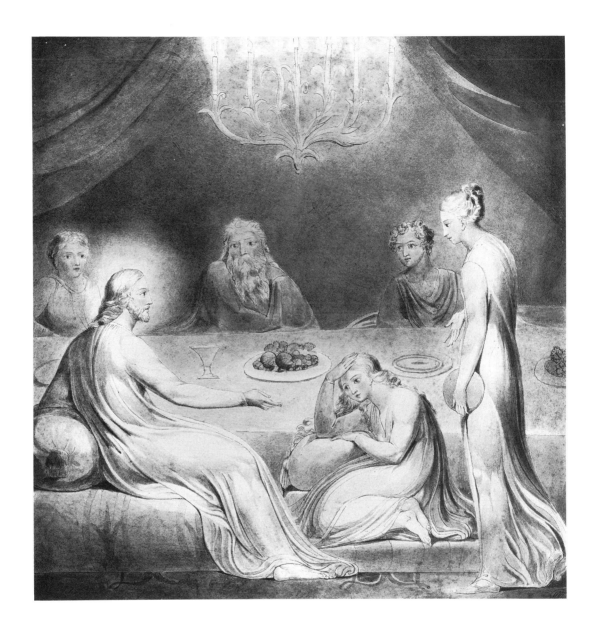

1 See Butlin, *Paintings and Drawings*, p. 372 (entry 489).

46 John Everett Millais
(1829–1896)

*The Eve of St Agnes: Interior
at Knole near Sevenoaks*

Signed 'J M' [monogram]
20.8 x 27.4 cm; D.141–1906

There is an important structure of fascination in Keats' poem 'The Eve of St Agnes'. At the beginning of the story Porphyro, who has come 'across the moors', stands waiting to enter the Baron's fortified house where all his enemies are celebrating. Porphyro, the poem relates:

> implores
> All saints to give him sight of Madeleine,
> But for one moment in the tedious hours,
> That he might gaze and worship all unseen;
> Perchance, speak, kneel, touch, kiss – in sooth such
> things have been.[1]

By the end of the story Porphyro and Madeleine have decided to escape, fleeing from the house of dynastic power and rivalry, back across the moors. But Porphyro's willingness to steal away with Madeleine is not mentioned until very near the end of the poem, when Madeleine's lament for her love and her life prompts his proposal of marriage and escape. For most of the poem we are kept in the dark about the extent and kind of their knowledge of each other and, so far as we are aware, Porphyro's foremost intent is to obtain that sight of Madeleine so that 'he might gaze and worship all unseen'.

Millais' watercolour, painted in 1863 after a very similar oil painting had been exhibited at the Royal Academy in April of that year, presents us with the opportunity to remain suspended in that position of fascination, to gaze unseen.[2] Recognition of this is perhaps deflected by the degree of apparent correspondence between the detail of this scene and of Keats' text, as if the painter were operating under cover of fidelity to a text.

Having persuaded the old servant Angela, against her better judgement, to hide him in a closet in Madeleine's room, Porphyro sees her enter, kneel and pray. He 'grew faint', but then:

> Anon his heart revives: her vespers done,
> Of all its wreathed pearls her hair she frees;
> Unclasps her warmed jewels one by one;
> Loosens her fragrant bodice; by degrees
> Her rich attire creeps rustling to her knees;
> Half-hidden, like a mermaid in seaweed,
> Pensive awhile she dreams awake, and sees,
> In fancy, fair St. Agnes in her bed,
> But dares not look behind, or all the charm is fled.[3]

The staging of this watercolour by Millais thus compensates for the inability to represent the imaginary object of the desire of vision, the woman standing in the room, *as imaginary* – if St Agnes were to appear to us she would be an object of our vision and thus not simply the fantasy of the woman – by enabling us to see behind the curtains which the woman is looking at or through. This indeterminacy allows that notion of the image as faithful to the text to coexist with the possibility of further fantasy about the woman and the bed. The bed may be imagined to be her destiny, our destiny, hers and ours, which she wants or does not know she wants, given that apparent position seen looking. Perhaps she cannot see the bed, but only the curtains: thus, they act as an imaginary screen, on which we can further imagine that she projects or has had projected for her something which she wants to see. But the notion of a fidelity to the text might interrupt and block recognition of these possibilities of imagination. For, later in the poem, once Madeleine has got into the bed and fallen asleep, Porphyro creeps out across the carpet, 'And 'tween the curtains peep'd'. Between these episodes, Keats' poem does not relate Madeleine getting undressed. Instead, suddenly, she is in bed and Porphyro is left gazing 'upon her empty dress'.

The indeterminacy in Keats' poem between Madeleine remaining and becoming the object of desire of Porphyro is similar to the effect of Millais' painting. However, these two movements run as if in reverse, with the figure suspended in a position of unconscious striptease, while the light falls on her, and we remain definitively unseeable. Thus the becoming object acts as if to precede the remaining object of desire, the appearance enduring as if to enable denial of this.

Subtitling this painting *Interior at Knole, near Sevenoaks* tends to beg all these questions of our relation to the represented scene. For that denial operates most powerfully by a sort of forgetting of the frame which enables us to imagine that we are hidden within the bedroom, like Porphyro, but also that we can remain

outside it. The point of view, across the furniture in the fore-ground, as if we were further into the room on the left, allows for a sort of imaginary reserve of space behind us so that we could imagine retreating as if indefinitely, remaining unseen by the woman. The perspective construction, however, which is so emphasised by the shadow of the window which falls across the woman, enables, as it always does, a point of imaginary nonbe-ing, outside of space, time suspended, happening over there if at all. And not being caught in that fall of light as she is, her shadow extending across the floor into our view, we can console ourselves with imagining that she remains captivated by fantasy while we might believe that we are merely observing.

When Millais painted the version of this subject in oils, he began it in a bedroom at Knole, using his wife Effie as a model. He found the light insufficiently strong, however. He finished the scene back in London, with the aid of a professional model

and a lantern. This bringing together of different spaces and dif-ferent lights, as if into one, reminds us of the effacement of dif-ferences of space in the image and the staging required to recre-ate and maintain the spectacle of women as objects of desire.

1 John Keats, 'The Eve of St Agnes' in *The Poetical Works*, ed. H.W. Garrod, 2nd edn., Clarendon Press, Oxford, 1958, (pp. 236–56), p. 239, lines 77–80.
2 For details of the oil painting see Tate Gallery, *The Pre-Raphaelites*, Tate Gallery/Penguin Books, London, 1984, pp. 199–200 (entry 122). Cp. also the earlier *St Agnes' Eve* watercolour (pp. 267–8; entry 200), relating to Tennyson's poem.
3 Keats, 'The Eve of St Agnes' in *Poetical Works*, p. 247, lines 226–34.

47 Dante Gabriel Rossetti (1828–1882)

The Borgia Family

Signed and dated 'D.G.R. 1863'
36.2 x 37.8 cm; 72–1902

This is probably the second watercolour of a scene which Rossetti derived, with only minor compositional variations, from a pen and ink sketch of 1850 (Birmingham Museum and Art Gallery, 478'04). That sketch is inscribed with two lines adapted from the opening speech of Shakespeare's *Richard the Third*. The Duke of Gloucester, the future Richard III, describing himself as 'deform'd, Unfinish'd' and as hating 'the idle pleasures of these days', announces his intentions to disrupt the peace and curtail the celebrations of the victor of the civil wars, 'this sun of York', King Edward IV. Rossetti's citation of this text:

To caper nimbly in a lady's chamber
To the lascivious pleasing of a lute[1]

substitutes 'to caper' for 'he capers'. Thus he shifts the text from exemplifying Richard's disgust at pleasure, making it instead the text of a possible longing. Also, however, it becomes the text of a kind of expectation of the consequences of imagining this longing acted out. The scene, now identifiable as of a family, if a particularly notorious one, is a kind of restaging of a fantasy about what would have occurred following such a capering.

The sketch and all the subsequent versions of the composition belonged to George Price Boyce (see entry 70 below). In his diary he describes how Rossetti borrowed back the first watercolour: '[He] has changed the subject into a "Borgia" and made the old grey-haired man into a Pope'.[2] The dropping of the quotation and the shift in association from an English to an Italian court might suggest that Rossetti is freeing the subject from any remaining tinge of distaste or ambivalence, so that it might become one of his works which has come to be identified with an unqualified celebration of sensuous pleasures, as if there had been an easy metonymy between pleasures of colour, music and sex.

But that shift of identification of the figure to that of a pope,

and a pope who may be identified as the woman's father (she being Lucretia Borgia and the old man Pope Alexander VI) should alert us to the conditions of this displacement of distaste and ambivalence. Craning over the woman's shoulder, his face touching her hair as he embraces her, he gazes out at us threatening to interrupt any imaginary exchange of gazes with her we might want to enjoy. Such a qualification of the notion that Rossetti represents women as accessible can also be traced in other works of about this time.

There is a complex ambivalence to paintings such as *Fazio's Mistress* (1863) and *Monna Vanna* (1866), for example, which is usually ignored or suppressed in interpretations of Rossetti's work.[3] That Rossetti represented women under the cover of identification of national and sexual exoticism acts to confirm, even while it appears to enable a shift outside, dominant currents of Victorian morality. Furthermore, not only did these women appear under that condition of identifiability – from which, after all, there is always a possibility of a temporary detachment – but they are represented in poses which *can* be interpreted as both distant and disdainful. This serves to maintain those identifications of the women as removed, and usually gladly removed to a position of implied transgression.

This suggests how it was possible for Rossetti more and more to live as if secluded, an outsider on the inside of Victorian society. His resistance to Ruskin's exhortations to develop his watercolour technique, if not by painting from nature – objectified, thereby, as outside the house and town – then at least visiting the countryside to 'make memoranda fast, work at home in the inn, and *walk* among the hills'[4] – is indicative of a desire not to risk this position. Further consideration of this interior can suggest how this marked his work.

The figure peering in through the window in *The Borgia Family* recovers a position of viewing which might seem to be unavailable to us, namely to look without being looked at. The cordoning off of the woman and older man by the children in the foreground and the older figures, perhaps servants, towards the left rear, creates an imaginary interior of pleasure but also of censorship of desire. Those children are not only identifiable as the offspring of a sexuality demanded and enforced (as well as transgressed) by this pope, but they are also to be seen dancing, as if already caught up in this fate of desire. The figure peering in at the window supplements a look which is threatened by the drama of the composition, seeing but not seen. Such a supplement is desirable if, as is the case in other works by Rossetti

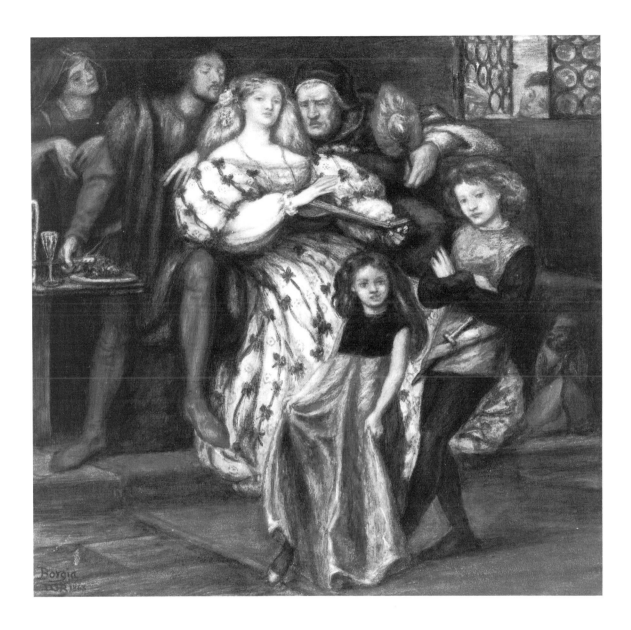

such as *The Girlhood of Mary Virgin* and *The Annunciation*, there may be traced a fantasy if not of incest, as in those earlier works, then of paedophilia. For the little girl at the front, holding up her dress, is caught up in the drama of transgressive sexuality, as if soliciting the viewer. A view from outside, such as the figure at the window enjoys, enables a temporary and fantasmatic escape from the contradictions of remaining inside, resistant to society, unable to discover a way of changing it.

1 See V. Surtees, *The Paintings and Drawings of Dante Gabriel Rossetti (1828–1882): A Catalogue Raisonné*, 2 vols., Clarendon Press, Oxford, 1971, vol. I, p. 47 (entry 47; pl. 36).

2 V. Surtees, ed., *The Diaries of George Price Boyce*, Real World, Norwich, 1980, p. 26 [entry for 3 January 1859].

3 See Tate Gallery, *Pre-Raphaelites*, p. 200, entry 123 and p. 214, entry 136.

4 J. Ruskin to D.G. Rossetti, October 1855, in W.M. Rossetti, ed., *Ruskin, Rossetti, Pre-Raphaelitism: Papers 1854–1862* (1899), AMS Press, New York, 1971, p. 104.

48 Simeon Solomon
(1840—1905)

Isaac and Rebecca

Signed and dated 'S.S. 4/1/63'
29.3 x 20.3 cm; P.46–1925

This watercolour was completed at what has been identified as
the end of the first period of Simeon Solomon's career as a
painter.[1] As that identification shows, however, it has seemed
easier to classify his work chronologically, than to explain either
the relations among them or the similarities and differences
between them and the works of his contemporaries, taking into
account the complexity of the different phases of his life.

Isaac and Rebecca is one of the last of his paintings representing
a scene from the Pentateuch. Thus, in so far as it represents a
scene central to Jewish history and law, it can be aligned with
works like *Isaac Offered* of 1858, the first of his works to be
shown at the Royal Academy. He, more than his older brother
Abraham or his older sister Rebecca, both of whom were tal-
ented and successful painters, appears to have been involved in
reworking the contents and forms of his Jewish upbringing.

The transition from works derived from Jewish history and
themes and motifs taken from Hellenic and Christian traditions
is not abrupt and never simple: the sources of late works like
Love at the Waters of Oblivion remain complex and difficult to
trace. But there is a movement away from the Jewish tradition
that followed a break with his family, with whose values his
homosexuality seems to have been incompatible. His friendship
with Swinburne and Pater, a lack of dissimulation about his sex-
uality, unusual for the 1860s in London and Oxbridge society,
and his arrest in February 1873 on a charge of sodomy has
encouraged, besides fascination and censure, a schizophrenic
view: first a dutiful son of the Hebraic tradition, then a kind of
camp pillager of certain traditions and mythologies.[2] As
Swinburne put it, perhaps symptomatically, 'Grecian form and
beauty divide the allegiance of his spirit with Hebrew shadow
and majesty'.[3]

Attention to the textual sources for this painting may help to
explain something of the shift which Solomon managed in a way

which does not simply confirm the thesis of camp, and the reac-
tion to that of censure. There are four significant scenes in
Genesis in which Isaac and Rebecca may be imagined to stand
together. First in Genesis 24. 67, following the meeting of
Abraham's servant and Rebecca at the well, they are introduced
and Isaac brings her 'into his mother Sarah's tent...and she
became his wife'. Second in Genesis 26. 8, Isaac is observed by
the king of the hostile Philistines 'sporting with Rebecca his
wife'. He has told this ruler of the unfriendly territory to which
he and his wife have been forced to flee because of a famine
that she is his sister: 'lest, said he, the men of the place should
kill me for Rebecca'. The third occasion follows from the decep-
tion that has been practised on Isaac by Rebecca and Jacob: of
dressing Jacob, the second son, in goats' skins in order that the
now blind Isaac will believe that he is the first son, the hirsute
Esau. Rebecca and Jacob deceive Isaac into giving his blessing
and his inheritance to the second-born of the twin brothers.
Subsequently, in Genesis 27.46, Rebecca speaks to Isaac, lament-
ing the weariness of her life, going on to insist on the impor-
tance of a marriage of their son, Jacob, to a woman from their
tribe and family, not one from the land 'wherein thou art a
stranger'.

Solomon's painting, while it would seem mostly obviously to
derive from the marriage scene in the tent, is not unrelatable to
the other texts. Isaac's eyes are nearly shut. Rebecca's closed
eyes can be imagined to be overdetermined: not simply the
expected withdrawal of the look connoting obedience, but also
contrition, as if her deception of her husband were at stake.
Their poses might not seem animated enough to be thought of
as 'sporting', but this suspended drama of touch is shown, is
seen by others. And, given that suspension, the question of
touch in the scene of Isaac's deception by Jacob assisted by
Rebecca and the skins of goats may be recollected.

In general, then, the dependence of the man on sight and on
the woman emerges as a significant issue, one which is qualified
and displaced by that touch. The very sense which could not
protect the father against the deception of his son and wife
becomes the one which, none the less, is shown as a source of
pleasure and attraction. Our vision does not enjoy this, and we
might miss it, given the strength and contrasts of the colouring
and the echoing lines of the composition. Nevertheless, if we
admit the possibility of a deception by the eye, we are perhaps
more able to enjoy its pleasures.

It is perhaps not insignificant that Simeon Solomon had a sis-

ter who was called Rebecca. Such a biographical detail might lead us to imagine that the painter might have been somewhat distanced from the inherited narratives of paternal deception. Moreover, following the argument of this study, that such images of interiors never just leave us on the outside, certain of how to position ourselves and the image in interpretation, the sense that visibility exceeds the law and its transgression is something which this image, with its complex drama of touch, suggests.

1 This is implicit in Lionel Lambourne, 'Simeon Solomon: Artist and Myth' in Geffrye Museum and Birmingham City Museum and Art Gallery, *Solomon: A Family of Painters*, I.L.E.A., London, 1988 (pp. 24–7), p. 25.
2 See Gayle Seymour, 'The Trial and its Aftermath' in *Solomon*, pp. 28–30.
3 Quoted by Monica Bohm-Duchen, 'The Jewish Background' in *Solomon* (pp. 8–11), p. 11.

49 Ford Madox Brown (1821–1893)

Elijah Restoring the Widow's Son

Signed and dated 'F Madox Brown. 68'
94 x 61.2 cm; 268–1895

This is the last of three version of this subject which Brown painted between 1864 and 1868.[1] The larger of the two water-colours, this version differs from the oil painting in Birmingham Museum and Art Gallery in effect largely as a consequence of depth and weight of shadow. In this respect, this watercolour might be said to approach more nearly to an ideal which, above any other, provided the terms for the identifiability of Pre-Raphaelite paintings: namely, the integration of differences of tonal value, degrees of light and shade, into colour. Thus, the illusion of depth and the differentiation of objects were approached, in theory at least, by the juxtaposition and contrast of differing hues.[2] Brown, never a member of the Pre-Raphaelite Brotherhood, nor ever explicitly dedicated to this formal end, none the less shared in this tendency to explore pictorial articulation in this way.

The appositeness of stylistic generalisations about Pre-Raphaelite paintings, among others, has been rightly questioned.[3] However, if we interpret this long-standing acount of the difference in appearance of these mid-Victorian paintings as a change in the possibilities of the narration of images, we can uncover some of the ends to which this apparent change in style was put.

Brown advertised this picture as an illustration of 1 Kings 17. 23. During a drought, the widow's son falls dangerously ill. The prophet Elijah, who has miraculously maintained the house's supply of food and drink, takes the boy, who seems to be dying, from the widow and retires to the loft from which, after having lain on the child three times, he descends carrying the now restored son. In his text, Brown claims, and appears justified in so doing, that he has been faithful to actuality in his work. The boy's dress, for example, is derived from 'Egyptian funereal trappings': 'Without this the subject (the coming to life) could not be expressed by the painter's art.'[4] Consistency seems to have been maintained by means of a similar source for the woman's clothes and by appearing to follow the 'Egyptian custom' of writing over and around the door. This text, from Deuteronomy 6. 4–9, is Moses' first proclamation of the first commandment, followed by a series of injunctions that his words should be remembered and passed on to subsequent generations. The inscription concludes, 'And thou shalt write [these words] upon the posts of thy house, and on thy gates.'

The claimed and perhaps apparent fidelity to the text, however, tends to conceal a certain impossibility of this. There is a very significant displacement of that desire for fidelity, as I shall show. But, let us follow it through from Brown's general claim, that he could not have expressed the subject, the 'coming to life' without these means. The fantasy of the life of the picture is, however, a cover for a kind of desire to exorcise the haunting of the present by the past.

Brown avoids a representation of the moment of the boy's restoration to health in favour of the return of the boy to the mother. The painting shows not only the loft, deep in shadow save for one bright light, where the cure was brought about, but also the similarly brightly lit interior of the house. This avoidance would probably have been dictated by the desire not to show the contact of man and boy lying together. There is further shifting of the narratable scene. For, in showing the interior of the house, Brown is keeping open the possibility of appearing to fulfil the demands of the text: 'Elijah took the child, and brought him down out of the chamber *into the house*, and delivered him unto his mother' (my emphases).

This effect of the suspension of the scene, poised as if to render its textual sources visible, represented, is one of the procedures of the project of Pre-Raphaelitism, one which suggests how the movement could claim to be *reclaiming*. But the stylistic project, of replacing tonal values by colour values, is never fully accomplished, if only because tonal values cannot be definitively suppressed. Such a *replacing* would, indeed, have had a kind of compensatory logic as well as one of overcoming and supplanting, one which, as with this image, would carry out and confirm the apparent ends of a tradition of Western, Christian painting. Indeed, in the case of Brown's painting, that project of the Christian tradition haunts the Pre-Raphaelite one; a kind of haunting of the image by those darkened recesses of the loft and interior of the house, a haunting of the image by that part of the story which Brown decided to neglect. Brown, moreover, seems to want to have controlled these shadows: the shadow of the

bird on the wall of the house, Brown claimed, was on its way to its pottery nest typifying 'the return of the soul to the body'.

Thus, and in further ways, Brown wanted the inferrable future to seem controllable. The chicken with its chick on its back might be interpreted as a prefiguration of the restoration about to take place, an image of a kind of excess of the household which will be reconstructed, across this threshold, in an imaginable harmony. The means of this apparent control is the saturation of the image by these details, at once justifiable as historically accurate and recuperable as symbolic. Complicit with projects of imperial archaeology, this also helps to explain why Brown, like an early D.W. Griffith, was so attached to this notion of reconstruction and readability. If the construction of the anticipation of the moment represented can be imagined to lead to the future, then this will have been where the artist will address us from. Such a positioning, an *avant-gardism*, is itself partly responsible for the guilt which Brown would seem to have done penance for by these efforts of conscientiousness.

One limit of this logic can be inferred from the Hebraic text which Brown includes inscribed around the door frame. Here that which appears is a reminder of a readability which cannot be translated and be brought to life by the painter. However, given this formal resistance of the text, Brown has made it into one which testifies to the fidelity of the household represented here, and for which it is seen to be rewarded. For they have indeed written the text which commands them to write the text, as if they will remain caught in fidelity for ever. It is only by imagining that others fulfilled such a demand that Brown was able to appear to subject himself. Such a moral and political logic, then, kept open a margin in which the imperial project might appear to be justified.

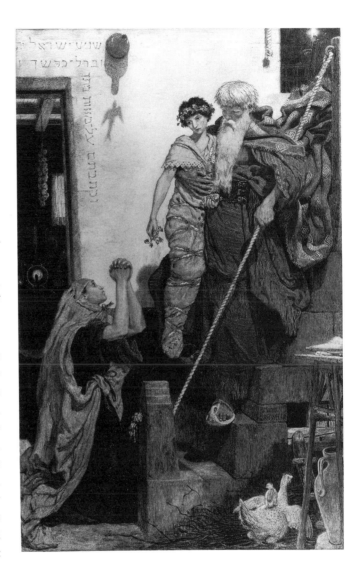

1 See Tate Gallery, *Pre-Raphaelites*, pp. 203–4, entry 127.

2 On strictures about proper painting in colour see Ruskin, *Pre-Raphaelitism* (1851) in *Works*, vol. XXII (pp. 337–93), pp. 363–4.

3 Marcia Pointon, ed., 'Introduction' in *Pre-Raphaelites Re-Viewed*, Manchester University Press, 1989, pp. 1–10.

4 See Tate Gallery, *Pre-Raphaelites*, p. 203.

50 Edward Coley Burne-Jones (1833–1898)

Dorigen of Bretaigne longing for the Safe Return of her Husband

Gouache; signed 'E B J'
26.7 x 37.4 cm; C.A.I. 10

In 1870 Burne-Jones, having refused to paint over the genitals and pubic hair of the male figure in his painting *Phyllis and Demophoön*, resigned his membership of the Old Water-Colour Society, where he had been exhibiting since 1864. He responded to the committee's attempt at censorship of the representation of the male body by claiming that he would not allow any extrinsic consideration to intrude on 'the necessity for absolute freedom in my work'.[1] This small gouache was painted in the following year, without any immediate expectation of exhibition. Interestingly, despite this, and despite Burne-Jones' claim, we can understand this painting as necessarily unable to exemplify that notion of absolute freedom.

If we do not merely accept the identification offered by the title, then we might be led to imagine a certain indeterminacy of gender in the figure stretched out in front of the narrow window in this painting. A reading of Chaucer's 'Franklin's Tale' from *The Canterbury Tales*, the source referred to by the title, will enable us to trace some possible confusions. In the poem, Dorigen certainly laments the departure of her husband Arveragus and she certainly longs for his return from the campaign over the sea in England. As Chaucer has it, 'She moorneth, waketh, wayleth, fasteth, pleyneth.'[2] Her anxieties focus on the rocks that lie just off the coast, waiting, it seems to her, to sink the ships that might return. She questions whether they can be anything but a 'foul confusion' in what she once thought was God's good scheme.

In the poem, however, her complaints are delivered from the cliff top. The one who may be found on his knees is Aurelius, a young squire who is in love with Dorigen. He offers her his love, and she rejects him. As if in pity for his suffering, she adds that she will love him only when the coast has been cleared of rocks. Aurelius is distressed at the apparent impossibility of this:

He to his hous is goon with sorweful herte;
He seeth he may nat fro his deeth asterte.
Him semed that he felte his herte colde;
Up to the hevene his handes he gan holde,
And on his knowes bare he sette him doun.[3]

And from his bare knees he prays for assistance in his apparently impossible task. What is apparently impossible may, none the less, appear to be possible. Aurelius, after two years of fruitless pining, discovers a man versed in 'magik naturel' who can teach him to make it appear as if the rocks have disappeared. Aurelius learns his art in the magician's study, the only place in the story in which books are to be found.

Thus, in several ways, it appears that Burne-Jones has employed aspects of setting, pose and gesture which seem to have derived from the character of Aurelius in what we are led to identify as the figure of Dorigen. The painting can only appear to confirm or disconfirm this, because the androgyny which would be required by this thesis can only be *imaginary* in so far as it depends on a judgement of appearance. But such constructions of the imagination play their part, indeed play a part in all parts, all identifications. It is interesting to imagine that Burne-Jones might have been involved in such an imaginary construction of his picture: given his retreat from exhibition in England, his shift from watercolour to gouache, with its connotations here of sadness and foreboding, the identification with a hybrid of Dorigen and Aurelius is not unimaginable; someone confined, despairing and apparently powerless in passion, save by the intervention of an art.

We may not know. But we can infer conditions which would have enabled such a fantasy to develop. The notion of an image of Dorigen longing for the safe return of her husband, but also standing cursing the rocks would have tended to put in question the imagined identity of propertied women in Victorian Britain, who might be stoical, loyal, faithful, but less often passionately angry. Such an imagined identity would have also encouraged her to be shifted indoors, shown suffering her longing. Looking out in exhausted expectation, there would be little chance of imagining her going out to a dance (as Dorigen does in Chaucer's poem) and perhaps little chance that she would even consider being unfaithful, given this condition (unlikely as it is that she will notice anyone anyway). The desire to identify the desire of women as the desire for a husband would have conditioned this representation of her – if that is what it is – as captivated by expectation.

Burne-Jones' painting also tends to promote a sense of a control of this expectation. The reaching out of the figure towards the limits of the window frame, as if trying to control the view, fails before our vision of her – as well as before the activity and vision of the artist. This apparent control of vision and of illusion in this interior, from a position which renders the outside imaginable, is achieved at the expense of a confirmation of a restricted imagination.

1 See Martin Harrison and Bill Waters, *Burne-Jones*, Barrie and Jenkins, London, 1973, p. 100; also Roget, *History*, vol. II, p. 117.
2 Geoffrey Chaucer 'The Franklin's Tale' in *Works*, ed. F. Robinson, 2nd edn., Oxford University Press, 1957, p. 136, line 819.
3 Ibid., p. 138, lines 1021–5.

51 Edward Killingworth Johnson
(1825–1913)

A Young Widow

Watercolour and gouache; signed and dated
'E.K. Johnson 1877'
52.1 x 34.6 cm; E.808–1959

As with Millais' *The Eve of St Agnes* (entry 46 above), we can see and imagine that we cannot be seen. Our look does not seem to be met by the look of the figure of the woman. She stands turned away from the plane of the picture, her head bowed and turned a little to the right, back across our line of imaginary vision. We *can* therefore also imagine that she has withdrawn her look, as if she did not want to have been seen seeing. Thus it is as if in contrition, as well as any imaginable grief, that her gaze seems to us to be cast down, focussing on the dress which she displays as if to remind herself that she was married.

For, at the same time as she shows it to herself, she is caught showing it to us, holding it up in between her and us as if she might let it fall. Imagining the conditions of this falling can take us closer to the disturbing logics of this picture. Perhaps it would become too heavy: she would thus be weak, weakened perhaps by her grief. Our attention might then be justified as preparing to assist; but it could also satisfy itself that it had the power to give. Perhaps it would be despair that she could not bring back the past that she was reminding herself of: in which case, she could be accused, given that structure of looks outlined above, of failing in the propriety of her observance of her widowhood; or, again, just to be in need of our attention. Perhaps it would be frustration and anger with herself at seeking to remain captivated by memory: in which case, she would be open to the charge that, once again, she was failing in her duty and, perhaps worse, risking forgetting who she was and what had happened. But then, of course, we could remind her of her duty, her duty to remember, to *observe* her state, play the part of the authority of conscience, the ever violent, self-contradictory voice of the moral legislator.

Perhaps there are imaginable ways out: for her, in imagination, questioning whatever got her into this position of being so trapped in a propriety of appearances. But short of us imagining her not being in this position, perhaps leaving the stage, then there seems little relief from having to make a *scene* of grief. Indeed, even an imaginable exit would tend to confirm this making a scene, so much the logic of the dress she wears as well as the one she holds in her hands. Were she to be imagined to leave, this could be recuperated as a loss of control, loss of a sense of propriety. The moment before exit, were she to have let the dress fall, would – as would all those other scenarios – take place as a kind of unconscious striptease, doubly unconscious for certain viewers entertaining that assortment of moral judgements, imagining that all they might be witnessing would be her frailty.

Such interpretations of this painting suggest that we should be careful before we reiterate the clichés concerning the dedication of Victorian painting to morality. This can always be qualified by a questioning of the supposed morality of morality, and the very possibility of it being *accomplished* in painting. For one thing the above interpretations have shown is that the contradictions between those inferrable moral positions can remain unconscious if we do not reflect on vision itself. Seeing a scene representing another apparently acting with propriety always needs to forget seeing that scene: to forget being put in certain positions, with certain limits of imagination given, if seeing is to support the possibility of the reiteration of moral judgements.

In 1870, seven years before this picture was painted, the Married Women's Property Act was passed, giving women greater rights of ownership within marriage.[1] Such a move risked provoking resentment which may well have been displaced on to a scene like this, a scene of inheritance. Perhaps the satisfaction gained by a vision which wanted to hold to certain moral judgements would have been one which did not want to believe that women could be admitted as owners of property. And the satisfaction of such viewers might have been to imagine that the woman represented in this picture wanted to cast it all away.

1 See Lee Holcombe, '"That Legislative Abortion": The Married Women's Property Act of 1870' in *Wives and Property: Reform of the Married Women's Property Law in Nineteenth-Century England*, Martin Robertson, Oxford, 1983, pp. 166–83, in which the complexities of the issues of inherited property within marriage are outlined.

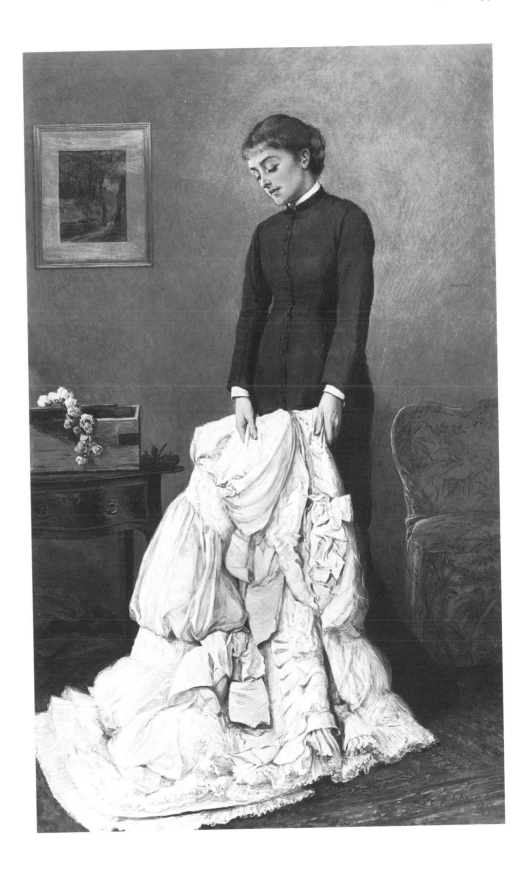

52 Albert Moore
(1841–1893)

An Open Book

41.9 x 31.2 cm; 42–1884

The rejection of Albert Moore's designs for the frieze on the exterior of the Albert Hall left him outside the support given to many artists by the allied interests of the monarchy, the government and industry. From the 1860s onwards, Moore tended not to seek to satisfy the demands of projects supported by such interests to provide representations, allegorical and symbolic, of the forces which they wanted to be understood to be at work in society.[1] However, despite this and despite his association from 1877 with the Grosvenor Gallery, which seemed at the time to provide a site of exhibition not constrained by the proprieties of the Royal Academy,[2] Moore's work can be understood to be marked by those forces of mid to late Victorian industrial and imperial society. A hint of this is given by the provenance of this work: acquired by purchase from the artist in 1884, this watercolour found a place in the National Collection of Watercolours as an imagined exemplification of the values of careful preparation and study, subordinated to a final design. Thus it would have been understood in an institution whose founding purpose had been to provide examples in a curriculum of the dedication of art to the practices of industry and commerce. This would have provided one of the justifications for the title of this work.

However, the notion of legibility implied by that title has further ramifications. The desire to imagine that the framed design is readable as a design – that is, something from which further, more apparently finished work is to be derived – tends to enforce a teleology of productivity, such as was promoted by those forces mentioned above. It is a particular and partial reading, however, which imagines that Moore proceeded by preparing his studies, then moving on to synthesise and fulfil them by completing the framed image. Nor is it sufficient to imagine that the procedure operated as if in reverse, the work begun, with the studies being rehearsals, conducted after the first night to iron out the difficulties which have appeared. Both of these models still imagine that the move is towards completeness and mastery,

and both of them forget the very framing of the site of a design. That in itself is not mastery: limitation, determination of the outside and inside of a design, not by an act of pure force, but a decision which might enable the appearance of completion. Such a limitation, not simply empirical, but implying these strictures, tends to be missed when there is a sort of reframing, a kind of effacement of the having been framed by a new framing. Such a move we can infer here from the outlining of the design in washed colour, intended perhaps to fit the work for a passe-partout and perhaps an exhibition frame. Thus the work would appear more nearly a work, less that pedagogical object implied above.

Given the recent and repeated reaffirmations of the forces of industry and commerce, and the renewed attempts to contain and control the significance of the past – such as is exemplified perhaps most notably by the pressures on the Victoria and Albert Museum – it is thus not sufficient to leave things here. For that effacement of framing and its vicissitudes mentioned above will always be for the framing of something or other, something which is not simply within the control of those forces and the values which those forces would promote. Moore's work can thus be understood to testify not only to confirmation of the operation of those forces and their imaginary rule, but also to something which that rule would not wish to recognise.

The imaginary rule of those forces would be confirmed by an interpretation of this work which stressed the luxury of the setting and imagined a kind of relaxation of the figure in that setting, released by the comforts brought by industry and commerce to dream. Such an interpretation is latent in the notion that this work, like others by Moore and by other late Victorian classicists like Leighton and Alma-Tadema, represents the dream of the artist, a result of a sort of magnificent detachment from society. The very reattachment implied by this work, of imagining the dream of another, and thus a reattachment to a possibility of society, is thereby ignored. Of course, the interpretation of such a representation of a woman as given over and giving herself over to luxury, indeed to an imaginable luxury of imagination, would be part of the very justification of international commerce and industry. Problems with their *justification* are very germane here, and will not simply disappear. So it is interesting to note that in the case of this work, such justification operates, if at all, by implying a kind of displacement of the enjoyment of the benefits of those forces and the order which supposedly

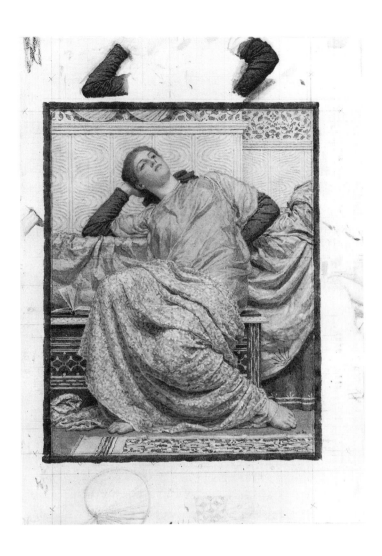

makes them available – for they are immanently associated with disorder – into the past, a past which implies a different imperium, that of Rome.

As with the concerns about a sort of infection by the decline of Italy in the very movement to assimilate and go beyond it that are described above in relation to British landscape painting of the eighteenth century (see chapter 1), there is a comparable movement here, of a kind of control of the notion of decadence by referral to the example of Rome. It is as if there has been a kind of suspension of what appears present in the past, a past thereby which would not communicate with ours, or our present. All this unravels when it is realised that our present is an imaginary one, sustained by representations such as this one.

Thus, Moore's *An Open Book* allowed for a kind of justification of the imagined order of the rule of the forces of industry and commerce which both wanted to ignore the necessary lack of order and imagine it could be recovered in the controlled dispositions of domestic space. The dedication of the accumulation of property to the imagined comforts of a woman breaks down when it is realised that she has been ordered in image, disposed along with the disposition of the inanimate, in a movement which is not peaceful, but which has sought to dedicate its partiality to the construction of a controlling design. The non-recognition of this, and the dream of the absence of the frame, is a fantasy of the peaceful compliance of the imagination.

1 See Marina Warner, *Monuments and Maidens: The Allegory of the Female Form*, Pan Books, London, 1987, for example 'The Front Page (London)', pp. 38–60, for an account tracing some parallels between mid-Victorian and late-twentieth-century allegorical representations of women.

2 See Frances Spalding, *Magnificent Dreams: Burne-Jones and the Late Victorians*, Phaidon, Oxford, 1978, pp. 1–31.

6

THRESHOLDS OF THE FOREIGN

53 William Alexander
(1767–1816)

Emperor of China's Gardens,
Imperial Palace, Pekin

Signed 'W A'
23.5 x 35.5 cm; 2930–1876

In 1792 the government of William Pitt sent a deputation, led by Lord Macartney, to China to petition the Chinese authorities to allow Britain to establish a diplomatic ministry there. This water-colour by William Alexander derives from sketches he made on that trip, for which he was official draughtsman.[1] The care and attention to detail of Alexander's image encourages us to think of this image as a documentary one. But we should remember the general argument about the medium and the form of the watercolour that came to be made in the nineteenth century if we suspect that there is nothing more at stake than the relay of the appearances of China. For at the same time as this image seems to convey with a kind of diplomatic self-sacrifice the detail of those appearances, there is also another kind of diplomatic effect, one which sustains a notion of the effect of the possibility of government, a kind of seduction into security of the addressee of the image.

This is accomplished largely by the composition of the image. At the centre of the middle-distance sits the dome and tower of the palace on the hill, around which, we may infer, are to be found a variety of buildings more or less clustered together among the trees and beyond the perimeter wall of the gardens. The continuity of this wall may be fantasised, for it seems unbroken, except perhaps at the far left of the image. The structure to the right seems less a gateway than some false promise of one. At the edge of the estate, perhaps it receives travellers from the river. Perhaps it just announces passage, failing to allow it. Beyond the walled gardens, on the hills to the left and right, pagodas mark the horizon. At a limit of the scene, they none the less promise an extension of the view into the distance.

Our view, however, also takes in the river which runs around the wall of the gardens of the palace. Our position, without the imaginary ground of another bank or a boat, can drift, almost as if it might extend its view to encircle what lies before it, drifting the waters of the world. In our temporary rest, then, we see further signs of drifting and of attempts at control by those in the boats on the water before us. In the boat with sail flying flags to the left of centre, figures stand with parasols raised, presumably protecting the figures sat in the boat. The detail of this discourages us from recognising that the boat sits at a slight angle to the perimeter wall, as if drifting, the sail inclined to catch the wind to carry along the river to the left. The figure in the foreground in the left-most boat, attempting to steer, seems to be seeking to hold the boat against the current. And while he is watched by the figures sat directly behind him, we are faced by the rather corpulent figure who sits between them.

One of the imaginary destinations of the boats in the foreground is a rendez-vous with the boats in the distance. Perhaps I should say ships, for these seem identifiable as seagoing vessels, carrying British flags, moored as if waiting to make contact. The image can thus be imagined to precede that contact, our vision therefore in advance of the establishment of relations. Given this, the composition takes on significance as the bearer of traces of absolute order – the position of the centralised tower-dome – but also of the decline in order around that centre. Set adrift on the river, the Chinese court would have lost its control over its implied hierarchy. The figure sitting facing us in the boat to the right would thus be a kind of failed regulator, seeking to hold us in his gaze, while at the same time our vision informed us that he was less than all-seeing. Furthermore, in that smaller boat, he is unlikely to be the emperor himself; if he were, it would further suggest that such signs of disorder were attributable to the British mission and the expected encounter with them.

Thus this image would have relayed that diplomatic effect spoken of above, a fantasy of security testified to by the displacement brought about by the operations of the authorised intercessors. Such a fantasy, however, contains within it a repetition of the very possibility of order which is here imaginable as being that of another political culture. Testimony that this notion of despotic force does not simply belong abroad is to be found in Coleridge's *Kubla Khan: Or, A Vision in a Dream*, written in 1798 although not published until 1816. In the poem, the fantasy of order emerges as the possible assimilation, retrogressive, mythological, of the power of the foreign despot, a power the pleasure of which would be denied by precisely that political culture which depended on the communicative uncertainty involved in diplomacy.

The poem opens with a narrative which would relate what had happened in a past which had no past, when the land was of one age, and the decree of the ruler was carried out without delay or apparent conflict:

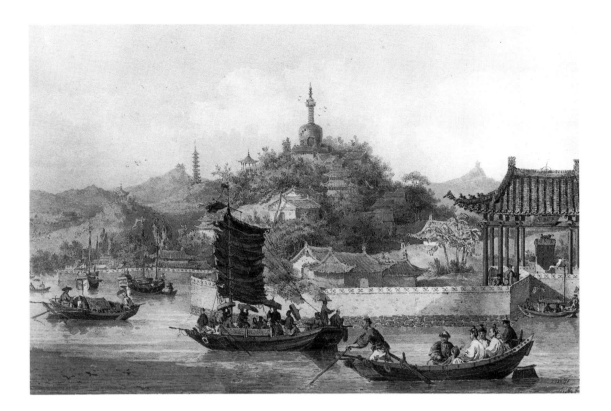

In Xanadu did Kubla Khan
A stately pleasure-dome decree:
Where Alph the sacred river, ran
Through caverns measureless to man
 Down to a sunless sea.
So twice five miles of fertile ground
With walls and towers were girdled round:
And here were gardens bright with sinuous rills,
Where blossomed many an incense-bearing tree;
And here were forests ancient as the hills,
Enfolding sunny spots of greenery.[2]

The past and the threat of conflict emerges in the sounds of the river as it plunges on from the domain of Kubla Khan, sinking 'in tumult to a lifeless ocean':

And 'mid this tumult Kubla heard from far
Ancestral voices prophesying war.[3]

The para-rhyme of this couplet breaks the fantasy of control and of the present, a dissonance which tends to be forgotten in the concluding section of the poem. The narrator recalls a dream of a woman of Abyssinia, singing and playing a dulcimer – perhaps the sweetest of instruments, not least here because of its *name* – whose music, if revived, would enable the reconstruction of the dome. The consequences of this imagined recovery of the powers of Kubla Khan would be to defeat the very past of the narrator, the mythological roots of Christendom:

I would build that dome in air,
That sunny dome! those caves of ice!
And all who heard should see them there,
And all should cry, Beware! Beware!
His flashing eyes, his floating hair!
Weave a circle round him thrice,
And close your eyes with holy dread,
For he on honey-dew hath fed,
And drunk the milk of Paradise.[4]

The conclusion of this complex poem, it should be noted, holds itself in the conditional tense until the last sentence, the final imperative. This in itself indicates that assimilation mentioned above, one which by implication now enables the narrator to exceed the powers of the fallen despot. For he has survived paradise, that fall in that garden, and remains at the centre in a position of command.

The parallels with Alexander's image are not then simply at the level of the descriptive or the documentary. There is a kind of implied supplementation: to see the power of despotism at risk is to be able to imagine the centre as a command of the vision of others. The traces of failed command of the Chinese court at sea on the river enables that fantasy of security mentioned above precisely by the relay of a prospect in which government without relay may be imagined still to be in place.

1 Clark, *Tempting Prospect*, p. 58.
2 S.T. Coleridge, *Select Poetry and Prose*, ed. S. Potter, Nonesuch, London (pp. 93–5), p. 94, lines 1–11.
3 Ibid., lines 29–30. 4 Ibid., lines 46–54

54 Samuel Prout
(1783–1852)

Porch of Ratisbon [Regensburg] Cathedral

Signed 'S Prout'
64.5 x 46.7 cm; 1040–1873

Ruskin's advocacy of the works of Samuel Prout, concluding with the encomia in *Notes on Prout and Hunt* of 1879–80, has provided us with an interesting account of the effects of Prout's images of foreign cities on a British critic. Ruskin's narrative of mastery begins with the painter's first journey abroad, to France in 1819, the works deriving from which testifying to Prout's fascination for 'fragments of carved stone'. This fascination for parts gives way, according to Ruskin, to an absolute reliability of his painting in its representation 'of certain social facts only to be gathered, and the image of certain pathetic beauties only to be seen, at the particular moment in the history of (what we are pleased to call) civilisation'.[1] This parenthetical qualification of the 'history of...civilisation' represents a sort of covert admission of the effects of Prout's work, the 'we' of 'we are pleased', being the audience of his work. If we consider *Porch of Ratisbon Cathedral* in relation to these notions, we shall see that the imaginary constitution of its audience is enabled by the representation of another, apparently less judicious and less well informed.

Ruskin judged that, 'There is *no* stone carving, *no* vitality of architecture like Prout's.'[2] *Porch of Ratisbon Cathedral* suggests that such a judgement would be sustained by a contrast of architecture and carved figures with the uncarved people standing at the threshold of the entrance. Ruskin claims that he admires the 'decomposing composition' of living objects in Prout's work. He goes on to say that, by this, he means 'the frank and unforced, but marvellously intricate' arrangement of members of the crowd. Such crowds would thus be 'moving and natural'. Ruskin does not want to be thought to be praising the sense of the mortality of the members of the crowd; nor does he want to admit to an anxiety about that crowd seeming to decompose. Nevertheless, both of these prospects are implicit in Prout's work, even if both of them are controlled by that contrast of figures and statues.

For, if the greater vitality can be imagined to inhere in the statues, then the threat of the mortality of members of the crowd is displaced and surpassed; furthermore, the very vitality of the crowd can be understood to be less forceful and implicitly less threatening. What little movement there is to be inferred can be contained as 'natural', on the way to that mortal fate to which the statues testify and which they appear, in Ruskin's narrative of this 'moment in the history of... civilisation', to redeem. This explains Ruskin's separation of 'certain social facts' and 'the image of certain pathetic beauties' which Prout's paintings seemed to him to have brought together.

Ruskin's constructions are all but sustained by this image. The variety of pose of the statues, the different inclinations of their faces, contrasts with the lack of differentiation of the members of the crowd. Those furthest from us are too small for their expressions to be identified; those nearest are, almost without exception turned from us. Thus a paranoia about the crowd would be sustained, even if it would also be assuaged. For the figure standing in the foreground gazing up at the statues' faces can be seen to be captivated by that in which he might imagine himself and in thrall to that which will outlast him.

This last point helps to explain apparent relations to the crowd, such as those that are embedded in Ruskin's account. For the attraction of the crowd to the ritual which may be imagined to be taking place in the cathedral is only overcome – rather than simply left to be imagined as impossible – by another attraction, that of the figure standing in the foreground for the statue. Our interest can thus distance itself, seem to take place within a larger framework, one of 'the history of (what we are pleased to call) civilisation'; pleased precisely because we seem to witness this moment of failed transition, of captivation by idols, from a place which seems not to take place, but which is outside and separate from that difficult drama of the crowd.

1 Ruskin, 'Notes on Prout and Hunt' (1879–80) in *Works*, vol. XIV, (pp. 369–454), p. 391.
2 Ruskin, *Modern Painters*, vol. I, part II, sec. I, ch. VII in *Works*, vol. III, p. 217.

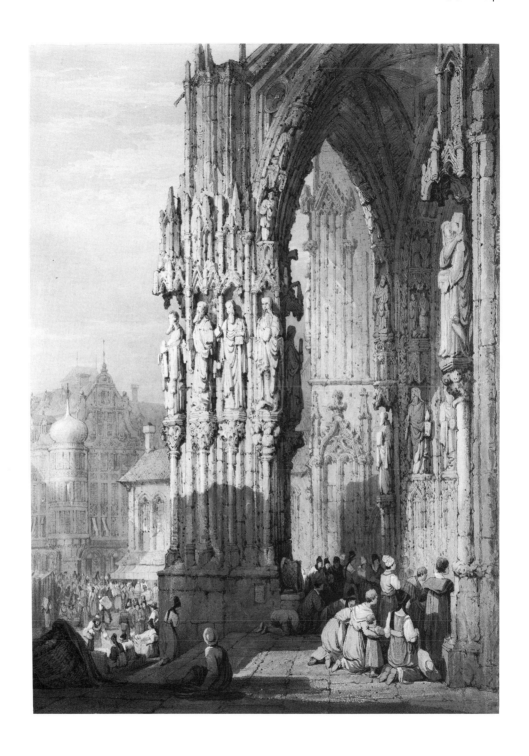

55 Richard Parkes Bonington
(1802–1828)

Corso Sant'Anastasia, Verona,
with the Palace of Prince Maffei

Signed and dated 'R P B 1826'
23.5 x 15.9 cm; 3047–1876

Martin Hardie, following Ruskin, criticised Bonington for his drawing, even while he praised him for his colouring: 'An architectural sky-line in a Bonington drawing is vastly inferior to a sky-line by Prout'.[1] This judgement is symptomatic of a difficulty which Bonington's work has presented to the tradition of watercolour criticism in which Hardie worked. The corollary of this difficulty is usually a recourse to an aesthetic judgement, an affirmation of the effect of Bonington's painting in watercolour which this remark may be taken to exemplify:

> Nobody in the modern school, and probably no one before him, possessed the lightness of execution, which particularly in watercolour makes his work, as it were, diamond-like; charming and seducing the eye, independently of the actual subject matter or imitation.[2]

The apparent excess of effect, then, drawing viewers against their better judgement into a desire for something is latent in that objection to the accuracy of the representation and the generic propriety of a painting by Bonington. The affirmation of this excess, however, misses this attraction into a desire for something, and the possible attendant anxiety, by means of the contention that this effect operates 'independently of the actual subject matter or imitation'. This contention relies on a generalisation of the example, and a teleology of the nonimitative, which is indeed characteristic of notions of 'the modern school'. In order to understand the ambivalence of certain viewers to the effects of Bonington's work, we need to suspend that teleology, return to the question of an example and question the notion of imitation. The *Corso Sant'Anastasia* provides us with an opportunity.

The notion of the 'diamond-like' effect of Bonington's work

has interesting implications: something which holds the eye by a sort of controlled brightness, in which the passage of light may appear – if the diamond is a good one – to be traceable. This suggests a way of construing the effect of the *Corso Sant'Anatasia*: an attraction to a tracing of imaginary passage, but one which is blocked. Hardie's complaint about the inferiority of Bonington's sky-lines to those of Prout's implies, therefore, a frustration at not being able to identify the painter's traces with the limit of the represented scene, not simply in a desire for a dedication of the painter's efforts to representation, but in order to be able to imagine a security of point of view, guaranteed by the expectation of being able to place a prospect such as this in a world of easy passage.

The frustration of this expectation of passage in relation to Bonington's work, along with a further indication of the ways in which this expectation is sustained by other watercolours, can be inferred from this example of more recent criticism of *Corso Sant'Anastasia*:

> It is characteristic that Bonington chose to paint a street, suppressing the feature that blocks the vista so that the eye is forced to dwell on sharply projecting water spouts and the layered effect of uneven balconies. Thomas Shotter Boys [see entry 56 in this selection] would undoubtedly have made more of the terminating archway, emphasized the architectural features and more accurately defined the perspective.[3]

This testimony to the double effect of this watercolour of inviting passage and frustrating it, of apparently blocking the view – a construction which, given that it expects that further definition would enable a paradoxical effect of continuation beyond, is *imaginary* – also indicates the corollary of this frustration: a sense of being forced. The objects left to dwell on may always remain arguable, as may the precise sense of dwelling, but the effect of forcing, brought about by a blockage is germane.

The low point of view along this street, from a position somewhat to the left, encourages an acceleration into the distance, not only by the general view of more or less perspectively disposed buildings, but also by details: the quick diminution in scale between the two figures, presumably men, depicted in long brown garments, both with headwear, standing to the left, the first at the edge of the pavement in the foreground, the latter barring part of our view of the furthest point of the left-hand terrace of buildings, is a case in point. To the right, are three figures, presumably women, all wearing light coloured shawls over

their heads. The expectation of passage, through this shadowed street towards the light and perhaps beyond the archway, is carried quickly, among other means, by the rhythm of the placing of these figures. Blockage of the view, the frustration of imaginary passage, returns us to a scene with which our relations are complicated. Perhaps it alights on the waterspouts, and protests being forced. This, though, is already a *denial* of the forcing of that very identification.

The imaginary return of vision along the street has to reckon with that forcing, if only by virtue of having identified the street as a street. Those figures described above are interesting because they do not seem to meet our gaze, hold it in that imaginary position of being able to recognise the other as the same, as the bearer of a face. The lack of this possibility of orientation perhaps enforces the desire to dwell, to be able to rest there. But we seem on the outside even as we imagine being able to enter, as the depth of the shadows in and on the buildings, their apertures, reinforces.

A certain agitation may be felt. It is not one which cannot be avoided. As Bonington's subsequent use of this composition for an oil painting in the Paul Mellon Collection at the Yale Center for British Art shows, in which the street is occupied by a procession of Catholic clergy, there is perhaps an obvious route of detachment from the scene, as was seen to mark Prout's *Porch of Ratisbon Cathedral*. By showing the people engaged in a ritual and thus in thrall – the possibility of which is perhaps prefigured by the statue which sits on the corner of the building to the right, high above the street, in the watercolour – viewers may still imagine themselves to be part of an enlightened community. Such a position of imaginary community will always have to forget that it needs to imitate being in thrall, let itself be seduced, before being able to imagine that detachment.

1 Hardie, *Watercolour Painting*, vol. II, p. 183. Cp. Marcia Pointon, *The Bonington Circle: English Watercolour and Anglo-French Landscape 1790–1855*, Hendon Press, Brighton, 1985, pp. 85–6.

2 Hardie, *Watercolour Painting*, vol. II, p. 180.

3 Marcia Pointon, *Bonington, Francia and Wyld*, B.T. Batsford and Victoria and Albert Museum, London, 1985, p. 141.

56 Thomas Shotter Boys
(1803–1874)

Quai de la Grève, Paris, in 1837

Signed and dated 'Thomas Boys 1837'
28.8 x 40.2 cm; 456–1882

Boys' *Picturesque Architecture in Paris, Ghent, Antwerp, Rouen* was published in 1839. The images in this book, claimed Boys, demonstrated that the foundations which had been laid by predecessors such as Girtin, in his representations of Paris, had been corrupted and abused by more recent artists. As with his *London As It Is* of 1842, Boys believed that he had exposed what he termed the 'lying' of artists in the topographical tradition such as Frederick Nash and A.C. Pugin.[1] This claim, however, failed to ensure the success of Boys' publishing projects, and his career was henceforth marked by an inability to win critical approval or any very extensive market for his works. This was not due simply to the affront that his accusation may have caused, but rather to what it betrays of his sense of remaining faithful to the tradition he claimed to be able to identify, the misconstruction of which can be understood to determine the claim of truthfulness he implictly made for his own work.

Quai de la Grève presents us with a scene which is marked by the recent, notably the representation of some of the street lights recently installed in Paris. However, what is recent does not inhere in these elements, nor in any particular object in the scene, despite what may have been Boys' intentions. The diffused composition is marked by traces of something apparently more recent than this, namely the gathering of the crowd in the middle-distance around some object of attention which remains obscure to us. The direction into the scene provided by the two men in the foreground, to left and right, comes to seem to be frustrated as we can only identify those rather quotidian elements, no matter how recently set in place, which form the stage. The trolley, barrow and other accoutrements of trade, although identifiable as what may seem to form the everyday, do not organise the view.

This obscurity of what moves the Parisian people is compounded by the unformed nature of that crowd. Thus, an anxiety would not have been allayed, an anxiety about what could seem to give order to the disorder of the streets. The exclusion from the recognition of what draws the people together would have failed to attract and hold the displacement of anxieties about identifiability and recognition on the London streets.

These difficulties with the redetermination of the topographical as the representation of the recent would have in part determined the brightness and intensity of Boys' colouring here, something which he was concerned to achieve in reproduction too. Its force, however, tends to remind us that we are on the outside here, a brightness which does not hold the attention of the figures in the scene and one which relates somewhat ironically to that recent installation of theirs. It operates as an insurance against the kind of complexity of involvement demanded by Bonington's work, which Boys followed in the earlier part of his career, but which he moved away from in the mid 1830s.

His recasting of the topographical tradition, then, concerned this recovery of place as something marked by the recent, something which would, however, always fail to be quite *contemporary*. As the colouring fails to disconfirm this, so does that apparently supplementary addition of the painter's signature and date, the time of the image and its implied production now distended to a year, having to be content to offer his audience something which *will have been* a record of the latest in Paris. In the delay between these two impossibilities, Boys protested the betrayal of the imaginary foundations in image of the topographical to which he, as topographer of the present, could not remain faithful.

1 See James Roundell, 'Invention and Recognition' in *Thomas Shotter Boys 1803–1874*, Octopus Books, London 1974, p. 45.

57 James Holland
(1799–1870)

Hospital of the Pietà, Venice

Signed and dated 'J H [18]44'
38.4 x 25.2 cm; 1767–1900

Holland's first visit to Venice was in 1835 and it seems probable that he did not visit the city again before 1844. It remains possible, however, that *Hospital of the Pietà* was one of the many watercolours which he derived from his earlier notes of that city, rather than, as the inscription with its properly Italian 'Venezia' might suggest, a work completed *in situ*.[1] However, the ambiguities and undecidabilities that attend the inscription of this painting do more than hint at Holland's concern for productivity, much as this was characteristic of his career as a painter. They testify to a necessary condition of representation, rather than just to the apparent legitimation of the object for exchange in the market.

As in the previous work by Boys, the signature may be taken to be a part of the scene which appears to be represented here, caught up as it is as part of that which appears in perspectival construction. Two possibilities of interpretation present themselves: either the painter marked the site with his initials, date and name of place and proceeded to paint it; or he added these afterwards, as signatures and so forth are often expected to be added, as if they were part of that scene. There are two obvious consequences of these possibilities: either the painter, who might be imagined to be representing the scene has actually disturbed and changed it; or he has so marked the representation so that it is not simply a representation – both less than a representation, in so far as he has appeared, in this case, to remove something; and more than one, given that the work bears this trace of the presentation – and associated legitimations – of the work as representation.

Of course, the way to avoid these issues is to imagine that we can divide the inscription between apparent and actual, between the name of the place and the legitimation of the image as a representation, between information and authorisation, so that we would be able to identify it for processes of attribution and the law. But the way in which this image has been marked makes these not unusual separations rather more difficult. One way of indicating this is to seek to understand the time implied by the image and its complex of traces, a time which may be suppressed in the reading of the inscription as merely providing us with a reliable source for a historical narrative.

For, while the division of the inscription into apparent and actual cannot be certain, the division itself is possible. It could, of course, make our interpretation complex, rather than simplify it, if we took the signature as actual and the name of the place as apparent. The effect of this would be to put in question the scenes of belonging which both of those marks act to assure: the belonging of the signature to the signer and the name of the building to the building, the building to its site and so forth. The former, thus, would act as the guarantee of identifiability in circulation; the latter, the response to conditions of apparent impossibility of circulation. In so far as there is an effect of representation, then, there is an effect of something appearing to be able to circulate, not to be detachable, which is that which seems to have been represented. The effect of the presentation of a representation depends on there having been an effect of presentation, a suspension of the passage of time.

These questions all bear on an understanding of Holland's *Hospital of the Pietà, Venice*, not just in its general conditions of possibility, but in the detail of its effects. For Venice, city of the water, is somewhere where circulation seems to be risked: not just, in its capacity of trading port between East and West, of goods, but of the very siting of the city, orientation by means of that differentiation of East and West, in turn, by means of it appearing to hold its position. The women in the window looking down the canal, with a view of the boat which we do not share, can be imagined to be both more and less aware of this: they can see the boat, sign of traffic, but in seeing it as a sign, they will have failed to see the instability of what relays it to them. We are perhaps in a better position to pick up on this, as receivers of the image. The painting above the poor-box, hung at an angle to the wall, besides being part of a structure of persuasion to donate, is at risk of the elements and of appropriation. The poor-box itself remains in a similar position of risk, although guarded by whatever effect of respect that having taken a risk *may* promote. Positioned thus, in such close promixity to the inscription and the relay it implies, the box is caught up in the vicissitudes of circulation too: perhaps money gets given, but perhaps it does not get received.

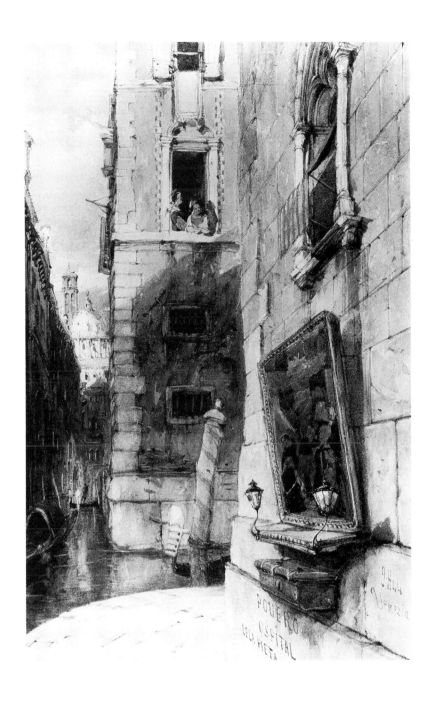

This interpretation of the box seems improbable for a number of reasons, chief among them is the very division between actual and apparent outlined above, and the division it implies in the tradition of watercolour criticism which I have sought to call into question. Holland's later views of Venice, such as this one, would perhaps be described by that tradition as atmospheric, that uncertain excess of the topographical reserved for the apparently unnaturalistic, such as the diffuseness of colour and line in this work. This sense of atmosphere would suit a certain avoidance of the questions outlined above about representations and about Venice; an avoidance of the uncertainty of the city, poised between a certain determination of the difference between East and West. The occluded view of Holland's painting might thus just appear to offer a warrantable luxury of indetermination at the core of a set of beliefs about that geopolitics. The questions of circulation and representation raised above, however, should indicate that representation and circulation operate only at the risk of their impossibility.

1 See Roget, *History*, vol. II, p. 251.

58 Alfred Elmore
(1815–1881)

Two Women on a Balcony

21.9 x 13.3 cm; E.881–1933

Elmore's travels, from the mid 1830s to the mid 1840s, took him from London, where he was a student at the Royal Academy, to many of the larger cities of western Europe. Many of the watercolours he painted which might date from this time were used by him as sources for later works in oils, which often represented scenes of domestic life set in the Medieval and Renaissance past.[1] In whatever way this particular watercolour was derived or used, we can infer from it that the appeal of such works to a mid-nineteenth-century audience in England would have been to enable certain fantasies about domestic life which conditions in London at the time would have made desirable; fantasies, themselves conditions of a lack of division, of an absence of division.[2]

There is a particular indeterminacy to our point of view. While the lines of the balcony ledge and the curtains above it suggest that we view the scene from the left, the position of the women, in particular the profile of the woman on the left, suggests that we should be further to the right. The unease of this positioning is minimised by the apparent synthesising of the elements of the view: similarity of line and wash tend to encourage the eye to travel across the surface, from curtain, to figure and dress and even out to the buildings beyond, linking them in a patterning of the surface. This kind of association of part with part, which gets into difficulty at the edge of that balcony, where those swathes of material lie in a rather different rhythm across it, and nearly breaks down as the buildings diminish in size in the effect of recession beyond the framing curtains, can none the less recover itself by returning to the figures of the women, as it is encouraged to do by the fall of light from high on the right. If we were disinclined to focus, the triangle of curtain hanging from the upper edge of the scene would act to direct our look.

Here, however, in the implied relations between these figures the synthesis of the inside and out, over the threshold of the house, tends to get more difficult. The woman on the right seems attentive to the one on the left, as if, like us, her look was dependent. The position of the one on the left, however, partly as a consequence of the look of the other, and partly because she seems to be able to look down from the balcony to the scene below as well as at the face of the other, seeing things that we cannot see, suggests that she might be in command. Perhaps she is older than the other woman, around whose shoulders her hand rests; perhaps she has reason to suspect the activity that may be taking place in the places we cannot see, activity which might – so we can infer – bring into question her current position.

Such an interpretation of the vocabulary of marks and composition of this image might be objected to on the grounds that it seems to disrupt the harmonies and the projected pleasures of the scene. This objection, however, forgets the disharmony necessary to the apparent synthesis of part with part such as this painting encourages, a disharmony which is rendered remarkable by such images. That Elmore has here employed a vocabulary of dress which implies a setting which was much earlier than contemporary, indicates that this fantasy of an absence of division could more easily be articulated in relation to the past than to the present. Moreover, the realisation of division, the conclusion of the fiction, could be coped with better by imagining that not only had this taken place long ago, but that it was more likely to have happened or, indeed, to happen somewhere else, where they wore such elaborate clothes, than here. If this proved still too haunting, then the suspicions about the figure of the woman to the left might confirm that a domestic order in which women hold such positions of influence might have predisposed that scene of a fantasy of an absence of division to dissolution.

1 Lambourne and Hamilton, *British Watercolours*, p. 122.
2 See Stephen Heath, 'On Suture' in *Questions of Cinema*, Macmillan, Basingstoke and London, 1981, pp. 76–112.

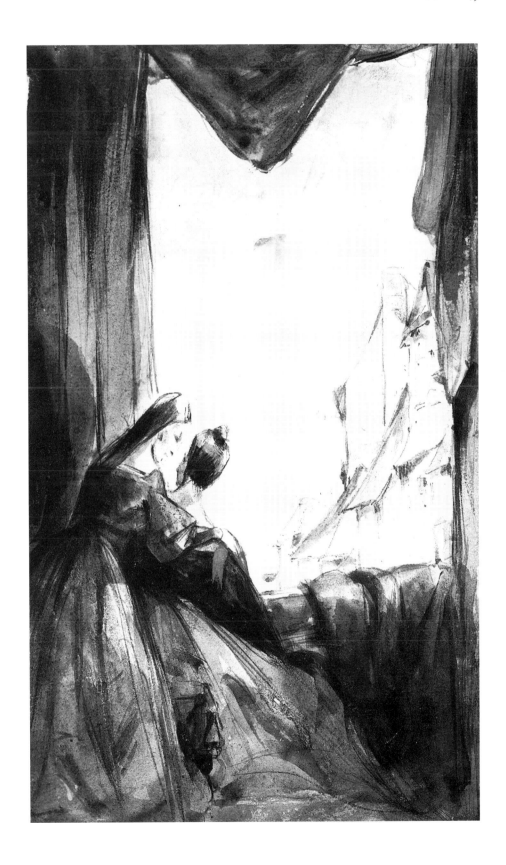

59 David Roberts
(1796–1864)

The Interior of the Capilla de los Reyes in Granada Cathedral, showing the Tombs of Ferdinand and Isabella, Philip and Juana

73.7 x 90.2 cm; 78–1881

The Capilla Real was built in Granada under the orders of King Ferdinand and Queen Isabella to serve as their mausoleum and to commemorate, in the city of their final victory of 1492, their defeat of the Moors, the Moslem dynasty which had ruled large parts of the Iberian peninsula for the previous seven and a half centuries. This watercolour drawing of the chapel and the tombs of the so-called 'Catholic monarchs' was derived by Roberts from sketches made in Spain in early 1833, once he had returned to England. It was his practice to provide large, careful drawings which, as the grid of squares suggests, could be used by engravers to produce designs for reproduction. Engraved images derived from Roberts' 1833 tour of Granada were published in Jennings' *Landscape Annual* in 1835. Later the designs were used as the basis of coloured lithographs, and published in Roberts' *Picturesque Sketches in Spain* of 1837. In between, Roberts used this design to paint an oil, which was exhibited at the Royal Academy in 1836.[1]

Such processes of production and reproduction formed the basis of Roberts' lucrative career. The success of the images of Spain was later exceeded by that of images of Egypt and Syria, which Roberts visited in 1838. The watercolour in this selection is thus an example of an artistry of productivity, one in which proliferation of images has often overwhelmed attention to the significance of these scenes of foreign parts. The apparent dedication of Roberts' efforts to this end, however, was not simply an extrinsic conduct of working processes; the works themselves indicate, among other things, a kind of justification for a certain ethic of work, one which in turn can be understood to play its part in a culture of the justification of British imperial foreign policy.

The above-mentioned sense of the dedication of Roberts' work can be understood to be implied by the following response by one critic to the colour lithographs in *Picturesque Sketches in Spain*: 'There is no country in which all the gorgeous pageantry of the Catholic religion has been, and still is, so profusely and ostentatiously displayed as in Spain, and a large proportion of these sketches are devoted to its illustration by Mr Roberts.'[2] The doubling of adverbs here in the judgement that this pageantry is 'profusely and ostentatiously displayed' is an excess which would need to go unrecognised in order to sustain the judgement of the excessiveness of that pageantry. The notion of unostentatious display is secondary to display as such, which must stand out, attract attention, if at the risk of the judgement of ostentation. This critic's version of Roberts' work suggests how display can come to be seen as excessive: the devotion of Roberts' work to this text of propriety is itself part of the means of the maintenance of that notion of propriety, the inclusion of that which attracts viewing within a forgettable frame. Contained within the covers of a book, such colourful designs, themselves the product of processes which could be celebrated as the justification of a dedication to and a relief from the necessities of productivity, could have their attractiveness put aside, under apparent control.

The etymology of ostentation, from *ostendere* meaning 'to stretch out to view', reminds us that Roberts' works could not themselves do without the powers of attraction of display which they none the less appeared, to some, to put under control. In *The Capilla de los Reyes*, this control is suggested by the very format of the image, offering an imaginary security of viewing position. The light falls from the right into the building, running across our line of vision, as if to illuminate for our vision, and not disturb it. The incompletion of the image might seem to be just a contingency, one which awaits completion elsewhere, at the hands of the engravers. The building appears to have been laid out for an image such as this, its lines of construction running in simple angles to our line of vision. Thus, the building would appear as the result of architecture, as the realisation of some virtual, perhaps rational construction.

This effect of images confirming the notion of architecture as control of building, such as is implicit in the analyses of the works by Turner and Girtin elsewhere in this selection (see chapter 4, entries 34, 35 and 37), is one version of a control of display, such as was mentioned above. It might therefore seem strange to reflect that Roberts, in this work which seems so dedicated to the careful description of the scene in the cathedral at Granada, has rendered the painting which hangs on the wall to the left of the scene in a rather different way. Excessive to the mere function of providing guidelines to the engravers, the

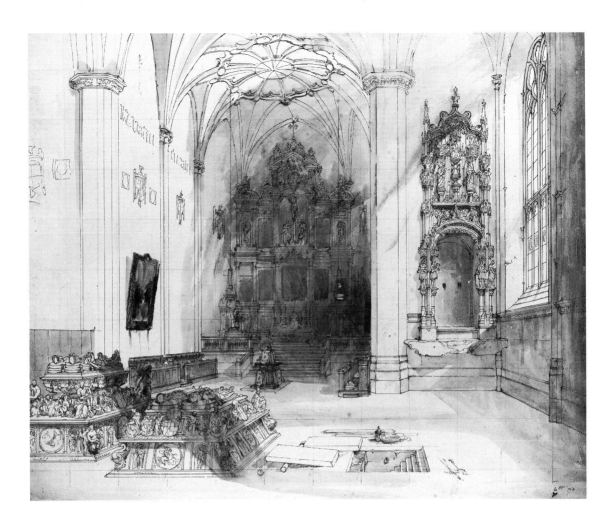

colourful, vaguely delineated forms of the painting functions, within this scene of dedicated drawing, in two ways: on the one hand, it seems to contain the attraction that might be felt for this scene as part of a repertoire of images of the exotic Spain; on the other, it affirms the attraction of the image necessary to the display of that which can then be judged to be ostentatious.

This possibility of affirmation would have been necessary if the attraction to this scene was not simply to risk getting out of control. Without that painting in the image, the aperture in the floor of the cathedral, the outlined and shadowed area to the right of the tombs, would have become rather too obviously the focus of interest, the object of imaginary completion. The four members of the Catholic Royal Family of Spain are buried beneath the cathedral floor. Without that painting, their example would have seemed too unequivocally stressed, the recovery of the possibility of that judgement of the meretriciousness of Catholic Spain less likely. The ambivalence of manifest approval for them as Christian conquerors of Islamic rulers and latent suspicion of their rule, as monarchs who deployed the power of

Rome, a suspicion of the use of ostentation in the maintenance of power, would not have been reproduced.

Roberts was not always securely on course to providing images which sustained these judgements and beliefs. As the following text from a letter written while in Granada suggests, however, the threat of the confusion of work and pleasure, and of the dissolution of the dedication of painting to such ends, was allayed: 'And now I am going to smoke a cigar, and go to bed, to dream of Moors and Christians, tournaments and battles, painting and architecture.'[3] The confusion existed as a dream, one in which the conscious segregation of identities had been put in question. Painting, then, was one of the means whereby the apparent identity of consciousness, in its dedication to processes of reason, such as architecture, could be reaffirmed. At the same time as painting seemed to reaffirm this notion of rationality, it could also play its part in the renegotiation of the values and meanings of Christendom.

1 See J. Ballantine, *The Life of David Roberts R.A.*, Adam and Charles Black, Edinburgh, 1866, p. 249; see also K. Sim, *David Roberts R.A. 1796–1864: A Biography*, Quartet, London, 1984, p. 63.

2 Sim, ibid., p. 113. 3 Ibid., p. 76.

60 John Frederick Lewis
(1805–1876)

The Hhareem

47 x 67.3 cm; P.1–1949

This is not, as was once supposed, the lower left-hand section of the watercolour exhibited at the annual show of the Old Water-Colour Society in 1850. Sold at Christie's in 1909, that earlier work, measuring approximately twice the height and width of this later painting, is known from a photographic reproduction of 1908. This nonappearance of the earlier work may have prompted the speculations concerning this later watercolour, which is undoubtedly similar to that portion of the former, speculations determined by a desire to repair a loss. Such tendencies, however, can be understood to have had a bearing on Lewis' decision to paint the latter as this abbreviation of the composition of that earlier, notorious work.[1]

Painted while he was in Cairo, where he lived from 1840 to 1851, the first *Hhareem* was sent for exhibition in England before Lewis left Egypt.[2] The anxiety about the reception of the painting which may be inferred was almost completely dispelled, as the critics were almost unanimous in praising the achievement of the painter. So great was their admiration for the painter that they managed to avoid paying any attention to the scene which that work represented: the apparent unveiling of a woman by a black slave, presumably a eunuch, for the gazes of the assembled pasha and the other women of his harem.

This avoidance is remarkable. The critic in the *Athenaeum*, previewing the work, praised the painter's thoroughness, concluding the account of his brilliance by advertising how 'completely the painter has triumphed in his treatment over his elements – how he has banished anything like grossness and sensuality'.[3] Perhaps the critic knew that Lewis was sitting it out in Cairo, fearful of what he might be imagined to have imported. The triumph over 'his elements' is, in any case, a moral hyperbole, the implicit values of which – control, absence of sensuousness, general judgement against excess – are established in a way which betrays a political fantasy. The act of banishment would itself exceed, by implication, any such despotic power that the figure of the pasha, this ruler of the harem, could exercise. The imaginary command of vision, of seeing someone else in thrall

to an object of vision, as the pasha was in the earlier version, could not be more clearly demonstrated.

The review in the magazine *The Critic* again concentrates on the technical virtues which the picture implies. Anticipating Ruskin's identification of Lewis as a Pre-Raphaelite in 1851, this notice indicates how the values of progress were staked in that general praise of technique:

> The love of precision in detail is gaining ground in England, and in no instance, perhaps, has the public seen it carried so far as here. The colour is harmonious and of a subdued richness: the hand has dared, and dared with success, whatsoever the eye saw, and the picture is altogether unique. May it not remain so long![4]

Perhaps Lewis' later preoccupation with scenes of harems – he painted at least six others, as well as this one – was a result of being captivated by this account of his work, these terms of his reassimilation to English society. This reassimilation, the acceptance of this representation of male polygamy and of its witness, the disavowal of which as an issue is marked by all these moral judgements, is accomplished by a certain telling metaphor. This notion of 'precision in detail', itself almost a denial of the cutting out, the *cision* of detailing, as a control of an imaginary object avoids a specification of the kind of relation to that object. Object relations thus move on, indifferently, appearing to *gain ground*. Thus, the territorial ambition of assimilation is maintained, unable to admit the possibility of admitting without controlling whatever the eye might see.

One critic, however, dissented from this general approbation. The review in the *Athenaeum* had singled out the background for special praise: 'Perhaps the most remarkable novelty in the conduct of the whole work is the almost miraculous perfection with which this background is designed and completed.'[5] The connotations of the phrase 'the conduct of the whole work' demonstrate again the maintenance of a modern aesthetic project in moral terms. The critic in *The Times*, however, identified that same background in different terms, ones which none the less indicate the further implication of such connotations in a notion of progress:

> The accuracy in depicting the minutest details of costume and still life, the absence of human rotundity, the dubious perspective which belong [sic] to the screens of from the Celestial Empire, seem to have been taken by Mr. Lewis for his model. He has succeeded to wonder, and the Oriental treatment is in a sort of harmony with the Oriental subject; but is this sort of thing likely to conduce to progress in art?[6]

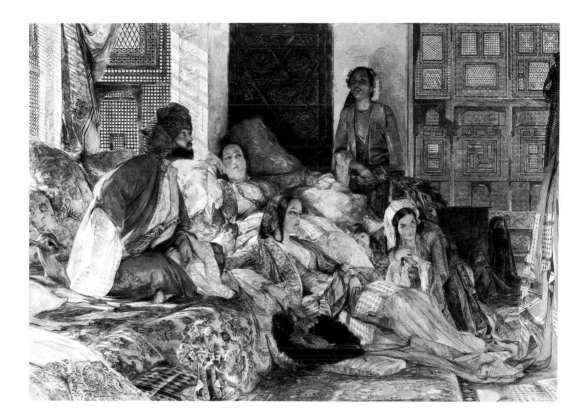

The grammatical lapse of 'belong' brought about by trying to attribute a dubious perspective to the East is testimony to a radical disturbance. It is implied in the use of the phrase 'Celestial Empire', which was more usually used of China than of Northern Africa, a sense that the East is now so close that it would be better if it were banished above. The anxiety that the painter has followed an alien system as his model betrays what the other critics wanted to suppress, that there was a permeability of cultures, a possibility of an assimilation operating in the other direction.

This testimony to the insecurity of the differences between East and West conceived of *as a division* – of uncertainty and certainty in the epistemological security of perspectival systems, for example – betrays a suppression of a loss of a sense of distance. The complaint about 'the absence of human rotundity', coupled with the complaint about the picture's perspective, suggests, along with the question about progress in art, a resistance to the idea of the modern in painting remarked upon above. One of the effects of that minimisation of chiaroscuro that characterises Pre-Raphaelitesque works is to change the sense of an object, the terms of imaginary access to it. Without this, this critic felt a loss of a certainty of distance, a kind of collapse which he has identified with the absence of proper guiding limits to the representation of bodies. Perhaps the figure of the woman on the sofa reclining against the wall would be the best example of this, a figure whose position, apparently securely placed here, with an expression which suggests that she is not without influence,

even if it is being called into question, indicates the operation of a more complex politics than mere despotism, in a space which is not simply all permeable, nor all containable.

The protest about the screens, then, is indicative of this desire to imagine the scene of the harem closed, to close the threshold of the interior opened to view. Perhaps there was a suppression of a recognition that the theme of dependence on vision and the objects that it appears to be able to isolate called into question the notion of security of vision apparently provided by this image. Perhaps there was a sense of the end of an easy version of the politics of the East. In general, however, such difficulties were avoided in the commentary on the earlier painting. Perhaps this later version of a part of that composition, leaving us just that fabric hanging as if from a figure on the right, was a reaction to that apparent absence of complexity in most of the commentary, an attempt to isolate and bring to notice these politics of vision. Perhaps, by the late nineteenth century, after 1882, when Britain invaded Cairo, it was well known to whom such people might be in thrall. Later, in the twentieth century, this became unclear. The desire to know the objects of their desires became, once more, an issue.

1 Arts Council of Great Britain, *Great Victorian Pictures: their paths to fame*, London, 1978, pp. 51–2.
2 M. Lewis, *J.F. Lewis R.A. 1805–1876*, F. Lewis, London, 1978, pp. 20–6.
3 Arts Council, *Great Victorian Pictures*, p. 52.
4 Ibid., p. 52. 5 Ibid. 6 Ibid.

61 John Frederick Lewis
(1805–1876)

Life in the Harem, Cairo

Signed and dated 'J F L 1858'
60.6 x 47.7. cm; 679–1893

Painted during the final year of Lewis' three-year presidency of the Old Water-Colour Society, *Life in the Harem, Cairo* appears, on first reflection, to sustain many of the notions of mid-Victorian society concerning Egypt and its forms of existence which were at issue in relation to the previous work. Similar judgements concerning technique would have been supported, enabling an avoidance of certain questions, a possibility of fantasies of another domestic space. The detail of the delineation of fabric, dress, flowers and lattice work would all sustain notions of luxury, one which might be judged excessive in disavowal of the attraction of that detail which would sustain that very fascination.

The figure of the woman on the divan might get caught up in this disavowal. While the woman to the right makes her way towards the chamber, her dress catching the light as she does so, the seated woman does little more than wait, perhaps not even looking at the flowers she holds, so lowered are her eyes. Such a position seems to defer to our gaze, as if she were turned away from a look, appearing not to focus on an object, not exercising her gaze. Thus she might deflect the criticism that she is enjoying the luxury mentioned above, and even a place in authority which the positions of the black man outside the chamber, who seems as if he were not approaching, but rather standing in waiting, and the other woman imply.

Yet something about the woman seated on the divan does not quite square with a notion that she is acting out the virtues demanded of Victorian women. The lower part of her face, particularly her mouth, appears turned towards us. There is little of the 'grossness and sensuality' feared by the critic of *The Hhareem* (see entry 60). But perhaps there is just that little break in the imagined proprieties which might otherwise mean that this was a kind of exercise in reaffirming Victorian domestic morality.

This break would probably have gone largely unnoticed, so far as it concerned moral judgements of women. That possibility of sexual play in the incipient reaction to a look might have been assimilated by a judgement which wanted to reaffirm the place of women in the home, in that other domestic sphere, their sight and the sight of them directed and controlled. The fantasy, indeed, would be that this could take place for the viewer, the woman's glance being a solicitation of one who imagines themselves in the position of the absent patriarch. After all, the scene outside seems to give a commanding view of the city beyond, one which would fit both conditions of this fantasy.

All this, however, is disturbed by the mirror. Such a fantasy of control is the first thing to unravel. For, if a mirror allows a viewer to assume a position of imaginary control over him or herself, by being able to shift that which is seen to and fro, then the mirror in a painting, already appearing to reflect something for us, fails to be available for this.[1] This limiting of imaginary control in *Life in the Harem, Cairo* by the mirror is carried through by what appears there. For the appearance of the fan in the mirror, tilted though it is towards the divan below, fails to correspond to anything which we can see on that divan. Fantasies of control, of the coherence of the visual field, might try to adjust this effect by standing tall, trying to see a trace of the edge of the woman's skirt beneath the fan in the mirror; or, by stooping low, seeking to see that trace above it, as if the fan lay this side of the woman on the divan, but just too close to us, as it were, for it to have been caught in the image. Neither of these strategies can overcome the detachment of the image from us, its falling out of a logic of representation: either the space within the scene distends, becomes voluminous for the mirror, and unavailable to us; or the scene has to be imagined to envelop us, holding us in a merely imaginary totality, as its limit encroaches upon ours, beyond its frame.

The only way in which something of that interest of control can be maintained is to imagine that there has been some miraculous substitution of the appearance of the fan for the appearance of the woman, as if the space of the image were invaded by the possibility of its transfiguration. The transfiguration offered, however, undoes the spectacle of the image. If the appearance of the woman can be substituted for by the appearance of a fan, then the scene of luxury becomes that from which the woman is removable, subtractable. Thereby she escapes from the logic whereby she would be merely another among many possessions. Alternatively, she may remain, the imagined key object of this scene, always on the way to appearing to be transfigured as the

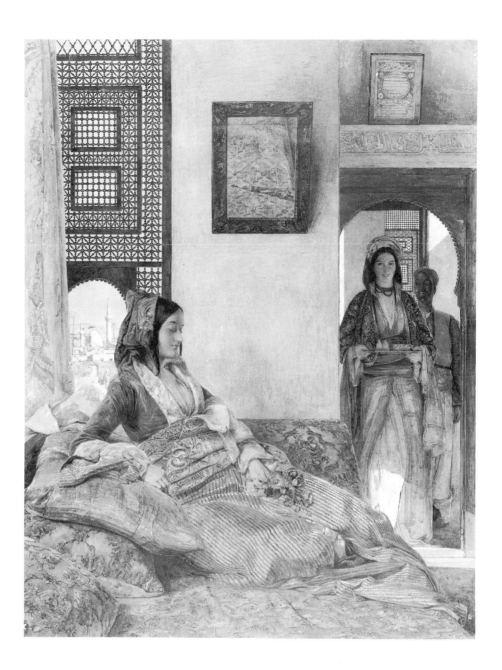

fan, as if her destiny, in another logic of psychoanalysis, were to become phallic.[2]

This sense of time which is necessary to this last construction of the image, and latent in the one before, detaches this image from those general logics of representation on which those interpretations depend. There is a kind of failed relay of appearances within the image, consequent upon interruption and delay, one which introduces a play into the processes of identification, its laws and structure of the pathological. Furthermore, this image corresponds no longer to a notion of the assimilation of that which appears nor to that ideology of progress of artistic forms which was so evident in the criticism of the other work by Lewis in this selection and so much part of that tradition of watercolour criticism which would claim works such as these as exemplary of a national superiority.

1 On the image in the mirror being 'mastered and found empty' see Jacques Lacan, 'The Mirror Stage as Formative in the Function of the I as Revealed in Psychoanalytic Experience' (1949) in *Ecrits*, trans. A. Sheridan, Tavistock Publications, London, 1977 (pp. 1–7), p. 1.
2 See Jacques Lacan, 'The Signification of the Phallus' (1958) in *Ecrits*, pp. 281–91, especially p. 290.

62 Edward Lear
(1812–1888)

Tripolitza

Dated (twice) 'Tripolizza (27) March 15. 1849
(2 P.M.)' and 'Tripolizza March 15. 1849'
31.5 x 52.7 cm; P.2–1930

Lear was one of the most widely travelled artists of his day, spending a number of years travelling, drawing and painting in Italy, Greece, the Ionian Islands, Albania, Egypt, Palestine – as it then was – and India. Like David Roberts (see entry 59), Lear's travels came to seem determined by an economy of production. In a letter of 1861, he gives an account of his frustration with the process of deriving engravings from drawings made on some of those travels, a frustration which seems to have remotivated his desire to escape from his studio:

> No life is more *shocking* to me than sitting motionless like a petrified gorilla as to my body & limbs hour after hour – my hand meanwhile, peck peck pecking at billions of damnable little dots & lines, while my mind is fretting and fuming through every moment of the weary day's work.[1]

But for this remotivation of the desire to travel, this reflection might be reaccommodated in a logic of productivity and exchange. It was the case that Lear, on his return from many of his travels, found that he was obliged to earn money to pay off debts. However, he had become attached to the cycle of travelling, sketching and producing saleable works for reasons which cannot be reduced to this necessity.

Another extract from a letter, this one written in 1848, just before he embarked on the tour of Greece and the Peloponnese on which he drew and painted this watercolour work, suggests something of the complex of reasons for this compulsion to journey:

> I cannot but think that Greece has been most imperfectly illustrated...the vast yet beautifully simple sweeping lines of the hills have hardly been represented I fancy – not the primitive dry foregrounds of Elgin marble peasants &c. What do you think of a huge work (if I can *do* all Greece?)[2]

The general determination of artistic production in England by the example of Greece, represented preeminently since the 1820s, by the example of the Elgin marbles – or so the case for an art which concentrated on representations of bodies was put – has, by 1848, for Lear, given way to a synoptic ambition: to include such figures as may have been imagined to derive from the same land as the marble sculptures in a representation which would show, by tracing the signs of the land, the limits of that imagined site of origin. This aim, phrased after the anticolonial wars of Greek independence, was perhaps already determined by the general desire to make of Greece a country of respectable boundaries, an example of a nation.

Under this cover, the notion of the 'primitive dry foregrounds of the Elgin marble peasants', such as *Tripolitza* may have been imagined to exemplify, would ensure a kind of recovery of the notion of the properly human body, one which belonged, but one which could also, in a certain hierarchy, be detachable from this site as the figure enabling recognition of another belonging, this time to a general notion of humanity. Lear's later anxiety, expressed above as 'sitting motionless like a petrified gorilla', would have been determined by this notion, as would the other notions of the infection of the human by the animal in his so-called nonsense verse, much as it would also have been remotivated by the diffusion of Darwinism.

The possibility of recovering this rather imbedded notion of the body by means of a staging of belonging thus determined the aim, which may now seem not unusual, to '*do* all Greece'. Lear's ambition, however, is interestingly different to the aim of a tourist who might expect, or might have been promised the opportunity, to 'do all *of*' some place or other. Such an ambition, to see all that is remarkable in some locality, region, country or continent, presupposes the 'in' of this place, the establishment of its boundaries. The function of the photograph, to stage the remarkable in its frame, is, in relation to this project, determined by the forgetting of this necessity. Lear's aim 'to *do* all Greece' returns the emphasis to activity (which in the often contradictory aims and necessities of holidays may also be forgotten); activity which would produce 'a huge work'.

This phrasing of an ambition to produce the colossal might be traced back to the project of the representation of bodies mentioned above, a displacement of the rule of an ideal for that of another, this time a nation. In any case, we can infer that Lear's project could only get underway by crossing a boundary, that of the nation from which he travelled, a boundary the forgetting of which would have been part of the cause of him finding himself frustrated at confinement there on his return. For, given the example of this work, it is as if the only boundary which would intervene is the one which has been left behind.

The horizon is low, lowest to the left of centre as if in correspondence with the easiest imaginary route, from the left fore-

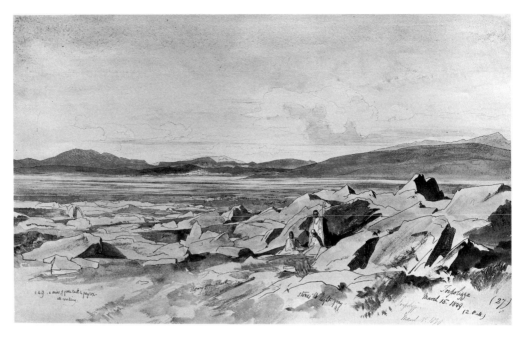

ground, across the plain ahead. The possibility of imaginary passage is, however, interrupted: not just by those figures on this side of the rocks, who rather seem to be camped near the shadows, even if one of them does stand tall as if to look at us; but also by the positions of the inscriptions, which themselves break that representational logic, even if it is only to appear to promise its fulfilment. The look of the standing figure and the inscriptions are related: the challenge to the gaze which imagines passage is deflected into the identification of a moment – '(2 P.M.)' – but also into the plan of development of the work, one which allows for the dropping of the more precise specification of the time in the other dating and placing of the work. This inscription might be read as an instruction: '1. to 9. – a series of green earth & grayrox – all receding'. This occurrence within the frame of his painting by that which might seem to belong to that above-mentioned nonsense verse only disguises other questions of belonging, which this sketch puts into question. 'Grayrox', as a compound of adjective and rewritten noun, promises an attachment of the colour to the object, a prospect of an effect of completion. This would be within the greater prospect of a recovery of a sense of distance, distance as traversible, 'all receding' away from the foreground which would be created, even while it only exists in this image in an interrupted, heterogeneous state. The threat of the other sense of 'all receding', of everything slipping further away, beyond the possibility of imaginary traversal, would thus be allayed.

For it would only be possible for there to be that assurance of borders without the continued threat of the exercise of force to police them if borders could be exceeded, gone beyond. That this returned to haunt Lear can be inferred from another of his practices apparently determined by a logic of productivity, the mass production of watercolours which he called his 'tyrants'.[3]

From the beginning of the 1860s or so, Lear seems to have begun to lay out sheets of paper of similar size on the floor of his studio, presumably all bearing marks as guidelines for the washes and bodycolour which he proceeded to lay on methodically, area by corresponding area. Perhaps, unlike the practice of engraving, this gave him the opportunity to move in and out of the space which these sheets defined. Thus, they would have seemed to tyrannise him less than that sedentary activity.

In this rather strange prefiguration of the painting practice of Jackson Pollock, which also has been written about as exemplifying the freedom of the artist, there is evidence of the limitation of the freedom of others. Lear's mass-produced watercolours testify to a repetition of the political logic of tyranny so much a part of the politics of imperialism, part of a logic of justification of controlling that which was imagined to tyrannise. In this case, Lear's works presented the audience with an impossibility of any simple identification of the original and its copies. Calling into question the valuation of the unique and authentic in this way was to tyrannise the market – by continuing to appear to work in the way it wanted – and to provide testimony to its legislative role by providing it with works none of which could simply be identified as the original of the others. The implication of this, given their nature as prospects, was to offer an image of imaginary endlessness in such a fashion that the confinement and rule within the borders of the realm to which Lear kept on returning could be forgotten. The comparison with Pollock is, thus, not merely formal.

1 Quoted in Vivien Noakes, *Edward Lear 1812–1888*, Royal Academy of Arts/Weidenfeld, London, 1988, p. 23.

2 Ibid., p. 107.

3 See Noakes, 'Introduction', ibid., p. 11 and pp. 126–7 (entry 39).

7

PROSPECTS OF THE PICTURESQUE

63 Cornelius Varley
(1781–1873)

The Market Place, Ross, Herefordshire

Signed and dated 'Cornelius Varley 1803'
29.6 x 45.7 cm; 108–1895

The inscription on this work, 'Drawn on the Spot', invites us to relate it to the site which it appears to represent. An anecdote told after the visit to the town of Ross-on-Wye by Varley, Joshua Cristall and William Havell, who were en route for a tour of Wales (see Varley's *Part of Cader Idris and Tal-y-Llyn*, entry 24 above), encourages us also to relate it to the occasion of that drawing tour:

> While sketching in the market-place Varley excited Havell's envy by using a sheet of ass's skin for a palette. The latter, being burdened with the weight of an earthen palette, was charmed with the lightness of his friend's contrivance. Varley thereupon pulled out another sheet and gave it to him. This so delighted Havell that he stuck his earthen palette up in the market-place and pelted it with stones until he had broken it into pieces, much to the amusement of a crowd of spectators.[1]

As Varley's later career in the invention, construction and selling of instruments of vision suggests (see entry 24), the artist seems to have been concerned to make the painting of such on-the-spot images as easy as possible. Havell's reaction suggests something of how the activity of the travelling painters was to make a site of somewhere: interrupting the travelling and seeking to *establish* a spot by painting there. Havell's destruction of his earthen palette, perhaps in itself a figure for having been too attached to the ground, also made a spot of the place, as a site for taking aim and throwing.

This logic of destruction making a site is not the same as the making of a site in image. Indeed, as will unfold in the section concerned with the picturesque, it is precisely by imagining decay and destruction and finding a way of imagining it suspended, that this particular category of the painting of watercolours operated to produce such a hold over its audiences.

Some of the ways in which this was accomplished can be inferred from Varley's *The Market Place*.

If the occasion of the painting was this journey, the image painted there tends to suspend a notion of passage. This is despite the broad sweep of the well-worn, but cambered and drained road from left foreground to right middle-distance, which seems to offer a route out of town. The contrast with the view of the route to the left, which seems to continue further into town, running as it does back out of the picture, is emphasised by the tilt of the horizon to the right, as if we were being carried in that direction. A limit of this imaginary journey, however, is implied by the contrasts of the shadowed arcade running along that slope ahead of us, with the relative blankness of the sky above and, in particular, the brightness of the light imagined off to the right, around that bend in the road.

The relay of this light to us is complex. Some of it seems to be carried from the facade of the timbered building in front of the arcade to the left. In any case, by the time it seems to have reached us, it seems to have diminished in intensity, rendering visible the scene before us. This relay of the light allows us to infer that that which appears to render visible could, however, also blind, were those things which seemed to have been rendered visible not there to defer and diminish its force. This possibility of destruction, the loss of the very possibility of seeing what we can see, enables what we can see to appear to survive such a possibility.

Such is one of the possibilities of that which painting can appear to give, the very possibility of a maintenance of vision. In the case of this example of the picturesque, that apparent maintenance of vision also gives this scene of the market place of a town, of buildings and the space between them. On occasions other than this, at sunrise or sunset (for it seems impossible to be certain which here), the scene might have been more marked by signs of activity. The man waiting with the horse figures the possibility of departure from the scene as much as activity in it. Thus, this scene appears to await activity, enduring without it, unthreatened by it. The possibility of the decline of these old buildings seems to have become a function of our point of view, that tilting of the horizon. The possibility of their ruin has been diminished by the effect of the giving of the spot from which to view them, the control of the destruction of that possibility of vision.

1 Roget, *History*, vol. I, p. 172.

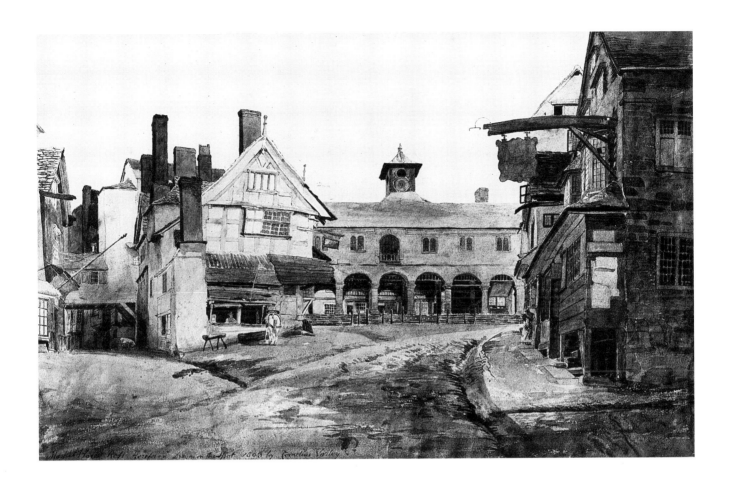

Market Place, Ross. Drawn on the spot 1803 by Cornelius Varley

64 Luke Clennell
(1781–1840)

The Sawpit

Signed and dated 'L Clennell 1810'
39.4 x 58.4 cm; F.A. 586

By the time this work was painted, Clennell had been in London for six years. Having been released from his apprenticeship with Thomas Bewick in Newcastle, Clennell – probably against the advice of his teacher, who disliked the city – moved south and established an engraving workshop, producing in particular small, detailed wood engravings, very much in the mode of Bewick, largely for the illustration of books. Shortly before 1810, the year in which he became a member of the Associated Artists in Water-Colours, a group formed to rival the Society of Painters in Water-Colours, Clennell began to paint watercolours on a scale similar to this work.[1]

One can imagine, therefore, that this new activity signalled the possibility of releasing himself from the constraints of designing for and executing wood engravings into a larger field. Perhaps he did not reckon with the evaluations of that which he produced. The following, rather summary account of his work by Austin Dobson is taken from the *Dictionary of National Biography*: 'Fineness and delicacy are less conspicuous in his work than breadth, spirit and rapidity of handling.'[2] The indelicacy for which Clennell is indicted here is not simply the omission of detail for which his engraving was praised, but for a certain contravention of a sense of propriety, which obtained before and after the end of the nineteenth century when the above account was written. For the effect of *The Sawpit* is not to render this scene of labour for construction in a way which could not be imagined to exceed that labour in its intensity.

For Clennell's image shows us not a heroic, nor a stoical version of labour, but one of negotiated and planned cooperation. Cooperation should not be understood here in its imagined moral sense, of a kind of exchange of the roles of master and servant, which cannot be equalised, but rather as a subjection to something common. This is implied, for example, by the composition, with the two figures *co*operating the saw, the imagin-

able end of which would be the buildings which rise behind them. Thus subjection would be to the task in hand and the tool, and whatever else one might imagine had contracted them to do this.

Such scenes of work, painted at the beginning of the nineteenth century, could not then suppress the traces of relations of subordination implied in them. One way in which this recognition was deflected, however, was to show those labouring in such a way as they could be imagined to accept its necessity.[3] Clennell's image does not easily sustain this consolatory illusion: the figures are either turned from us, turned away from our look, or too far away for their expressions to be identified with any ease. Their relation in their work resists being imagined as mediated by those virtues of acceptance. The remonstrances of the man standing to the right in the middle-distance, even if he is not imagined to be in charge of this mock well-composed scheme, would not be assimilable to the notion of a happily coexistent workforce.

One of the reasons for including this work in this section of the picturesque is as a counter-type to that category, so as to suggest something of its limits. For the picturesque was used as a category into which subjects and styles of different images were subsumed, among them those which seemed, for one reason or the other, to lack delicacy or any other such moral notions, masquerading under the guise of the judgement of art. Clennell's work would have failed to be so subsumed, if only because the topic of architecture as ruin was so much part of the concern of theorisers of the picturesque. For example, this is William Gilpin from his *On Picturesque Beauty* of 1791:

> Should we wish to give [an example of Palladian architecture] picturesque beauty, we must use the mallet, instead of the chisel: we must beat down one half of it, deface the other, and throw the mutilated members around in heaps. In short, from a *smooth* building we must turn it into a *rough* ruin.[4]

The destruction that is imagined here runs close to an uncanny anthropomorphism of the building. This itself is determined by a desire for recognition which is put at risk by the very subjection of others to building, such as is often forgotten in the discourse of architecture.[5] That destruction is in effect a metaphoric transfer of identity, in order that that identity might be overcome. This resubjection of building as architecture necessarily forgets that process of construction and its vicissitudes.

Thus, Clennell's image might have exhibited the appropriate

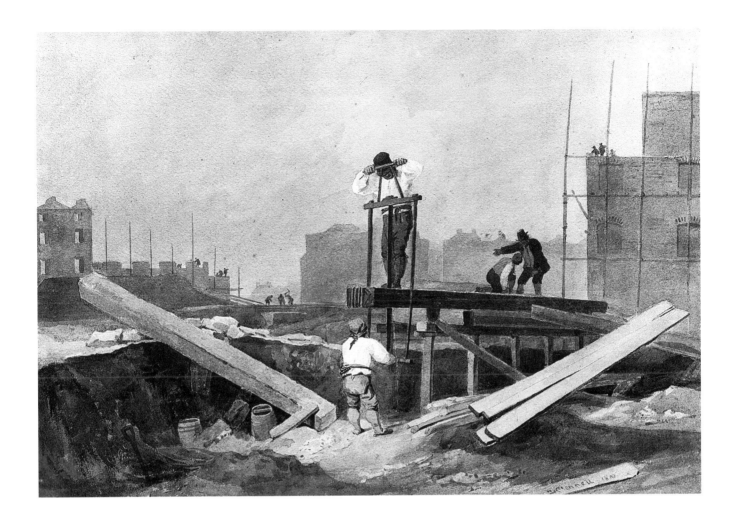

signs of roughness. The processes of construction which it rep-
resents, however, would have left it outside that category of the
identification of images, the picturesque.

1 Lambourne and Hamilton, *British Watercolours*, p. 66.
2 Austin Dobson, 'Luke Clennell' in L. Stephen and S. Lee, eds.,
 Dictionary of National Biography, 22 vols., Smith Elder and Co.,
 London, 1885–1911, vol. IV (pp. 491–3), p. 493.
3 John Barrell, *The Dark Side of the Landscape: The Rural Poor in English
 Painting 1730–1840*, Cambridge University Press, 1980, particularly on
 the shift of identifications from 'happy husbandmen' to 'labouring
 poor', p. 31.
4 Gilpin, 'On Picturesque Beauty' in *Three Essays*, p. 7.
5 Martin Heidegger, 'Building, Dwelling, Thinking' in *Poetry, Language,
 Thought*, trans A. Hofstadter, Harper and Row, New York, 1975, pp.
 143–62.

65 John Crome
(1768–1821)

Old Houses at Norwich

71.1 x 53.4 cm; s. ex. 8–1885

It is easier to imagine Crome's *Old Houses at Norwich* being taken as an exemplification of the category picturesque than Clennell's *The Sawpit* (entry 64). Like Varley's *The Market Place, Ross, Herefordshire* (entry 63), there is a positioning of this apparently ruined structure against the light, making of it an instance of what seems to survive that sight-threatening encounter. However, as with the painting by Varley, we should be careful before we either identify the painter's activity with that possibility of destruction, as Gilpin's criticism encouraged, or forget altogether that relationship of the picturesque to destruction.

Subsequent accounts, from the mid nineteenth century onwards, tend to put aside this latter consideration and, in so doing, they suppress the process of certain sites and places coming to seem picturesque. Indeed, the history of the category, as a possibility of identifying subjects which had been considered unworthy of pictorial representation as none the less providing a distinctive kind of pleasure in representation, was denied. This is the case in the following retrospective identification of the subjects of the work of John Crome by Richard and Samuel Redgrave. The description of Norwich, Crome's home town, projects the effect of the images, of maintaining what seems to be in decline, back on to the subjects of those images:

> The city itself was picturesque, full of antiquarian interest, and seemed as if it had slept while other cities of the kingdom were up and at work. The lanes in the suburbs, the banks of the river, the heaths, the commons, were wild, untrimmed and picturesque; the old labourer's cottage with its thatched roof, the farms with their rural homesteads, were scattered close around the city; villas and terraces had not yet, like drilled intruders, broken in upon their picturesque decay.[1]

The very reiteration of the term 'picturesque' is telling: the city, the land and its houses are linked, with the first of these personified, having woken, appearance somewhat dishevelled, yet to summon itself into action. The city is thus what has survived, not yet moved by the drama of work. This fantasy of a self-maintaining city has to pay the price of witnessing the invasion of 'villas and terraces', 'like drilled intruders', a kind of militia, forcibly bringing the place to order.

It is thus a fantasy of an absence of force in the institution of place which conditions this nostalgia. Indicative of this is the brief remark that, given the city's condition as described above, it was able 'to call into life an instinctive love of art' in the young Crome, as if the city itself was appealing, paradoxically, to have its quiet and peaceful self recorded for posterity. It seems that *Old Houses at Norwich* was painted sometime between 1807 and 1809. During these years, Crome was a leading member of the Norwich Society of Artists, founded in 1803. But he also became involved in exhibiting in London, for example with the Associated Artists in Water-Colours (see entry 64), whose first exhibition was held in 1808. Furthermore, given that Norwich was becoming part of a more complex pattern of transportation and trade, it would be mistaken to omit to trace in this image the indications of the complexities of the coexistence of the old and the new, that which marks this image with the conflicts of transition.[2]

The figure of the boy in the foreground to the right appears to be carrying away an armful of wood. The other boy, standing by the wheelbarrow, seems to have turned to watch him, looking round in our direction as he does. Thus, with the other figures in the picture apparently engaged in their activities, we are involved in a drama of vision: witnesses to the look of the boy by the wheelbarrow, who seems to share in the tasks of clearing away with the woman to the left, and to the departure of the boy with the wood. The suspension of the activity of the boy by the wheelbarrow, and his inferable position as commanded, rather than commander, allows for the inference that he is unable, even while his attention has been caught, to control the departing figure.

This drama on the margins of what is, given the washing line of clothes and the curtaining off of the interior of the house alongside the exposed staircase, still an occupied dwelling, indicates something of those conflicts of transition mentioned above. Are we to imagine that what is being carried away is surplus, beyond the requirements of even this indigent household? The implicit conflict over resources would only be suppressed by an identification of the figure of the departing boy as a thief,

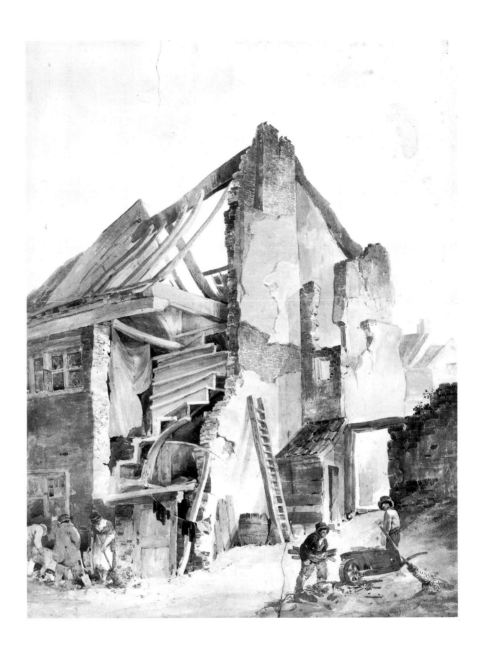

by the implicit identification of our looking with the interests of legislation and regulation.

Either way the image fails to fulfil the double blindness of the judgement of the Redgraves: neither as image of happy coexistence before the disruption of the suburbanisation of the city; nor as harmony after the institution of private property, the invasion of the limits of the place. This example of the picturesque is a reminder of the continued threat of decay and the struggle to maintain that which remains even after that act of forceful institution.

1 Redgrave and Redgrave, *Century of British Painters*, p. 347.

2 N.L. Goldberg, *John Crome the Elder*, New York University Press, 1978, p. 256 (entry 177); see also D. and T. Clifford, *John Crome*, Faber and Faber, London, 1958, pp. 51–60.

66 Peter De Wint
(1784–1849)

Old Houses on the High Bridge, Lincoln

39.7 x 51.7 cm; 179–1898

De Wint is best known for his watercolours of wide expanses of land, prospects, as the poet John Clare put it, in which 'a bit of flat scenery on a few inches of paper appears so many miles'.[1] He has been accused, however, of neglecting the demands of detail and structure, particularly in his rendering of buildings. As Martin Hardie put it:

> He was never very curious or exact about structure, whether in architecture or in trees. The shape and mass interested him far more than the details. In his suggestion of the spirit of historic buildings he fell far short of Girtin or Cotman.[2]

Such an objection sounds paradoxical: structure and detail might be imagined to belong to reason, to disciplined attention, with 'shape and mass' being more essential to whatever 'spirit' historic buildings might be said to have, or to be able to relay. This would be to neglect two things, however: that all buildings are *historic*, if by that is meant that they *have been* built; and that, if historic is to mean more than this, then it depends on other, supplementary criteria, ones which do not have to be identified with large-scale considerations such as shape and mass – as if historic buildings were always on a large scale, always massive, resistant thereby to time.

Nevertheless, that notion of 'spirit' which Hardie promotes is indeed that which endures through time, belonging to something by virtue of its essence, rather than its mere existence. The function of watercolours by Girtin and Cotman in promoting these notions is discussed elsewhere (see entries 34, 35 and 68). Something of the apparent failure of De Wint to satisfy these imaginary notions of the spirit of historic buildings can be inferred from *Old Houses on the High Bridge, Lincoln*.

Undated, it has been estimated that this watercolour was painted between about 1806 and 1812. Such an uncertainty of chronology is rather to the point, however. The line of houses receding from us into the scene from the left appears to face the sun, so undifferentiated are the washes which seem to represent them. Only the shadows under the eaves indicate that the sun is not opposite, but somewhat raised above them. Nevertheless, the predominating effect is one of a flooding by light, as the tonal differences which might separate out one area from another for identification are relatively minimal. The houses on the bridge seem close to dissolving into a pattern of interlocking patches of colour. The pathway on this side of the river becomes indistinguishable with certainty from that river.

The site represented here is known as 'The Glory Hole'. Thus, De Wint's painting plays a part in representing a site apparently remarkable for its dramas of light. But the image does something other than the site itself, allowing for a continued reflection both on a certain resistance of the appearances of things and on the light which enables there to be appearances. This is because of the relations between time and representation implied by the image, ones which do not square with that notion of the 'spirit' of the 'historic' noted above. Hardie's notion of detail and structure, indicative of an endurance of reason in history, is a salvaging of continuity, one which this drama of near dissolution would threaten. As the name 'The Glory Hole' implies, there is an apocalyptic prospect latent in this scene.

Beyond the bridge lies an even more undifferentiated scene, one in which there might be nothing to defer and mitigate the force of the light, the very loss of the possibility of traces out of which a history might be constructed, the time of an overwhelming present. The defence against this possibility is thus an enclosure, one in which things still appear unclear, but which none the less maintains the possibility of construction and orientation. Remembering the other images by De Wint of 'a flat bit of scenery', we may surmise that he was concerned to establish the limits within which the prospect of a future could be imagined. Noting some of his other watercolours of architecture, of more obviously monumental subjects, which Hardie would have seen, it can be inferred that the sense of domination of a scene by such structures would have encouraged a further interest in other imaginary and symbolic limits. In this painting, the apocalyptic significance of 'The Glory Hole' vies with a sense of what remains, despite such dramas of finality, suggesting a sense of the historic not to be captured in the narratives of spirit.

1 D. Scrase, *Drawings and Watercolours by Peter De Wint*, Fitzwilliam Museum/Cambridge University Press, 1979, p. xiv.
2 Hardie, *Watercolour Painting*, vol. II, p. 214.

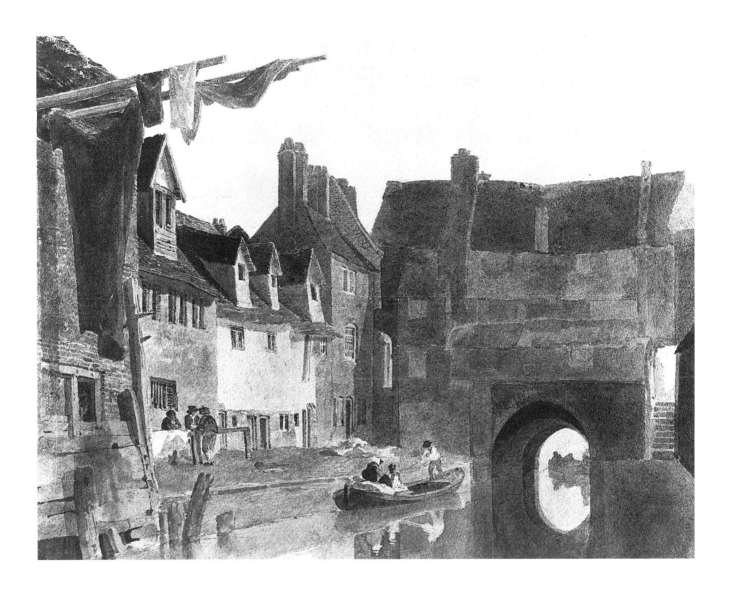

67 David Cox
(1783–1859)

Water Mill, North Wales

38.1 x 53.4 cm; 3028–1876

As with some of the works of Peter De Wint, it has proved difficult to date many of David Cox's watercolours with much sense of certainty. It has been suggested that *Water Mill, North Wales* dates from the first decade of the nineteenth century, painted shortly after Cox's first recorded visit to Wales in 1805.[1] But so generically conservative was Cox, it is possible that it dates from much later.[2] The subsequent challenge to the legitimacy of a *hierarchy* of genres has tended to discourage questions of genre and its exemplification from being posed. Once again, as with De Wint (see entry 66 above), this painting by Cox may allow us to explore what is at stake in a certain conservatism in visual art in relation to questions of genre and progress.

Cox's categorisation and hints at performance within those categories to be found in his *Treatise on Landscape Painting* of 1813 and *Progressive Lessons on Landscape* of 1816 suggest that limits to the progressive depended on a particular vocabulary of feeling, one which tries to relate feeling and genre. From the former of those two works comes what reads not only as an instruction for the production of a work such as *Water Mill, North Wales*, but also as an interpretation of it:

> a Cottage or a Village scene requires a soft and simple admixture of tones, calculated to produce pleasure without astonishment; awakening all the delightful sensations of the bosom, without trenching on the nobler provinces of feeling.[3]

This text seems to account for some of the general features of this watercolour. The range of hues and tones is narrow, contrasts are slight, as if in correspondence with that version of feeling here which would imagine it without violent shifts or extremes. Furthermore, the identification of this with a scene of other-than-noble accommodation would seem just to confirm that sense of belonging of those feelings in sites such as these, as if one could avoid shifts and extremes of feeling by seeking to convince oneself that one was satisfied with a peaceful, well-housed lot.

The 'admixture' that Cox speaks of is not simply formal, then, at least so far as this example is concerned. The limited dissolution of the forms of the trees and their foliage carries with it certain connotations. Tending in some cases towards the rounded, they also tend, to the left and right, towards the smoke-like. This condensation and displacement tends to distract attention from what otherwise would be the discordant form of the blasted tree. Almost sliding from view, this form is an isolated trace of a more violent moment, one which the theory of landscape painting on which Cox drew would have identified as an 'accident of nature', as if the rest of that nature might be considered intentional and thus fitted for its generic categorisation.

The trace of this event here, however, reminds us that such notions of the proper range of feelings to be evoked by such an image – as if feelings indeed occupied some single, calibrated scale – tend to leave something by means of which what is repressed and excluded may be identified. Furthermore, the staging of this scene implies, with that damaged tree the result of some action of which there now appears little sign, that the improper feeling in question might be thought of as archaic, as if outside the time of the passing of the days. The corollary of this, however, is a fear of its recurrence; something which the forgetting of that element which does not square with a cyclical sense of time and with a notion of proper feeling cannot finally repress. Silently, the smoke testifies to the burning of a fire.

1 See Birmingham City Museum and Art Galleries, *David Cox 1783–1859: A Bicentenary Exhibition*, Birmingham, 1983, p. 47.
2 For this implication see John Murdoch, 'Cox: Doctrine, Style and Meaning' in Birmingham City Museum and Art Galleries, *David Cox*, pp. 9–20.
3 David Cox, *A Treatise on Landscape Painting in Watercolours*, p. 11.

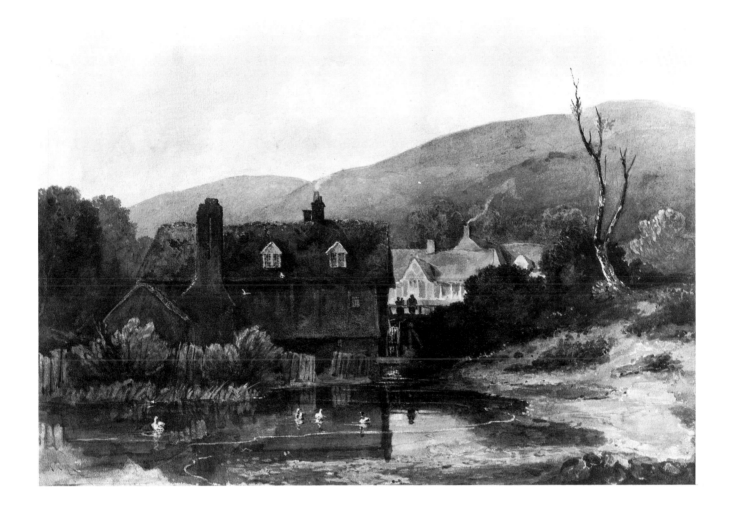

68 John Sell Cotman
(1782–1842)

Interior of Crosby Hall

Signed and dated 'J S Cotman 1831'
40 x 56.8 cm; P.19–1927

In 1824 Cotman sold the drawings he had made on a number of tours of Normandy at auction, thus signalling the failure of a project 'to bring out a *Splendid Book* (if I can find engravers to join with me) on the picturesque scenery of this delightful country'. Some of these drawings were bought by John Britton, who published engravings derived from them in his *Series of Engraved Specimens of the Architectural Antiquities of Normandy* in 1828.[1] This fate is indicative of a certain dissonance of Cotman's work with the category of the picturesque, something which tended to find more easy accommodation in the category of the antiquarian. The connotations of the latter, of a kind of exclusive fascination coupled with an intense and meticulous focus on the object of enquiry, are themselves indicative of the wider margins within which some of Cotman's later work found some recognition.

The differences between these categories have further implications, ones which may be understood to have marked this work by Cotman. Painted in 1831 and exhibited in the same year at the annual exhibition of the Old Water-Colour Society, at which Cotman had begun to show six years before, *Interior of Crosby Hall* betrays both the interests of preservation and precise identification which may be associated with the antiquarian and the fears which determine them; namely, the fears of an inability to identify and preserve. The implied antagonism, then, to the picturesque would be an anxiety about the ruin, and about destruction, which lie, more or less latent, in the practice and theory of that genre. Many of Cotman's watercolours of sites of architectural interest, in particular, perhaps, those of Normandy, with their careful drawing and precisely applied washes, often suggestive of bright and even light, can be understood to fail to satisfy this urge of the picturesque. *Interior of Crosby Hall* can thus be understood to be determined by a resistance to that, but also to an implied excess of it.

Crosby Hall, built in 1466 near Bishopsgate in London, was later divided by the addition of a floor. The interruption of the rank of windows to the right and to the fall of light from them in Cotman's image, however, is rendered less notable by the richly coloured, variegated cloud of light which seems to billow into the room from the left across the fabric which lies across the objects at the end of the hall. This seems to disturb at least the man in black, sitting with his back to us at the table to the right. The other figure seems relatively oblivious, engaged in the demands of commerce, its scales and ledgers.

In 1830 Crosby Hall belonged to a firm of packers, who, presumably, received that which they were to pack there, storing it for later transportation and keeping a check on what had passed through the building.[2] It would be anachronistic to imagine that this firm had behaved like some more recent company moving its premises to some renowned building, acting as custodians of some selected site to deflect attention which their activities elsewhere might attract. More likely, they had moved into a building fallen out of use. Cotman's meticulous and dramatic image reads, however, as if he were conducting an argument with mere reuse, without a sense of the strangeness of the past.

For this little costume drama of the hall and figures, that group reminiscent of the guild roots of trade and commerce, the one distracted by the drama of the light, draws us in two directions: the dress of the figures and their props, along with the meticulous rendering of some of the architecture, suggest that we are witnessing a reconstruction of the medieval past; on the other hand, the strange drama of light and colour suggests something which both engages us in expectation of something about to happen, while also, given the antiquarian-like reconstruction of the scene, seems as if suspended, never quite having happened.

Given this, the image by Cotman exceeds the antiquarian. Despite its attentiveness to the architecture of the site, it suggests something which cannot be caught up in the development of historical projects, including those of architecture. A sense of haunting is apposite: something left behind, an excess of a sense of being here, now and then gone. Thus, while the picturesque would stress the suspension of a process of destruction of the past, and the antiquarian its survival, this image by Cotman, this interrupted interior, testifies to a past which was not, nor is not, included in a present and which, in leaving its traces, disturbs the projects of survival, among them the organisation, use and reuse of space.

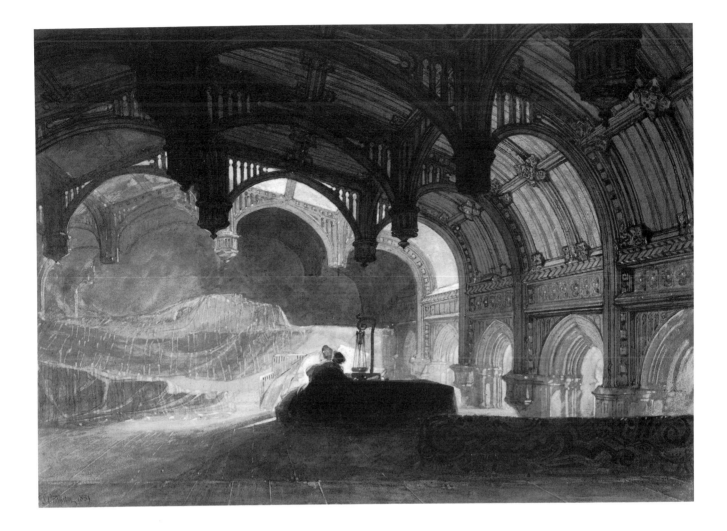

1 Marjorie Althorpe-Guyton, 'Cotman and Normandy' in Arts Council,
 Cotman 1782–1842, pp. 27–9.
2 See M. Hardie, *Watercolour Painting*, vol. II, p. 91.

69 George Cattermole
(1800–1868)

Interior of a Baronial Hall

Signed 'G C'
33.3 x 44.4 cm; 1454–1869

Interiors, unlike prospects, would seem necessarily limited and finite. However, as consideration of the previous work by Cotman suggested, imaginary interiors have their imaginary outsides too. Perhaps more than any other work in this selection, Cattermole's *Interior of a Baronial Hall* allows for fantasies of endlessness. Unidentifiably marked to the left and right outside the limit of the first archway, the scene appears to recede from us, all but straight ahead, the end of the hall appearing far away in the distance, lit in such a way that a first glance might cause us to imagine that our imaginary journey into it had no end. Such a prospect, however, of not reaching a goal, being absorbed ever inwards, suggests its own anxieties. The threat of disappearance which this implies can be compensated for by the supplementary condition of this fantasy: that we are already on the outside, detached from, but being reached for by the figure who approaches us from the shadows under that first controlling arch.

This interlaced structure of vision and of fantasy allows us to understand the ways in which the topic of this image, the view of the feudal past, operated in Victorian culture. George Cattermole, although he painted and exhibited in a variety of genres, landscapes and architectural subjects among them, was renowned for his paintings of figures: what J.L. Roget, in his history of the Old Water-Colour Society, where Cattermole exhibited from 1828 to 1850, called 'the living attributes of the past'.[1] This odd mixture of a notion of resurrection and of property, the figures both surviving, but also being possessed by the past, is testimony to some of the larger forces in Victorian, Christian culture. A more particularised account of Cattermole's work, from the criticism of Thackeray, suggests how this was caught up in more obviously political structures:

Monks, cavaliers, battles, banditti, knightly halls, and awful enchanted forests in which knights and distressed damsels wander, the pomp and circumstance of feudal war, are the subjects in which Mr Cattermole chiefly delights.[2]

This summary implies a familiarity with the majority of Cattermole's paintings in which the figures are more dominant, often greater in size than half the height of the image. Perhaps Thackeray did not know this example. If he had done so, he might not have cast aside so quickly the remark about 'the pomp and circumstance of feudal war'.

In itself the remark draws attention to a fantasy of the theatricality of war, but one which here implies a certain involvement in the drama of dynasties vying for monarchical preeminence. The structure and topic of *Interior of a Baronial Hall* is caught up in this. Following the two routes implied above, we can find ourselves caught up in the confusion of the endlessness of this scene of apparent preparations for a feast, as if we might lose a position of being subject to authority; only to regain it by imagining that we are in command here. Those attendant suits of armour shift: from guarding the way to becoming our charges, at our disposal, prepared for or, more likely, given the signs of a feast, having succeeded in battle. In this way, we are caught up in a monarchical fantasy, with ourselves as possible monarchs-to-be.

This kind of identification marks that most significant of transitions in the appeal of the monarchy in Britain, its presentation as family, as corresponding in that way to the institutions in which its subjects are supposed to find themselves. The condition of such a fantasy is hereby shown: it is one in which the rule of a monarch might be imagined by anyone, a kind of supplement, indeed, to the very subjection latent in that familial order.

In 1850 Cattermole stopped producing watercolours, turning instead to oil painting. He came to regard the exhibition of watercolours in gold frames as pretentious, preferring that they be housed in white mounts.[3] *Interior of a Baronial Hall* was not exhibited during his lifetime. Such a fate is indicative of those fantasies detailed above: better that these should occur in a domestic setting, where they might more easily sustain that identification with a commanding ruler, where the margins might come to seem less fixed.

1 Roget, *History*, vol. II, p. 61.
2 Quoted by Hardie, *Watercolour Painting*, vol. III, p. 89.
3 Roget, *History*, vol. II, p. 68.

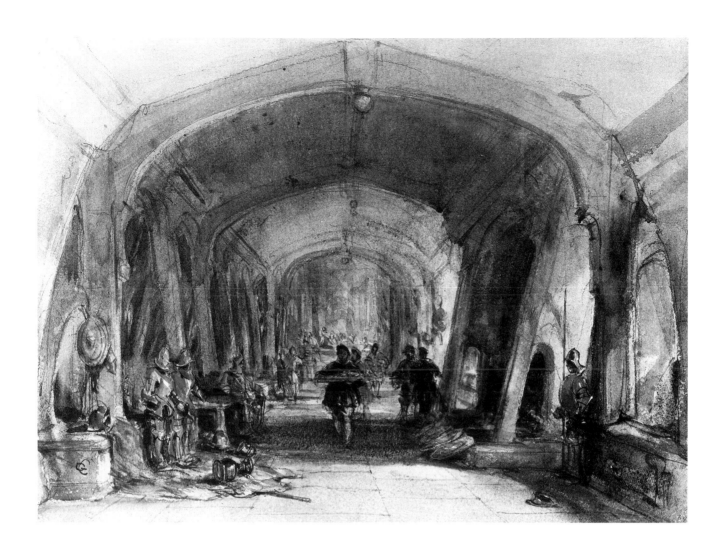

70 George Price Boyce
(1826–1897)

Tithe Barn, Bradford-on-Avon

Signed and dated 'G P Boyce [18]78'
21.6 x 53 cm; 175–1894

Notions of the feudal did not only operate in Victorian culture in the relatively discreet and compensatory manner implied by the consideration of George Cattermole's *Interior of a Baronial Hall* (entry 69). George Price Boyce's works played a part, like other watercolours in this selection, in enabling the redetermination of the vocabularies of architecture, making aspects of the feudal available for the design of certain civil institutions. This may seem to be somewhat detached from the priorities of the picturesque, such as Boyce inherited them from his predecessors. It has sometimes been noted, for example, that Boyce was confirmed in his desire to be a painter when he encountered David Cox in 1851, sketching at Bettws-y-Coed in Wales.[1] However, latent in that picturesque tradition, as I have indicated above, is a preoccupation with desires to destroy and anxieties about recovering and maintaining the ruined. Even in this version of the picturesque, these two tendencies are implicit.

The meticulousness and careful use of colour of Boyce's painting in *Tithe Barn, Bradford-on-Avon* is conditioned by an anxious care for the necessity of effacement of the support, however partial or slight, in painting. Partial, indeed, though this may seem to be in many watercolours, the shift to a greater opacity of colour would have brought it more to notice, risking that tradition as it did so. Boyce's procedure seems to have compensated for this greater proximity to a recognition of effacement by the discipline of the articulation of the tonal values of the local colour. This version of Pre-Raphaelite theory is not – as other versions are not (see, for example, entry 49 above) – perfect. What would have been recognisable as tonal treatment returns in *Tithe Barn*, supplementing the terms of this theory, detailing areas under the gables and around the windows of the barn, to indicate the direction of the fall of light from the sun, apparently sinking in the sky beyond the far hill.

This isolation of those features of this structure is not unprecedented. The windows in particular attracted notice. In his diary entry for 20 June 1872, Boyce wrote:

Called upon Mr. Robson and Mr. J.J. Stevenson about the proposed School Board school next door to me. Mr. Stevenson produced my 'Back of an Old House, Dorchester' drawing, which seemed to be in the office for the sake of making people who would other wise prefer purple slates on drab stocks and cement and thin window bars and plate glass, swallow red tiles and red brick and thick window bars.[2]

Robson and Stevenson, based in Great George Street in Westminster, indeed became the architects commissioned to design and build many schools, as the 1870 Education Act required. The proliferation of red-brick, red-tiled school buildings with windows with thick bars can be traced from here. The persuasion which Boyce reports was thus of those who initally favoured the use of more recent materials, in a vocabulary – at least so far as the windows were concerned – which would have been identifiable as prefiguring later international modernism.[3]

However much Boyce may have not wanted his work to play such a role, his images did suggest ways of deploying remnants of the architectural past in a way which enabled an avoidance of some of the disciplinary connotations of that vocabulary. The use of tonal shadowing on the windows in *Tithe Barn* would have drawn attention to these limits of the inside of the building; suggesting that it was here that a species of pathos was concentrated, as if those thick-barred windows were caught up in obscuring themselves; as if they might be drawn out of this obscurity to play their part in an architecture which might stress a continuity with the past; a recovery of the limits of an authority in England, rather than merely its more recent institution.

Boyce's friendships with Philip Webb and William Morris are indicative of an involvement in that part of the history of architecture of the last century and a half which has recently resurfaced as an area of controversy. With the collapse of international modernism and the return of notions of the vernacular in the reflective and less reflective discourses of post-modernism, it is important to note that the effacement of the institution of the limits of institutions by an appeal to a past in which authority and subjection can be fantasised as nonexistent is nothing new.

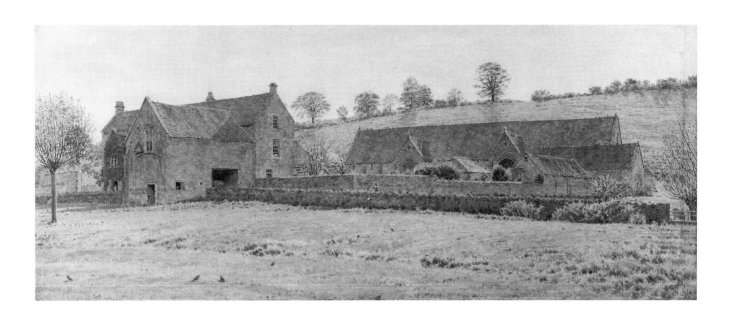

1 See Surtees, ed., *Diaries of G.P. Boyce*, pp. 2–3. Also Hardie, *Watercolour Painting*, vol. III, p. 89.

2 Ibid., pp. 54–5 (20. 6. 1872).

3 For example Nikolaus Pevsner, 'A Style for the Age' in *The Sources of Modern Architecture and Design*, Thames and Hudson, London, 1968, pp. 9–18.

71 Helen Allingham
(1848–1926)

Cottage at Chiddingfold, Surrey

Signed 'H. Allingham'
39.3 x 33 cm; P.20–1917

Helen Paterson – as she was before her marriage to the poet William Allingham – studied with Miles Birket Foster and Fred Walker at the Royal Academy School. An initial comparison with their work might suggest that hers was a less dramatic reuse of the traditions of the representation of the rural. However, the example of *Cottage at Chiddingfold, Surrey* suggests that she tended to treat topics which those other artists, precisely in their concern for drama, incident in the countryside, tended to avoid.

This can be inferred from the following extract from her husband's diary. They had moved out of London to Witley, a village in Surrey. Nearby was the village of Chiddingfold and, a little further away, that of Blackdown, where Tennyson had a house. In the entry for 21 August 1881, William Allingham gives an account of one of their many meetings:

> H. and I to Blackdown – Foxholes. H. draws. Tennyson and I sit with her.
>
> Beauty and picturesqueness – T. says, 'take a trim, snug, unbeautiful house, half ruin it, and you make it picturesque; same as to ragged clothes, etc.' I argue that neglect alone will not make a thing picturesque, there must be beauty *in* it. For a thing to be absolutely 'beautiful' it must have regularity. The beauty in a picturesque neglected object comes from nature regaining her sway over it. T. would not be drawn out of the commonplaces of the subject.[1]

William Allingham's concern to draw Tennyson further may itself have been motivated by an avoidance. That attraction of the ruin discussed above is shifted here towards a moralistic discourse, one which is prepared in the use of 'ruin' as a verb which Allingham attributes to Tennyson, but which is consolidated by Allingham's phrase, 'a picturesque neglected object'. The absence of attention, it is implied, is attended by an attraction to repossess, make it an object. Between the sway of nature

and that identification of neglect lies a proprietorial interest, one which nature, as the personified woman, would exceed.

Helen Allingham's painting does not quite fit either the thesis of destruction or that of neglect, certainly not in its moralistic articulation. The house – cottage seeming rather too modest an identification – appears to be in a state of decline: the roof seems to be sinking, an effect exacerbated by the tendency of the left and right faces of the building to appear as if they are turning inwards, folding in along that central line of collapse. The 'sway' of nature, if such is implied, would thus be a drama of forces, the prospect of the failure of the building to resist a fall.

The drama enacted across the threshold of the house's garden demonstrates a resistance to, and not an acceptance, of that prospect. The moral discourse of neglect might seek to attach itself here, by identifying the figure of the younger woman standing on the path as leaving, perhaps because she has contravened some rule of the household. Her look towards the older woman laying out the washing on the hedge to the left might thus seem to be a resentful one, a rivalry of a younger servant with an older one. She would thus be identified as culpable for leaving a house which we can identify as in need of care. Yet, if we do not presume resentment, we may detach the figure of the departing servant from this position of confirming the hierarchy of the house. If her look is thought of as an appeal, or more plausibly, a recollection of an appeal, then the older servant might be the object of a regret and sadness that she could not assist her in remaining and is herself caught within the boundaries of this economy. Then, the position of the younger servant on the pathway comes to seem not to be paying attention to the woman at the gate, the prospect of her turning away coming to seem, in turn, to threaten the woman at the gate with the baby with being a hand short, lacking assistance.

No doubt these narratives are not exhaustive. But they do suggest that the drama of the will which marks the theory of the picturesque in its relation to destruction does not necessarily get diverted into a moralism. Here, there are signs of a drama which cannot be reduced to that, a drama of a domestic economy and hierarchy suspended, during which time the impossibility of certain recognition of the causes of that drama may suggest a greater complexity of political and economic forces than the picturesque has often been thought to be involved in.

1 H. Allingham and D. Radford, eds., *William Allingham: A Diary*, Penguin Books, Harmondsworth, 1985, p. 312.

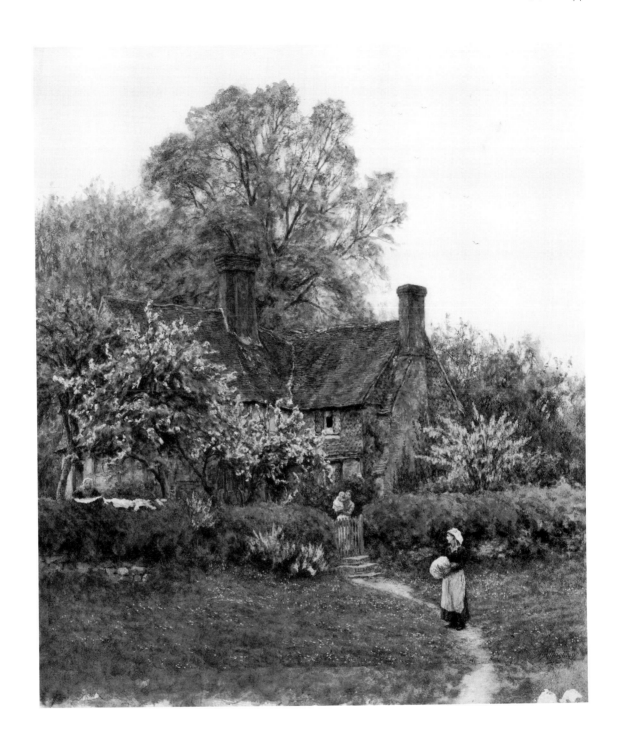

72 Walter Fryer Stocks
(active *circa* 1862– *circa* 1903)

The Last Gleam

Signed and dated 'W. F. Stocks 1866'
40 x 32.1 cm; F.A. 659

Unlike George Price Boyce's *Tithe Barn, Bradford-on-Avon* (entry 70), this version of the feudal does not lend itself so obviously to a sense of a recovery of its remains. However, the staging of this scene at sunset does suggest on the one hand a certain desperation of the lack of the prospect of that recovery and, thus, on the other, a certain crisis in the tradition of the picturesque, one which Boyce's work tends to avoid.

The fall of sunlight across the corner of the ruined building is represented by an intense commingling of touches of colour. This is accompanied by a sense that the light which falls here does not get relayed – for example, into the darkness below – and instead breaks up, even as it animates that section of the building. This capture of the light and the building is rendered remarkable by the flock of birds who are flying around that pinnacle; denser in numbers towards the exposed corner of the building as if this were their resting place from which they had been disturbed. Yet these birds are not simply victims, not merely surrogates for a displacement from occupation. They also haunt that same building, preying on its availability, making of its ruined state a site of occupation.

The title to this painting, *The Last Gleam*, stresses that fall of light, testimony to a pathos of this ruin. Thus, this pathos would attach to the notion of the authority and rule of the feudal. It is germane that the building is not easily identified simply with institutions of either state or church. There is thus a possibility of fantasising a loss of their easy coexistence. The pathos of this possible object of loss corresponds to the imaginary absence of a horizon to the left *beyond* the trees from where the sun shines. Hence the intensification of the effect of pathos, as if this ruined building were unable to guard a domain the limit of which was being breached by the sun. Such a structure to this prospect is confirmed by that circling flock of birds: disturbed, perhaps preparing to migrate, they are also identifiable as what threatens to invade and take over.

This paranoia of occupation that accompanies the threat of a loss of domain is one reading of this picture, one version deriving from the interpretation that the title commences. We could retitle it *The First Gleam*, but this would be to neglect the very drama of endurance in which the building, even in its ruined state, is involved. The possibility that this is neither the last nor the first gleam would enable us to retain a sense that there is decay, a falling towards uninhabitable conditions, which is not identifiable with the will and intention of others, and thus not a cause for paranoia. The implied limit of the picturesque is therefore that the attraction to the possibility of destruction risks sustaining a notion that construction could succeed the clearing away that this had brought about, without having to deal with the remains that are left. Stocks' image, outside the framework of its inherited interpretation, implies that, whatever the project of destruction and reconstruction, the problem of remains will not go away.

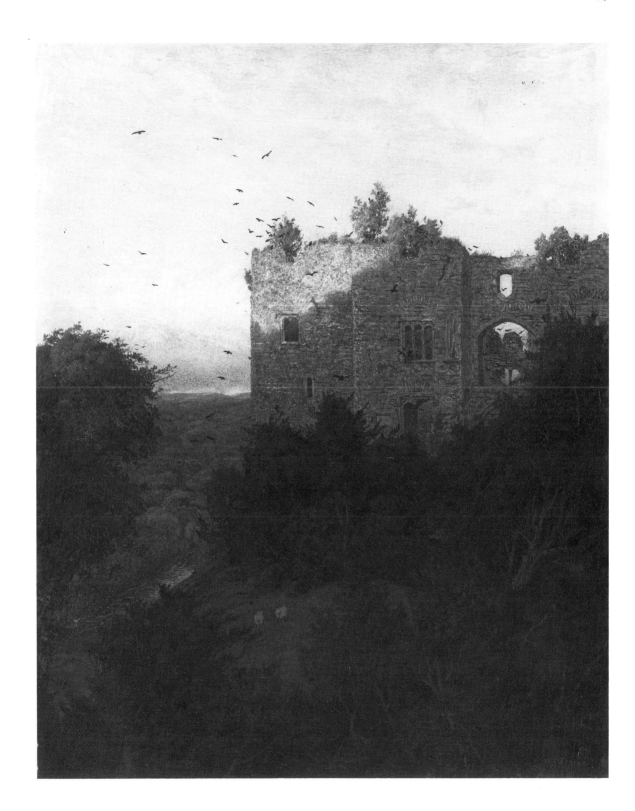

73 John William North
(1842–1924)

1914 in England

Signed and dated 'J. W. N. A. R. A. 1914'
38.2 x 25.4 cm; P.12–1914

North's interest in attracting and holding the attention of the spectator of his watercolours seems to have required even greater elaboration than that implied by Stocks' colouring. North spent a number of years developing a surface for watercolour painting from linen, the aim of which was to make a support which would hold touches of the densest of bodycolouring, such as go to create the pointillist-like appearance of parts of a work such as this, but would also survive repeated scraping and removal of those touches.[1] As can also be inferred from *1914 in England*, however, this linen-based paper does not hold the lighter, less dense washes of colour as easily as paper made of wood or other fabrics.

Despite this practical difficulty of light washing, though, it is still very much part of the vocabulary of North's work. The horizon may be more distant and imaginary access to it may be more difficult than in other works in this selection, but that sense of an indeterminacy of horizon is still part of this prospect of the picturesque. Indeed, it is the very difficulty of creating this sense of indeterminacy which would have seemed to justify it. At a time when Britain's involvement in imperial–political complexities was about to emerge in war, this attention seems to have been part of a desire not to recognise the struggle over boundaries which was latent in those complexities.

Instead, attention was to be maintained on what was near. The dense touches of colour which make up the hanging branches of the tree and the near ground in *1914 in England* thus construct a protective interlacing within which the produce of nature can be collected and enjoyed. The very construction of this interlacement comes to bear connotations of protection, as if the efforts of the painter were to complete the seclusion of the place, enabling its benefits to be enjoyed. The problem of this notion of dedication to the maintenance of the inside – as our point of view implies – is that we are outside this cocoon, witnessing it having been constructed.

This position on the outside is already marked within the frame of the image, as well as being a consequence of our view of the relation between what is represented and what represents – and has represented – it. The dating of the image marks the work with a time which is not the time of the involvement in creating and maintaining this canopied scene; it is a remarking of the possibility of the time preceding the act of dating *and* the time of that act being over, the image now caught up in the succession of years. This apparent opening up of the inside of this image to the passage of time – as much as the title would close it down again and assign it to that year – may still allow us to forget that that outside is not beyond the possibility of place.

The appeal of this work depends in part, therefore, on the imaginary participation in the maintenance of an interior, a dedication to which would thus put at risk the space that its witnessing required. The possibility of retaining a sense of the indeterminacy of the horizon would thus have been a compensation for this incipient sacrifice; the possibility of forgetting the involvement of this interior with its exterior and the loss of the certainty of that limit in war.

1 See H.L. Mallalieu, *The Dictionary of British Watercolour Artists up to 1920*, 2nd edn., 3 vols., vol. I, Antique Collectors Club, Woodbridge, Suffolk, 1986, p. 253.

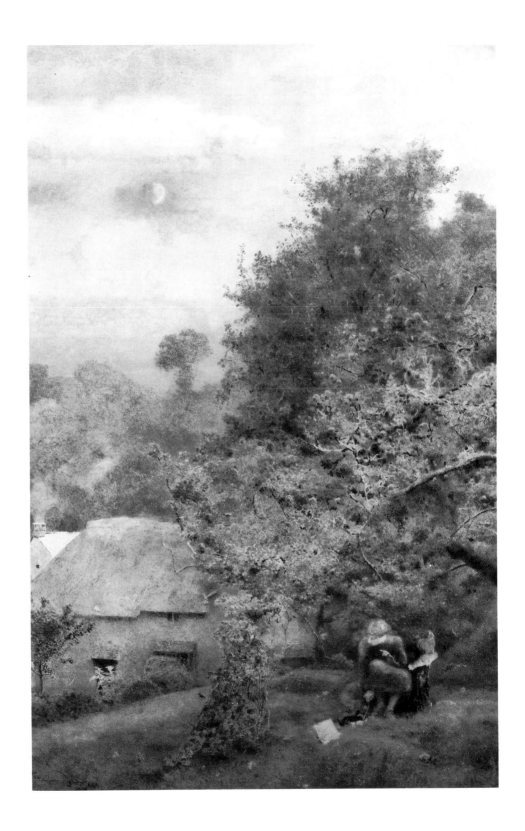

8

PROSPECTS OF THE LAND

74 Samuel Palmer
(1805–1881)

At Score, near Ifracombe

34.3 x 49.8 cm; E.1901–1919

Palmer's writings have often been used to interpret his paintings, particularly those which, like the second of his works in this selection, *Landscape with a Barn, Shoreham, Kent* (entry 75), seem to exceed categorisation as descriptive. With their broad touches, rounded, sometimes almost grotesque forms and complex, often enclosed compositions, the watercolours of the late 1820s and 1830s have often been placed alongside his writings as if they illustrated them. Readings of these paintings have tended towards the symbolic, presented as exemplifications of Palmer's beliefs.[1] Consideration of this rather different work, *At Score, near Ilfracombe*, will indicate the insufficiency of this approach. For here we can find testimony to a certain impossibility of the descriptive project, a certain excess which frustrates the idea of description such as it was, and is, articulated in notions of naturalism.

When his friend and fellow artist, John Linnell, advised Palmer in 1828 that 'by making studies of the Shoreham scenery [he] could get a thousand a year', Palmer, not refusing to admit that he might have to do this, replied, 'I will, God help me, never be a naturalist by profession.'[2] Palmer, as it seemed to him, already needed faith not to profess this creed. In this way, he confirms an opposition between naturalism and revelation, the latter determined as an intervention from beyond the apparent temporal and spatial order of the world. This confirmation by opposition need not be repeated. If we recognise that naturalism is itself a belief, we can see how a certain understanding of the relations between the world, images and representation determines that belief and, indeed, *reproduces* the possibility of a belief in revelation. Thus we can understand why Palmer's career seems to split into these two aspects.

Naturalism holds out the prospect of a totalisation of the world as a single spatio-temporal reality which would include, assimilate and efface those things that would testify to that totality.[3] This prospect applies as much to measuring devices and experimental apparatus, as it does to images. There are two consequences of this which are particularly significant here: first, naturalism remains a belief, one which requires a temporal suspension of the demonstration of what it nevertheless presumes; and second, the inclusion of that which is identified as confirming its belief entails the determination of the limit of that thing, of the differences between its inside and outside. This determination entails the production of an outside from which it can be understood to have been accomplished. Thus, the notion of that single spatio-temporal reality entails that the one for whom the belief is confirmed is determined as being outside the inside, outside that world. Hence the return of revelation, as the expectation of the disconfirmation of being outside the inside, the hope of the demonstration of being inside an inside which has ceased to be an inside.

This argument may be followed, in some of its ramifications, by a consideration of this work and the one following it by Palmer. The apparent incompleteness of *At Score, near Ilfracombe* may be interpreted in different ways. It might, for example, be determined as a sketch, such as this account by his son, A. H. Palmer, from his biography of his father, would encourage us to do:

> He seldom attempted to attain in one sketch more than the pith or kernel of the subject; but upon a separate paper, or on the margin, he made memoranda of appropriate figures, cattle, or clouds which happened to appear, together with notes explaining the deficiencies of the sketch in peculiarly subtle or exquisite passages... These notes he was able to read and make use of many years afterwards, and in a peculiar manner.[4]

The suspension remarked upon above is clear here. The notion of Palmer making 'memoranda' in his sketches which he then made use of later, however, implies a kind of injunction to assimilate, reinclude the margin in a later work. As A.H. Palmer also implies, however, this was something which Palmer was *able* to do. The remark about him doing so 'in a peculiar manner' may be interpreted to imply that this reuse did not always serve that confirmation of naturalism. The notion of memoranda is thus deployed to suggest a certain recognisable organisation, one in which the artist instructs himself in the possibility of accomplishing something later. But, just like the circulation of memoranda in other organisations, they are exposed to the possibility of going astray, of informing other goals than the expected ones.

The failure of a teleology of sketch to work in this criticism of father by son is marked in the difference between 'pith and kernel'. The notion that both of these belong to natural things, things which grow, discourages questioning of the path plotted out here. To imagine that the one thing exists to produce another, a sketch a work, like a tree a fruit, or a father a son, might be said to forget the pith in favour of the kernel. Discarding the inside of the outside, one is left with the inside, or so the rhetoric would suggest. Thus might an image such as this one be thought to confirm notions of naturalism.

Palmer's own supplementary inscription of this image may be read in such a way to confirm the above. It would appear to be among those 'notes explaining the deficiencies of the sketch in peculiarly subtle or exquisite passages'. The text in the bottom left-hand corner reads, 'N. B. * The catching lights on the furze bushes above – very soft'. To read it only in this way, however, would be to discard something of the inside of this image, of the relation between its inside and its possible outsides. The mark which I have rendered here in this text as "*" indicates a kind of translation between image and text, one which does not necessarily mark a deficiency. For the position that this inscription has, as indicated by the above, enables us to read it also as a remark about the image. Rather than merely implying the painter's failure to achieve the softness of the lights catching on the furze bushes, and instructing himself to do better next time, it also reads as a claim about the image: that lights are very soft, indeed that the catching by these lights is so soft that we might not notice. Thus it testifies to the softness of the 'catching' of the eye which this particular effect of description achieves.

Those memoranda-like notes, that 'N. B.' and the '*', accomplish this turning back towards naturalism only if we forget the differences between those marks and the marks to which they draw our attention. The notion of the descriptive in images forgets the catching of the eye, assimilating the function of the mark to the presentation of the thing. Its excess over and above description is forgotten and the different readings of the relations between inside and out put aside to confirm us in a position outside the inside.

1 See, for example, G. Grigson, *Samuel Palmer: The Visionary Years*, Kegan Paul, London, 1947, p. 33 on Palmer 'seeing religiously'.
2 Raymond Lister, *Samuel Palmer and the 'Ancients'*, Fitzwilliam Museum, Cambridge, 1984, p. 14.
3 Cp. E. Husserl, *Werke*, vol. III, p. 63, quoted in Bryson, *Word and Image*, p. 8.
4 A.H. Palmer, *The Life and Letters of Samuel Palmer Painter and Etcher*, (1892), Eric and Joan Stevens, London, 1972, p. 76.

75 Samuel Palmer
(1805–1881)

Landscape with a Barn, Shoreham, Kent

Signed 'Saml. Palmer fect.'
27.8 x 45 cm; P.88–1937

In 1827, after a previous visit, Palmer moved from London – 'the great national dust-hole' as he later called it – to the village of Shoreham in Kent. *Landscape with a Barn* is one of the earliest surviving works done after this move, and one of the first with those traits which have come to be identified as conveying the artist's religious beliefs.[1] The conditions of this retreat – in many senses of the word – are less often remarked upon. Most notably, the way in which the paintings themselves function to enable such an apparent affirmation is often neglected.

It should be noted that Palmer's work in this vein did not outlast the mid-1830s. Subsequently, his work in watercolour was marked by a variety of precedents, of composition and topic; landscape paintings in a manner which followed that general tendency of watercolour work mentioned above, of appearing to mimic the range of effects of oils. Thus, in the post-Ruskinian tradition of watercolour criticism, they have been neglected for appearing to betray the proper destiny of the medium. We can infer from this work why watercolours from his time in Shoreham have come to be exempted, in more recent criticism, from those demands, without a more general shift in criteria.

For there is every reason, given the preoccupations of that tradition of modernist criticism, to consider a work such as *Landscape with a Barn* as an illegitimate redirection of the possibilities of a certain kind of painting. The painter appears not merely to have schematised the forms of the objects, but to have superscribed the work in a way which calls for a symbolic reading. In this case, the twisting of the snake around the trunk of the tree in the left middle-distance would be read as enabling an identification of this scene as Edenic and, probably, prelapsarian. The reasons that this kind of reading has gained ground,

exempting such works by Palmer from that tradition which would stigmatise symbolic readings, can be inferred from the conditions of the retreat mentioned above.

For Palmer's career and these works sustain fantasies of the possibility of retreat as such, not merely individual, but against the general grain of the difficulties of imagining the rural separate from, and unaffected by, what occurs in metropolitan and industrial sites. The interest which Palmer showed in Blake's late work, in particular the woodcuts to Virgil's *Eclogues* of 1820–1, in which a discourse of the harmonious relations between labour and the land were remotivated by small, densely worked images, suggests one source for this possibility. But the persistence of the question of borders between, for example, 'the great national dust-hole' of London and a 'vision of little dells, and nooks, and corners of Paradise' of Kent remains.[2]

In the above consideration of *At Score, near Ilfracombe*, I suggested that one of the effects of a notion of naturalism was to create a position outside the world, an effect created by a certain understanding of images, one which necessarily proposed an inside. This notion of separation, and of metaphysical destiny, is no doubt desirable. But one of its corollaries, in its articulation as a belief, is the identification of something which does exist as belonging to that inside. Palmer's identification of London as a 'dust-hole' is indicative of this: a site of remains, of the inanimate. The restriction of this threat to a metaphysical destiny conditioned the production of paintings like these which appear to enclose and limit, while at the same time seeming unmarked by the inanimate.

It is not just that the image may be associated with a time of harvest. The painting of the sky, with its bright cloud forms apparently moving not in, but across the sky, the upper region of which seems to close in over us, tends to enclose. The pathway seems broken into sections by the fall of light, all but defeating its function as a navigable way. Its sharp turn out of view beyond the broken fence takes us to a limit here. If we imagine it broken from this side, we imagine an escape, the presence of the snake, suspended in its domain, seems something which has been left behind, in confirmation of the postlapsarian narrative. If, however, we imagine the fence broken from the other side, as the difficulty of passage into the view encourages, there is a sense of an invasion, of a disturbance of this domain

from beyond, one which may be prelapsarian and, thus, part of the cause of the loss which the fall brought about.

This imaginary suspension in the prelapsarian, brought about by the invasion of the other, enables a fantasy of a retreat behind boundaries to a position back inside the inside where, but for that invasion, the pleasures of the countryside could be enjoyed. The necessity of activity would be suspended too – the machinery of labour could be put away – while the activity of nature was left to appear unchecked. The dream of this condition, of the closure of a domain, is responsible for the continuing appeal of Palmer's Shoreham works.

1 See Grigson, *Samuel Palmer*, p. 35 for the claim that 'his life and painting circle around religion'.
2 See Hardie, *Watercolour Painting*, vol. II, pp. 159, 162.

76 John Linnell
(1792–1882)

Collecting the Flock

Signed and dated 'J Linnell 1862'
26 x 33.6 cm; 136–1892

By the beginning of the 1860s, John Linnell was one of the most successful landscape painters in England. Forgeries of his work seem to have begun to appear in about 1857. This transgression had perhaps seemed easier than it might have done, however, given some of the main reasons for his success. For there is a certain continuity of appeal from large-scale oils to this small watercolour, one which rested on the possibility of thinking of the landscape as readable in terms of Biblical parable. Earlier successes, like *The Eve of the Deluge* of 1848, were thus part of the reason for the later reuse of less obviously readable compositions to rearticulate the narratives of Christian culture.[1]

This shift was accompanied by an ostensible change of style. In the early 1850s, Ernest Gambart, the Liverpool dealer bought some works by Linnell at auction and then sent them to the artist asking that they be 'retouched in your present style'.[2] Linnell duly modified the finish of the works, loosening their definition of forms and blending what had been distinct colours into one another. This change, moving against the grain of the programme of Pre-Raphaelitism, was none the less part of an apparent reaffirmation of the propriety of those Christian narratives in which some of those Pre-Raphaelite works participated (see Ford Madox Brown's *Elijah Restoring the Widow's Son*, entry 49 above, for an example of this). Indeed, it was the extent to which this was understood to be the effect and cause of Linnell's style that his work was both popular, and, I imagine, easy prey for the imitators.

The connotations of this style in this example are to suggest a drama of the action where, it might be imagined, little was to be found. The agitation of the scene allows for the projection that this dispersal of the flock of sheep, which would be the obvious concern of the young shepherd, comes from beyond the frame. Thus the notion of the activity of the painter is recuperated as an imaginative participation in a disturbance of the scene which comes from somewhere over the horizon. The gathering storm appears to necessitate the collecting of the flock.

The position of the figure of the shepherd, caught in profile, turned neither away from nor towards his sheep is simultaneously expressive of neglect and impotence, as if the former might be caused by the latter. The latter effect is promoted over the former by the general difficulty of identifying the sheep and their whereabouts in this *sfumato* scene. As spectators, we can thus identify with his difficulty, turn his positioning into a topic of imaginary sympathy, as if his difficulty is the same as ours. This assimilation of this figure's situation would be rendered more complete by a narration, one which is necessarily, given that assimilation, a reiteration. Thus the variety of Christian parables about sheep and shepherds might be deployed.

The most powerful of these, given the pathos of the positioning of the figure, would be the identification of Christ with a shepherd. From the position of being merely someone whose charge of sheep has escaped him, thus enabling censure, he has become someone whose mission is to represent the taking charge of the errances of the animal. That traditional identification of what leads people astray would have hardly been resisted by this image, even if it has been complicated by that other trait of animals, appropriate to that sententious wisdom about sheep, of stupidity and a willingness to follow.

The limits of the view are interpretable here as a kind of confirming opposite to that position of the sheep in Holman Hunt's *Our English Coasts, 1852 (Strayed Sheep)*.[3] There, stranded on the down-slope of the cliff, they become the objects of pathos as they risk sliding over the edge of the isle. In Linnell's *Collecting the Flock*, the drama is of a threat from beyond, one which enables the denial of the very presuppositions of the narration of a threat from within, a threat apparently requiring the guiding hand of rule and rules.

1 Katharine Crouan, 'Introduction', *John Linnell: A Centennial Exhibition*, Fitzwilliam Museum/Cambridge University Press, 1982, (pp. ix–xx), pp. xviii, xxiv.
2 Ibid., p. xvii.
3 See Tate Gallery, *Pre-Raphaelites*, pp. 106–8, no. 48.

77 Anthony Vandyke Copley Fielding (1787–1855)

The Moor of Rannoch, Perthshire, Schiehallion in the Distance

Signed and dated 'Copley Fielding 1854'
45.7 x 80 cm; 596–1870

There seems to have been little response to the strictures articulated by Ruskin, Copley Fielding's most famous pupil, in the first volume of *Modern Painters* of 1843: there is little sign of a change in the work of someone exhorted by Ruskin to 'shake off his lethargy, break the shackles of habit' in order to reestablish 'his knowledge of form' and the 'judgement of the colourist'.[1] Ruskin's moral criticism of Fielding's lack of energy seems misplaced: during the forty years of his exhibiting career at the Society of Painters in Water-Colours (later the Old Water-Colour Society) he exhibited a record 1671 paintings.[2]

This late watercolour enables an understanding of what Ruskin judged to be the 'meretricious' appeal of Fielding's work; why he stipulated that the artist should employ some 'clear, strong, front chiaroscuro, allowing himself neither colour nor mist, nor any means of getting over the ground but downright drawing'. This, Ruskin claimed, would enable Fielding to discover 'sources of beauty of which he now takes no cognizance' in his practice of 'veiling mystery'.[3] This project of discovering sources of beauty, of attending to the near, is articulated by Ruskin in a way which denies the appeal of Fielding's work. The fantasy of the artist conducting himself properly in his passage 'over the ground', exercising that virtue of good, honest-to-goodness drawing, denies the attraction, while maintaining the goal of passage.

That attraction is evident in the following extract. Describing the 'brown moorland foregrounds' of his works, Ruskin admits that, like Turner's, they demonstrate one of the central lessons of 'modern landscape art' that 'the foreground might be sunk for the distance':

Wet broad sweeps of the brush, sparkling, careless, and as accidental as nature herself, always truthful as far as they went, implying knowledge, though not expressing it, suggested everything, while they represented nothing. But far off into the mountain distance came the sharp edge and the delicate form; the whole intention and execution of the picture being guided and exerted where the great impression of space and size was to be given. The spectator was compelled to go forward into the waste of the hills; there, where the sun broke wide upon the moor, he must walk and wander; he could not stumble and hesitate over the near rocks, nor stop to botanize on the first inches of his path.[4]

The signs of ambivalence emerge here. Ruskin's notion of the painter exemplifying a desire to escape the bonds of civil society and a 'delight in getting to the open fields and moors', as noted above, has as its corollary this sense of being compelled by that same example to imagine doing likewise, as if there were not other conditions which determined this. The spectator is thus in a condition of internal exile, as if banished by the artist from their sphere, unable even to dwell on what appears to lie near them, unable to gather it back into one or other domain of knowledge. The spectator is carried from wash to wash to the limit of its apparently furthest edge, where the gathering of the hue at the limit of the spread of that wash, doubles to represent the limit of that imaginary scene.

Ruskin comes to object to Fielding's practice not simply because of the repeated use of the techniques of watercolouring and the making familiar of their effects. Embedded in this, as the above extract makes clear, is a particular crisis of the relations between those techniques and the site represented. Fielding's landscapes included many places in Wales and Scotland which, like this example, appeared to Ruskin to show those outer reaches of the territory of the nation as wastes, but which indicate rather the movement to bring these far-flung portions of the kingdom within the imaginary reach of the spectator. The exclusion of Fielding from Ruskin's canon of watercolourists was, thus, a denial of the function of watercolour painting, as he himself had articulated it, to enable that imaginary reach. To redeem that sense of internal exile, Ruskin drew these sites back into the notional landscape of Christian culture, proposed the self-denial of that imaginary reaching in an attention to the detail of what lay nearest at hand. Apparently abandoned, the project came to seem to be the resistance of temptation, an ambivalence of botanising on the way.

What Ruskin objected to in Fielding's work was thus a certain spread of that desire to escape, a suspicion of its provocation. What he forgot, however, was that a sense of belonging was confirmed by these works, a sense of belonging of these territories to that imaginary object, the nation, and of the passage of the spectator through them. The denial of their appeal was thus a desire to forget the consequences of that maintenance of that sense of belonging, of its extension over the horizon, beyond the limits of the realm.

1 Ruskin, *Modern Painters*, vol. I, part II, sec.III, ch. IV, *Works*, vol. III, pp. 399–400.
2 Lambourne and Hamilton, *British Watercolours*, p. 130.
3 Ruskin, *Modern Painters*, vol. I, part II, sec. IV, ch. III, *Works*, vol. III, p. 471.
4 Ruskin, *Modern Painters*, vol. I, part II, sec. II, ch. IV, *Works*, vol.III, pp. 323–4.

78 John Ruskin
(1819–1900)

Pines under the Petit Charmoz

Ink and watercolour; inscribed 'To Bessie, – Who knew
the meaning of them – J. R. With much love, 24th
February 1888. Chamoni. Study of rounded turf and pine
grouping 1846 [crossed through] no – must be later – I
forget. J. Ruskin Brantwood 1879.'
48 x 33.3 cm; E. 405–1986

Ruskin's double inscription of this drawing implies a reinterpre-
tation of his own work which is symptomatic of some of the
shifts and suppressions in his thinking which have been outlined
above. The first dating of 1879, describing the work as a 'Study
of rounded turf and pine grouping', unlike the later inscription,
indicates a concern for the date of the work's production.
Ruskin's uncertainty at the time of this earlier dating may be
attributed to something of the following. Ruskin visited the Alps
in 1846. He returned some ten years later. Between these two
visits, he wrote and published the third and fourth volumes of
Modern Painters, the latter, entitled *Of Mountain Beauty*, an
extended account of the history of the representation of moun-
tains, the general argument of which is divided between a fulfil-
ment of possibility in the works of Turner and an affirmation of
the endlessness of the demand to represent such subjects.

Suggesting a dating of this work to 1856 or later, therefore,
might encourage an interpretation of it as exemplifying that
demand. The initial impulse of the 1879 dating, however, sug-
gests that the work was done when Ruskin's preoccupations
were somewhat different. Recent biographical work would sug-
gest, for example, that Ruskin's interests in geology might have
been determining. That 1879 description – 'Study of rounded
turf and pine grouping' – would square, in part, with this. The
sense that there were signs of the composition of the earth, such
that the artist might produce studies of them, fits with Ruskin's
objections to the views of Charles Lyell who, in his *Principles of
Geology* of 1833, argued that the fate of the masses which com-
posed the earth was to suffer inevitable decay.[1] The composition
of this work would thus be interpretable as the participation of

the geological in sustaining the biological, the generalised
'grouping' of which would defend against that proposition of
inevitable decay, such as Ruskin can be understood to have
feared.

Ruskin's subsequent inscription of 1888 suggests that he had
resigned himself not to seek further to clarify the questions of
geology and society which had preoccupied him. The 1888 dedi-
cation of the work, 'To Bessie – who knew the meaning of
them…', suggests that Ruskin is confirming a society of meaning,
even while he makes that society one which we cannot share.
This rhetoric, however, maintains the possibility of meaning that
his version of the sublime of mountain scenery promoted. It is
within that framework that Ruskin's sense of the appropriate-
ness of the world in representation as the confirmation of
notions of creation and recreation can be maintained.

The following account from volume III, part IV, chapter XVII
of *Modern Painters* is significant as it is indicative of some of the
limitations of Ruskin's conception of the relations between
painting and politics. Here we can follow something of the split
in his criticism between social and political questions and the
formalities of painting, watercolour included. In general, what is
at stake here is the apparently sublime effect of the mountains,
one which, according to Ruskin, renders the perception of the
limit of the view, the summit, exclusive of significance. This
determination of the limits of the significance of the visible,
apparently phenomenological, betrays particular interests of
'association', a term overdetermined here, the manifest sense of
a link of and for meaning being haunted by particular notions of
the social. These include a certain nonrecognition of the com-
plexity of the international, in favour of a generalisable ideal of
the moral:

> so long as our idea of the multitudes who inhabit the ravines
> at the foot remains indistinct, that idea comes to the aid of all
> the other associations which increase our delight. But let it
> once arrest us, and entice us to follow out some clear course
> of thought respecting the causes of the prosperity or misfor-
> tunes of the Alpine villagers, and the snowy peak ceases to be
> visible, or holds its place only as a white spot upon the retina,
> while we pursue our meditations upon the religion or the
> political economy of the mountaineers.[2]

The mountain holds 'its place…as a white spot' only if we
remember, and do not let the Alpine villagers forget, that they
live at the mountain's foot. Their society, apparently already

formed, despite our presence, seems as if it ought to remain governed by this natural phenomenon. The 'delight' at them living under the mountain remains a delight so long as they remain 'multitudes', 'indistinct', not separated from one another. The fear of the disorder which this separation might entail, like the disorder of British society, is determined by the sense that there might not be justifiable rule by anything. The blurred afterimage of the mountain enables us to consider their vicissitudes from a position which knows that order will need to be reestablished.

Ruskin composes this watercolour of the slopes of the mountain, the peak remaining only imaginable, in order *not* to show the limit of that imaginary object of rule. Reiterated in image, the sense of its dominance would be exposed as reiterated, thus risking its role in maintaining a point of common subjection of the Alpine villagers, a society suffering its difficulties and hardships, but suffering them together, undifferentiated among themselves. Rather, what needs showing is that which can be imagined to have been composed, in this image of a 'grouping', even before the work of the artist, an image of a region which mediates between the summit and the foot. Perhaps those in the know, like Bessie, might recognise these versions of the hierarchy of society guaranteed by the hierarchy and harmony of nature to be a fiction.

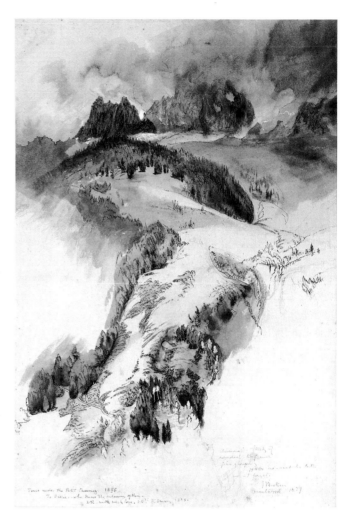

1 See Tim Hilton, *Ruskin: The Early Years*, Oxford University Press, 1985, p. 31 onwards.
2 J. Ruskin, *Modern Painters*, vol. III, part IV, ch. VII, *Works*, vol. V, p. 357.

79 Robert Tucker Pain
(active *circa* 1863–1877)

A Misty Morning at Tal-y-Llyn, North Wales

Signed and dated 'R. T. Pain July 1865'
35 x 51 cm; 1801–1888

Pain lived and worked for most of the year in Surrey and London, sending landscapes such as this one, derived from his visits to Wales, Cornwall, Scotland and Switzerland, for exhibition at the Royal Academy. Thus he continued the established practice of watercolourists painting the further flung regions of the nation, accompanied by the occasional scene from the more dramatic, more difficult terrain of the Alps. The reasons for this economy of works can be inferred from *A Misty Morning at Tal-y-Llyn*.

Unlike Cornelius Varley's painting *Part of Cader Idris and Tal-y-Llyn* (entry 24), we are not on our own with the view, left to imagine extending the reach of our vision by an effort of ascent. There are too many signs of belatedness here.[1] The traveller is there before us, as is that path which runs across the fall and rise of the lower reaches of the hill before us. And before him, and facing us, as if to compensate for his being turned away, lies that house. This site of habitation might seem somewhat eerie: with its two darkened windows, it seems impossible to tell whether it is occupied or not. Indeed, from there a look might be trained in our direction. The traveller enables such an anxiety to be controlled. Perhaps it is his house, in which case the scene would reproduce a dream of being at home even at the foot of the hills in the further flung regions. If not, this limit to our vision of the darkened windows of the house is compensated for by the traveller there before us, who may be imagined to have a view down the length of the valley, as if he were heading off beyond the domain of this dwelling.

Having arrived second, however, we are better placed to reflect on the limits of vision. After all, the ascent of the hills and perhaps the passage down the valley threaten to be engulfed in mist. It seems better that we follow where others have already gone and established dwellings. After all, that which lies beneath the summit and in the valley is various, detailed and clear. Our vision can glance from detail to detail, could be housed here, letting others go off path-breaking.

Pain's occasional works representing Swiss landscapes would thus fit in with this general project of rediscovering the sites already identified with the limits of the difficulty of passage. Such a careful elaboration of detail in these images representing those sites of limit allows the eye to roam while maintaining the possibility of passage beyond. This re-representation of regions already reached, but rediscovered for occupation, was not dissonant with a sense of maintaining the extension of the possibility of such occupation at home and abroad.

1 Cp. Joseph Leo Koerner, 'Borrowed Sight: The Halted Traveller in Caspar David Friedrich and William Wordsworth', *Word and Image*, vol. 1, no. 2, April–June 1985, pp. 149–63.

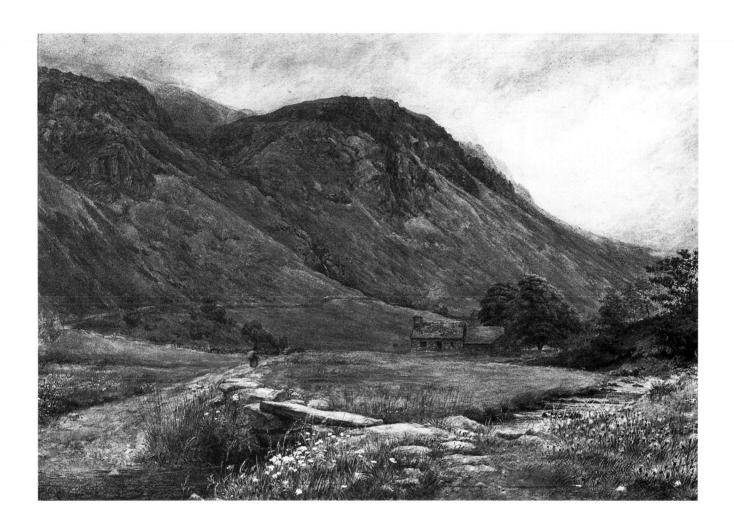

80 John Kennedy
(active *circa* 1855–1865)

Rumbling Bridge, near Dunkeld

34.6 x 24.4 cm; A.L. 2091

John Kennedy, head of the Dundee School of Art, was also author of two books, *The First Grade Freehand Drawing Book* and *The First Grade Practical Geometry*, both of which were published in 1863. Both of the concerns exemplified by those books can be understood to be at work in this watercolour, tested against something which was understood to challenge, in different ways, the claims of freehand drawing and practical geometry. This work may be understood as a demonstration of those skills, but one which is not simply practical, nor free. Rather, as the different claims of the priorities of practical geometry and freehand drawing suggest, the work may be shown to displace the tensions between them by the treatment of this particular topic.

The bridge is seen a little from the right, the depth of the arch seeming to appear under its rim to the left, and from above its foundations, though not so high as we see over its parapet. Reaching lower on the right than the left, with the edge of that parapet running down from left to right, the arch of the bridge is so composed on the paper that a tangent at its apex would run closer in parallel to the upper edge of the paper than that walkway. Thus attention is drawn to the geometry of the arch, as what enables the bridge to span the ravine. The function of the bridge may be imperfect, not only as it appears suspended on this uncertain ground of rocks of differing size, shape and formation, but also as it would appear to carry us with greater momentum from left to right than from right to left. Imperfect though the effects of foundation and building may be, unable to iron out the difficulties of its ground, prone to precipitating greater and lesser progress in the world it serves, the geometry, even in this rural example of construction, enables passage to be achieved.

Seen from that position a little raised and to the right, that passage that the bridge enables seems, because it is out of view, to be all the more desirable. The foreground of the image falls away, from the small plateaux of rocks, over their edges into the narrowing gaps between. The ground only emerges from shadow under the arch, developing into the multiplicity of touches beyond, a sort of weave of light, river, flora and rock. Spanning that shift from darknesss into light is the bridge, our view of which, bringing its lines of construction to notice, seems thus superior not only to a view from the uncertain ground beneath but also to one from above, a view which would remain oblivious to what seems to hold the construction in place.

The values of practical geometry are thus confirmed by an effect of the ideality of that discipline, derived from the example of this representation of the bridge which so confirms the role of geometry in its construction.[1] Such a notion is supported by the connotations of the rocks which, as was mentioned above in connection with Ruskin's *Pines under the Petit Charmoz* (entry 78), were the topic of a discovery of a question and dispute about the age of the earth. If such a science of the ideal, as geometry at least since Plato has often been construed to be, can be seen to achieve and maintain a world, even on the uncertain foundations of the earth, then the values of certain kinds of activity would be reaffirmed.

This reaffirmation includes freehand drawing. Defined as drawing without instruments, we can imagine effects which are far removed from those of this image, in which the artist has appeared to trace the details of different rocks as well as the bridge so carefully. Given, however, its supplementary definition as drawing which seeks to come as near as possible to the effects of drawing *with* instruments, we can see how this composition of a bridge spanning these rocks of uncertain age and uncertain stability works to affirm that kind of dedicated activity. Kennedy's image implies a dedication of activity to achieve as nearly as possible what may still, despite the variety of crises concerning geology and time in Victorian culture, come to appear to be given as the result of intentional acts guided by the forms of reason.

This reading of *Rumbling Bridge, near Dunkeld* suggests further how covert the values and meanings of passage could become. The reaffirmation of the values of construction and of passage, apparently justified by the operation of those forms of reason, may well have been forgotten in the pedagogical effects of this work.

1 Cp. J. Derrida, *Edmund Husserl's **Origin of Geometry**: An Introduction*, trans. J.P. Leavey, Harvester Books, Brighton, 1978, especially pp. 141–53

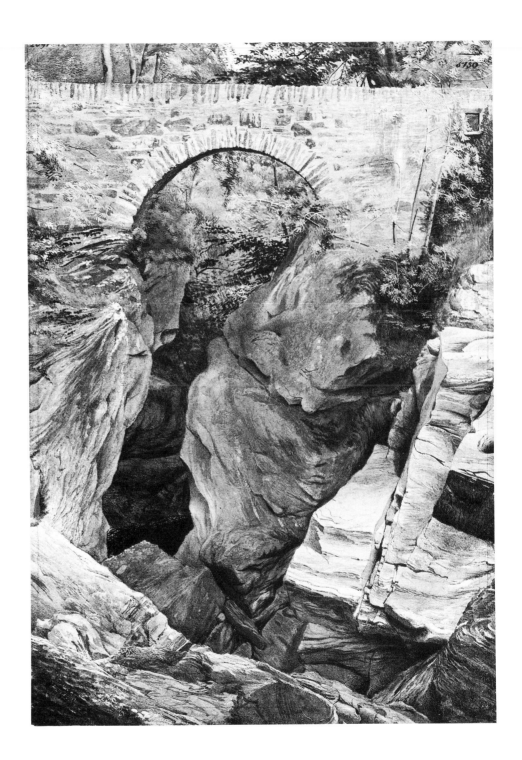

9

DOUBLING THRESHOLDS:
STILL-LIFE AND FLOWER PAINTING

81 Mary Moser
(1744–1819)

Vase of Flowers

Tempera
61 x 44.5 cm; 377–1872

Moser's career as a painter of flowers suggests some of the limitations under which women practised as artists in the eighteenth century. Even as a founder member of the Royal Academy, while she was in a position to benefit from the opportunity to show her work, she was also caught in a system which tended to confirm a certain understanding of still-life work and, therefore, of the capabilities and concerns of women. The position of still-life as the lowest of the genres of painting maintained it as a threshold between the applied and fine arts, the founding principle of the Academy. The latter, identified as exceeding usefulness, was justified in its instances by Academy doctrine as exemplifying the exercise of reason in the discovery of forms of appearance which, because they were supposed to be reasonable, could form the basis of an art which instructed its audience.

The qualified admission of still-life into his hierarchy of genres by Reynolds in the following account indicates some of the difficulties which it presented to this theory:

> Even the painter of still-life, whose highest ambition is to give a minute representation of every part of those low objects which he sets before him, deserves praise in proportion to his attainment; because no part of this excellent art, so much the ornament of polished life, is destitute of value and use.[1]

There is a failed circularity to this argument. Still-life can be admitted to the hierarchy of painting because its artistry, limited in its ambition by its attachment to 'low objects', nevertheless displays the value of raising up those objects to a position in 'polished life'; at the same time, however, it seems to confirm the difference between life and its polish, the essential and the ornamental, and is thus – to deflect attention from its position in relation to this determination of excess – also useful.

Reynolds wants his audience to forget the difference between the art and its subject matter, on which the generic identification is itself based, so that they can imagine that he is identifying the parts of the art of still-life painting with the objects which it represents, thus redeeming the 'value and use' of objects. Still-life would thus not be 'destitute', nor would its owners who, even if they only had the painting, would have something which could confirm the things which it represented in an economy of exchange, the possibility of getting something for their money. Thus Academy doctrine was justified by a covert appeal to the valuations of commerce.

The relationship of still-life painting to excess, however, is not simply an affirmation of the values of exchange. Indeed, the painting of things which may be exchanged delays and disrupts the logic of use and value, such as commerce and industry would understand them. Their justification of the priority of their activities maintains that things (and, by extension, things which are not really things) are valuable because they are useful: still-life painting breaks this relationship, showing the useful as not merely useful, as exceeding the useful in its apparent re-appearance in painting; leaving us to infer, when we do not simply assimilate the painting back into the cycle of exchange, that value may be a consequence of a valuation which itself exceeds, by not being guided by, the useful.[2]

Some of the consequences of this general argument may be traced through the entries on other works in this section. Moser's *Vase of Flowers* is no less an example of that general argument than any other painting. However, it also bears traces which testify to some of the reasons why such works were categorised in the lowest of the genres. For Reynolds' very concern with problems of categorisation betrays an avoidance of what is put at stake in a work such as this; betrays his concern for the 'ornament of polished life' as a particular version of the domestic, its limits and its rule.

For the image itself, in doubling the appearances of domestic life, is already a potential *re*division of that space, one which implies a renegotiation of its limits, of what belongs there and what does not. Situated towards the end of a shelf, the vase of flowers appears as if indoors. However, within the frame of the image, there is already a reframing of this possibility, one which reminds us, by its liminal place, that flowers pass across limits. The edge of the shelf is already marked with images of flowers. The flowers in the vase above, in contrast with the liminal grisaille-like painting of the image of flowers, seem all the more

exuberant, all the more likely to exceed their proper limits. This sense is compounded by the fall of flowers from the vase, exceeding the powers of arrangement which are here implied. Those within the vase, meanwhile, appear to support each other to the extent of forming an unlikely arrangement, carrying heavy things above light, large above small, not having been used to form a calculated pyramid, or an even and orderly composition.

This is not to say that this could not occur, that it is merely invented. For the picture enables the affirmation of such a possibility, perpetuating it beyond its momentariness, the passing time of the life of flowers, by the very composing of a composition such as this. The inventiveness is thus not simply that of the artist, as Reynolds implied above: that notion of the artist setting things before him (the privileged subject of the theory) as a kind of exercise fails to note the effect of the affirmation of other times and other agents of setting, ones which may not be simply the artist's, while they are not themselves without artistry.

The temporality of the image is interesting. That narrative of the painter as author setting things out and then representing them implies a salvaging of time. An image of flowers detached from their roots implies, in general, an outlasting of the flowers. But the general project of a salvaging of time implies a common loss of command over it. Here the different positions of the flowers imply differences between them in their survival of that moment. This is sustained by the differences between the apparent representational functions of the marks of the painter: some effacing each other to appear to disappear into the image of a flower; others less effaced, themselves exceeding their function to represent, leaving a trace of the tracing of the surface.

Painting as the covering of a surface, of some mark occurring on a support, between making visible and covering, is here multiplied as a complex of betweens: between the living and the dead, past and present, artist and artist, artistry and nature. Along with these comes the appearance of a detachment of this portion of domestic space, an opening of its inside, such that that inside becomes remarkable for not being closed.

It is interesting to note that Moser did not only paint single images, framed like this, ready for transportation. She was, for example, commissioned to paint a room at Frogmore House, one of the residences at Windsor Castle, for Queen Charlotte. There, her painting again marked the interior with something of its apparent exterior. The queen insisted that the room be called 'Miss Moser's room': perhaps this marking of the interior seemed excessive to her, a married woman, an excess which

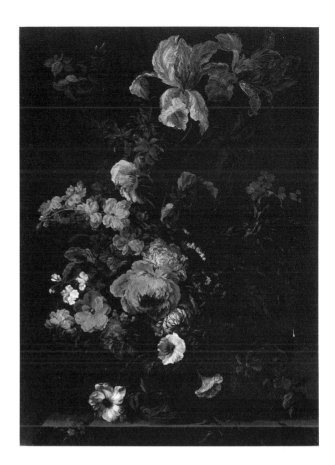

identification with the artist – a woman who was known by her maiden name throughout her career, despite her marriage to Hugh Lloyd – would have put under some control, facilitating an imaginary *re*establishment of the borders between the proper and the improper.[3]

The opening and detachment in circulation of domestic space implied by flower paintings like this, along with the range of interests which such work suggests, required a more elaborate critical reassignment by her fellow academicians. The insinuated tainting of the genre with the values of commerce was one way of closing the openings implied by such work, closing the threshold of a hierarchical critical order and redetermining the detachment of such images for commerce, the rule of circulation.

1 Reynolds, *Discourses*, p. 52.
2 For 'the commitment to the presentation of culture as circulating between luxury and necessity in a continuous cycle' in seventeenth-century Dutch and Spanish culture, see Norman Bryson, 'Rhopography' in *Looking at the Overlooked: Four Essays on Still-Life Painting*, Reaktion Books, London, 1990 (pp. 60–95), p. 62.
3 See Peter Mitchell, *European Flower Painting*, Adam and Charles Black, London, 1973, pp. 182–3.

82 James Hewlett
(1768–1836)

Hollyhocks, Roses etc.

57.2 x 45.7 cm; 1402–1888

A comparison of this painting of flowers by James Hewlett and the previous one by Moser suggests some interesting differences. The fall of light in the painting by Moser catches the surface on which the flowers are found more evenly than it strikes the flowers. In Hewlett's image, this relation is reversed. Here the flowers are illuminated and cast in stark shadow by a beam which, falling from the left, seems to have been interrupted in its passage by something out of view.

This is significant in relation to the relatively few traces of more precise location of these flowers in this image. The surface on which these flowers rest might be part of a number of sites: mantelpiece, bench, or even exterior architectural moulding. This indeterminacy of site, however, tends to be resolved by the direction of that fall of light, as if it were through an aperture, into this scene. Thus, the flowers seem to have been arranged and placed inside. Their relation to the outside, with that downward fall of light, is thus determined as a pathos of their suspended, once flourishing existence. With the flowers laid across this edge, an imaginary inside is created.

Hewlett's practice as a painter of flowers may be divided into two main parts: from 1799 to 1828 he showed paintings like this one at the Royal Academy; meanwhile he produced numerous illustrations, by a variety of means, for botanical textbooks.[1] Further consideration of this image, however, suggests that the interests of this latter activity were also at work in the former. The painting is so composed as to enable the identification of two specific species, hollyhocks and roses. The blooms of the flowers to the centre right are more brightly lit around their centres. It is as if they were craning round towards the light, yearning for the source of their life, revealing to us as they do so those parts identifiable, as part of a botanical project, as their male and female organs, their stamens and pistils.

Quiet murmurings of fantasy and scandal haunt this, and other paintings of flowers. That construction of an imaginary inside means that the proprieties of the science of botany cannot quite suppress other consequences of its drive to identification. The hermaphroditism of some flowers may be refigured as a fantasy of bisexuality, determined as a transgression of a proper heterosexuality. The possibilities of self-fertilisation may be treated as a figure for a secondary narcissism, anxious but too anxious to reproduce. The apparent abandonment of the processes of reproduction to the winds, or to the intercession of others, insect-like and otherwise, becomes a figure of an escape from a dedication of desire to reproduction, and a fantasy of a plurality of relations beyond the exigencies of coupling.

Hewlett's image, then, suggests the play of such notions as an imaginary interiority, a fantasy of something from beyond that inside given momentary release. This movement of incorporation, figured by the example of flowers, is marked at its limit by their inclination for that source of life mentioned above. The consequence of this elegiac notion is to confirm those fantasies of different forms of life as fantasies, as the threat of a general loss. Possibilities of different ways of life are reframed by a threat of the loss of species identity.[2]

1 Lambourne and Hamilton, eds., *British Watercolours*, p. 184.
2 See Michel Foucault, 'Life, Labour, Language' in *The Order of Things*, trans. A. Sheridan, Tavistock Publications, London, 1970, especially pp. 263–80, for an account of early nineteenth-century biology in which the generalised notion of 'life' as the possibility and limitation of beings emerges.

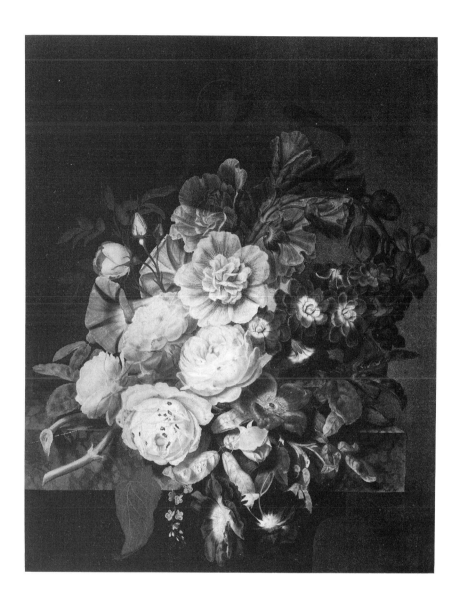

83 Anne Frances Byrne
(1775–1837)

Roses and Grapes

Signed and dated '1826'
40 x 41.9 cm; 1358–1874

In 1805 Anne Byrne was elected an associate exhibitor of the Society of Painters in Water-Colours. She had been exhibiting flower and still-life paintings at the Royal Academy since 1796 and it was their renown, and the example of Academy sanction, which seems to have been responsible for the Society waiving its year-old rule against the exhibition of such subjects. She was the first woman to exhibit at the Society's exhibitions, sending works regularly – except for the seven years during which oil paintings were admitted for show – until 1833.[1] Barred from full membership, she was, as the Society's records put it, 'exempt from the trouble of official duties'. Acceptance of this limitation on her participation was bought by an exemption from liability for any losses which the Society might have.

The ban on women becoming full members of the Society was not lifted until 1889. Helen Allingham (see entry 71) was the first to be elected to such membership in the following year. Like the Academy, who, despite having among their founder members Mary Moser (see entry 81) and Angelica Kauffmann (1741–1807), elected no women to full membership until 1936, having modified their constitution so as to prevent it, the Society denied and avoided the claims to interest of the work of women artists.[2]

This avoidance can be traced in critical reaction to Anne Byrne's works. Richard Redgrave praised them for combining 'a charming freshness' with 'a great richness of colour', assimilating an awkward heterogeneity, such as we can trace in *Roses and Grapes*, under the notion of 'freshness', hinting indeed at the possibility of naïveté; warning against this difficulty by the hint of improper excessiveness in that 'richness of colour', which is, nevertheless, promoted as a compensation.[3] For *Roses and Grapes* is indicative of a heterogeneity of sites, both inside and outside, the avoidance of which was necessary if notions of the lowly pretensions of still-life painting were to be maintained.

The foreground, seen from a low and close position, is accompanied by a dramatically receding distance. Something of this drama is mitigated by the dark curtain which blocks our view. This veil, however, by not veiling all, is more provocative of an interest in that distance, one which simultaneously threatens to recall the possibility of the very division of that distance, its separation into bounded areas. Given, furthermore, that this boundary of the veil is itself only partial, it implies a limit to vision's capacities to identify the completion of a boundary, its closure. Thus the boundary which it implies comes to seem permeable.

Thus, this scene, which at first might seem to be a sort of naturalisation of those flowers and fruits, an attempt to return them to their proper places, is remarkable for its play with the notion of a proper site. This staging of the near and the far suggests the discovery of the latter in the former. For, while roses may without much difficulty be identified as belonging in the English garden, grapes are less easily identified in this way. Traces of a different site and a different climate haunt this version of the near-to-hand and turn this into a margin in which the domestic and the extra-domestic interlace.

Reactions like those of Richard Redgrave reemerge as disavowals. For those notions of 'richness' and 'freshness' sound so much like the claims of someone trying to persuade you to enjoy something which, although it may taste strong, is not likely to do you any harm. This identification of palette and painting is further testimony to a discourse of taste which can only acknowledge the relations of trade and commerce with works like these, if at all, as questions of consumption.

1 See E.C. Clayton, 'English Female Artists' in Roget, *History*, vol. I, p. 552.
2 Roget, *History*, vol. I, pp. 209–10; and S. C. Hutchinson, *The History of the Royal Academy 1768–1968*, 2nd edn., Robert Royce, London, 1986, p. 161.
3 Quoted in Roget, *History*, vol. I, p. 209.

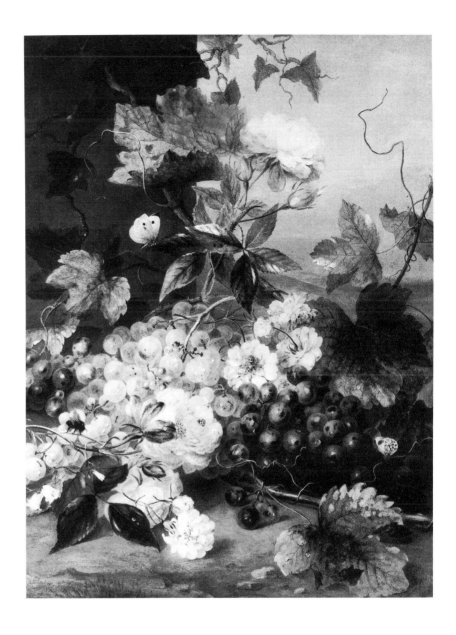

84 Louisa Hay Kerr [Mrs Alexander Kerr] (active *circa* 1840–1850)

Opium or White Poppy

Inscribed 'Papaver Orientale. Eastern Poppy.
Class polyandria and order monogynia. 1845'
33 x 26.6 cm; D. 191–1899

The growth in popularity of botany during the nineteenth century remarked upon above (see entry 82) may be traced in incipient forms in texts of the late eighteenth century. There we can find indications of problems of vision, pleasure and science which suggest why an image such as Louisa Hay Kerr's *Opium Poppy* was composed and painted in this way. Such a consideration will indicate that notions of the benefits of science could not always be sustained and that images such as this one were part of a supplementation of the claims of science's beneficial effects. However, like the discoveries of science, the image could not, nor cannot, be relied on to perform only this function. Like the flower itself, its image plays a role which is undecidably pleasurable, damaging and curative.

In the seventh of the ten sections, or 'walks', which comprise his last work, *Reveries of a Solitary Walker*, Jean Jacques Rousseau presents an account of his enthusiasm for observing, collecting, categorising and documenting flora. This account seems designed to entice the lay reader, someone not among the audience for his *Letters on Botany*, published in 1773, four years before the seventh 'walk' was written. In this later text, Rousseau invites his reader to come to share in the pleasures of the world of plants; in 'a living, fascinating and enchanting spectacle, the only one of which his eyes and heart can never grow weary'.[1] The reasons why Rousseau maintains the value of botany in these terms of spectacle and the fascination of vision emerges as he protests the appropriation of science.

The audience who cannot read him are identified as diverted from this pleasure of vision. The English, he suggests, are not so bad as the French in this respect. The latter 'have remained so barbarous in this respect that a Paris wit who saw a collector's garden in London full of rare plants and trees, could only exclaim by way of praise: "What a splendid garden for an apothecary!"'[2] This, maintains Rousseau, betrays an attitude 'which always brings things back to our material interest, causing us to seek in all things either profits or remedies'. Medicine, as a practice and a promise of profit and remedy, is a prime culprit of this. Interestingly, Rousseau expresses his censure of medicine in terms of an improper vision, a kind of projection: 'medicine has so seized on the plants and transformed them into medicaments that we hardly see anything in them except something which does not really exist, the supposed curative values ascribed to them by every Tom, Dick or Harry'.[3] Thus there is a strain of Rousseau's apology for botany which, in the pursuit of knowledge for its own sake, will enable the recovery of a vision which enjoys the spectacle without projecting; will be able to be fascinated without succumbing to an expectation of benefit.

The prospect which Rousseau holds out is one in which the expectations of remedy and profit, and their accompanying projections, are overcome in favour of the botanical project. The bridge to this is described as one in which 'All individual objects escape [the observer]; he sees and feels nothing but the unity of all things.'[4] In order for this state to be brought about, says Rousseau, this 'recreation of the eyes', one has only to 'love pleasure in order to yield to such delightful sensations' as are afforded by 'the sweet smells, bright colours and the most elegant shapes' of the plants of the fields.[5]

This intervention of the sense of smell in the 'recreation of the eyes' is momentary. Rousseau passes on from this, generalising this moment of recreation into one in which those objects which possess those capacities 'strike' the senses of the observer. But this passage is somewhat more dangerous than Rousseau may be thought to imply. For it is precisely at this point that the feeling of 'the unity of all things' may be brought about by senses other than vision. The notion that one needs to be struck in order to restore the eyes, recover a sense of the unity of all things, implies a certain extension of the pleasures of the senses which may not be restricted either to vision or to smell. Rousseau does not admit this possibility in order to keep apart the possibilities that the remedies of medicine and the remedies of the senses and of thinking can be differentiated. The possibility that the consumption of substances which strike the senses *may* contribute to his notion of recreation is skirted. The prospect of a cycle in which the eye identifies for ingestion in order that it might be restored, but would have to fall again in order that such restoration might take place, a cycle of repetition, haunts this recommendation of botany.

Rousseau's complex account indicates a number of guiding notions for understanding the apparent occasion of this image. The recreation of the eye, one which may take us from interested to disinterested science, between medicine and botany, entails a risk which cannot be controlled by that eye: a play of the dangerous supplement of intoxication in order to achieve that ecstasy of the sense of the unity of being about which he writes. The more one tries to control and direct the use of this supplement, the more one risks promoting the desirability of exceeding that control. The more one observes and classifies, the less the spectacle fascinates, and the more the desirability of escaping the spectacular by means of that supplement occurs.

Kerr's painting thus approaches a limit of the project of botanical illustration. The poppy, source of opium and laudanum, imported from the East, became the topic of a struggle to close borders which had been opened, China objecting to the effects of trade which had, so they claimed, corrupted indigenous cultivation into the production of a narcotic. The Opium Wars began in 1839, ending in 1858 when the Chinese Government agreed to legalise its trade. But the poppy would not stay within borders in the West either. From a remedy to a poison, painkiller to an addictive hallucinogen, its effects could not quite be predicted. Its inclusion within a botanical framework thus testifies to the instability of that science, and the cycle of observation and the deferral, but *not* the suppression, of the desirability of exceeding that relation of eye and thing.

Its isolation on the page thus serves to maintain and promote that relation of observation between eye and thing. Without traces of its site of discovery, the more the prospect that the spectacle will be reconstituted around it may be imagined. Within that dangerous margin, however, in which that fails to occur, identification and classification intervene to seek to defer the threat of that failure. Kerr has provided us with examples. In the bottom right-hand corner of the sheet, she has noted, in pre-Linnaean fashion, the botanical class and order: respectively 'polyandria' and 'monogynia'; many stamens and one pistil. Moment of imaginary ecstasy, of an excess of identification beyond its dedication to the ends of botany, a possibility of a projective seeing, of being a member of a polyandrous class and a monogynous order. In this image, the pleasures of touch, of laying on the paint, suspend, in the possibilities of trangressive fantasy, the rush of the desire for the unity of being.

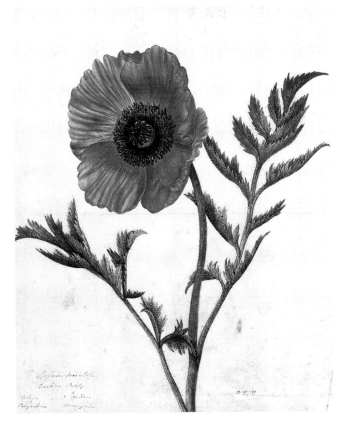

1 Jean-Jacques Rousseau, *Reveries of the Solitary Walker*, trans. P. France, Penguin, Harmondsworth, 1979, p. 108.

2 Ibid., p. 110.

3 Ibid., p. 109.

4 Ibid., p. 108.

5 Ibid., pp. 108–9.

85 Peter De Wint
(1784–1849)

Still Life. A Barrel, Jug,
Bottle, Basin etc. on a Table

33.6 x 49.8 cm; P.1–1928

This work is unusual among De Wint's surviving still-life paint-ings. There are a number of other watercolours which seem to have been quickly painted and left to appear unfinished, con-forming without difficulty to the paradigm of the still-life as 'exercise'. As if to confirm the appropriateness of this notion of still-life, one of his pupils described De Wint's teaching process in the following way: 'He would take any convenient objects he could find in the room and set them in a group on the table, with a towel or other white cloth carelessly thrown against them. These he required to be carefully imitated.'[1] The opposition here between the careless pedagogue and the pupil who is enjoined to be careful indicates one of the reasons for the decline of still-life precisely because of this possibility of setting it as an exer-cise, a possibility which pedagogical and institutional theory maintained by considering the genre as the lowest component of a hierarchy. In this position, it was more vulnerable than any other to dissension; less recognition being given to still-life than for performance in any other genre. Boredom thus haunts still-life; the very boredom which might have been displaced by its practice coming to taint the genre itself, so marked is it by this possibility of a pedagogical relation.

The notion, however, that boredom is displaced by the prac-tice of still-life is also suggested by the very drama of that care-less disposition of the cloth. This is not simply theatrical, although it is that. The isolation of a space against which objects might become notably visible, within which light be relayed most dramatically – such as has been noted of Cézanne's still-life, for example – breaches an interior. That framing of an inte-rior opens it to the relay of an exteriority and to the possibility of an imaginary play of the threshold between inside and out. Unlike Cézanne, however, De Wint did not see fit to follow through the possibilities of the white cloth as the effective effacement of the limit of the interior in this work. It may be

noted, of course, that, often, neither did Cézanne, leaving us instead with an open, so-called unfinished weave of cloth, apples and other things as if to affirm that exercise of the demands of an exercise over himself.[2]

This still-life by De Wint, however, serves to indicate the ways in which an interior may be opened to the play of an exte-rior in still-life, without there being a synthesis of the two. Composed against a surface which we are drawn, by the shad-ows it carries, to identify as a wall, but which frustrates that same identification by seeming to disappear into those very shadows, the things on this table may, in one way or another, be identified as partially open. These different receptacles might be thought to be arranged as if to illustrate some function, perhaps in some recipe or process of decanting, were it not for the odd presence of the gnarled and decayed branch of a tree which hangs over the edge of the table to the right. Hanging over the edge, like the thick material on which the basin rests, these things in this position thus seem to exceed that destiny of func-tion.

The common reaction to this, in the history of the criticism of still-life, as was indicated above concerning Reynolds' judge-ments (see entry 81), is to recuperate this as the function of exceeding function, containing and reassigning other excesses in the process. De Wint's *Still-Life* invites such a judgement only to render it ridiculous. That portion of a tree, next to all these apparently well-formed things, will not be assimilated to func-tion. Nor will it quite allow us to figure the exterior as a site which harmoniously contains the interior. Besides intervening here to disrupt that pass at a notion of a well-organised table in terms of function, and the identification of the image with the harmonising of the excess of that, it also suggests the play of force in that exterior. Damaged by storm, or by decay, it is also cut, an apparently partial object. Thus, a paradox emerges: the apparently partial succeeds in creating an imaginary totality where what seems to be whole does not; the barrel, jug, bottle and basin, appearing as if *part* of some other occasion, be it exercise of painting or, no less justifiably, some process of domestic activity.

This is not the end of the question of the branch of a tree. Perhaps its most enigmatic effect is brought about by the incompleteness of its incompleteness, the missing end of the end, appearing as if cut off by the frame of the image. This edge and this absence of an imaginary lack is thus not the lack of something, of the possibility of closing the scene. Imaginary

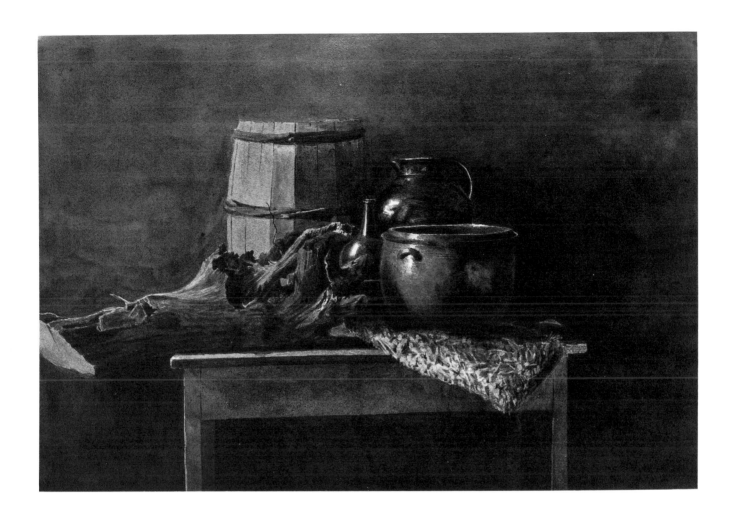

totalisation of the scene as an interior fails to account for the
possibility of its attachment; while imaginary totalisation of the
scene as an exterior, following through the apparent disappear-
ance of the wall and imagining the (improbable) situation of this
table outside, would fail to note the possibility of detachment,
one from another, of image and world, the divisions of exterior-
ity and the opening of its inside.

1 Scrase, *De Wint*, p. 15.

2 On Cézanne's 'destructiveness', but contra the conclusions of Meyer
 Schapiro concerning the 'detached aspect of the world that [Cézanne]
 finally shapes into a serenely ordered whole', from 'Cézanne' (1959)
 in *Modern Art: 19th and 20th Centuries*, George Braziller, New York,
 1978 (pp. 39–41), p. 41.

86 William Henry Hunt
(1790–1864)

Hawthorn Blossoms and Bird's Nest

17.5 x 33 cm; 1470–1869

One of the stranger symptoms of nineteenth-century art criticism is the renaming of William Henry Hunt as 'Bird's Nest Hunt'. Without pretending that the first coining of this has been tracked down, which would, in any case, entail a regress of authorisation, its significance as symptom can be discerned from the omission of it from a commentary of remarks about some of those nests themselves. This reading confirms that Hunt's renaming as Bird's Nest indicates a play on the possibility of taking a certain parental part, one which did not feel constrained to observe the proprieties of gender, but which none the less gathered something back into a scene of familial and domestic inheritance.

In his *Notes on Prout and Hunt* of 1879–80, Ruskin exalts Hunt's painting of flowers for going beyond the notion that such paintings exist to adorn, flatter and please 'noblesse'. This he associates with the practice of previous painters which, he says, imply 'that the highest honours which flowers can attain are in being wreathed into grace of garlands, or assembled in variegation of bouquets'. The fantasy of an artless art of composition leads him to a general criticism of still-life:

> Irrespectively of these ornamental virtues and culinary utilities, the painter never seems to perceive any condition of beauty in the things themselves, which would make them worth regard for their own sake; nor, even in these appointed functions, are they ever supposed to be worth painting, unless the pleasures they procure be distinguished as those of the most exalted society.[1]

There is an equivocation about beauty here which misdirects Ruskin's latter account. The phrase 'condition of beauty' is ambiguous: either the state or the determination of 'beauty in the things themselves'. Shifting through this notion of a state of a thing, as if beauty were a property of things, and not a relation of perceiver and perceived, creating a sense of things 'worth regard for their own sake', Ruskin proceeds to claim that Hunt's work exemplifies this interestless interest and this artless art.

It is symptomatic of this construction of beauty that Ruskin finds a way of disavowing the violence of that notion of the beautiful state of things by an attribution of violence to others. Hunt's work is characterised as follows:

> his primroses fresh from the bank, and hawthorns white from the hedge, confess at once their artless origin in the village lane – they have evidently been gathered only at the choice, and thrown down at the caprice, of the farmer's children; and cheerfully disclaim all hope of ever contributing to the splendours of the great.[2]

This notion that the farmer's children have 'thrown down' the flowers is not only that trace of a disavowal of the violence of identification, the identification of a sense of beauty with a thing; it is also a rather odd displacement of it. For it is not the flowers in Hunt's works which seem to have been transplanted, let alone thrown down. Rather, it is the nests, which seem to be down, if not thrown; oddly exposed, their clutches of eggs unprotected by parental guard. That kind of guard has been projected, figured as absent, in the scenario of the farmer's children, roaming out into the village; and Ruskin recovers it as a function of the imaginary placement, and the consequent production of a pathos, of the image.

This account of Hunt's image denies its composition, by, rather literally, naturalising it. Furthermore it betrays the sense of the errant which haunts this scene of an imagined family of birds. The image encourages it: partially revealed as it is, the nest is also turned away out of the light, producing a limit which vision cannot pass. To overcome this entails imagining the image as part of a totality, one which inevitably gets caught up with other projections.

1 Ruskin, 'Notes on Prout and Hunt' (1879–80) in *Works*, vol. XIV, (pp. 369–454), p. 377.
2 Ibid., p. 378.

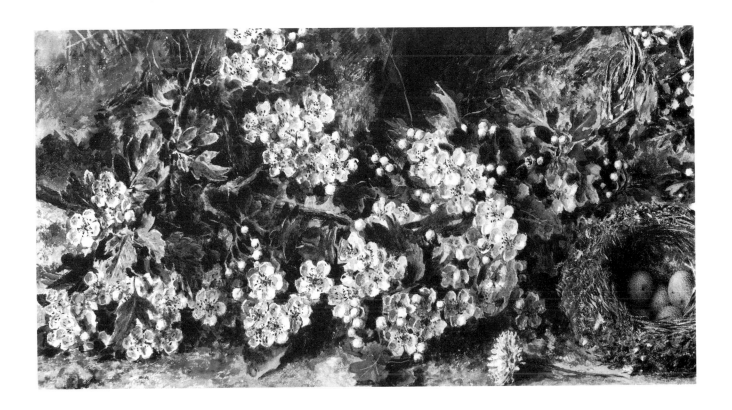

87 Marian Emma Chase
(1844–1905)

Wild Flowers

Signed and dated 'Marian Chase 1872'
30.8 x 24.5 cm; 1106–1886

Marian Chase's election to full membership in 1879 of the New Society of Painters in Water-Colours (a society which later became the Institute, then the Royal Institute of Painters in Water-Colours) was, like the election of Helen Allingham to the Old Society in the following year (see entry 71), an instance of an alleviation of a disadvantage under which women had worked as artists. Again, however, this admission to membership did not result in a direct way in recognition of the questions raised by their works.[1]

Comparison with Hunt's *Hawthorn Blossoms and Bird's Nest* (entry 86) suggests some interesting differences. Where Hunt has painted an image in which the fall of light is rather focussed, producing the sense noted above that part of the subject is hidden, this scene by Chase appears lit in a more complex way. The brightness of the light on the plants nearest to us, on leaves, flowers, and most noticeably on the stems of the plants in the middle and to the left of the composition, is contrasted with a wide range of tonal values. The effect of this in an image which implies such a close point of view is to render the discovery of any one off-stage source of light uncertain. This effect, which is not quite diffusion or refraction, as these notions both imply that single, undivided source of light, is to render the place which is given by this representation in a way which implies interesting notions about its borders.

Perhaps the most obvious consequence of this is to hold at bay what otherwise might intervene as a narrative of pathos. The crossing of the scene by the corridor of shadowed space behind the brightly lit plants, at the edge of which lies the broken-stemmed flower, may be identified as the point of passage of that which has damaged this plant. The pathos of such a notion, however, would be a sense that there *should* have been some kind of protection here, some more efficient framing of this space. Chase's image does not prevent that narrative of pathos – no image could quite do that – but it does not provoke it in the way that Hunt's image can be understood to do. For the permeability of the space continues to be given: by that fall of light; by the complexity of the composition which makes identifications of foreground, middleground and background less than certain; as well as by any inference that this or that agent has, in passing through, broken this plant.

What seems inappropriate, then, is any notion that this space has been invaded, or remains to be invaded. That identification, that source of a narrative of pathos, blocks recognition of the permeability of any border which might be instituted to defend this space. Such a sentimental interpretation would also remain blind to the difficulty of identifying the site of this scene, of the uncertainty of assigning to some place definitively inside or outside some cultivated region or a titled estate. For, despite the title *Wild Flowers*, this remains undecidable, it not being clear that these plants have taken root in some space claimed as place, garden, field or park. Such a blindness would be that of a vision which is used to imagining that there existed a position outside the world from which such borders could be established, a position which could guarantee that desire for possession.

Recognition of these issues bears on the inherited version of the careers of watercolourists like Chase, women who seem, according to the repetition of a hierarchy of visual art practices, to have had nothing better to do. Recognition of that legacy of the regulative function of the societies of exhibition of the nineteenth century is not simply, therefore, some generalised task of setting the record straight. Rather, it provokes the possibility of following through what has prevented the recognition of the issues that are raised when the notion of the natural affinity of women artists for subjects such as these is not simply presumed and related complexes of pathos break down.

1 See for example Charles Holme, ed., *The Royal Institute of Painters in Watercolours*, The Studio, London, 1906, p. xxxvi.

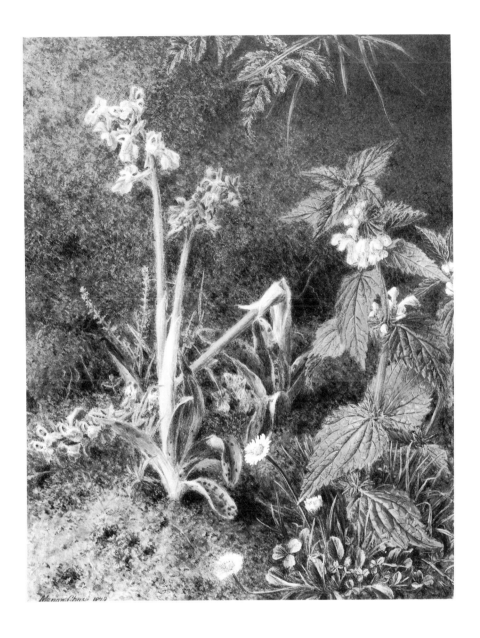

88 Vanessa Bell
(1879–1961)

Flower-Piece

Signed 'V. Bell'
35.3 x 25.4 cm; p.45–1931

In 1916 Vanessa Bell and her husband Clive moved from London to live in a farmhouse called Charleston near the village of Firle, not far from Lewes in Sussex. Here, Vanessa, Clive Bell and Duncan Grant, with occasional assistance from Roger Fry, and the encouragement of the purchaser John Maynard Keynes, refurbished and redecorated the house. Three years earlier, the Omega workshops had been founded by Fry. Goods from the workshops were brought to the house, but the house was also a site of production: of fabrics, pottery – lampshades as well as crockery. Most notably, perhaps, things were painted: tables, chairs, beds, doors, door frames and window-sills.[1]

The move to Charleston thus became a way of maintaining a sense of some of the possibilities of notions of manufacture and design with which the workshops were becoming less and less easily identifiable. The independence of the Omega workshops from larger manufacturing corporations was already giving way, as was a sense of their integrity: having already been imitated, designs were being sold from which other, larger companies manufactured items. This, in retrospect, given recent affirmations of the values of design, may not seem significant. But, just as those affirmations have tended to cover a complex politics of production, its shifts, declines, costs and damages, so the example of Charleston can come to seem to be just the scene of the inevitability of this, part of the justification of that notion of design.

Such, indeed, was the legacy of late nineteenth-century aesthetic, social criticism which Fry inherited from thinkers and artists like William Morris. Morris' dictum, 'Allow nothing into your home which is not beautiful', may be traced, detached from the mere identification of his thinking as socialist, in the projects of the apparently failed or failing aristocracy of taste of early twentieth-century Bloomsbury culture.[2] A history of the political and social implications of discourses of taste needs to acknowl-

edge the complexity of the association of the aesthetic and political in a variety of projects. The dangers of such an association cannot be understood merely by blaming either, or both, left- or right-wing appropriations (as if such associations did, indeed, belong to someone).

The policing of the border and of the interior explicit in Morris' phrase needs to be acknowledged, if it is not to be simply repeated in an analysis of that which was made in the name of Omega. The anxieties which are implicit in the definition and maintenance of borders *and* the exceeding of them are both at work in the decoration of the farmhouse at Charleston. Accepting that its decoration was partly determined by the desire to produce an example of what Omega and its principles might still be imagined to achieve, it would not be sufficient to restrict it to this exemplification. Effects of a closure of the interior may be traced through the house. Putting aside the indifference of judgements of stylistic continuity (themselves part of that above-mentioned aesthetic–political discourse), signs of the differentiation of function become readable: fish painted in the kitchen; classical urns painted in the study. These are also, of course, traces of an exterior, signalling that such an effect of the closure of an interior is accomplished, if at all, by an inclusion. Characteristic of its guarantee would be the identifiability of a body apparently whole, unmarked by this necessity to incorporate in order to manage its limits. Hence the image of the body of a fish; while the painted funerary urn may be imagined to provide a sort of final enclosure of a body, not now open or vulnerable, having suffered vulnerability and decimation.

In relation to such multiplications of movements of the inclusion of traces of exteriorities, this image by Vanessa Bell may be understood as a reopening of a relation to an exterior. Overcoming the frame, we may identify our viewing position as being within a room. The vase and its charge of flowers on a window-sill, as well as being identifiable as the site of a division of interior from exterior, presents us with a crossing of the traces of the latter into the former: flowers themselves, light, perhaps even a sense of movement. This, however, is not the only way to interpret the marks which appear to represent these things. The broad, open weave of washes continues to offer a sense of these traces of the exterior, the flowers and the fall of light.

At that inner edge of the window, the trace of the painter approaches the condition of being interpretable only as the confirmation of the interior, of the representation and of the image,

the one by the other. Around that, however, those other traces come to seem not simply looser, but less the effacement of one another. The construction of an imaginary interior emerges thus not merely as the negation of the exterior and an incorporation of its trace, but as an indifference to the space of their differentiation.

1 See Isabelle Anscombe, *Omega and After: Bloomsbury and the Decorative Arts*, Thames and Hudson, London, 1981, pp. 72–102, especially pp. 108–9.
2 See, for example, Pevsner, *Sources of Modern Architecture and Design*, pp. 18–29.

89 David Jones
(1895–1974)

The Violin

Signed and dated 'David Jones 1932'
57.2 x 78.8 cm; P.1–1940

While he was a student at the then Camberwell School of Arts and Crafts from 1910 to 1914, David Jones was taught by A. S. Hartrick. Besides being a practitioner whose images are marked by interests in the works of both Victorian illustrators and French post-impressionists, Hartrick was also a revisionist historian of watercolour painting. In his autobiography of 1939, *A Painter's Pilgrimage*, Jones' teacher gives a full version of his history of watercolour, reminding his readers that the art did not begin in England in the eighteenth century. Before that there were the manuscript illuminators of the eighth century, not to mention the work of Holbein or Hilliard, or of Dürer. Watercolour was used in the tombs of Egypt, and by the Chinese, Japanese and Persians. Hartrick maintained that this history supported him in the construction of a certain rule: 'I believe the above facts bear witness: that in figure painting in watercolour it is necessary to use gouache (i.e. body-colour) or else a pen line in order to keep the necessary control of form to suggest solidity.'[1] Hartrick's appeal to this history to legitimise what might otherwise seem obvious – that a transparent wash does not easily carry connotations of solidity – does not disguise what also gets legitimised: namely, the aim 'to keep the necessary control of form'.

This rearticulation of the history of watercolour painting is marked by the contemporaneous concern, associated most notably with the criticism of Roger Fry and Clive Bell, for the establishment and maintenance of a sense of form in painting. Jones maintained that he found the criticism of Fry and Bell important in changing his practice: 'For one of the most rewarding notions implicit in the post-Impressionist idea was that a work is a "thing" and not (necessarily) the impression of some other thing.'[2] This version of post-Fry post-impressionism is peculiar. 'Not (necessarily) the impression of some other thing' is readable in at least two ways: Jones implies both that a work

may not just be a thing, its traces may represent, be dedicated to something else; and also that the work is not, *necessarily* not, 'the impression of some other thing'. This rather hidden position implies further readings: that the work does not represent some other thing; but also, it is not the impression of the artist, or his instruments. This does not signify only that Jones is against thinking of work as the impression of impressionism; but also that he disavows that there is an impression, a marking of the surface.

Jones' later work confirms the above account of his thinking. Excluded from the 7 & 5 Society by Ben Nicholson, Jones got caught up in the production of another version of the opposition of abstract and representational work. His work becomes more and more complexly involved in narratives of national legend, tales, for example, of Arthur, Guinevere and the knights, and in dedication to sacramental scenes and texts. However, it never loses the sense of a proliferation of mark-making in excess of its apparently legendary and representational goal. Jones later justified this as a trait of a characteristically English art. Using terms borrowed from Gerard Manley Hopkins to describe the land, 'pied, partied and brindled', he presents a notion of indigenous art as necessarily conditioned by this: 'fretted, meandering, countered', he terms it, testifying to, but failing to recognise an anxiety that there are no such proper characteristics. This gets caught up in an inevitable struggle of nationalisms until another disavowal, this time of the possibility of racism, intervenes: 'Fairness, a kind of blondeness (except that the word "blonde" has an altogether wrong association), belong to this characteristic of English art.'[3] These readings of Jones' criticism indicate that, if we are not to follow the chain which led Jones from Hartrick's notions of control, to post-impressionism, through the anxieties about the identity and function of art to these nationalist and racist notions, then we need to treat the question of the mark differently, beyond that trap between control and its disavowal.

In *The Violin*, different, but also similar painted marks are used for apparently different ends. A thin wash may seem to define the colour and the limit of an object, as with the green of the curtain to the left. Another wash, however, will become ambiguous, as with the yellow above it, becoming, in its excess of description, undecidably a veil and a ground of what is beyond. The red of the floor is also the red of the table, and the red of the scrolled head of the violin. A dense but stippled red also marks the table, neither descriptive nor not. Washes of blue

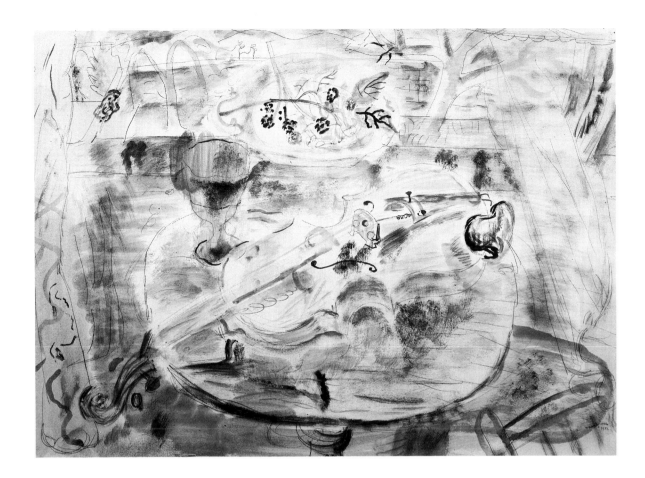

are used to mark areas of likely shadow, but also a pattern on the curtain and an excess of shadow, on the chair-like form in the lower right and on the goblet on the table. This part of the work is perhaps the most curious: more than the excess of shadow, here the mark seems to approach erasure. This, however, seems rhetorical in the sense that the marking of the surface in blue, in a movement up and down the surface of the image, quotes a figure of erasure, of a scribble. It does not efface, although it obscures, the pencil marks underneath.

It is the pencil marks which appear to give the limits which are then transgressed or exceeded. Jones wanted to read this as a version of control and release. As later images of goblets turned chalices suggest, images which have been identified with his Catholicism, this notion of control and release was ritual and transcendental.[4] This is perhaps the predominating sense of the image, of a scene appearing but also appearing to disappear, a dream of the supersession of such thresholds of visibility. But those marks which do efface the surface and appear to represent, like those in black representing the blackberries on the dish, or the peg, screws, chin rest or holes in the sound box of the violin, indicate that this apparent drama of control and release is organised around a distribution of traces which create imaginary substantiality before appearing to go beyond it.

Like the other still-life paintings in this section, Jones' *Violin* testifies to a renegotiation of the differences between interiors and exteriors. The exterior that he believed he had guaranteed, that version of England which was apparently tolerant of variety, but in actuality was guaranteed by an exclusive nationalism, was constructed around an opposition of interior and exterior, one which a careful consideration of his work indicates was a fantasy of overcoming the differences between them.

1 Quoted in Paul Hills, 'The Art of David Jones' in Tate Gallery, *David Jones*, London, 1981, p. 38.
2 David Jones, 'Art and Sacrament' (1955) in *Epoch and Artist*, ed. H. Grisewood, Faber and Faber, London, 1959 (pp.143–79), p. 171.
3 David Jones, 'An Aspect of the Art of England' (undated) in *The Dying Gaul and Other Writings*, ed. H. Grisewood, Faber and Faber, London, 1978, pp. 59–62.
4 See Kenneth Clark, 'Some Recent Paintings of David Jones', *Agenda: David Jones Special Edition*, vol. 5, nos. 1–3, Spring–Summer 1967, pp. 99–100.

10

THRESHOLDS OF MODERNISM

90 James Dickson Innes
(1887–1914)

Seaford

Signed and dated 'D. Innes 07.'
27.3 x 37.5 cm; P.24–1963

Innes' later work has been compared with French post-impressionism, and used as an example of a kind of pathos of imitation which, while it failed to achieve the heights of what it imitated, was nevertheless heading in the right direction. His death in 1914 is thus taken to signify an interruption of the destination of modern art, one which he might have contributed to achieving. The reaffirmation of this notion of modern art, an international modernism, would thus redeem his death.

Innes' earlier work as a student at the Slade between 1905 and 1908, following a curriculum which owed much to the notions and projects of Ruskin, is thus treated as a mere prelude. The blindness to the issues of the modern and the national that were involved in this redefinition of the ends of art, as I have outlined them in the introduction above, have been part of a more general misconstruction of the ends of international modernism: part of a forgetting of the vicissitudes of that project of modernism, one which remains uncomprehending of the return of questions of the national.[1]

A consideration of this watercolour of 1907 suggests that Innes' later paintings, landscapes in which the elements of the painting are often closed to one another, linked as if by a rhythm across the surface, was in part determined by the limits which he treated in his earlier work. His turn towards the use of opaque colour to define parts of the surface was determined by an anxiety, which is implicit in this work, concerning the vocabulary of watercolour: the association of translucence with permeability.

As a student, Innes seems to have been interested in the work of Turner and we can follow through some of the implications of this in a comparison of *Seaford* with Turner's *Lyons* (entry 40). Both paintings situate us as if we were looking at a bright sun. Neither of them simply represent that sun, however. Both show the sun as if not appearing itself, as outside and beyond us; instead, they show what appears despite an apparent excess of light, an excess which would, were it not for what intervenes as a barrier, threaten to blind; make us unable to differentiate between ourselves and things by means of vision. This imaginary loss of vision, however, is mediated for us. In Turner's *Lyons*, edges of buildings and a jetty on the river, traced against the light, provide us with figures of what will survive our imaginary loss.

In *Seaford* the breakwater and the figure standing at the edge of the water appear to supplement this threat of loss. The former, translucent, but also opaque, not only bars the light, sending a shadow in our direction, one which will lengthen as the sun goes down, but promises to interrupt the imaginable engulfment by the sea to which a loss of vision would leave us vulnerable. This loss of a capacity to see limits is also supplemented by the figure who, standing at the water's edge with head bowed, seems to retain the minimal identity such as a silhouette would offer, even if we imagine him blind. His apparent engrossment, however, also enables us to imagine that the figure can still see, even if it is only a partial, less comprehensive vision.

Innes' prospect, then, stages a scene which enables us to imagine a loss of limit, a loss of a certain knowledge of what we can nevertheless imagine ourselves within. In this, it shares with the works of other artists considered above that effect of the prospect which enables us to imagine that we can recover a view of what we might become unable to see, restoring the site of this scene to a greater whole. Like Turner, Innes thematises this prospect of a loss of vision. *Seaford*, however, does this in relation to a scene which enabled an audience in Britain to imagine recovering a view of the limit of what they remained within; while *Lyons* enabled them to gather and retain a sense of what lay beyond those shores, a way-station beyond the border.

Innes' later works often redeployed scenes of the meeting of sea and land, seen often as if from across water to the edge of land. Treating the encroachment of the sea and the threat of the loss of limit which it figured was renounced by him in favour of a painting which appeared to show their separability, discrete areas, linked, if at all, by rhythmic movement from edge to edge. In this, his later work was also marked by borders, ones which seemed more easy to traverse. That this possibility was established by an imaginary overcoming of the differences between inside and out, the assimilation of the latter to the former, was subsequently forgotten.[2]

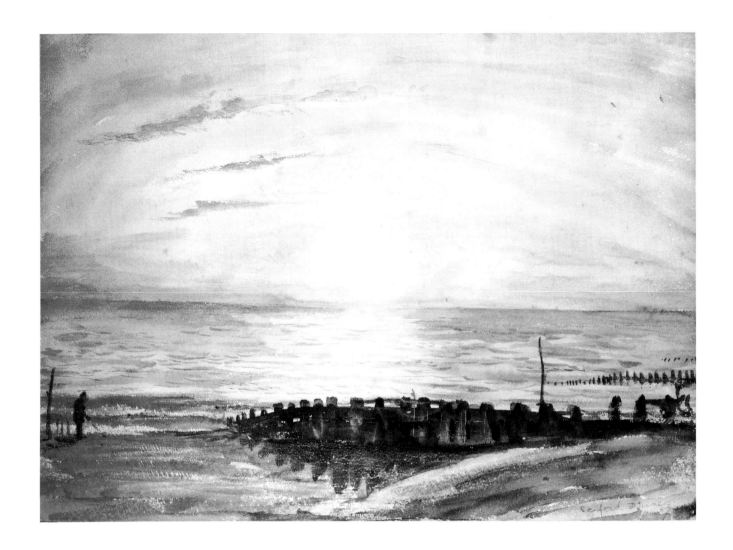

1 See John Rothenstein, 'James Dickson Innes 1887–1914' in *Modern English Painters: Volume II Nash to Bawden*, Macdonald, London, 1984, pp. 252–63, especially pp. 253–5.

2 See Sigmund Freud, on the sources of religion in 'a sensation of "eternity", a feeling as of something limitless, unbounded – as it were, "oceanic" ' in 'Civilization and its Discontents' (1930 [1929]), trans. Joan Riviere, *The Standard Edition of the Complete Works of Sigmund Freud*, 24 vols., ed. James Strachey with Anna Freud, Hogarth Press, London, 1953–74, vol. XXI, 1961 (pp. 64–145), p. 64.

91 Robert Polehill Bevan
(1865–1925)

Rosemary, Devon

Stamped 'R P B.'
31.7 x 45.7 cm; P. 29–1963

Unlike Innes' *Seaford*, this work of 1915 by Robert Bevan does not appear concerned with questions of the limit of the territory of a nation. However, the view is divided in such a way to suggest why the vocabulary which represents the foliage of the trees, the buildings, fences and, indeed, plots of land has been structured so as to encourage us to shift from one to the other, linking them in imagination as we do so. This linking enables a kind of looking which discourages acknowledging the divisions of the scene from what is not represented, but which none the less marks the site around which a sense of enclosure has been constructed.

The *coulisse* of trees on the right frames the view, doubling the limit of the represented scene. Their position on the paper, rising almost to meet the lines of trees on the far hill enables our eye to travel upwards across the surface, as well as across and round. These two imaginary routes into the scene both tend to arc to the left, the former appearing able to descend the hill at the back, while the latter, with its slightly more difficult journey, leaves us to imagine what ascending that ground might be like, as it turns into the picture along the line of the trees at the side of field. There, to the right of centre, where that line of trees falls away from us, we return to the forms of the large trees comprising the *coulisse*. Thus, we may imagine going around again, the eye tracing out complementary arcs, in a movement which seems easy, given the imaginary grasping of the slightly angular forms which have got us underway.

Such arcing movement may cause us not to notice the river which runs through the scene in the middleground beyond the further limit of the nearest field. Blocked out on the left, by the relatively emphatic markings which define the tree between the two small buildings inside the field's boundary, and to the right, the river seems to blend into the pattern of those other horizontally delimited areas which our eye has been encouraged to tra-

verse. The sense of a passage of the river through the valley is thus minimised, its route, if anything, likely to be imagined as a hemming in of the foreground and middle-distance. We are encouraged either to forget it tracing its way through the scene before us, or to imagine that it keeps us protected, in our slightly elevated viewing position, on this side of the valley.

The traditional identifications of the sources of Bevan's pictorial vocabulary can be understood to confirm a desire to construct a sense of enclosure such as we find in *Rosemary, Devon*. Between 1890 and 1894 he lived and worked at Pont Aven in Brittany, following other artists, among them Paul Gauguin, Maurice Bernard, André Dauchez and, for a while, Vincent van Gogh, who had made of this part of Brittany a site of an imaginable renewal of artistic practice. The dissemination of a notion of such a renewal by an encounter with the supposedly archaic life of the peasants of the regions, a notion belied by the development of tourism which preceded them there, drew Bevan.[1] The difficulties of maintaining that promise of identification, which necessitated the imaginary enclosure of a region which had already been traversed by a complex of political and economic forces, are implicit in his subsequent move to Exmoor, where he lived for the next three years.

Bevan's subsequent association with the Camden Town Group might lead one to imagine that he had renounced this desire for identification with the rural. In a certain sense the painting of *Rosemary, Devon* suggests that he was unable any longer to maintain that notion of the archaic. From 1912, he had been a progressively more frequent visitor to the estate of Harold Harrison, an ex-ranch owner, retired from Argentina. This, in itself a testimony to a *pattern* of colonial trade which gathered its capital for reinvestment back in England, provided Bevan with a retreat from London. This retreat, in so far as Bevan seems to have been more and more glad to take it, suggests that his practice in the city became part of an economy of the survival and maintenance of notions which sustained his paintings of both the city and the country. Scenes of markets, among them horse-markets, notable for a perverse sense of order, were supplemented by the representation of a countryside from which the source of that order might be imagined to be guaranteed.[2]

The disconnectedness of this enclosed scene suggests, however, that this sense of a source of order has become rather lacking in force. A similar failure of a sense of order can be inferred from a passage from W. B. Yeats' poem, *Ancestral Houses*.

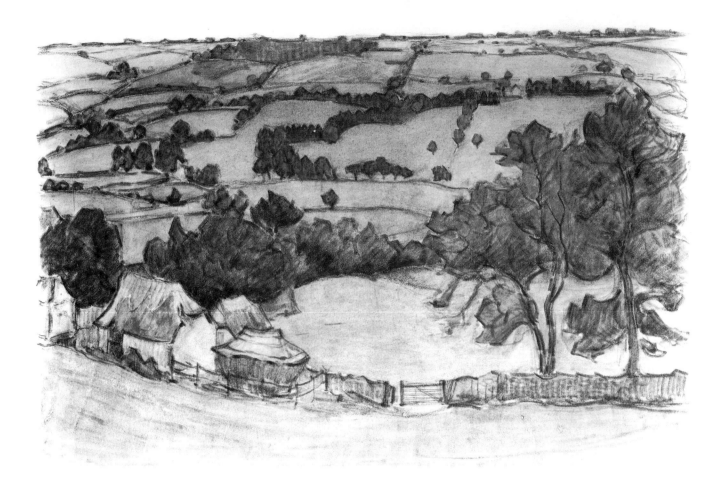

Written in 1923, this text of the remnants of quasi-patrician rule in the countryside is marked by an absurdity which might not have been evident before the war. In any case, the situation in Ireland which marked Yeats' writing renders point by point comparison inappropriate. Nevertheless, the reinvention of a site of order which does not seem to lack vitality is shown to have become difficult precisely because the imagined validity of a hierarchy of acts of establishing boundaries, of enclosing ground, has gone:

> Surely among a rich man's flowering lawns,
> Amid the rustle of his planted hills,
> Life overflows without ambitious pains;
> And rains down life until the basin spills,
> And mounts more dizzy high the more it rains
> As though to choose whatever shape it wills
> And never stoop to a mechanical
> Or servile shape, at others' beck and call.[3]

Not being 'at others' beck and call', being master of what is surveyed, can no longer be relied on, even from within such an estate. As Yeats goes on, these now seem 'Mere dreams, mere dreams!' Bevan relates an anecdote of showing one of the landscapes he had painted at Rosemary to the postman, who is supposed to have said, 'That field is laid out beautiful.'[4] The confirmation, from someone bearing things undecidably from inside or outside the district, might have maintained him in the illusion that there was no illusion here.

1 See Fred Orton and Griselda Pollock, 'Les Données Bretonnantes: La Prairie de la Représentation', *Art History*, vol. 3, no. 3, September 1980, pp. 314–44.
2 See Wendy Baron and Malcolm Cormack, *The Camden Town Group*, Yale Center for British Art, New Haven, 1980, pp. 2–11.
3 W.B. Yeats, 'Meditations in Time of Civil War I. Ancestral Homes' (1923) in *The Poems*, ed. R. J. Finneran, Collier Macmillan, New York, 1983, p. 200, lines 1–8.
4 R.A. Bevan, *Robert Bevan 1865–1925: A Memoir by his Son*, Studio Vista, London, 1965, p. 21.

92 Paul Nash
(1889–1946)

Old Front Line, St Eloi, Ypres Salient

22.2 x 20.3 cm; P.22–1960

Between April 1917, when Paul Nash went as a soldier, and November 1917, when he returned as an official war artist, two battles had been fought at Ypres. In July and September two offensives had been staged by the British and allied armies. These later proved part of a wider advance, pushing back the German front line which, since 1914, had been held across this ground. Sent home to recover after breaking a rib falling into a trench, Nash brought back several drawings of the front, exhibited them, and was returned by the authorities to depict what he called 'one of the most famous battle-fields in the war'. This picture is most likely to have been painted as part of that commission.[1]

In 1916 Nash wrote of the difficulty and the challenge of painting the trenches of the First World War: 'The idea has dwelt so long in my mind and always seemed so impossible that a hint of its realization excited me tremendously.'[2] An idea of some of the conditions under which it became possible for Nash to paint the trenches, and some of the effects of doing so, may be inferred from a well-known and complex example of representability. After the earlier massacres at Ypres, in 1914, 1915 and 1916, and before Nash went back as an official war artist, the place had come to be known as 'Wipers'. This renaming figures the carnage of trench warfare during the First World War as a cleansing, as well as an eradication. It also refigures the place as that which cleanses, as well as that which has been, implicitly, in the disfigurement of the name, eradicated and replaced. The identity of the combatants, from either side, is temporarily put aside to return as having been subsumed into the eradicating and cleansing force of the name. In representing the destruction which took place at Ypres, a refiguring of language takes place, reclaiming the site in the sounds of English, while it reenacts the force of that destruction.

This becoming-representable did not follow the same paths in the painting of Nash. This is not simply because painting had

some other path, already laid out for it; indeed, because of the tradition of watercolour in enabling the identification, the naming of place, there was a barrier. In a letter to his wife, written during his trip as an official war artist, Nash mentions a wood, 'a place with an evil name'. But he does not repeat that name. Naming, as a possibility, is displaced: 'Sunset and sunrise are blasphemous, they are mockeries to man, only the black rain out of the bruised and swollen clouds all through the bitter black of night is a fit atmosphere in such a land.'[3] This displacement, this identification of sunset and sunrise as blasphemous, is ambiguous: naming them may seem so; but they, so Nash says, like blasphemers, are blasphemous. Out of this identification, Nash recovers another name, this time that of 'man', as if it now becomes possible to believe in him, them, him as them, him the victim of their 'mockeries'. These traces of consolation, however, are followed by an account which would render the scene unrepresented to vision, all black, threatening indeed, in a return of the hubris of taking on the identity of being mocked, to choke those who breathed.

The possibility that Nash's work was enabled by the identification with the blasphemed will have to remain a suggestion in this brief essay. The prospect that there might be no prospect, only the indifference of black, suggests, however, that Nash's watercolour is constructed around a possibility of a maintenance of vision, under a threat and even a desire that it be unable to see. This can be inferred from the composition of the scene.

The stretches of land seem to go on beyond the limits of our vision in two senses. Falling away from us into the picture on the right, the edge of the trench, disappearing around the corner, seems unlimited. On the left, rising and blocking our view, looms the other peak of the trench, tilting back towards us as if it might complete that blocking of our vision by burying us. The threat to vision of sunsets and their imaginary control in pictures have been considered above (see entries 40 and 90). Here Nash brings the prospect of a loss of light into a relation with its anticipated return. The moon, figure of borrowed light, not only promises this return, but also, in its bounded, schematic representation, gives us a figure of another region, this time one whose limits we can see.

Nash's later work, other paintings relating to the First and the Second World Wars, is marked by the vocabulary that he developed here. The dissonances of the land and that which marks it continued in different ways. In this work such dissonances arise in the contrast of the former undulating masses and the rem-

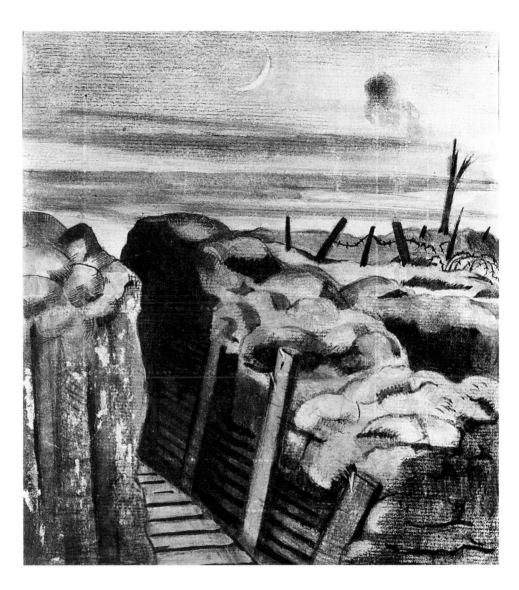

nants of geometry of the posts, with the tree almost reduced to an aspect of that same order; in later works, Nash uses the order of geometry to represent, in prophetic style, the gathered wheat of harvest. His post-First World War work has thus been identi-fied as modernist.[4] The trajectory of his career is complex, but one thing that is suggested by the above consideration of *Old Front Line, St Eloi, Ypres Salient* is that a recognisably modernist vocabulary may be constructed around an anticipation of a loss and a return of vision. Furthermore, what accompanies such vocabularies as modernist, repeatable as a means of construc-tion, would be a displacement, and sometimes a denial, of the possibility of a participation in a drama of destruction that it seems, in that activity of construction, to have gone beyond.

1 See Rothenstein, *Modern English Painters II*, pp. 13–21.
2 Ibid., p. 21.
3 Ibid., p. 22.
4 For a critical account of this see Charles Harrison, *English Art and Modernism 1900–1939*, Allen Lane, Harmondsworth, 1981, pp. 167–74.

93 Edward Burra
(1905–1976)

Back Garden

33.9 x 23.5 cm; P.8–1980

Burra's use of watercolour has been identified as tending towards the opaque, rather than to the translucent. The following version of this draws what, for the traditional identification of the effects of watercolour's translucency, is the obvious conclusion: 'His almost exclusive use of watercolour – probably because he found it easier to manipulate than oils given his crippled hands – is unusual in that it ignores precisely that medium's ability to suggest distance.'[1] This practical reason for Burra's interest in watercolour, whatever its plausibility, tends, however, to reduce that interest. And, as I have sought to show elsewhere in this selection, that idea of distance which has been associated with watercolour painting is an idealisation, an imaginary construction of the limitless beyond that which any particular painting may be identified as representing. This idealisation of distance gives way, when we come to consider Burra's *Back Garden*, to a complex of differences between the near and the far which vision itself does not determine and cannot quite control.

Within the imaginary perimeter of the garden, things are rather crowded. This in itself, however, does not account for the relations between the figures and the things around and between them. As we look and try to infer relations, looking itself becomes something which seems determined. This emerges from a consideration of the differences between the looks of the different eyes, differences between looking and seeing, but also differences in seeing. For it is notable that, among all these eyes, the ones that seem to be looking are those which are the least prominent.

While the butterfly's eyes are large and globular, it does not seem that we can identify what it is looking at or what it might see. It is not flying out of view because it has seen something; it is just flying out of view, our view. This suggests what seeing somebody as looking entails: not simply seeing their eyes, but identifying what those eyes might see. Such an identification requires that we imagine that those eyes can see and that they

can see something which we can see, or can imagine seeing. Thus we might imagine the butterfly after a fly, or the all-but fleshless fish seeing all that is going on above it.

This identification suggests an important relation. To imagine something as all-seeing is to imagine it as all-knowing as well, able to identify all that we imagine that it can see. This presupposes that everything is identifiable, that laws of identity have already been laid down. The position of the man, standing behind the sheet on the washing line, peering out over the top of it towards the women, suggests that, so far as his relation to them is concerned, a law of identity has been determined.

His position suggests that of a voyeur, wanting to see, but not be seen, until his transgressive view of the other is confirmed by its denial or prevention. Hence the pleasure of the voyeur in the glimpse, the partial sighting which would suspend the confirmation of the imagined identity of the other, one which would seem to be given by the agent, imagined or otherwise, who may come to prevent the viewing of the other. The expectation of retribution which the voyeur suffers is thus consequent upon a disavowal of the very identity for which confirmation is sought.

Hence the production and reproduction of shame, the drama of which seems to accompany the man behind the sheet who, with head bowed, may be seen seeing. However, the search for confirmation of identity of the thing seen, which is implicit in the voyeur's position, need not be completed by us. If we were to identify this image by Burra as a comedy of watching the voyeur, the man getting his glimpse of the women on the other side of the sheet, we would be forgetting our part in the identification of what is being seen, what is being looked at, a law of identity in seeing. A consideration of the women, of the positions and their seeing, suggests a further interpretation.

They too could be subsumed into a scene of social comedy. This would be to reproduce certain clichés of identification: that they are gossips, neglecting their work, not really listening to each other, only trying to impress on the other their version of what has taken place. Their gestures may be interpreted to confirm this; gesturing, with arms, with bodies, as if trying to catch the eye of the other, hold them in a look which allows their version of what has taken place to be passed on. The reproduction of this identification, however, would neglect the differences between the positions of the eyes of these two women, and the differences to be inferred within, and beyond, the above scenario.

The woman to the right, seen in profile, gesturing to the left, seems involved in activity, unconscious of the other. The woman to the left, with her pupil nearly emerging from the socket of her eye, stands with her fist clenched, her body held back behind that control of possible force, as if suffering the performance, but also the neglect of the women to the right. This scenario, however, is constructed around the possibility of identifying the woman to the right as effectively blind, unable to see the other, unable to see the tension showing and, by implication, unable to imagine seeing herself perform in this way. Once again, this implies forgetting that we ourselves are participating in the maintenance of a law of identity in these identifications of what is seen. The eye of the woman to the right is perhaps the least noticeable of all of the eyes in this scene. Seeing her in profile, that eye can seem not to see by virtue of our forgetting that we are in her line of vision.

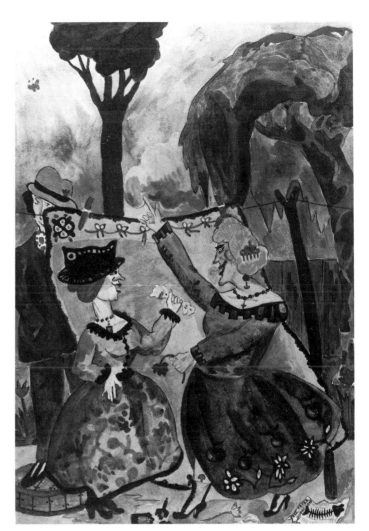

The source of the maintenance of the identity of the other by means of vision thus emerges as an imaginary blinding of the other, one who can be seen and not see. Blindness may remind us that the sighted may, sometimes, not be looking, may even not be looking for that which they want to find, and, indeed, may not see that which they expect to see. Burra's painting of the woman to the right seems to enable us who can see to see, and imagine not being seen by, someone who has forgotten to look, the woman to the right, gesturing, apparently oblivious to the other woman and also, perhaps, to the broken bottle which lies on the ground before her.

'Everything looks menacing; I'm always expecting something calamitous to happen', wrote Burra.[2] The precise sources of this menace may not now be identified. But the fear that emerges here is from a sense of seeing dominated by the look, the search for the confirmation of identity in vision. Caught up in this, the displacement of fear operates around the construction of an image in which the dramas of looking, the confirmation of the identities of men and women, are staged within a limit which turns around the blinding of the other and the playing out of fantasies of retribution. Seeing caught only within this scene, captivated by the expectation of the look, forgets that there is seeing without looking, seeing not necessarily on the way to looking or being seen.

1 George Melly, 'The Art of Edward Burra' in Arts Council of Great Britain, *Edward Burra*, London, 1985, p. 16.
2 John Rothenstein, *Edward Burra*, Tate Gallery, London, 1973, p. 35.

94 Charles Ginner
(1878–1952)

Through a Cornish Window

Signed 'C. Ginner'
43.8 x 28.5 cm; P.8–1928

Born and educated in France, Ginner came to England in 1910, the year of the first of the two exhibitons curated by Roger Fry at the Grafton Gallery, 'Manet and the Post-Impressionists', which were to become influential in the understanding of modernist practice in Britain (see entries 88, 89 and 90 above). It is interesting to reflect, therefore, that Ginner's agenda, which he shared with other members of the Camden Town Group, ran contrary to this influence. In his article, 'Neo-Realism', of 1914, Ginner articulates a position contrary to the classicism and the preoccupation with form characteristic of Roger Fry. The critical sources of this contrary position derive, as can be inferred from the following example, from the tradition relayed, in part, by Ruskin: 'All great painters by direct intercourse with Nature have extracted from her facts which others have not observed, and interpreted them by methods which are personal and expressive of themselves.'[1] This justification of practice, which, as in Ruskin, borrows from other means and ends of observation, leaves the artist in a position of duty, the consolation of which is the addition, exemplified here by Ginnner, of a claim to expressive uniqueness, of having expressed uniqueness. This consolation, however, undermines the very claim to the extraction of facts, leaving art as the corruption of those other processes of observation, which are thereby confirmed, once again, in their preeminence.

Ginner defended against a realisation of this by the appeal to method. Such an appeal may be compared with the similar justifications given of Seurat's practice, from whose example Ginner appears to have derived some aspects of his practice of painting, who, according to Maurice Denis for example, attempted to overcome the crisis of impressionism, its denegation as mere subjectivity, by being 'the first who tried to substitute a considered working method for this more or less haphazard improvisation on nature'.[2] This formation of a double bind in the justifica-

tions of certain practices of modern art, the claim to method as a paradoxical confirmation of the threat of the presence of subjectivity, is one in which Ginner's manifesto is caught.

Ginner's translation from France to England is indicative of an interesting trait in the construction of modernist agendas, and other legislative programmes in general. The legislator can get away with it more easily if they can get away, appear to go back beyond the limit of the inside which they have been instrumental in forming.[3] The interest of this proposition so far as it concerns the works which would be made into examples of those agendas for art is that traces of their nonidentity with such programmes may be discovered. We can infer from Ginner's *Through a Cornish Window* how the topic of his exercise of an apparently methodical practice testifies to a particular fragmentation of the site of his avowal of a modernist agenda, a desire to reconstruct the interior within which that method might be imagined to function. His reproduction of the Ruskinian credo and its prejudicial personification of nature, as if nature were something out there, the certain exterior of these agendas of practice, suggests that the correlative reproduction of the order of nations, which Ruskin was shown above to maintain, threatens to descend into a clamour of demands for autonomy.

The title indicates that the question of a region is at stake. The implication that the window itself is Cornish suggests that such a view enables the projection and reproduction of a notion of a delimited site. The composition of the picture enables this by rendering undecidable the limit of the land beyond the window and out to the left, from over which the sun's light seems to fall. From higher than the upper inside limit of the frame of the panes of glass, the light's own lower limit is not given. The vertigo that this suggests, as if suspended on a ground which falls away and disappears to the left of the view, is counteracted by the rise of hill and by the differentiation of hues, characteristic of Ginner's practice and identified as part of that method mentioned earlier. Their density and intensity hold the eye before this scene outside the window.

On this side, however, there are indications of the construction and maintenance of an interior. Suspended in front of the central vertical of the window frame from the curtain rail hangs the spherical lobster pot. Appearing on the one hand as a sphere and on the other as a receptacle in which to trap and bring back inside that which lives not merely beyond but across the limits of the land and sea, it conjoins the predominating effects of this scene in a way which supplements the rest of the picture. For

while we may infer the absence of the limit of the outside which helps to maintain our imaginary position on the inside, the pot presents us with traces gathered into a delimitation of an inside the outside of which we can see.

This side of the plant, which performs another such bridging role, the part of the chair in view would appear to be the culmination of this effect of the construction and maintenance of the position of the interior within a secure exterior. It is strange to note, therefore, that the fall of light on it seems not to square with the construction of the exterior outlined above. The curtain behind it, marked too by an excess of light, does not block the illumination of the edges of the chair. It is as if there might be another source, out to the left, through another opening of the interior which we are not shown. In any case, perhaps this does not grate very much. The chair, into which we might imagine sitting, turning our backs on the view out of the window, including the windows of the building opposite, may be imagined to receive us.

This final suggestion of the construction and maintenance of the interior suggests how the notion of a region comes about: somewhere the borders of which may be given from without and yet would not, were it to be granted its separate identity, debar access from within the greater whole. This suspended identity, along with the suspension of a realisation of that fragmentation mentioned above, is kept at bay by Ginner's painting.

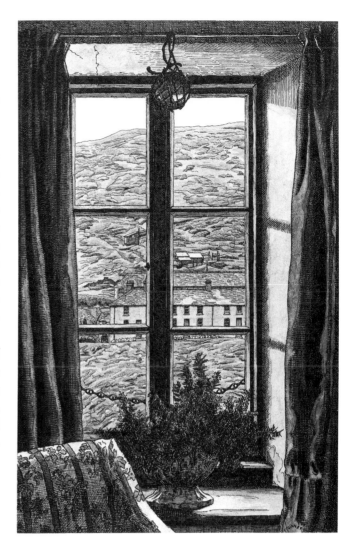

1 Quoted in Simon Watney, *English Post-Impressionism*, Studio Vista/Eastview Editions, London, 1980, p. 118.

2 Maurice Denis, 'From Gauguin and Van Gogh to Classicism' (1909) in Francis Frascina and Charles Harrison, eds., *Modern Art and Modernism: A Critical Anthology*, Harper and Row/The Open University, London, 1982 (pp. 51–5), p. 52.

3 See Bennington, 'Postal politics and the institution of the nation' in Bhabha, ed., *Nation and Narration*, pp. 131–2.

95 David Jones
(1895–1976)

No. 1 Elm Row

Signed and dated 'David Jones 1927'
55.9 x 38.1 cm; Circ. 2–1940

Between 1915 and 1918 David Jones, as a soldier in the Royal Welsh Fusiliers, was stationed in the trenches. Later, in a posthumously published text, he came to make the following connection between his experiences of the war and his later painting: 'A trench lived in in 1915 might easily "get into" a picture of a back garden in 1925 and by one of those hidden processes, transmogrify it – impart somehow or other, a vitality which otherwise it might not possess.'[1] The emergence from latency of these memories, which were later to become the topic of the first of his two book-length poems *In Parenthesis*, is accompanied by what seems to be a denial. For to come to associate the trenches with vitality, and not with death, either required those memories to be separated, permitted to return only as the denial of death having taken place; or the supposed vitality of the paintings which he produced in the 1920s was actually something other than vitality as well.

No. 1 Elm Row suggests that the latter was the case. Although this seems more likely to be a picture of a front garden, if garden it is, it shares with those earlier pictures of back gardens – the first of which was done at his parents' house in Brockley, South London in 1925 – an elevated view from which to view something outside a house.[2] It would be a simplification to say, however, that this painting, among others, implies a viewing position inside some house or other, as if Jones only had to find himself received by others in order to recover and rework his memories. Indeed, because of the withdrawal of possibilities of recognising the destruction which had taken place, the return seems to have entailed an extended period of latency. The discovery of possibilities of the representation of destruction and loss seems to have entailed a reformation of those sites, of gardens and interiors, before the sense of vitality which Jones mentions could seem to have returned.

The scene is constructed as if to receive our sight falling into it. Things only become identifiable as we pick out the path, the trees beyond and the house to the right. From this upper limit of identifiability, there is a descent towards what we recognise as the ground, the path and the part-marked area to the right. That part-marked area, partly unmarked, brings us to a limit of identifiability as well, as if there were a void beneath us. This effect of vertigo is countered by the painting of the lower left-hand portion of the image. Here, the left-most area, with its downward, more continuous strokes, allows us to recapitulate descent. The interval between this and the smaller, more broken marks, some of which appear to have been made upwards across the surface, interrupts this descent, encouraging us to draw back.

The identification of this portion of the image as a curtain and perhaps the surface of a descending wall would enable us to close the scene, an imaginary exterior to an imaginary interior. In doing so, we would forget this effect of a drop and the temporary loss of the possibility of identifying traces with things. Furthermore we would miss an opportunity to acknowledge that whatever sense of vitality this picture may impart is a consequence of that imaginary participation in the image, one aspect of which is that fall and the consequent imaginary loss of sight of this scene.

The return of the trenches in some Jones' paintings of the 1920s was thus mediated by the construction of a possibility of imaginary loss of vision, an activity which included the imaginary loss of the possibility of enjoying that activity, of becoming the agent of its destruction. This movement of reincorporation of the destruction of the First World War, the painter's (unacknowledged) identification, made possible the sense of vitality which he received from his work.

Furthermore, it enabled a greater recuperation of those earlier events. *In Parenthesis*, begun in 1928, is a complex narrative, not least because it keeps slipping from one present tense to another, sometimes into texts of legend and mythology as if back in time, if not before it; sometimes beyond something having taken place, which is now recalled. One of the things which escapes this shifting of present tenses is the trench. As in the following description, however, it does so by appearing itself to have shifted, unstable at the height and at its depth, recovering an equilibrium to enable the action to continue:

Small hung-edges, and under-cuts, things just holding, things ripe to fall, crumpled, caved, redistributed their weights, established a fresh sequence of stresses, found a level – and small gulleys filled, and high projections made low.[3]

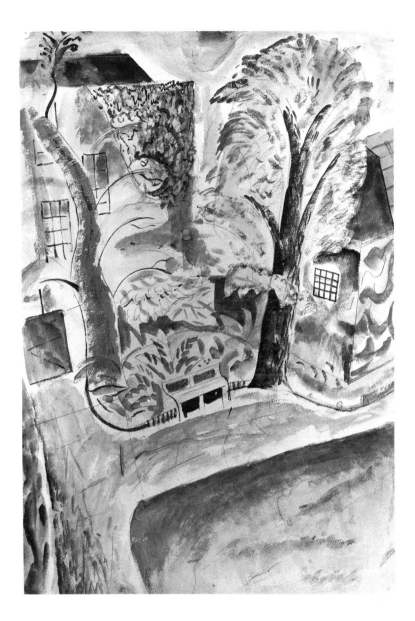

This text recollecting the trench presents it as giving a ground only as a temporary support, a ground which is a combination of things rising and falling. Such a recollection of instability and the destruction of which it was a part was made possible by paintings like *No. 1 Elm Row* in which losing sight by falling, being received into the ground, had been rendered imaginable.

1 Jones, 'Art in Relation to War' in *The Dying Gaul*, p. 140.
2 See Tate Gallery, *David Jones*, pp. 82–3 (entries 32–6).
3 David Jones, *In Parenthesis* (1937), Faber and Faber, London, 1982, p. 86.

96 Gilbert Spencer
(1893–1979)

Winter Landscape seen through a Window

Signed and dated 'Gilbert Spencer 1936'
44.8 x 57 cm; P.6–1938

By 1936, when he produced this work, Gilbert Spencer had been Professor of Painting at the Royal College of Art in London for about four years. Although he taught in the city, he spent as much time as he could outside it. As he puts it in his *Memoirs of a Painter*, he was a 'born countryman'. Given this example of his work, it is perhaps surprising to read that he went painting outdoors as often as he could, 'chasing the events': 'Not that I was a purist about the subtleties some feel regarding the changing light, but I very rarely touched a landscape indoors.'[1] There he would paint 'plain air', he says. This translation and displacement of painting 'en plein air' suggests a number of things about Spencer's practice. Missing here is that sense of 'en plein air' of being captivated by the intensity of something seen outdoors. Having to 'chase the events', Spencer is admitting to not having been so caught, not following the 'subtleties' of 'the changing light', not captivated, a bit bored. These admissions slide through under the guise of a claim of straightforwardness, honest as the day is long, just painting plain old air, presumably having given up chasing the events.

Spencer's *Memoirs* provide a further framework for considering *Winter Landscape seen through a Window*, a framework by means of which the part played by the framing of the view through the window may be interpreted. He begins chapter twelve with an account of midwinter at his and his wife's cottage in Upper Basildon in Essex. After having described how far south one could see from the heights nearby, over the Chiltern Hills, into Berkshire, occasionally as far as Hampshire, he goes on to describe a scene of concern for a more limited vision: 'Several of our windows were newly leaded. With the exception of one in the old part of the cottage, which had G. Evans 1888 scratched on it, we had them changed, so that when opened we felt we were out of doors. In winter I drew and painted many pictures from these windows.'[2] Disliking the 'modern studio' he had set up in the garden, maintaining that he was 'no "studio" artist', Spencer's replacement of the windows was thus none the less part of a desire to maintain some relation with the outside.

The opening of the window in the image creates a number of different effects. The upper part of the inside of the frame appears to catch the light. Not a subtle effect perhaps, but it does suggest something happening in what is otherwise a rather still scene. The contrast with the shadowed portion of the frame of the right-hand pane tends to draw the eye to this part of the image. Shifting across this area of contrasts, there is an effect of something else happening too. The lines of the branches of the tree, crossing the surface on either side of the shadowed frame, become another kind of event for vision, one which we cannot see for sure, but which appears to be happening to us. This break in the line of something, concentrated at this point, is a kind of reinclusion of the effect of taking in this illusion, taking it to be part of the room which it appears to represent.

Spencer's pleasure in an extensive prospect which, during winter, he was less able to enjoy found a consolation in representing the frame of the window and of doubling its effect. That pleasure of being able to move in order to compose the sight of something through a window, interrupt it, give yourself a view of part of it, is the pleasure of being able to imagine it whole. This concerns not only the tree, but also the very exterior of which it itself is a part and which Spencer wanted to let – one might say, *draw* – into his site of confinement.

This construction of an interior traces out a desire for another captivation, by something elsewhere, outside. Such a reaction to the minor modernisations of the house which Spencer and his wife went in for might seem insignificant. But, just as the inscription, 'G. Evans 1888' was left in this domestic project, so this image carries with it traces of a past which supplement that apparent lack of the present. On the window-sill, the book rests open. Overlapping the inner edge of the sill, and with the wrought scroll of the window catch resting on one of its corners, it seems to cross the limit, not only between inside and out, but also between the past and the present. Somewhat ossified and, like the form of the catch, rather *passé*, according to the tenor of the interior, this volume of possible inscription none the less remains as testimony to a past which is not all effaced in the events of the present. Like the name and date left engraved on the window, this volume indicates something of Spencer's ambivalence about projects of the modern.

1 Gilbert Spencer, *Memoirs of a Painter*, Chatto, London, 1974, p. 118.
2 Ibid., p. 124.

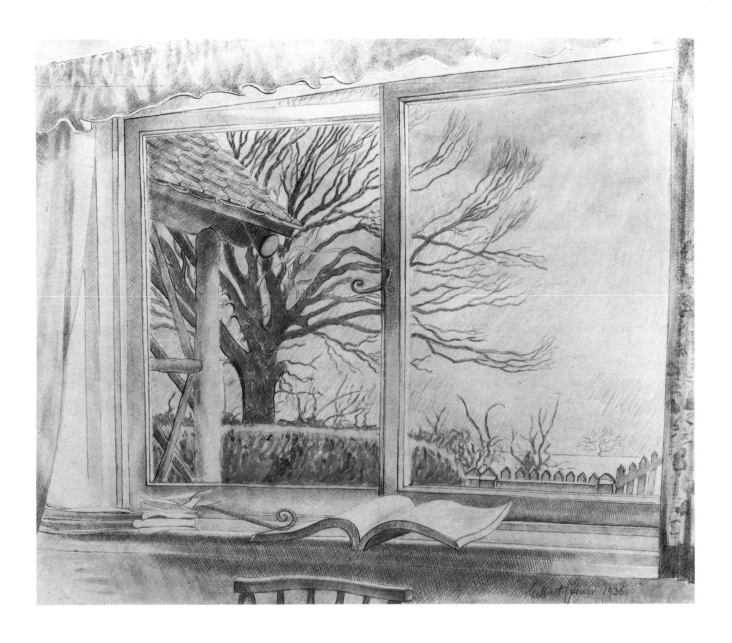

97 Edward Bawden
(1903–1989)

'Christ! I have been many Times to Church'

Signed and dated 'Edward Bawden 1933'
46.1 x 68.4 cm; P.15–1964

The scene appears strangely enclosed. To the left, the thick, shadowed hedge and overhanging trees form a dense border. Around, towards the back of the churchyard, the trees interlace. Even the pathway running past the church to the gate at the back seems to conclude there. Large trees rise up to the left and right towards the sky, seeming to obscure much of it. The sky hardly appears distant; a woven pattern of white and blue, neither of which gives a certain impression of being further away than the other.

The sky and the foliage seem substantialised, as do the shadows on the trunks of the trees. Paradoxically, this tends to suggest the relative insubstantiality of that on which the shadows fall, apparently etched into the surface of things. This sense of insubstantiality marks the church and the gravestone nearest to the tower. The church, despite being framed by the trees, and delineated so carefully, is flattened, its roof rendered difficult to pick out. The deep shadows in the windows and doorway seem to mark the inside of an exterior which seems to lack a certain interior. And with the gravestone also apparently bleached by light, this enclosed scene comes to be seen marked by absences.

Bawden painted this watercolour in 1933 while he was living at Brick House in Great Bardfield, Essex. Returning to the county of his birth, from London, he had rented the house with Eric Ravilious (see entry 98), whom he had met at the Royal College in the 1920s.[1] Bawden's work had been varied: murals, book illustrations, posters for London Underground, the Empire Marketing Board and for railway companies and airlines. He had also produced posters for Shell, representing different places in the countryside, accessible, but separated from towns and cities.

These particular incitements to travel by car had to negotiate this central paradox, of being accessible but separate. The destinations recommended by advertising had to be represented as aims which could be included within the orbit of the car; yet, if the project of recreation, the project of motoring for leisure, was to succeed in fantasy, those destinations also had to seem separate from that orbit. Journeying from place to place needed the destination to become recognisable in such a way that a return could be expected, one which would allow the traveller to return to a life which itself remained recognisable. This *limitation* of the effects of journeying is part of an ideology of the mere expansion of a network of travel, taking in more and more sites and places.

The interests which this served can be inferred from an example. On a poster of 1932, designed by Bawden, the slogan 'Stoke-on-Trent but Shell on the Road' was used.[2] The connotations of spillage and pollution are perhaps obvious now: what hid them then was perhaps the construction of an imaginary network which, segregating points of destination and departure, promised a command of the 'links' in between. Even now, if the fantasy of this network, constructed around the apparent substitutability of *names*, is not recognised, then the loss of command of those links still seems to be secondary, a mere upset in the prospect of expecting to be able simply to traverse a link, without leaving a trace. Shell wanted its customers to return, both to their point of departure and as customers, and doubtless still does. Its name names the route, renders it legible, offering a fantasy of a command of a network, an authority which would control the possibilities of travelling as a return to the point of departure. Such an appeal offers the motorist the fantasy of recreating and reproducing a life and its limits, despite the prospect of its extension.

Images like those by Bawden for Shell thus worked in a number of different ways: as framings of route and of destination; as images rendering certain sites recognisable; as sanctioning the interest in those forms of recreation by means of an interest in visual art, thus legitimising the novel pursuits of motoring for leisure; and thus, perhaps the most significant of the connotations of the images deployed in these advertisements, a sense that these new activities could be pursued without disrupting a certain continuity, a continuity suggested by the apparent traditionality of the means used by such artists as Bawden.

This painting, although it does not seem to have been a reaction to a specific commission, may be interpreted in the light of these above interests and effects. Bawden's involvement was not simply one of complicity. Such a notion requires will and decision. There are indications, however, of a common determination of the redefinition of the rural in a desire for an enclosure, one constructed around a repair of the damage which contact within the increasingly interdependent structure of city, town and country threatened. When Bawden writes, in 1929, of his and Ravilious' discovery of a church in a village in Essex, on

their search for the retreat, which Brick House was later to become, the desire for enclosure emerges:

> The day [Ravilious] arrived we biked out to a place five or six miles away, which I had been keeping in my eye for some time. It is a small village, with a fine church, in front of which stands a duck pond diapered over with ducks, and overshadowed by elms; the whole enclosed in a semi-private manner.[3]

The imaginary containment *within* the eye is supported by the production of a notion of the whole. The duck pond 'stands'; not sunk, not permeable in its depths; with the ducks covering it, repairing the outer limit like a nappy, containing a possibility of leakage. The 'semi-private' enclosure thus contains and tends to suppress traces of nonenclosure, an apparent lack of privacy, a failure of limit.

At Brick House, Bawden and Ravilious refashioned and reworked the exterior and the interior: relaid the garden, hung new wallpaper, which Bawden had been designing since 1925, painted woodwork with waves, mermaids, foliage and fruit.[4] Like Charleston (see entry 88), the house became a complex of traces of the exterior on the interior, as well as a reforming of the exterior according to the vocabulary of the interior. Such a crossing of domains, as if repaired by their remarking, a remarking apparently dedicated to the end of the construction of a possibility of a retreat (a place which would appear to guarantee return), is at work in *'Christ! I have been many Times to Church'*.

The pathway which runs through the churchyard, past the church to that occluded perimeter noted above, also runs back to the front right of the image. The figure of the woman standing over the edge of the path, turned towards the church,

enables a kind of enclosure to be brought about. With her back turned, facing away to our right, we may imagine passing into the churchyard before us, initially without being seen. On our return, however, we would come into her view. But the possibility that we would interrupt her, prove unwelcome, is displaced and compensated for. The fall of her shadow across the path creates a boundary. The same light which renders the gravestone and the roof of the church all but absent provides this shadow, which, in its apparent presence, like the rest of the shadows, supplements that absence. Figuring an imaginary compensation for her possible condition of being in mourning, of grief at loss, the shadow also binds the opening of the scene by the pathway. Her apparent captivation by the view allows us to retreat, withdrawing our gaze, as if in respect.

These effects are latent in the title. The phrase, 'Christ! I have been many times to Church', may be imagined, as an utterance, to be ours or hers. As ours, it enables that withdrawal, either as a statement of sacrifice or protest. As hers, it becomes the possibility of her retreating, breaking her captivation, removing herself from the scene, leaving it behind in a condition of imaginary enclosure which she has been instrumental in creating. Such a fantasy of the repair of the limits of an exterior, with its deployment of the figure of a woman as the guarantee of its interior, is part of that fantasy of the reproduction of structures of life outlined above.

1 See Rothenstein, 'Edward Bawden' in *Modern English Painters II*, pp. 300–12.
2 Ibid., p. 303.
3 Ibid., p. 306.
4 Ibid., p. 306. See also Douglas Percy Bliss, *Edward Bawden*, The Pendomer Press, Godalming, undated, pp. 70–9.

98 Eric Ravilious

(1903–1942)

A Farmhouse Bedroom

Signed 'Eric Ravilious'
45.1 x 54 cm; Circ. 284–1939

Like Bawden, Ravilious worked in a variety of ways for different organisations. As well as watercolours, three exhibitions of which were held during the 1930s, Ravilious produced book illustrations. He also designed for interiors and the theatre, and painted murals at, among other places, Balliol College, Oxford.[1] Given this variety, there is a tendency to interpret his work stylistically, tracing the apparent repetition of marks from one instance to the next, as if this ensured that there was a unity to his activities. *A Farmhouse Bedroom* might be used as a guide in this respect, as if an image of an interior, with its wallpapers, floor-coverings and furniture, were a pattern book by which we could learn to recognise the products guaranteed by his style, a key to a nostalgic reconstruction of 1930s interior decor.

To do so, however, would be to neglect what that construction of a style depends on. The effect of style is in its repeatability, from one site to another: from within an image, to an interior; or from an interior to an image. The consequence of an effect of style is therefore an effacement and forgetting of an alterity, an assimilation of one thing to another. To regard this image by Ravilious as that pattern book mentioned above is to assimilate it, by means of a notion of style, into an imaginary totality: of his works; of his style; of interiors, more or less actual and imaginary.

The fantasy of a closed, but occupiable private space that this assimilation produces may be unravelled. Indeed, once it is acknowledged that Ravilious' image presents us with a scene from an imaginary viewpoint slightly to the right, enabling us to look down the length of the corridor created by the partition of the space to see that there is, at the end of that corridor, no exit, the desirability of that closed space dissipates, along with its conditions, the assimilation of space to space, site of image to site of viewing. The pleasure that our eye may have had in shifting from one mark to another, following a pattern, breaking into

another, imagining their continuation elsewhere, turns into a realisation of having participated in the imaginary completion of a space. To reflect that this scene, with its implied source of light somewhere to the left of us, creating that wedge of shadow to the right of the partition, is like nothing so much as a theatrical set is only to defer the realisation of participating in this construction. For to imagine this scene as the site of the other as actor is to suspend realisation of the actor as other, as not merely someone ready to play out our fantasies.

If we go back to the way in which our eye has followed the pattern, created a sense of space out of the weave of different surfaces, we may realise that in the process the differences between the marks have been passed over. Reaching the edge of what looks like the corner of a rug in the right foreground is already to have assimilated these different marks and the spatial difference between them. This may be felt in the shift from area to area, the sense of dissonance being, in part, the recollection of this homogenisation. The possibility that this may provide the occasion for a judgement that, here, 'things clash', that the decor does not harmonise, may thus be recognised as part of the attempt to close off this scene, dismiss it, once again, as that pattern book, even if this time a discarded one; a discarded pattern for the dream of a perfectible interior.

The bed provides an apparent relief for the eye, an interruption to following the traces of pattern and pattern. The plain white enables the eye to run more quickly over the surface. This is partly responsible for the effect of ambivalence which the bed creates. For while the eye tends to move quickly here, the bed itself would seem to offer a place of rest. The dissonance of these two creates the ambivalence, as if one were only being invited to allow the eye to shift back to the surfaces from which it has come. The dissipation of an expectation of rest renders the bed as much a site of capture as the room. The climb of the eye up the length of the bed to a position of rest from which we might look back thus becomes undesirable, the disembodiment of that eye becoming all the more insistent an effect.

Capture within this scene, of one or other imaginary kind, thus becomes the occasion for reflection on the possibility of that capture. The agitation felt by the eye comes to be interpretable as a kind of affirmation of differences within a space, a way of coping with confinement. This suggests that judgements of taste, against such interiors, tend to forget the reanimation which dissonance sustains, even if in so doing it risks merely recreating a site of captivation.

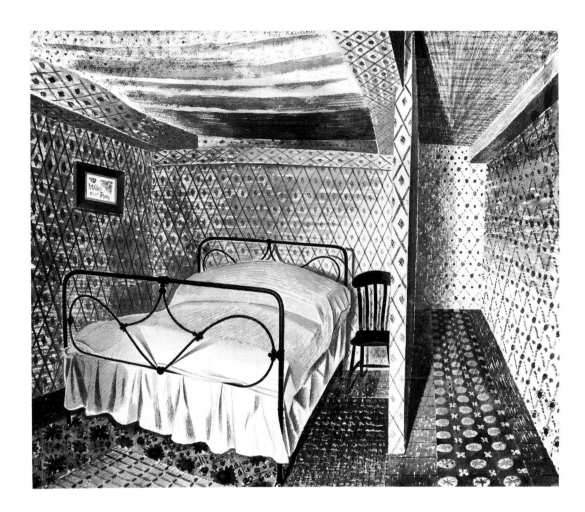

Ravilious' image, however, testifies to this effect too. The doubling of the frame of the image by the frame of what appears to be a small tapestry, hung on the wall to the left of the bed, with its decorated corners and unreadable text, includes this text for the other, the other who is not present, but who might be, unlike us, caught within this scene. No doubt that is why such tapestries, bearing texts of so-called homespun wisdom, are included in rooms. That so often they carry messages of hope, or faith, is testimony to the despair and lack of hope that they expect. Unreadable to us in this image, however, we are left to imagine what the consolation might be for having been trapped in such a scene, acknowledging the effect of resignation that this frame within the frame creates, an effect which this image by Eric Ravilious goes beyond.

1 Freda Constable and Sue Simon, *The England of Eric Ravilious*, Scolar Press, London, 1982, pp. 21–30.

99 John Piper

(1903–1992)

The River Approach, Fawley Court,
Buckinghamshire

Signed and dated 'John Piper 1940'
37.8 x 53.3 cm; E. 1150–1949

This watercolour by Piper represents a gateway on the edge of an estate of a house notable for being one of the few examples of domestic architecture by Christopher Wren. The first house had stood derelict for forty years when, in 1682, Wren redesigned it and had it rebuilt. It is thus remarkable that Piper decided not to represent that building by one of Brtiain's most revered architects, but instead this quasi-classical structure on the periphery of the estate. This is significant in suggesting some of the tensions within the project which came to be called 'Recording Britain', which was the commissioning occasion for this work.

Sponsored by the wartime Ministry of Labour and National Service, the project was coordinated by representatives of the Royal College of Art, the National Gallery and the Royal Academy, who were responsible for employing 97 artists, who produced 1,549 works, representing sites in almost all counties of England, Scotland and Wales. These works were reproduced and published in a series of volumes, accompanied by commentaries on the places represented, by the Pilgrim Trust.[1] Like the National Trust and the Council for the Preservation of Rural England, the Pilgrim Trust was established to protect and conserve sites that seemed under threat of erosion, decay and destruction. Following the outbreak of the Second World War, the lobby of the Pilgrim Trust found that its interest had come to seem identifiable with that of the nation.

In the introduction to the first volume, published in 1946, the chairman of the Trust, Lord Macmillan, reaffirmed this. The commissioned artists, he says, had been 'invited to make a number of topographical water-colour drawings of places and buildings characteristic of national interest, particularly those exposed to the danger of destruction by the operations of war'.[2] This

post-war reaffirmation of a notion of a national interest did not, however, seem easy to make, particularly so far as it concerned such sites as Fawley Court. The text which accompanies Piper's image refers only in a rather perfunctory way to what it represents, calling the arch 'graceful'. A long account of the history of the house precedes this, noting Wren's part, giving a long and enthusiastic description of the interior, concluding with a dismissive account of the follies and ruins in the garden. These and that arch are summarised in the last sentence of the account: 'These "picturesque" features are of varying dates, but may be said to be, for the most part, about a hundred years younger than the house.'[3] All these elements are somewhat extrinsic to the interest of the writer, who preferred to forget that exposure to destruction which the end of the war displaced, but did not conclude, concentrating them into the 'picturesque' additions, repeating that formation of the picturesque as the object of the displacement of a desire to destroy (see chapter 7 above).

This version of Fawley Court is not quite Piper's. For although it uses a vocabulary which may be identified with the picturesque, pen being used to emphasise certain edges and irregularities, the gathering of flora around the arch does not seem to present an inevitable threat. This is mostly because of the effect of the fall of light on the arch, rendering it simpler, less marked, and easier to separate from the encroaching growth. Indeed, the contrast of light on and beyond the arch with the shadow within it tends to absorb those connotations of destruction into a sense of the definition of this structure which straddles the edge of the estate.

It is notable that this scene appears to represent the view looking out of the estate. With the River Thames lying somewhere out of view, beyond the perimeter, the view that Piper has represented puts us in a position of being able to observe the entry of others into the estate. Such a decision is part of a suspension of the urge to destroy which is a key effect of Piper's work. In this case, its suspension turns into a position of watchful observance, as if put on guard, waiting for an intruder. The prominence of the round aperture in the inside wall of the gateway, just above that area which might provoke greatest alertness, of observation in anticipation of an invader, allows for a displacement and dissipation of that tension. The window both lightens the shadows and enables the continuance of a view. The corresponding danger, of being framed for the vision of another by this aperture, like the danger of being so framed by the arch, is minimised by the viewing position, somewhat off to the right.

Piper admitted that he liked painting old buildings, adding that 'sitting down to paint a new house would give me the same feeling as sitting down to paint a new-born baby. It's just one of those things I'd rather not do.'[4] The implied interest in the marks of the passage of time – marks which, for Piper, a new house or a baby seem to have lacked – is necessary to the possibility of the displacement of an urge to destroy. A sense of their absence risks the nonrecognition of this urge. Piper's 'Recording Britain' commissions thus sustained his preoccupations, but at the risk that they remained unrecognised, subsumed into ideologies of British identity and interest. The notion that there is a national interest which precedes war is a fiction which the effect of its production, the displacement, suspension and imaginary redirection of conflict in works like these belies. The notion that there is one national interest after war forgets its production and risks remaining blind to the differences of interest which often go under that unifying title.

The project which became known as 'Recording Britain' had initially been proposed under the heading 'Recording the Changing Face of Britain'. The editorial interests at the end of the Second World War which brought about this change betray the desires to forget and suppress change and conflict. This painting by Piper suggests that survival requires the recognition of both.

1 The Pilgrim Trust, *Recording Britain*, ed. A. Palmer, 4 vols., Geoffrey Cumberledge/Oxford University Press, London, 1946–9.

2 Lord Macmillan, 'Introduction' in Pilgrim Trust, *Recording Britain*, vol. I, pp. v–vi.

3 Ibid., p. 168.

4 From 'Buildings in English Art' (1941) in Tate Gallery, *John Piper*, London, 1983, p. 38.

100 Frances Hodgkins
(1869–1947)

In Perspective

Signed 'Frances Hodgkins'
51 x 65.4 cm; Circ. 285–1939

Painted in 1936, *In Perspective* is one of a number of paintings, in oils as well as in watercolours, which Frances Hodgkins painted in the later part of her career and which differ importantly from her earlier work. But the changes in the general appearance of paintings by her from the late 1920s onwards, when, as a member of the 7 & 5 Society, she came into contact with an incipient *avant-garde* formation, cannot be assimilated to a notion of a development from representational towards the nonrepresentational. Her works before this time, painted in New Zealand where she was born, or Morocco which she visited in 1901, or Paris where she lived until the outbreak of the First World War, during which time she had the opportunity to follow earlier *avant-garde* formations, are not reducible to this simple teleology of modern art.[1]

There is a shift in her practice during the later part of her career. But rather than construing it as part of a progressive movement of abstraction, a kind of fragment of a larger totality of work done in the 1930s, it may be seen instead as a shift between different vocabularies and different topics, one which enabled a bridging of issues which had previously remained separate, for her but also for others.

It is notable that, during the period towards the end of which *In Perspective* was painted, Hodgkins was urgently itinerant, moving from London, to Essex, Sussex, Somerset and the South of France. Sending work to her dealer, Arthur Howell of St George's Gallery, she also wrote letters to him. In one of these, she relates how she finds the countryside in France beautiful:

But let me tell you that in my humility I have not lifted up my eyes higher than the red earth or the broken earthenware strewn about making such lovely shapes in the pure clear light...you may hear them clink as you unroll the watercolours I am sending along to you by this same post.[2]

This remark about imagined sound, the sound imagined for the receiver, is indicative of an interest in a kind of shifting, here between vision and sound, but one which may also be related to the shifts from mark to mark in a work such as *In Perspective*. This shifting may be understood to relate, in turn, to that activity of travelling mentioned above. But it differs from it, in not being reducible to a list of destinations, an excess of movement which cannot be objectified by any view of a place. Hodgkins' remark suggests, therefore, a displacement of the expectation of receiving an image of place, a view of a site of her location. The relations she suggests between place and its place, the derivation of earthenware from the earth, but also a sense of the temporariness of this derivation, is not to be caught and suspended in a panoramic view. The imagined 'clink' interrupts the capture of vision.

In Perspective suggests a similar resistance to synoptic, commanding vision, to orientation by means of sight above and apart from things. Seeking to identify what the painting represents helps to indicate why this is the case. Perhaps easiest to identify are houses to the left and right, in the distance, and, in a different way, the pot plant nearer to us. The position of this plant, and the marks which seem to comprise it, are interesting: at the edge on the surface, it is quickly recognisable and quickly passed. The part it plays in reminding us of a threshold over which, in identifying it, our look has reached is also marked in the other elements of the image.

The lines which seem to construct that incomplete armature of a house make the plant and its part in the construction of an interior remarkable. With more apparently missing to the left than to the right, there is, between the armature and the plant, an absence of threshold that this plant none the less figures. This gap leaves us uncertain as to whether our eye passes through something which is in the process of construction or not; uncertain as to whether there is yet, or has been, a threshold formed. From this position of being neither certainly inside nor outside, we may imagine that we can resolve our imaginary passage between the uprights of the armature into the distance to the right, past those more recognisable houses. But this imaginary destination leaves us with a series of nearly vertical parallel markings. These are neither descriptive of any certain object, nor unrelatable, as parts of these constructions, to the objects which have been identified.

These undecidabilities, between inside and out and between identifiability and unidentifiability, help to produce the effect of

shifting mentioned above. From house to house, but also from interior to exterior of interior, without a destination beyond, without a mark which neither remarkable as the beginning or end of an outside or an inside, this painting suggests something of the complexity of experiences of finding shelter, but never finding it sufficient. Hodgkins does not retreat to escape, nor construct an interior in which others might be imagined to belong, such as Ravilious' *A Farmhouse Bedroom* (entry 98) suggested. Unlike *The Violin* by Jones (entry 89), the image does not operate with uncertain limits in order to move towards a movement of transformation, a release. The eye passes through, and is discouraged from assimilating, from identifying and including. The possibility of construction is not denied, even while the limits of its aims may be inferred.

As part of his role in presenting Hodgkins' work, Howell titled and categorised some of them. Whether he titled this work I do not know. He did, however, come up with a certain designation which may seem appropriate to this image, a designation of which Hodgkins certainly approved: 'You are very good with titles – do retain that excellent Still-life – Landscape. It is just "It".'[3] The terms of Hodgkins' approval suggest an enthusiasm, and also an acceptance. This positioning of her work, which crosses these categories of still-life and landscape, perhaps in that order, reminds us of the vicissitudes of those categorisations (see in particular chapter 9 above), but also of a perspective which does not expect them, or other possibilities of categorisation to disappear. In the shift between them, in the difficulties as well as the pleasures of those shifts, we may recognise something of which paintings do not speak, but enable us to tell.

1 See Arthur R. Howell, *Frances Hodgkins: Four Vital Years*, Rockcliff, London, 1951, for a general account, one which, however, enables this teleology to be projected.
2 Ibid., pp. 22–3.
3 Ibid., p. 56.

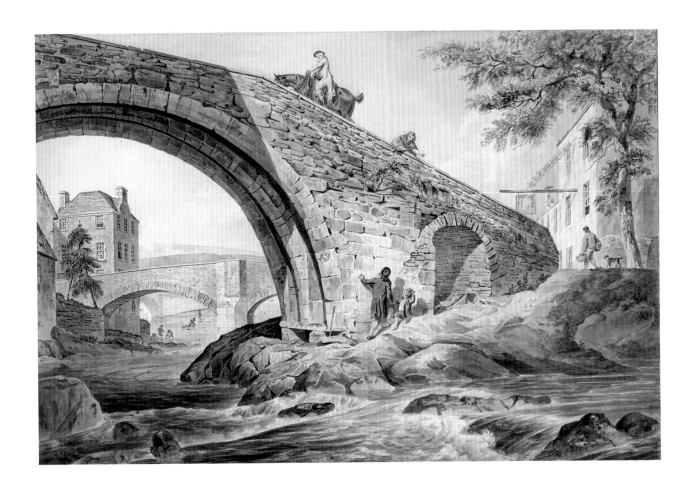

The Round Temple

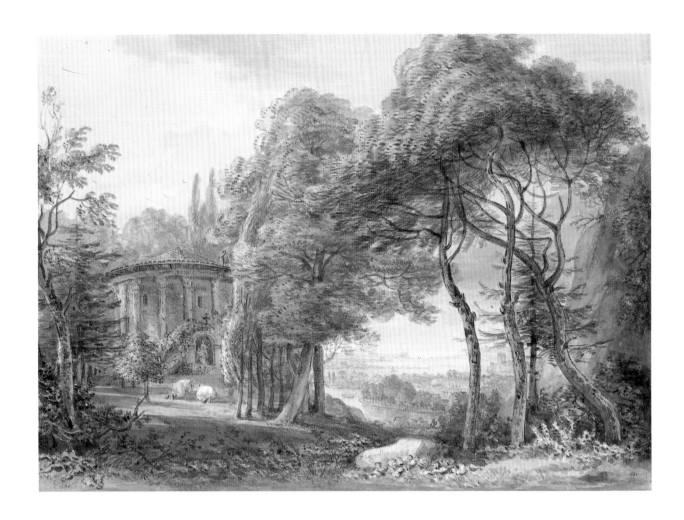

3 John Robert Cozens

Mountainous Landscape, with Beech Trees

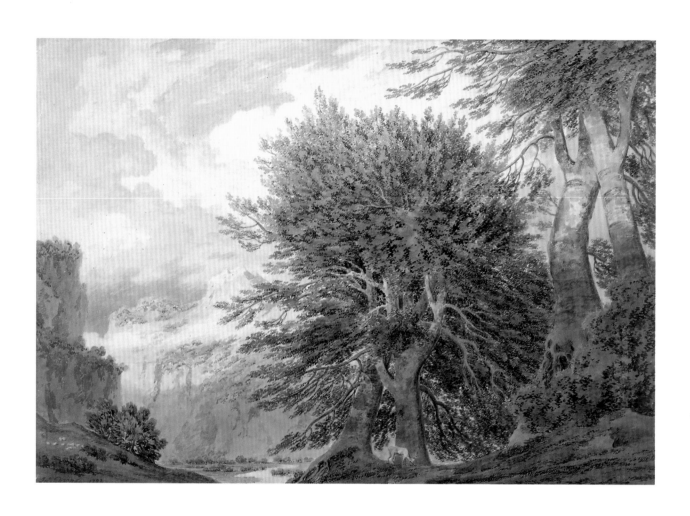

4 John Constable

Stoke Poges Church, Buckinghamshire: Illustration to Thomas Gray, 'Elegy in a Country Churchyard'

6 Thomas Girtin

Rievaulx Abbey, Yorkshire

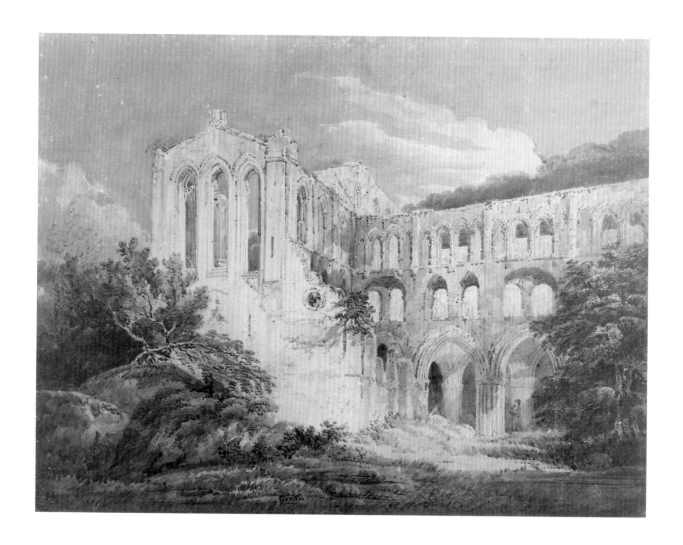

Lyons

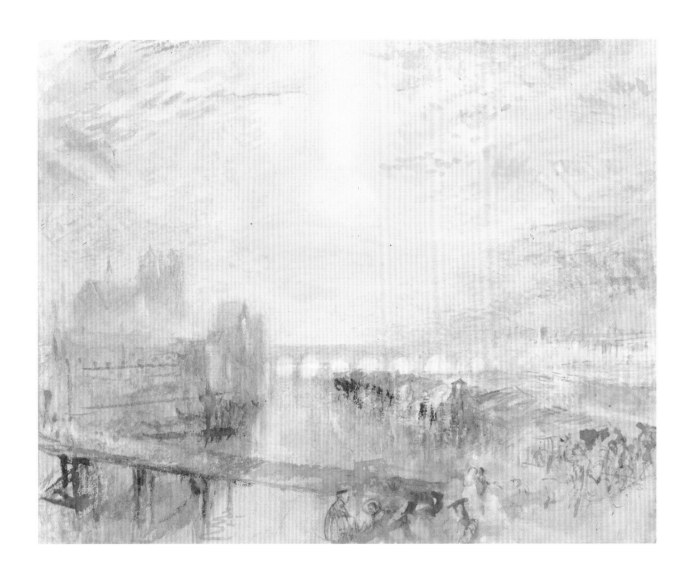

The Eve of St Agnes: Interior at Knole near Sevenoaks

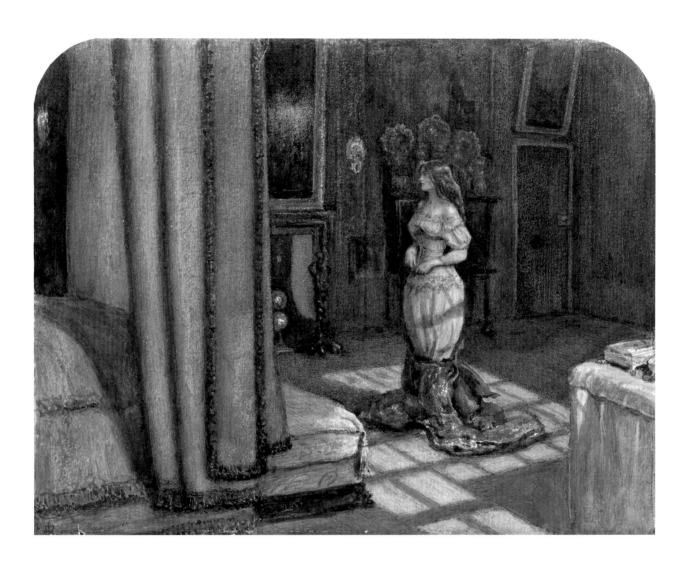

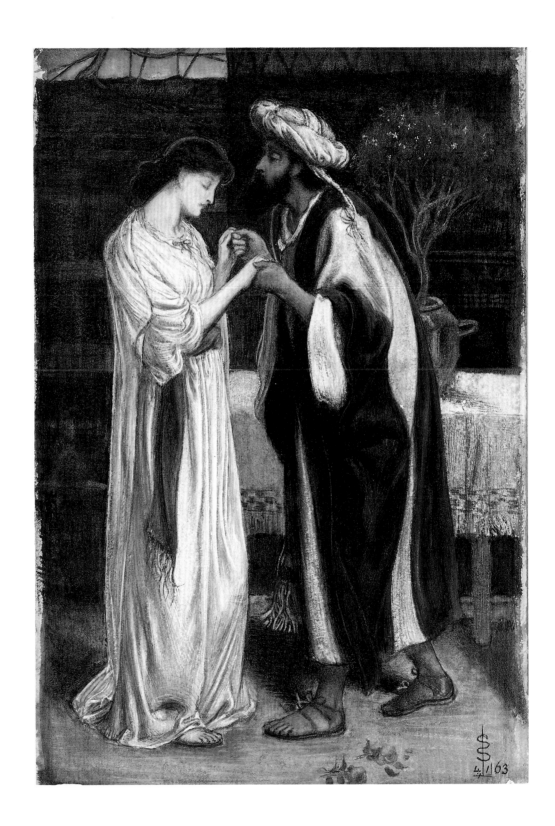

Emperor of China's Gardens, Imperial Palace, Pekin

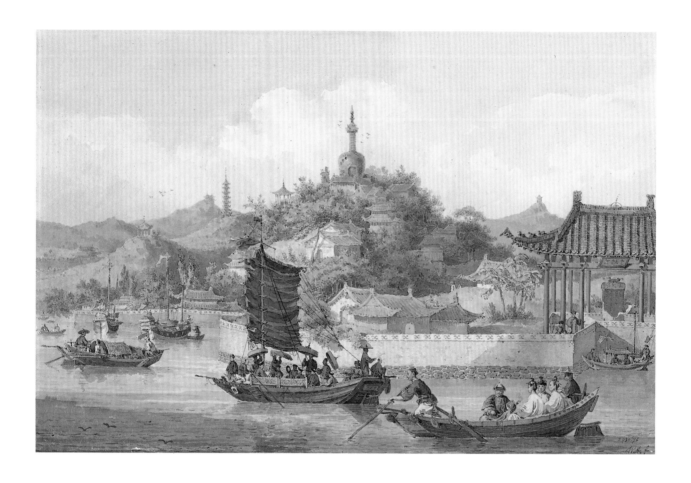

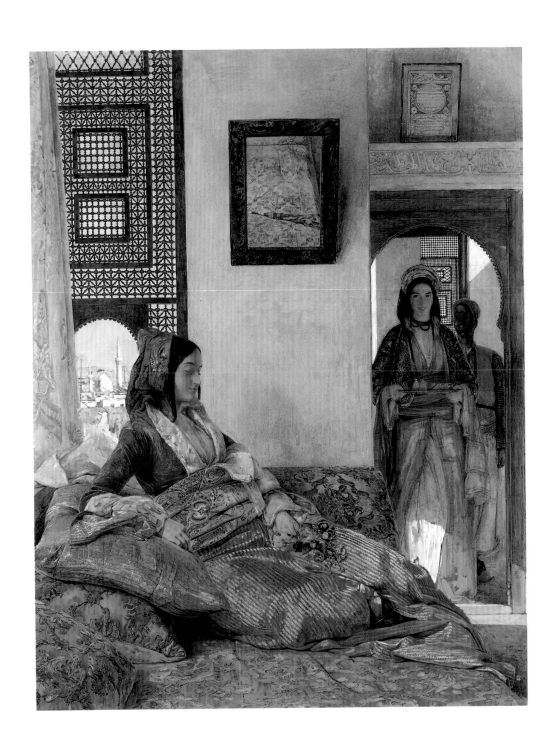

The Market Place, Ross, Herefordshire

Landscape with a Barn, Shoreham, Kent

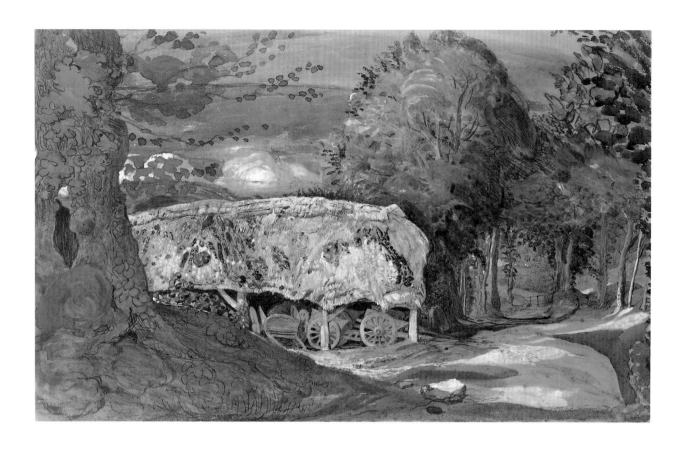

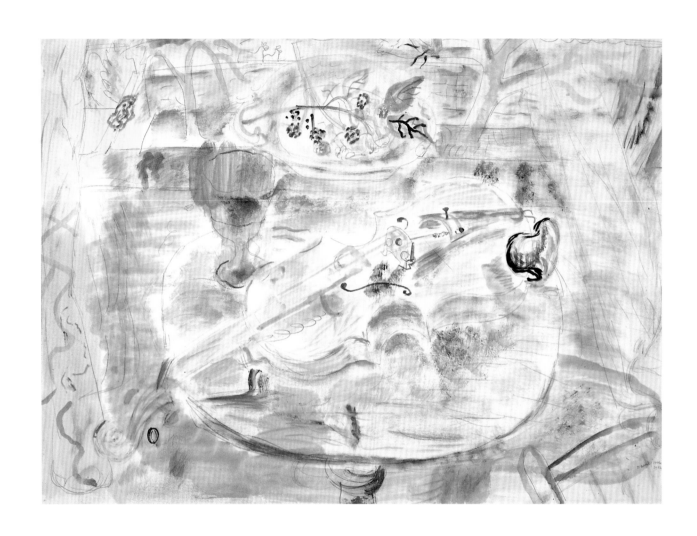

Bibliography

Allingham, Helen and Radford, D., eds. *William Allingham: A Diary*, Penguin Books, Harmondsworth, 1985.

Anderson, Benedict.*Imagined Communities: Reflections on the Origin and Spread of Nationalism*, Verso, London, 1983.

Anscombe, Isabelle. *Omega and After: Bloomsbury and the Decorative Arts*, Thames and Hudson, London, 1981.

Arts Council of Great Britain. *Edward Burra*, London, 1985.

Great Victorian Pictures: their paths to fame, London, 1978.

John Sell Cotman 1782–1842, Arts Council/Herbert Press, London, 1982.

Ballantine, J. *The Life of David Roberts R.A.*, Adam and Charles Black, Edinburgh, 1866.

Baron, Wendy and Cormack, Malcolm. *The Camden Town Group*, Yale Center for British Art, New Haven, 1980.

Barrell, John. *The Dark Side of the Landscape: The Rural Poor in English Painting 1730–1840*, Cambridge University Press, 1980.

The Political Theory of Painting from Reynolds to Hazlitt: 'The Body of the Public', Yale University Press, New Haven, Conn. and London, 1986.

'The Private Comedy of Thomas Rowlandson', *Art History*, vol. 6, no. 4, December 1983, pp. 423–40.

Barrell, John, ed. *Painting and the Politics of Culture: New Essays on British Art 1700–1850*, Oxford University Press, 1992.

Barthes, Roland. *Image–Music–Text*, trans. Stephen Heath, Fontana, London, 1977.

Bell, C. and Girtin, T. 'The Drawings and Sketches of John Robert Cozens: A Catalogue with an Historical Introduction', *Proceedings of the Walpole Society*, vol. 23, London, 1934–5.

Bevan, R. A. *Robert Bevan 1865–1925: A Memoir by his Son*, Studio Vista, London, 1965.

Bhabha, Homi, ed. *Nation and Narration*, Routledge, London and New York, 1990.

Bindman, David, ed. *William Blake: Catalogue of the Collection in the Fitzwilliam Museum Cambridge*, Fitzwilliam Museum/W. Heffer and Sons, Cambridge, 1970.

Binyon, Lawrence. *English Watercolours*, 2nd edn., Black, London, 1946.

Birmingham City Museum and Art Galleries. *David Cox 1783–1859: A Bicentenary Exhibition*, Birmingham, 1983.

Blake, William. *Milton*, eds. K.P. and R.R. Easson, Thames and Hudson, London, 1978.
 The Poems, eds. W.H. Stevenson and D.V. Erdman, Longmans, London, 1971.

Bliss, Douglas Percy. *Edward Bawden*, The Pendomer Press, Godalming, undated.

Boswell, James. *Life of Johnson*, ed. G.B. Hill, 6 vols., Oxford University Press, 1934–50.

Bryson, Norman. *Looking at the Overlooked: Four Essays on Still-Life Painting*, Reaktion Books, London, 1990.
 Word and Image: French Painting of the Ancien Regime, Cambridge University Press, 1981.

Bryson, Norman, ed. *Calligram: Essays in the New Art History from France*, Cambridge University Press, 1988.

Bryson, Norman, Holly, Michael Ann and Moxey, Keith, eds. *Visual Theory: Painting and Interpretation*, Polity Press, Cambridge, 1991.

Bury, Adrian. *Rowlandson: Drawings*, Avalon Press, London, 1949.

Butlin, Martin. *The Paintings and Drawings of William Blake*, 2 vols., Paul Mellon Centre/Yale University Press, New Haven and London, 1981.

Butlin, Martin and Joll, Evelyn. *The Paintings of J.M.W. Turner*, rev. edn., Yale University Press, New Haven and London, 1984.

Chaucer, Geoffrey. *Works*, ed. F. Robinson, Oxford University Press, 1957.

Clark, Kenneth. *The Gothic Revival: An Essay in the History of Taste*, Constable and Co., London, 1928.
 'Some Recent Paintings of David Jones', *Agenda: David Jones Special Edition*, vol. 5, nos. 1–3, Spring–Summer 1967.

Clark, Michael. *The Tempting Prospect: A Social History of English Watercolours*, BM Books, London, 1981.

Clifford, D. and T. *John Crome*, Faber and Faber, London, 1958.

Cole, Alison. *Perspective*, National Gallery Publications/Dorling Kindersley, London, 1992.

Coleridge, Samuel Taylor. *Select Poetry and Prose*, ed. S. Potter, Nonesuch, London, 1971.

Constable, Freda and Simon, Sue. *The England of Eric Ravilious*, Scolar Press, London, 1982.

Cowper, William. *Poetical Works*, Drane and Chant, London, *circa* 1895.

Cox, David. *A Treatise on Landscape Painting and Effects in Water-Colours: From the First Rudiments to the Finished Picture*, S. & T. Fuller, London, 1813.

Crouan, Katharine. *John Linnell: A Centennial Exhibition*, Fitzwilliam Museum/Cambridge University Press, 1982.

Davis, Terence. *The Gothick Taste*, David and Charles, London/Newton Abbott, 1974.

Davison, Dennis, ed. *The Penguin Book of Eighteenth-Century Verse*, Penguin Books, Harmondsworth, 1973.

Derrida, Jacques. *Edmund Husserl's **Origin of Geometry**: An Introduction*, trans. J.P. Leavey, Harvester Books, Brighton, 1978.

Erdman, David V., ed. *The Poetry and Prose of William Blake*, Doubleday, New York, 1965.

Fitzgerald, F. *The Artists' Repository II*, London, 1787–90.

Fleming, John. *Robert Adam and his Circle in Edinburgh and Rome*, John Murray, London, 1962.

Foucault, Michel. *The Order of Things*, trans. A. Sheridan, Tavistock Publications, London, 1970.

Frascina, Francis and Harrison, Charles. *Modern Art and Modernism: A Critical Anthology*, Harper and Row/The Open University, London, 1982.

Freud, Sigmund. *The Standard Edition of the Complete Works of Sigmund Freud*, 24 vols., ed. James Strachey with Anna Freud, Hogarth Press, London, 1953–74.

Fry, Roger. *Vision and Design* (1920), Penguin Books, Harmondsworth, 1937.

Geffrye Museum and Birmingham City Museum and Art Gallery. *Solomon: A Family of Painters*, I.L.E.A., London, 1988.

Gibbon, Edward. *The Decline and Fall of the Roman Empire* (1787), abridged D. M. Low, Penguin Books, Harmondsworth, 1960.

Gilpin, William. *Three Essays: On Picturesque Beauty; On Picturesque Travel and On Sketching Landscape to which is Added a Poem, On Landscape Beauty* (2nd edn.; 1794), Gregg International, Westmead, Hampshire, 1972.

Girtin, T. and Loshak, D. *The Art of Thomas Girtin*, Adam and Charles Black, London, 1954.

Goldberg, N.L. *John Crome the Elder*, New York University Press, New York, 1978.

Gombrich, E.H. *Art and Illusion: A Study in the Psychology of Pictorial Representation*, 5th edn., Phaidon Press, London, 1977.

Gray, Thomas and Collins, William. *Poetical Works*, ed. R. Lonsdale, Oxford University Press, 1977.

Grigson, Geoffrey. *Samuel Palmer: The Visionary Years*, Kegan Paul, London, 1947.

Hamilton, Jean. *The Sketching Society 1799–1851*, Victoria and Albert Museum, London, 1971.

Hardie, Martin. *Watercolour Painting in Britain*, eds. Dudley Snelgrove, Jonathan Mayne and Basil Taylor, 3 vols., B.T. Batsford, London, 1966–72.

Harrison, Charles. *English Art and Modernism 1900–1939*, Allen Lane, Harmondsworth, 1981.

Harrison, Martin and Waters, Bill. *Burne-Jones*, Barrie and Jenkins, London, 1973.

Hayes, John. *Gainsborough: Paintings and Drawings*, Phaidon, London, 1975.
Rowlandson: Watercolours and Drawings, Phaidon, London, 1972.

Heath, Stephen. *Questions of Cinema*, Macmillan, Basingstoke and London, 1981.

Heidegger, Martin. *Poetry, Language, Thought*, trans A. Hofstadter, Harper and Row, New York, 1975.

Hilton, Tim. *Ruskin: The Early Years*, Oxford University Press, 1985.

H.R.H. The Prince Charles. 'The Mansion House Speech', *Modern Painters*, vol. 1, no. 1, Spring 1988, pp. 29–33.

Holcombe, Lee. *Wives and Property: Reform of the Married Women's Property Law in Nineteenth-Century England*, Martin Robertson, Oxford, 1983.

Holme, Charles. *The Royal Institute of Painters in Watercolours*, The Studio, London, 1906.

Howell, Arthur H. *Frances Hodgkins: Four Vital Years*, Rockcliff, London, 1951.

Hutchinson, S.C. *The History of the Royal Academy 1768–1968*, 2nd edn., Robert Royce, London, 1986.

Hyde, Ralph. *Panoramania! The Art and Entertainment of the All-Embracing View*, Trefoil Publications, London, 1988.

Jones, David. *The Dying Gaul and Other Writings*, ed. H. Grisewood, Faber and Faber, London, 1978.

Epoch and Artist, ed. H. Grisewood, Faber and Faber, London, 1959.

In Parenthesis (1937), Faber and Faber, London, 1982.

Kauffmann, C.M. *John Varley 1778–1842*, B.T. Batsford/Victoria and Albert Museum, London, 1984.

Keats, John. *The Poetical Works*, ed. H. W. Garrod, 2nd edn., Clarendon Press, Oxford, 1958.

Knowles, J., ed. *The Life and Writings of Henry Fuseli*, 3 vols., London, 1831.

Koerner, Joseph Leo. 'Borrowed Sight: The Halted Traveller in Caspar David Friedrich and William Wordsworth', *Word and Image*, vol. 1, no. 2, April–June 1985, pp. 149–63.

Lacan, Jacques. *Ecrits*, trans. A. Sheridan, Tavistock Publications, London, 1977.

Lambourne, Lionel and Hamilton, Jean, eds. *British Watercolours in the Victoria and Albert Museum: An Illustrated Summary Catalogue of the National Collection*, Sotheby Parke Bernet, London, 1980.

Larrisy, Edward. *William Blake*, Oxford University Press, 1985.

Lewis, M. *J.F. Lewis R.A. 1805–1876*, F. Lewis, London, 1978.

Lister, Raymond. *Samuel Palmer and the 'Ancients'*, Fitzwilliam Museum, Cambridge, 1984.

Lyotard, Jean-François. 'The Dream-Work Does Not Think', trans. Mary Lydon, *Oxford Literary Review*, vol. 6, no. 1, 1983, pp. 3–34.

Mallalieu, H.L. *The Dictionary of British Watercolour Artists up to 1920*, 2nd edn., 3 vols., Antique Collectors Club, Woodbridge, Suffolk, 1986.

Malthus, Thomas Robert. *An Essay on the Principle of Population and A Summary View of the Principle of Population*, ed. Antony Flew, Penguin Books, Harmondsworth, 1970.

Milano, Paolo, ed. *The Portable Dante*, Penguin Books, Harmondsworth, 1977.

Mitchell, Peter. *European Flower Painting*, Adam and Charles Black, London, 1973.

Morris, David. *Thomas Hearne 1744–1817: Watercolours and Drawings*, Bolton Museum and Art Gallery, 1985.

Noakes, Vivien. *Edward Lear 1812–1888*, Royal Academy of Arts/Weidenfeld, London, 1988.

Oppé, A.P. 'Francis Towne, landscape painter', *Proceedings of the Walpole Society*, vol. 8, London, 1919–20.

Orton, Fred and Pollock, Griselda. 'Les Données Bretonnantes: La Prairie de la Représentation', *Art History*, vol. 3, no. 3, September 1980, pp. 314–44.

Palmer, A.H. *The Life and Letters of Samuel Palmer Painter and Etcher.* (1892), Eric and Joan Stevens, London, 1972.

Parris, Leslie, Fleming-Williams, Ian and Shields, Conal. *Constable: Paintings, Watercolours and Drawings*, Tate Gallery, London, 1976.

Paul Mellon Foundation. *Francis Wheatley R.A. 1747–1801; Paintings, Drawings and Engravings*, Aldeburgh, 1965.

Paulson, Ronald. *Hogarth's Graphic Works*, 2 vols., rev. edn., Yale University Press, New Haven and London, 1970.

Pevsner, Nikolaus. *The Sources of Modern Architecture and Design*, Thames and Hudson, London, 1968.

The Pilgrim Trust. *Recording Britain*, ed. A. Palmer, 4 vols., Geoffrey Cumberledge/Oxford University Press, London, 1946–9.

Pointon, Marcia. *The Bonington Circle: English Watercolour and Anglo-French Landscape 1790–1855*, Hendon Press, Brighton, 1985.

 Bonington, Francia and Wyld, B.T. Batsford and Victoria and Albert Museum, London, 1985.

Pointon, Marcia, ed. *Pre-Raphaelites Re-Viewed*, Manchester University Press, 1989.

Pragnell, H.J. *The London Panoramas of Thomas Barker and Thomas Girtin*, London Topographical Society Monograph no. 109, London, 1968.

Redgrave, Richard and Samuel. *A Century of British Painters.* (1866), Phaidon Press, London, 1947.

Reynolds, Graham. *British Watercolours*, Victoria and Albert Museum, London, 1951.

Reynolds, Joshua. *Discourses on Art*, ed. R.R. Wark, Yale University Press, New Haven and London, 1975.

Roget, J.L. *A History of the 'Old Water-Colour' Society Now the Royal Society of Painters in Water Colours*, 2 vols., Longmans, Green and Co., London, 1891.

Rose, Gillian. *The Broken Middle: Out of Our Ancient Society*, Blackwell, Oxford, 1991.

Rosenthal, Michael. *Constable: The Painter and His Landscape*, Yale University Press, New Haven and London, 1983.

Rossetti, W.M., ed. *Ruskin, Rossetti, Pre-Raphaelitism: Papers 1854–1862* (1899), AMS Press, New York, 1971.

Rothenstein, John. *Edward Burra*, Tate Gallery, London, 1973.
 Modern English Painters II: Nash to Bawden, Macdonald, London, 1984.

Roundell, James. *Thomas Shotter Boys 1803–1874*, Octopus Books, London, 1974.

Rousseau, Jean Jacques. *Reveries of the Solitary Walker*, trans. P. France, Penguin, Harmondsworth, 1979.

Ruskin, John. *The Works of John Ruskin*, eds. E.T. Cook and A. Wedderburn, 39 vols., George Allen, London, 1903–12.

Sandby, William. *Thomas and Paul Sandby, Royal Academicians*, Seeley and Co. Ltd., London, 1892.

Schapiro, Meyer. *Modern Art: 19th and 20th Centuries*, George Braziller, New York, 1978.

Scrase, D. *Drawings and Watercolours by Peter De Wint*, Fitzwilliam Museum/Cambridge University Press, 1979.

Sim, K. *David Roberts R.A. 1796–1864: A Biography*, Quartet, London, 1984.

Sloan, Kim. *Alexander and John Robert Cozens: The Poetry of Landscape*, Yale University Press, New Haven and London, 1986.

Solkin, David H. *Richard Wilson and the Landscape of Reaction*, Tate Gallery, London, 1982.

Spalding, Frances. *Magnificent Dreams: Burne-Jones and the Late Victorians*, Phaidon, Oxford, 1978.

Spencer, Gilbert. *Memoirs of a Painter*, Chatto, London, 1974.

Stephen, L. and Lee, S., eds. *Dictionary of National Biography*, 22 vols., Smith Elder and Co., London, 1885–1901.

Stokes, Adrian. *The Image in Form: Selected Writings of Adrian Stokes*, ed. R. Wollheim, Penguin Books, Harmondsworth, 1972.

Surtees, Virginia. *The Paintings and Drawings of Dante Gabriel Rossetti (1828–1882): A Catalogue Raisonné*, 2 vols., Clarendon Press, Oxford, 1971.

Surtees, Virginia, ed. *The Diaries of George Price Boyce*, Real World, Norwich, 1980.

Tate Gallery. *Henry Fuseli*, London, 1975.

David Jones, London, 1981.

John Piper, London, 1983.

The Pre-Raphaelites, Tate Gallery/Penguin Books, London, 1984.

Taylor, Basil. *Joshua Cristall 1768–1847*, Victoria and Albert Museum, London, 1973.

Thomson, James. *Poetical Works*, William Nimmo, London and Edinburgh, 1878.

Wallace Collection. *Pictures and Drawings: Text with Historical Notes*, 6th edn., William Clowes and Sons Ltd., London, 1968.

Warner, Marina. *Monuments and Maidens: The Allegory of the Female Form*, Pan Books, London, 1987.

Watney, Simon. *English Post-Impressionism*, Studio Vista/Eastview Editions, London, 1980.

Webster, Mary. *Francis Wheatley*, Paul Mellon Foundation, London, 1970.

Whitworth Art Gallery/Victoria and Albert Museum. *Watercolours by Thomas Girtin*, London, 1975.

Williams, Iolo A. *Early English Watercolours and Some Cognate Drawings by Artists Born Not Later than 1785*, The Connoisseur, London, 1952.

Williams, Neville. *Chronology of the Modern World 1763–1965*, Penguin Books, Harmondsworth, 1975.

Wilton, Andrew. *The Art of Alexander and John Robert Cozens*, Yale Center for British Art, New Haven, 1980.

The Life and Work of J.M.W. Turner, Academy Editions, London, 1979.

Wordsworth, William. *The Prelude, 1799, 1805, 1850*, eds. J. Wordsworth, M.H. Abrams and S. Gill, Norton, New York, 1979.

Wordsworth, William and Coleridge, Samuel Taylor. *Lyrical Ballads* (1798), ed. H. Littledale, Oxford University Press, London, 1931.

Yeats, William Butler. *The Poems*, ed. R.J. Finneran, Collier Macmillan, New York, 1983.

Index of artists

Abbott, John White, *Corra Linn, One of the Falls of the Clyde* *page* 38

Adam, Robert, *Romantic Landscape, with Figures crossing a Bridge* 66

Alexander, William, *Emperor of China's Gardens, Imperial Palace, Pekin* 138

Allingham, Helen, *Cottage at Chiddingfold, Surrey* 176

Barber, Charles Vincent, *On the River Mawddach, Merionethshire, Cader Idris in the Distance* 76

Bawden, Edward, *'Christ! I have been many times to Church'* 234

Beauclerk, Diana, *Group of Gypsies and Female Rustics* 30

Bell, Vanessa, *Flower-Piece* 214

Bevan, Robert Polehill, *Rosemary, Devon* 222

Blake, William, *Christ in the House of Martha and Mary* or *The Penitent Magdalen* 120

Blake, William, *Moses and the Burning Bush* 118

Bonington, Richard Parkes, *Corso Sant'Anastasia, Verona, with the Palace of Prince Maffei* 142

Boyce, George Price, *Tithe Barn, Bradford-on-Avon* 174

Boys, Thomas Shotter, *Quai de la Grève, Paris, in 1837* 144

Brown, Ford Madox, *Elijah Restoring the Widow's Son* 128

Burne-Jones, Edward Coley, *Dorigen of Bretaigne longing for the Safe Return of her Husband* 130

Burra, Edward, *Back Garden* 226

Byrne, Anne Frances, *Roses and Grapes* 204

Cattermole, George, *Interior of a Baronial Hall* *page* 172

Catton, Charles, *View of the Bridges at Hawick* 34

Chase, Marian Emma, *Wild Flowers* 212

Chatelain, John Baptist Claude, *A View from the Summer House in Richmond Park down the River Thames* 44

Clennell, Luke, *The Sawpit* 162

Constable, John, *Design for an Illustration to Gray's 'Elegy', Stanza 3* 84

Constable, John, *Stoke Poges Church, Buckinghamshire: Illustration to Thomas Gray, 'Elegy in a Country Churchyard'* 82

Constable, John, *View in Borrowdale* 80

Cotman, John Sell, *The Devil's Bridge, Cardigan* 86

Cotman, John Sell, *Interior of Crosby Hall* 170

Cotman, John Sell, *On the Tees at Rockcliffe* 88

Cox, David, *Water Mill, North Wales* 168

Cox, David, *A Welsh Landscape* 78

Cozens, Alexander, *Landscape* 62

Cozens, John Robert, *Mountainous Landscape, with Beech Trees* 70

Cozens, John Robert, *View in the Island of Elba* 68

Cristall, Joshua, *Hastings Beach* 90

Crome, John, *Old Houses at Norwich* 164

Dayes, Edward, *Buckingham House, St James's Park* 56

De Wint, Peter, *Old Houses on the High Bridge, Lincoln* 166

De Wint, Peter, *Still Life. A Barrel, Jug, Bottle, Basin etc. on a Table* 208

Dighton, Robert, *A Windy Day – Scene outside the Shop of Bowles, the Printseller, in St Paul's Churchyard* 58

Elmore, Alfred, *Two Women on a Balcony* *page* 148

Fielding, Anthony Vandyke Copley, *The Moor of
 Rannoch, Perthshire, Schiehallion in the Distance* 190
Forrest, Thomas Theodosius, *York Stairs, the Thames,
 Blackfriars Bridge and St Paul's Cathedral* 46
Fuseli, Henry, *Woman in Fantastic Costume* 116

Gainsborough, Thomas, *Landscape: Storm Effect* 64
Ginner, Charles, *Through a Cornish Window* 228
Girtin, Thomas, *Louth Church, Lincolnshire* 96
Girtin, Thomas, *Porte St Denis, Paris* 100
Girtin, Thomas, *Rievaulx Abbey, Yorkshire* 98

Hearne, Thomas, *Durham Cathedral from the Opposite
 Bank of the Wear* 94
Hewlett, James, *Hollyhock, Roses etc.* 202
Hodgkins, Frances, *In Perspective* 240
Holland, James, *Hospital of the Pietà, Venice* 146
Hunt, William Henry, *Hawthorn Blossoms and Bird's Nest* 210

Innes, James Dickson, *Seaford* 220

Johnson, Edward Killingworth, *A Young Widow* 132
Jones, David, *No. 1 Elm Row* 230
Jones, David, *The Violin* 216

Kennedy, John, *Rumbling Bridge, near Dunkeld* 196
Kerr, Louisa Hay [Mrs Alexander Kerr], *Opium
 or White Poppy* 206

Lear, Edward, *Tripolitza* 156
Lewis, John Frederick, *The Hhareem* 152
Lewis, John Frederick, *Life in the Harem, Cairo* 154
Linnell, John, *Collecting the Flock* 188
Lister, Harriet [Mrs Amos Green], *View of the Castle
 and Cavern at Castleton, Derbyshire* 40

Millais, John Everett, *The Eve of St Agnes: Interior
 at Knole near Sevenoaks* 122
Moore, Albert, *An Open Book* 134
Moser, Mary, *Vase of Flowers* 200

Nash, Paul, *Old Front Line, St Eloi, Ypres Salient* 224
North, John William, *1914 in England* 180

Pain, Robert Tucker, *A Misty Morning at
 Tal-y-Llyn, North Wales* *page* 194
Palmer, Samuel, *At Score, near Ilfracombe* 184
Palmer, Samuel, *Landscape with a Barn, Shoreham, Kent* 186
Pars, William, *Killarney and Lake* 32
Pars, William, *St Peter's, Rome: View from above the Arco
 Scuro, near Pope Julius' Villa* 28
Piper, John, *The River Approach, Fawley Court,
 Buckinghamshire* 238
Prout, Samuel, *Porch of Ratisbon [Regensburg] Cathedral* 140

Ravilious, Eric, *A Farmhouse Bedroom* 236
Roberts, David, *The Interior of the Capilla de los Reyes
 in Granada Cathedral, showing the Tombs of Ferdinand
 and Isabella, Philip and Juana* 150
Rossetti, Dante Gabriel, *The Borgia Family* 124
Rowlandson, Thomas, *Vauxhall Gardens* 54
Ruskin, John, *Pines under the Petit Charmoz* 192

Sandby, Paul, *Moonlight on a River* 48
Sandby, Paul, *The 'Old Swan', Bayswater* 52
Sandby, Paul, *The Round Temple* 50
Skelton, Jonathan, *Tivoli: The Great Cascade* 26
Solomon, Simeon, *Isaac and Rebecca* 126
Spencer, Gilbert, *Winter Landscape seen through 232
 a Window* 178
Stocks, Walter Fryer, *The Last Gleam*
 36
Towne, Francis, *Rydal Water* 102
Turner, Joseph Mallord William, *Interior of 108
 Tintern Abbey*
Turner, Joseph Mallord William, *Lyons* 106
Turner, Joseph Mallord William, *Vignette: Linlithgow
 Palace by Moonlight* 104
Turner, Joseph Mallord William, *Warkworth Castle,
 Northumberland* 160
 74
Varley, Cornelius, *The Market Place, Ross, Herefordshire* 72
Varley, Cornelius, *Part of Cader Idris and Tal-y-Llyn*
Varley, John, *View in the Pass of Llanberis* 112
 114
Wheatley, Francis, *The Dismissal* 24
Wheatley, Francis, *The Reconciliation*
Wilson, Richard, *Landscape*